Cold War Photographic Diplomacy

Cold War Photographic Diplomacy

The US Information Agency and Africa

Darren Newbury

The Pennsylvania State University Press
University Park, Pennsylvania

Publication of this book has been aided by a grant from the Wyeth Foundation for American Art Publication Fund of CAA.

Library of Congress Cataloging-in-Publication Data
Names: Newbury, Darren, author.
Title: Cold War photographic diplomacy : the US Information Agency and Africa / Darren Newbury.
Other titles: US Information Agency and Africa
Description: University Park, Pennsylvania : The Pennsylvania State University, [2024] | Includes bibliographical references and index.
Summary: "Examines the United States Information Agency's program of photographic diplomacy with Africa, locating photography at the intersection of African decolonization, racial conflict in the United States, and the cultural Cold War"—Provided by publisher.
Identifiers: LCCN 2023040125 | ISBN 9780271095677 (hardback)
Subjects: LCSH: United States Information Agency—History. | Cold War—Photography. | Photography—Political aspects—United States—History—20th century. | Photography—Political aspects—Africa—History—20th century. | United States—Foreign relations—Africa. | Africa—Foreign relations—United States. | United States—Foreign relations—20th century. | Africa—Foreign relations—20th century.
Classification: LCC DT38.7 .N49 2024 | DDC 909.82/50222—dc23/eng/20230927
LC record available at https://lccn.loc.gov/2023040125

The Pennsylvania State University Press is a member of the Association of University Presses.

It is the policy of The Pennsylvania State University Press to use acid-free paper. Publications on uncoated stock satisfy the minimum requirements of American National Standard for Information Sciences—Permanence of Paper for Printed Library Material, ANSI Z39.48–1992.

Contents

Illustrations

The illustrations are derived from a variety of archival source materials: magazines, pamphlets, posters, original and copy negatives, contact sheets, and work prints of varying quality. Many of the originals bear the marks of their lives, first as working objects, and subsequently as archived ones, including crop marks and numbering in chinagraph pencil, as well as damage that has occurred over time. The reproductions here are intended to convey these markers of material history alongside the visual qualities of the photographs as images. The captions provide archival references, down to item level where possible, with quotations from original captions where these were present in the relevant archive file. Where an image is reproduced from an alternative source, as for example with UN photographs, both the image source and the USIA file location are referenced. The dates given are typically when the photograph was acquired or the assignment arrived with the agency, which may differ from when the photograph was made, in some cases by a few days, in others by months or years.

Preface

This book has its origins in an earlier research project on photography in South Africa. In 2010, twenty years after his death, the file held by the South African security services on photographer Ernest Cole became available under Freedom of Information legislation. The records it contained shed light on how the South African state viewed the young Black photographer and what they knew of his movements during the period immediately before his departure into exile in 1966. More important here, however, is what it revealed of his relationship to the public diplomacy arm of the US government during those last few weeks in the country. In seeking to ensure the protection of his negatives, and their safe passage abroad, Cole turned to the United States Information Service (USIS), making use of the support and encouragement they offered to young Black photographers and journalists. The security records recount that on April 25, 1966, just two weeks before he left South Africa, Cole went into the USIS offices in central Johannesburg to retrieve a collection of photographic negatives. In exile, Cole composed a letter to friend and fellow photographer Struan Robertson instructing him to contact someone named Rockweiler at the USIS office to arrange for his remaining negatives to be transported to London. Robert A. Rockweiler was director of the USIS office in Johannesburg in the mid-1960s.[1]

Cole is one of the most important Black photographers to emerge from South Africa during the apartheid period, and this incident adds to the intrigue surrounding his departure. But in seeking to understand its significance, I began to wonder more and more about what the public diplomacy arm of the US government was doing supporting a young and largely unknown Black photographer. It turns out that Cole's relationship with the USIS was hardly unusual. Since the late 1950s, USIS had begun to cultivate relationships with the non-White press in South Africa, even organizing "teas" on their premises in Johannesburg to "develop closer relationships" with Black editors and to provide their staff with "an opportunity to mingle with friendly, white Americans in a pleasant setting."[2] Broader questions began to take shape about the political context that fostered this engagement. What was the role of the United

States Information Agency (USIA) in South Africa, and indeed elsewhere on the continent, during this period? And how did photography feature in its activities? Before coming across this note in Cole's security file, I had little knowledge of USIA operations in Africa. Like many other photographic historians, no doubt, I was aware of USIA sponsorship for the global tour of Edward Steichen's exhibition *The Family of Man*. I had earlier argued that a number of South African photographers, including Cole, had been influenced by its presentation in Johannesburg in ways that challenged orthodox readings. Yet I soon discovered that USIA was engaged in the production of a vast amount of photographic material for dissemination overseas, material that is largely absent from the photo-historical literature. From the late 1950s, this program began to take a particular shape as it engaged with African decolonization abroad and racial conflict at home. It is almost as if, having defined Steichen's exhibition as the high point of a particular politically compromised form of photographic humanism or universalism, a chapter of photographic history was closed. If it is true from an art historical perspective that the late 1950s and early 1960s were a pivotal point for photography, the empirical weight of the USIA material and its internationalized production and dissemination suggested that there was something else to be accounted for here. This book is an attempt to grapple with the substantial collection of photographs and documents that comprise the USIA archive, and to delineate USIA's engagement with Africa, as both an idea and a continent of independent postcolonial nations coming into being.

Acknowledgments

No research project can be successful without the support, encouragement, and insights of others along the way, and I am grateful to the many people who have contributed to this book in large and small ways, knowingly or not. None of them bear responsibility for its flaws. I have been fortunate to present this research in progress at several conferences, symposia, and workshops. I am especially grateful to the late Andrea Noble and her colleague Thy Phu who invited me to join the Cold War Camera workshops in Guatemala and Mexico when this project was just beginning to take shape. Early versions of material published here have also been presented at the *17th ACASA Triennial Symposium on African Art*, Accra; *The Visual Subject*, University of the Western Cape, Cape Town; *Pictures of War: The Still Image in Conflict Since 1945*, Manchester Metropolitan University; *Aesthetics from the Margins*, Centre for African Studies, University of Basel; *Photographies in Motion: Explorations Across Space, Time, and Media*, University of Western Australia, Perth; *Towards a Political History of Photography: Social Movements and Photographic Practices*, Museo Nacional Centro de Arte Reina Sofia, Madrid; *Camera Education: Photographic Histories of Visual Literacy, Schooling and the Imagination*, Photographic History Research Centre, De Montfort University, Leicester; *The Politics of the Page: Visuality and Materiality in Illustrated Periodicals across Cold War Borders*; *Decolonisation and Photography in Africa*, Birkbeck History and Theory of Photography Research Centre; and the Royal Anthropological Institute. I want to thank the organizers of these events for the invitations to speak, and the participants for the feedback and insights they provided.

A number of archivists and librarians have assisted this project. Nick Natanson at the US National Archives provided insights into the USIA collections early on, which helped guide my initial enquiries, and the staff who work with the photography collections at College Park have always been helpful and made this a pleasant environment in which to work. I am grateful, too, to the staff who work in the more pressured environment of the document collections, and to Paul Watson who carefully scanned photographs and documents when the pandemic prevented me from traveling to Washington.

I thank the Lyndon Baines Johnson Foundation for the award of a Moody Foundation research grant, which made possible research at the LBJ Presidential Library in Austin, and Jenna De Graffenried who provided advice and support on using the collections. Archivists at the United Nations Photo Library and UNESCO, specifically Eng Sengsavang, have assisted with my enquiries relating to specific images and publications. I thank the University of Brighton for supporting research leave and travel that has enabled my research in the US, as well as attendance at several conferences, and contributing to the costs associated with image-based research and publication.

I am grateful to the following individuals and organizations who have assisted with picture research or granted permission for the use of photographs: Bill Cain; John P. Chapnick, Black Star Publishing Co.; Vanessa Erlichson, Polaris Images; Jon Gartenberg, Gartenberg Media Enterprises; Tutti Jackson, Ohio History Connection; Rowland Scherman; Laura Watts, Shutterstock; UNESCO; the United Nations; Vickie Wilson, Getty Research Institute; and Susan Wood. I am especially grateful to the Wyeth Foundation for American Art, in conjunction with the College Art Association, for the award of a publishing grant, enabling production values that do justice to the material. My sincere thanks go to Ellie Goodman, who saw the value of the project early on, and to all the staff at Penn State University Press who have assisted in bringing the book to publication.

I am indebted to many colleagues for assistance and encouragement as this project has evolved, and for the ways in which their own research has helped shape my understanding of the relationship between photography and history. In particular, I would like to thank Chris Morton, Lorena Rizzo, Kylie Thomas, and Richard Vokes, with whom I have had the great pleasure of collaborating on editing projects; as well as Ariella Azoulay; Jennifer Bajorek; Erina Duganne; Elizabeth Edwards; Tamar Garb; Erin Haney; Patricia Hayes, whose research on African photographic histories has provided an important touchstone; Gil Pasternak; Thy Phu; and Kelley Wilder.

This book is dedicated to the memory of my father, John Newbury (1939–2021).

Abbreviations

ANLCA	American Negro Leadership Conference on Africa
AP	Associated Press
BLM	Black Lives Matter
CIA	Central Intelligence Agency
COFO	Council of Federated Organizations
CPAO	Country Public Affairs Officers
CRC	Civil Rights Congress
CUT	Comité de l'unité togolaise
FAO	United Nations Food and Agriculture Organization
Frelimo	Frente de Libertação de Moçambique
FSA	Farm Security Administration
ICS	Information Center Service
IIA	International Information Administration
IMP	International Motion Picture Division
IMS	Motion Picture Service
INP	International Press and Publications Division
IPS	Press and Publications Service
Juvento	Mouvement de la jeunesse togolaise
NAACP	National Association for the Advancement of Colored People
NMAAHC	National Museum of African American History and Culture
OAU	Organisation of African Unity
OPS	Office of Public Safety
OWI	Office of War Information
PAO	Public Affairs Officer
RPC	Regional Production Center
RSC	Regional Service Center
SCLC	Southern Christian Leadership Conference
SNCC	Student Nonviolent Coordinating Committee
SPSS	Special Protocol Service Section
UN	United Nations

UNESCO	United Nations Educational, Scientific and Cultural Organization
USAID	United States Agency for International Development
USIA	United States Information Agency
USIS	United States Information Service
VOA	Voice of America

Photography, Race, and the Cold War Imagination

In the spring of 1952, the Office of Intelligence Research in the US Department of State convened a working group on "Racial Problems in Propaganda."[1] The initiative brought together representatives of the various media operations of the International Information Administration (IIA), a forerunner of the United States Information Agency (USIA), with representatives of regional bureaus, to begin to shape a more informed and better coordinated approach to handling race in international information and propaganda activities. There was no shortage of consideration of racial issues across the department and beyond; a "large accumulation of policy statements, position papers . . . and operating instructions governing media output and field programming" already existed.[2] Nevertheless, they felt that there was a pressing "need for policy and operational coordination," and a "basic document" on the question was "long overdue." The preliminary deliberations of the working group underscore the rise to prominence of "race" in the US government's diplomatic relations with the postwar world and provide an insight into the coordinates within which thinking on race in US foreign policy was framed.[3] The increasingly self-conscious and programmatic approach to the representation of race in US propaganda output taking shape during this period provides a necessary context for understanding the US government photography that is at the center of this study. The preoccupations and anxieties surrounding race and its relationship to foreign policy would only increase over the years ahead, becoming a central consideration in the information and media campaigns that issued from Washington, not least those directed at newly independent nations in Africa and the Third

World.[4] There were some dissenting voices; one of the contributors to the working group speculated that "undue emphasis on the progress of Negroes in the US might only seem to reveal the self-consciousness of an egocentric nation." But at this stage at least, they were in a minority.

For the main protagonists in this narrative, "race" was understood primarily as a social and historical (and to some extent political) category, largely, though not entirely, absent of the biological connotations that had marked the term's earlier history in colonial contexts. The emphasis was on social progress, integration, and civil rights as they were by turns enabled by US democracy and thwarted by the continued presence of White supremacy in US society. Predictably, despite appeals for a comprehensive approach, the priority was "the Negro question," which it was agreed "should be taken up first." This, it hardly needs stating, was a reaction to the widespread perception of racial injustice in the US among foreign publics. The Soviet Union was accused of leading the propagation of this partial and "distorted" view of the US, its coverage described as "unfair" in its failure to present any positive facts and, from the later 1940s, increasingly "lurid and fantastic." Among the materials brought together to inform the working group was an extensive list of charges made via Soviet media outlets on the treatment of African Americans, from employment discrimination and disenfranchisement to the prevalence of lynching in southern states. The presence of African Americans in prominent positions in public life was dismissed as "stage effects for American democracy."

In a US being shaken by McCarthyism, it is no surprise that there was a preoccupation with communist propaganda successes; however, the range of views expressed within the collated reports begins to hint at a more complex set of considerations. It was not simply a matter of combating Soviet propaganda and its allegedly distorted presentation of the US. Race was an issue with a much wider resonance for the postwar world. A report from the International Motion Picture Division (IMP) stressed that foreign attitudes to race in the US were "not mainly inspired by Communist charges" but rather "part of a vast world-wide trend, 'a rising tide of democratic sentiment and enlightenment.'" The second part of the sentence was underlined.

Regional reports outlined the salience of the issue to foreign populations and suggested that any approach needed to be attentive to the preoccupations of local audiences; however, they, too, hinted at shifting historical and political temporalities. Significant interest in the "Negro problem" in the US was recorded among many European audiences, particularly in relation to high-profile cases of racial injustice. Although US policy makers were mindful of the need to observe colonial sensitivities among European nations, and the "delicate" nature of distributing material promoting racial equality in East and Southern Africa, the populations of several countries

were recognized as having strong views on racial injustice. "Practically every Scandinavian," for example, had an opinion on the treatment of African Americans—"almost without exception" unfavorable to the US. In Germany, interpretation took a different inflection, directed backward toward the conflict from which the world had only recently emerged. Widespread German interest in coverage of racial incidents in the US was believed to be motivated by defensiveness and guilt in relation to recent history, as well as a reaction to Allied reeducation programs: "Germans of many political orientations use US racial discrimination to explain away Germany's persecution of the Jews, or to show that the Americans, who preach democracy in Germany, are really as bad as the Nazis at home."[5] Yet, at the same time, one can begin to make out the contours of an emerging postcolonial consciousness. In India, where attitudes were described as "complex," "Every American who goes to the area has to deal with frequent questions on the subject."[6] And, if racial discrimination was generally regarded to be of "low marginal importance" in the Far East, Indonesia stood out as an exception. African perspectives, on the other hand, are notable by their absence. There was a brief description of Muslim Arabs as "not concerned with the problem because they do not regard themselves as a colored race," issued from the Near East Bureau, which at this time also had responsibility for North, Central, and Southern Africa. And it was noted that communist material directed to sub-Saharan Africa often stressed the "Negro problem" in the US. But there was neither commentary nor analysis of the views of African populations or African press coverage. Although African decolonization was visible on the horizon, engagement with the continent was at an early stage in the evolution of US policy toward the postcolonial world.

Among the IIA media divisions, the fullest response to the "problem" of representing race in the US was prepared by IMP. The report acknowledged the significance of statements on race published by the United Nations Educational, Scientific and Cultural Organization (UNESCO) at the beginning of the decade, and the pamphlet *The Negro in American Life* (fig. 1) recently produced by the International Press and Publications Division (INP). The latter was distributed in multiple languages across Europe and Asia—a quarter of a million copies were printed for Germany—and provided a historical narrative of racial progress, heavily illustrated with photographs of integration across education, employment, housing, and the military, and including portraits of notable African Americans in culture and public life.[7] One of IMP's main conclusions was that although some material was "too obvious" in its treatment of African Americans, in the main the subject had hitherto been dealt with indirectly—"Charges have been answered only by implication." The indication, then, was to move US coverage of racial issues in a more explicit direction, toward what it described as an honest and frank approach, characterized in the following manner: "Of course, this is a

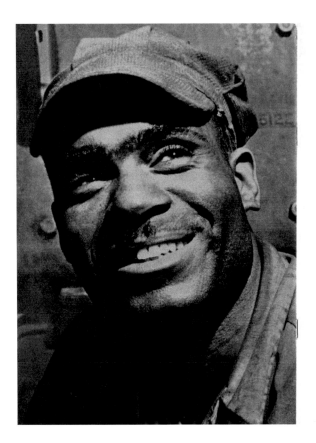

THE NEGRO
IN AMERICAN LIFE

Fig. 1 *The Negro in American Life*, 1952 (inside cover). Master File Copies of Pamphlets and Leaflets, Box 16, RG306, NARA. [Declassified Authority: NND30995.]

serious problem. But everybody in the US recognizes it, and we're doing a great deal to solve it." Or, citing from the INP pamphlet, "the truth lies neither in the exceptional [Ralph] Bunches nor in the exceptional lynchings."

Significant for the discussion here is the clear division between those aspects it recommended be dealt with through words and those suited for visual treatment: "The commentary should be used for the honest and unfavorable statements. The pictures should stress the progress made, with few if any seamy side pictures because they will be remembered longer than the commentary." The report entertained debates over the extent to which material should take a historical approach, with some arguing that audiences "may remember the bad yesterday better than the brighter today," and the balance between representing the experiences of ordinary African Americans versus profiles of prominent figures. The latter, it was suggested, may have already reached its saturation point. The Near East office, for example, explicitly stated that it did not want anything further on Ralph Bunche. The report also called for careful consideration of

"the degree of . . . pigmentation" in the presentation of material to audiences in India, for example. The most remarkable observation, however, was that the authors felt there remained a "final possibility": "If production is delayed long enough it is conceivable that Negroes would be so accepted that they would no longer be an issue." This possibility is described as "remote," in view of "Communists keeping the issue alive and the political struggles of colored nations abroad," but it was an extraordinary conclusion nonetheless. It revealed a startling lack of understanding of the problems at home on the part of those charged with communicating to the wider world.

It is not clear if this working group produced the intended "comprehensive statement"—it is not present in the archived file—but the question of race was one that would continue to demand attention and generate debate. The following year, and with a new US president in office, another working group was formed, this time under the title "Minorities in the United States."[8] Overlap with the previous membership was minimal, and its scope extended beyond fact-finding and programming considerations to include plans for use in the field, including the deployment of "minority" personnel abroad, but its deliberations echoed those above. Soviet coverage of racial strife in the US was accused of "transferring the worldwide revulsion against Nazism and its genocidal policies to the United States as the 'heirs of Hitler.'" With respect to European audiences, the report asked: "Does a more balanced knowledge of Negro progress in the United States influence a European to look more favorably on NATO?" The question was not simply rhetorical but rather was intended to set the agenda for research. If the views of audiences beyond Europe still appeared to be of secondary importance, there was nevertheless a growing awareness here, too, that the racial situation in the US was seen through an anti-colonial or postcolonial lens, recognition that "resentment in some areas against imputation of racial inferiority inherent in some past and present colonial situations" would inform responses to its coverage. It was not until December 1958, however, that the first reasonably comprehensive and authoritative set of guidelines on the subject was published, in the form of "Basic Planning and Guidance Paper No. 5."[9] By that time USIA had been in operation as an independent agency for five years, and in relation to race, much water had flowed under the bridge, some of it stained with the blood of racial violence—the paper references the murder of Emmett Till, *Brown vs. Board of Education*, and Little Rock, as well as the emergence of an Afro-Asian bloc. Race was now squarely on the foreign policy agenda.

Intertwined in this short narrative of the early evolution of US information policy on race are the main political and ideological currents that would shape the practice of government photography through the next decade and more: Cold War anti-communism, postwar anti-racism, civil rights, and postcolonial independence. The concerns packed into the working group documents would unfold into an extended visual

program. This book is a history of the photography that formed a central part of that program, as it was shaped for and by US diplomatic engagement with African nations during the period of decolonization from the late 1950s through the late 1960s. The study locates photography at the intersection of African decolonization, racial conflict in the US, and the cultural Cold War. The emergence of newly independent African nations on the world stage precipitated a contest for influence on the continent by the Cold War superpowers, which for the first time had African populations as its audience.[10] At the same time, the increasing global visibility of racial injustice and the struggle for civil rights undermined US claims to transcend colonial racism.

Race was at the heart of the Cold War imagination. The East-West ideological divide between a US model of capitalism and democracy and Soviet communism provided without doubt the central framing of the Cold War, but as recent scholarship on public diplomacy has demonstrated, the challenge that racial discrimination and the struggle for civil rights presented to the US image abroad meant that race was a significant site of contestation from the outset.[11] Even before civil rights activism achieved significant momentum and media coverage, "instances of racial terror were common enough that the Soviet public diplomats never wanted for material."[12] Soviet propagandists saw racial discrimination as a weakness in the US appeal to world opinion that they could exploit; and, in turn, the US found it necessary to put considerable effort into countering international perceptions of racial injustice. Mary Dudziak goes further, arguing that the priority given to civil rights under successive US administrations should be understood in the light of the foreign policy implications of what might otherwise have been regarded as a domestic issue: "US government officials realized that their ability to promote democracy among peoples of color around the world was seriously hampered by continuing racial injustice at home."[13] Moreover, as Jason Parker points out, what had begun as a bipolar confrontation, "evolved over time into a multipolar conversation" and, albeit slowly, the US began to understand the global south in terms beyond the lens of Cold War binarism.[14]

This book is not, or at least not only, a study of photography as propaganda. It would be a mistake to see photography as entirely instrumentalized in its deployment by the US government during the Cold War. The term "propaganda" is too constraining. In the postwar period, photography provided a medium of political imagination, extending beyond national boundaries.[15] While far from being autonomous in the setting of the Department of State and USIA, the medium nevertheless enfolded a history and set of ideas that exceeded any specific uses and shaped its reception across a range of contexts. At least some of those who were involved in this visual program were aware of the medium's currency in the postwar world and realized that anything they produced was in negotiation with the many photographic images beginning to

circulate more widely and rapidly across the globe. More or less self-consciously, they sought to harness a specifically postwar photography to the US diplomatic project.

Empirically, the study concentrates on the extensive, yet clearly demarcated, output of USIA, whose archives reveal an extended photographic project evolving in concert with the engagement with postcolonial Africa—a photography of relations. This represents a distinctive, yet underresearched, strand of Cold War photography. The USIA program of photographic diplomacy in Africa had several dimensions: the practice of photographing the political, cultural, and educational visits of Africans to the US, which provided a space for the imagination of international cooperation and friendship; the representation of the civil rights struggle for international audiences, presented as an example of democracy in action; and the picturing of a world of integration and racial coexistence. Ironically, the latter demanded an ever more intensive focus on the visual dynamics of racial interaction and representation. The later chapters take up these dimensions, examining the production and circulation of photographs and picture stories. Before delving deeper into the archival collections, however, I want to consider some of the ideas and intersections that shaped the medium in the postwar world and facilitated its enrollment in the service of US public diplomacy in Africa. The immediate postwar period was a formative time for photography, and the use of the medium by USIA did not take shape in isolation from these developments.

————

As the world emerged from the Second World War, photography was positioned as an integral part of a new order in which forms of mass communication and visual education were accorded a vital role. It was not simply that photography had become the preeminent medium for picturing the world but rather that the postwar years saw the emergence of "a world constituted by photography."[16] In other words, for a period the medium seemed to offer a universal language through which citizens of the world would recognize one another as part of "a global imagined community."[17] Edward Steichen's *The Family of Man* exhibition, the global tour of which was sponsored by USIA, has been taken as the paradigm example, and an exemplary object of critique. The idea of world photography, directed toward the future, ran through the debates of this period and informed numerous exhibitions, but I want to shift the frame slightly. It is necessary to look backward before looking forward. For photography of the postwar period to live up to its utopian promise, it had first to deal with the dystopia of the Second World War, a dystopia in which racialized ways of seeing had played a significant part. In the postwar period, a number of important developments within the medium did not simply espouse ideas of humanism or universalism in the abstract but took shape within the frame of "postwar anti-racism," to use Anthony Hazard's term.[18] Indeed, one can argue that photography was central to its articulation for public audiences.

Photography did not cease to be available for racist ends. But in powerful and institutionally supported ways, the medium became aligned with anti-racist visions. Postwar anti-racist photography is not wholly distinct from photographic humanism or universalism of course, they are arguably two sides of the same coin, but an insistence on the importance of the former brings particular visual relationships into sharper focus. In its emphasis on the abstract humanism of *The Family of Man* and its "consonance"[19] with American global hegemony, photographic historiography has neglected the anti-racist frame. Attention to postwar photographic anti-racism also challenges the dominant periodization of this photographic moment as one that "passed in a flash," as Blake Stimson put it, a point to which I will return.[20]

If photographic humanism and universalism embodied a utopian promise and a vision of the future, an emphasis on the photographic framing of postwar anti-racism demands a return to a preceding photographic moment. As the several references to Nazism in the deliberations of the Department of State working groups suggest, discussion of race during this formative period was inevitably contextualized with reference to the racial ideology viewed by many as a determining cause of the war. The photography that took shape at this moment was marked by an awareness of the need to educate, or rather reeducate, vision; the idea was central to the visual output of UNESCO and subsequently, I argue, informed the photographic production of USIA. In a carefully argued study, Amos Morris-Reich has explored the history of forms of racial photography that culminated in Germany under the Nazi regime. Central to his account is the interpenetration of structures of knowledge and visual experience in the racial imagination, and the evolution of scientific ideas and forms of demonstration into pedagogies of racial vision. For racial science, photography provided a means by which "racial difference could be identified . . . by every racially educated (Nordic) person, thereby rendering racial knowledge democratic."[21] Hans Günther's use of multiple photographic portraits in *Rassenkunde des Jüdischen Volkes*, published in 1930, provides one such example. This was not simply a project of empirical documentation. Underpinned by a hermeneutics of suspicion, its grid layout was intended to develop the viewer's attentiveness toward Jewish "racial markers," and to the perception of race. Its ultimate goal was "to constitute a racially conscious social subject."[22] The aspiration was nothing less than to bring into being "an imagined racial community."[23] One of Morris-Reich's contentions is that the catastrophe in which practices of racial photography participated and the condemnation that rightly followed have rendered the contemporary viewer unable to see these photographs in the way that their forebears once did, unable to feel their "experiential force."[24] The point I want to add here is that the negation of racial photography and racial vision in the postwar period should equally be understood as a project pursued, deliberately

and self-consciously, through photography. Its legacy is longer and deeper than often recognized.

The most immediate photographic challenge to the dominance of racial vision came at the end of the war, as Allied forces liberated the Nazi concentration camps. What began with the rounding up of German citizens in the vicinity of the camps and forcing them to witness atrocities committed in their name was soon extended to a wider population through photography. Posters with titles such as "Diese Schandtaten: Eure Schuld!" ("These Shameful Deeds: Your Fault!") and illustrated pamphlets such as *KZ: Bildbericht aus fünf Konzentrationslagern* (*Photo Report from Five Concentration Camps*) were produced and disseminated by the US government in occupied Europe to indict the German civilian population for their complicity in the crimes of the Nazi regime and establish a sense of collective national guilt.[25] Although not always articulated in terms of race per se, it is clear that this confrontation with images of humanity in a state of complete abjection, piles of naked corpses, was intended to shatter the ideology of racial superiority that underpinned the Nazi social order, to render its debasement of humanity beyond argument. It is telling that in the US account cited above, German responses to racial injustice in the US were interpreted in this context. This was a short-lived moment. It served, however, to mark a radical break with the racial photography of the past, and its impression would be felt in uses of the medium over the coming decades. It is remarkable, and yet no accident, that within a few years the idea that photography had an almost inherent capacity to foster mutual understanding would come to dominate thinking about the medium.

As the postwar world order took shape, with the formation of the United Nations (UN) in 1945 and UNESCO a year later, photography was called to serve an internationalist agenda.[26] Ariella Azoulay argues that exhibitions, posters, and publications depicting photographs of Nazi atrocities produced by permanent members of the UN served to legitimize the postwar world order of nation-states. This "visual literacy class in human rights" was intended to teach citizens "to distinguish violence that constituted a human rights violation from legitimate state violence necessary to secure peace, order, and the rule of law," a form of misrecognition and distancing that, she argues, diminished the civil capacity to identify and challenge violence.[27] This is a somewhat different argument than I am making here but not necessarily incompatible with it, in that in theory, if not always in practice, the "singular vision of new world order" ushered in at the end of the war was conceptualized as a comity of nations, not a world divided into racial groups.[28]

From the late 1940s, photography became part of a program of international anti-racist education framed in less graphic terms. This can clearly be seen in the case of UNESCO, where in opposition to the way in which science and photography came

together in the service of Nazi racial ideology, scientific authority was deployed in the service of anti-racism and accompanied by a program of visual education. In fact, some of these photographic developments have their origins in the prewar use of racial type photography against itself—for example, in the work of Franz Boas and Julian Huxley. The latter would go on to be the first director of UNESCO. As early as 1907, in a government-commissioned study of descendants of immigrants in the US, Boas had used anthropometric photographs to undermine the idea of essential racial characteristics in favor of an environmentalist explanatory framework. And *We Europeans: A Survey of "Racial" Problems*, a widely read book authored by Huxley and Alfred Haddon published in 1935, opened with sixteen head-and-shoulders portraits of well-dressed White men presented in a grid layout as national "types" and challenged the reader to identify their nationality.[29] It was in the postwar period, with racial science utterly discredited, however, that these ideas gained international institutional endorsement.

If the foundation of Nazi ideology lay in "the perception of the unlikeness of men," as the youth publication *The Nazi Primer* put it, the task for the new organs of world government was to ensure this precept was radically undermined.[30] In 1950, UNESCO issued the first of its statements on race. Photography would play an important role in the dissemination of its message. In a profile of the statement featured on the cover of its magazine *Courier*, the text was accompanied by a photographic collage of the faces of men and women from around the world, attesting not to their difference but to their similarity (fig. 2).[31] Informed by the UNESCO statement, Robert Ariss, anthropology curator at the Los Angeles Museum of History, Science, and Art, was tasked with creating an educational exhibit entitled *Man in Our Changing World*, which opened in 1952.[32] In addition to citing the UNESCO statement on race and the Universal Declaration of Human Rights, among its twenty-four panels it deployed the device of a photographic quiz intended to destabilize the idea that race was a simple matter of visual identification. Viewers invited to identify the origins of those portrayed were, according to the panel text, like "most people," "surprised to learn that it is often difficult to identify an individual's origin" and that "physical features and skin color are not always reliable guides."[33] A further, more precise reprise of the visual strategy employed in *We Europeans* appeared a few years later in an issue of *Courier*, aimed primarily at educators, entitled "Twisted Images: How Nations See Each Other" (1955). Echoing the presentation of portraits in grid format used as a means of identifying racial characteristics, the piece invited the reader to identify the nationality of nine individuals (fig. 3). (In this case, the selection included a single portrait of a woman.) The joke, at the reader's expense, was that all were British. The gentle humor does not diminish the fact that this, too, was intended as a lesson about the hazards of racialized vision. Where earlier iterations served to inform scientific and popular debate about notions

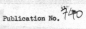

Publication No. 740

VOLUME III — N° 6 — 7 PRICE : 10 Cents (U. S.), 6 Pence (U. K.), or 20 Francs (FRANCE). JULY-AUGUST 1950

Courier

PUBLICATION OF THE UNITED NATIONS EDUCATIONAL, UNESCO SCIENTIFIC AND CULTURAL ORGANIZATION

FALLACIES OF RACISM EXPOSED

UNESCO PUBLISHES DECLARATION BY WORLD'S SCIENTISTS

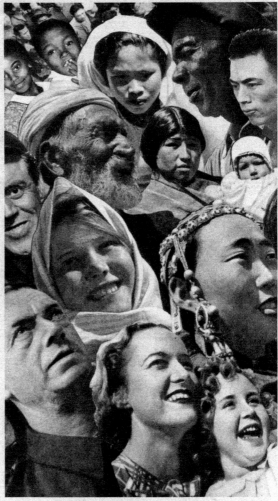

MORE than fifteen years ago, men and women of goodwill proposed to publish an international declaration which would expose "racial" discrimination and "racial" hatred as unscientific and false, as well as ugly and inhuman. The world at that time was running downhill toward World War II, and so-called "practical" considerations prevented publication of the statement — even if they could not prevent the war.

False myths and superstitions about race contributed directly to the war, and to the murder of peoples which became known as genocide — but victims of the war were of all colours and of all "races". Despite the universality of this agony and destruction, the myths and superstitions still survive — and still threaten the whole of mankind. The need for a sound unchallengeable statement of the facts, to counter this continuing threat, is a matter of urgency.

Accordingly, Unesco has called together a group of the world's most noted scientists, in the fields of biology, genetics, psychology, sociology and anthropology. These scientists have prepared a historic declaration of the known facts about human race, which is reprinted in this issue of the Courier.

Unesco offers this declaration as a weapon — and a practical weapon — to all men and women of goodwill who are engaged in the good fight for human brotherhood. Here is an official summary of the conclusions reached in the declaration :

● In matters of race, the only characteristics which anthropologists can effectively use as a basis for classifications are physical and physiological.

● According to present knowledge, there is no proof that the groups of mankind differ in their innate mental characteristics, whether in respect of intelligence or temperament. The scientific evidence indicates that the range of mental capacities in all ethnic groups is much the same.

● Historical and sociological studies support the view that the genetic differences are not of importance in determining the social and cultural differences between different groups of **Homo sapiens** and that the social and cultural changes in different groups have, in the main, been independent of changes in inborn constitution. Vast social changes have occurred which were not in any way connected with changes in racial type.

● There is no evidence that race mixture as such produces bad results from the biological point of view. The social results of race mixture, whether for good or ill, are to be traced to social factors.

● All normal human beings are capable of learning to share in a common life, to understand the nature of mutual service and reciprocity, and to respect social obligations and contracts. Such biological differences as exist between members of different ethnic groups have no relevance to problems of social and political organization, moral life and communication between human beings.

Lastly, biological studies lend support to the ethic of universal brotherhood ; for man is born with drives toward co-operation, and unless these drives are satisfied, men and nations alike fall ill. Man is born a social being, who can reach his fullest development only through interaction with his fellows. The denial at any point of this social bond between man and man brings with it disintegration. In this sense, every man is his brother's keeper. For every man is a piece of the continent, a part of the main, because he is involved in mankind.

(See pages 8 and 9 of this issue for the full text of the important statement on race, published by Unesco on July 18th, together with an article, "Race and Civilization", written by Dr. Alfred METRAUX, the well-known American anthropologist.)

Fig. 2 *Courier* III, no. 6–7, 1950. Reproduced courtesy of UNESCO. Original image source unknown.

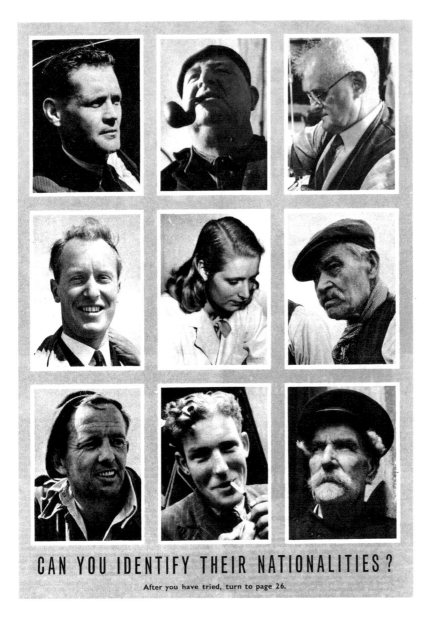

CAN YOU IDENTIFY THEIR NATIONALITIES?

After you have tried, turn to page 26.

Fig. 3 "Can You Identify Their Nationalities?" *Courier* 6, 1955. The original photographs were supplied by the Central Office of Information, London. Reproduced courtesy of UNESCO.

of race, in the postwar period they overlaid the horrific images of racial violence that had so marked the intervening years. It was a lesson not all wanted to learn, however. In the racial context of the US, *Man in Our Changing World* caused considerable controversy, leading to calls to close the exhibition or to censor those sections that challenged the identification of race and skin color or dealt with the "admixture of races."[34]

The transition from the use of shock images of the concentration camps as a form of reeducation to the less confrontational visual pedagogy developed by UNESCO represented a significant shift in how the medium was deployed in the context of

international exhibitions, even if there was continuity of purpose. There are several ways in which this shift might be interpreted, as some of the more recent scholarship on *The Family of Man* helps to illuminate. Although Steichen's use of a photograph of an atomic explosion drew attention to the present risk of human annihilation in a nuclear age, Viktoria Schmidt-Linsenhoff argues that *The Family of Man* exhibition should be read first and foremost as a denial of images of the Holocaust, "refut[ing] the horrific pictures from the liberated concentration camps without showing them."[35] Steichen's exhibition, she suggests, is addressed to the "breach of civilization" represented by Auschwitz, without ever making this explicit. From this perspective, images of the concentration camps are an absent presence in all photographic attempts to imagine peaceful coexistence after the horror of the Second World War, including the UNESCO examples discussed above. Schmidt-Linsenhoff's use of the term "denial" here draws on trauma theory, the idea that the "unconscious sub-text of the exhibition is that this will not happen again, because it never really took place."[36] But the swift ending to international efforts to educate the German population through exposure to images of Nazi horror also has a more historically and politically grounded explanation. As the war ended, indictment and vilification of German citizens was rapidly displaced by a need to reconceive of the population of West Germany as allies in the fight against communism, which was beginning to take precedence over punishment for crimes of the recent past. *The Family of Man* toured Germany during precisely this period of rehabilitation. In this context, it is interesting to note the recollections of photographers Helmut and Gabriele Nothelfer, who saw the exhibition in West Berlin: "Germans could walk through the exhibition with no fears, the photographs [were] not accusing them, they [did] not confront them with the horrible crimes of Nazi Germany."[37] Notwithstanding other theories, the change of approach clearly accorded with shifting political and diplomatic priorities.[38]

The movement from the use of photography as visual indictment to the imagination of world community was not limited to one or two exhibitions. It had longer-term structural implications for the employment of the medium in Europe and beyond as part of US cultural diplomacy. One of the lessons the US was beginning to learn was that if photography served as a form of indictment, it could find itself the accused as well as accuser. In her critique of Schmidt-Linsenhoff's argument, Sarah James points out that an awareness of the horror visited on the Japanese cities of Hiroshima and Nagasaki by the US shaped the politics of representation in *The Family of Man*, and that Steichen would have been mindful of the risk of collapsing the distinction between US military action and Nazi atrocities.[39] However, the US was not only sensitive to the visual equation of its military action in the Far East with the darkness at the heart of European civilization. The depiction of its treatment of African Americans

at home was equally fraught, and from the late 1940s onward this would be a major preoccupation. When the Soviet Union accused the US of being the "heirs of Hitler," it did so with respect to its record on racial injustice. Furthermore, Soviet accusations coincided with the efforts of the Civil Rights Congress (CRC) to bring the US government to account through its presentation to the UN in December 1951 of *We Charge Genocide*, a petition setting out the case for interpreting the violence and discrimination against African Americans as an act of genocide, as defined by the UN Convention on the Prevention and Punishment of the Crime of Genocide.[40] The frontispiece consisted of a single photograph, captioned "The Face of Genocide," showing the lynched bodies of Dooley Morton and Bert Moore in Columbus, Mississippi. The image caught the attention of the Department of State. In a communication to all US diplomatic and consular offices, Secretary of State Dean Acheson noted that despite being twenty-two years old, "the picture is still effective."[41] It is worth noting, too, that the original version of *The Family of Man* included a photograph of a lynching, even if Steichen chose to remove it after a few weeks for the "undue attention" it attracted.[42] Shamoon Zamir has taken the presence of this image as warrant for reading the exhibition as a sustained critique of the US record on race and civil rights, discernible even following its removal.[43] The argument relies on a careful interpretation of visual rhythms and associations that work across different rooms of the Museum of Modern Art installation, and in relation to contexts beyond. The case may be overstated, or at least there is not the evidence to show how widely Zamir's sophisticated reading of Steichen's selection and juxtaposition of images was shared among popular audiences, or indeed whether it was conceived in these terms by Steichen himself. Nevertheless, it is right that the exhibition should be read contextually in relation to events such as the CRC petition and the 1954 *Brown vs. Board of Education* decision, as well as the increasing international condemnation of racial injustice in the US. If Roland Barthes criticized Steichen for his lack of attention to the specific violence of racism and colonialism, asking what the parents of Emmett Till would have to say about the exhibition, it is nevertheless reasonable to argue that the fault lines that split the world along racial lines already ran through the exhibition.[44] Whether or not the decision to remove the lynching photograph was a direct result of discussions about the exhibition's planned international tour under the auspices of USIA, as Zamir implies, it is certainly the case that USIA officers would not have wanted to include the kind of image that was already being used to indict the US in the eyes of the world.[45] If it had not been removed earlier by Steichen, one suspects it would in all likelihood not have made it into the touring versions of the show.

One conclusion to be drawn from this brief analysis is that the division of labor imposed by US government information and communication officials, whereby

photography was predominantly aligned with the expression of visions of progress and the future, and anything unfavorable or on "the seamy side" should be rendered only in commentary, had its basis in a wider set of associations the medium had begun to acquire in the postwar period. Photography had become part of the language of international indictment, in institutions of international government, such as the UN, and in the court of world opinion with the advent of global mass communication. The visual slippage or equivalence between the racial violence of the Second World War and the US treatment of its own racial minorities was a risk that those charged with representing the image of the US abroad were at pains to avoid. Having instantiated a confrontational mode of photographic education to indict the German population for their racial crimes, it was uncomfortable to find themselves in the audience, identified as perpetrators.

―――――

To frame the argument only in terms of a reaction to the atrocities perpetrated in Europe, however, is to ignore other forces that were becoming equally important. The educational project of UNESCO to "establish the moral unity of mankind" may well have taken shape primarily as a response to events centered in Europe, nonetheless from the moment of its inception it became the focus of arguments around civil rights and anti-colonialism.[46] An article in the African American newspaper *The Chicago Defender* from 1947 posed the question of who most needed to learn lessons on race, and whether the UNESCO project would extend to "the re-education of many so-called 'civilized' peoples, peoples, for instance, who have been infected by the poison of racism."[47] Although at its inception UNESCO did not directly challenge the racial situation in the US—indeed quite the opposite, the US played a leading role in the organization and viewed it as an instrument of foreign policy—as its membership expanded to include many newly independent states the ability of the US to control the debate was significantly reduced. This is a point to which I will return, but first it is important to acknowledge the early 1950s as a moment in the history of US government photography when images of African Americans moved from the margins to the center.

In his study of the documentation of African American lives in the Farm Security Administration (FSA) photography of the 1930s, Nick Natanson identifies examples of penetrating and innovative coverage of African American life, representations of racial hierarchies, relative disadvantage, and even oppression: "The photographers collectively achieved a range and depth of black coverage that was rare in government or private photography."[48] He points out, however, that the most interesting and imaginative coverage of Black experience rarely saw the light of day in FSA in exhibitions and publications, and when it did its message was often muted, through cropping,

contextualization, and captioning. Quite simply, the perception from the top of the organization was that Black subject matter was less usable or valuable.

It is instructive in the light of Natanson's analysis, then, to consider a photograph from the FSA file that resurfaced in 1954 in a special issue of UNESCO's *Courier*, via the United States Information Service (USIS) office in Paris.[49] The special issue, with the theme of "The American Negro," was published in the wake of the Supreme Court decision on desegregation of the US school system (fig. 4). Over half of the illustrations were credited to USIS, depicting African American progress and achievement, as well as racial integration across education, housing, employment, and the military. The issue provides an example of the close cooperation and photographic exchange between USIA and UNESCO during this period. The message is virtually indistinguishable from the 1952 USIA pamphlet *The Negro in American Life*, and many of the images, though not the same photographs, are generically and thematically consistent. The photograph retrieved from the FSA archive included in the issue was taken by Dorothea Lange, although the photographer was not credited, and shows an African American couple seated together gazing out of the frame (fig. 5). It had been taken in 1937 as part of a series on a formerly enslaved couple living in a dilapidated antebellum mansion in Greene County, Georgia, filed under the title "Ex-slaves who occupy an old plantation house." In the context of the original series, Natanson argues, the photograph expressed a sense of historical irony, conveying a "story of an unaided couple scratching out a living amid the literal ruins of the civilization that had marked them."[50] It was first used by the FSA in 1940 in a small portable exhibition, entitled *New Start on the Land*. Here, however, its original context was completely "erased," though Natanson detects an element of resistance in the facial expressions of the subjects.[51] The photograph selected from the series was a close shot of the couple in which the backdrop is barely discernible. Yet even this was masked out for reproduction on the exhibition panel, leaving the couple against a neutral background. In the exhibition, which promoted the FSA program of farm loans, the photograph was juxtaposed with an image of a White couple—the image of the Black couple was presented as the "after FSA" image to its counterpart's "before." Notwithstanding the way in which the image had been severed from its original context and the photographer's interpretive stance, it is clear nonetheless that the exhibition designer, Edwin Rosskam, had misjudged the racial sensitivities of his audience. "The problem," Natanson points out, "was not that it misused a black image but that it used a black image at all, that the very inclusion might be interpreted as an agency commitment to a new sense of American community."[52] FSA regional officials in Texas, Arkansas, and even Wisconsin responded to the exhibition with serious misgivings about the inclusion of the Black couple. As one Texas state rehabilitation supervisor put it, the exhibition panels would be best stored

Fig. 4 "This Negro doctor who is the chief surgeon at the Ohio State Penitentiary, symbolizes the enormous progress of the Negro in the past 50 years in achieving equality of opportunity in the United States." *Courier* 6, 1954. Photograph by Mike Shea. Reproduced courtesy of UNESCO. Dr. Watson H. Walker was chief surgeon at Ohio State Penitentiary from 1949 to 1978.

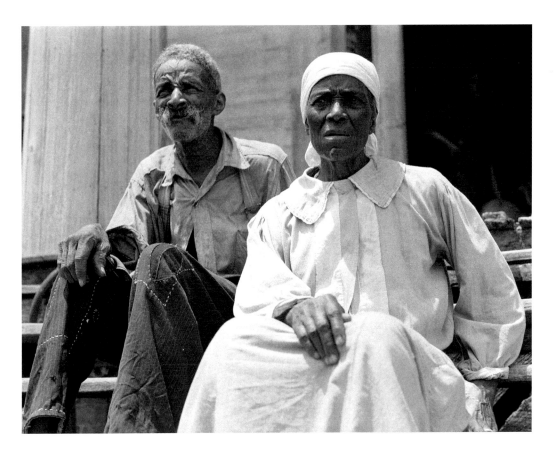

Fig. 5 Formerly enslaved couple who live in a decaying plantation house, Greene County, Georgia, July 1937. Photograph by Dorothea Lange. Library of Congress, Prints and Photographs Division, FSA/OWI Collection. LC-USF34-017944-C.

"in the warehouse unless we can obtain a substitute."[53] Along with many other such images of the Black experience recorded by FSA photographers, it remained out of public view.

The contrast with the postwar period in which this photograph reemerged could not be more striking. As the US turned its attention away from the domestic concerns of the depression years to those of the Cold War, photographs of African Americans were suddenly deemed not only usable but essential. That did not mean, of course, that the photographic record was restored to some original state. The photograph reproduced in *Courier* in 1954, alongside an article discussing the Supreme Court judgment, was the same close crop that appeared in the FSA exhibition, though in this case the background was not masked (fig. 6). The original context was only partially restored, through a caption that described the couple as having been enslaved through early childhood. Here, though, meaning was created through juxtaposition

Fig. 6 "Equal but Separate Signifies Unequal," *Courier* 6, 1954. Reproduced courtesy of UNESCO. Photograph of couple with child reproduced courtesy of Black Star Publishing Co.

with a very different image than in the 1940 exhibition. Lange's photograph was positioned beneath a larger image of a modern looking African American couple forming a family unit with their newborn baby child, who holds their loving attention. This latter image proved popular with USIA and was used in several published contexts, including as the cover image for *An African Looks at the American Negro*, a pamphlet first published in 1956 and reproduced in multiple print runs for global distribution, including to Ethiopia, Kenya, and Nigeria. Its depiction of African American familial intimacy was a theme that would come increasingly to the fore in agency output.[54] Ironically, here, the formerly enslaved couple have switched position, they are now the "before" to the young couple's "after"—the caption cites improvements in life expectancy, and the broader context speaks to the enhanced educational and life opportunities, which the viewer was to infer would be open to the child in the more recent image. None of this does justice to the subjects of course, who one suspects would have

retained the same skepticism toward the narrative of racial progress packaged here for international audiences as Lange's notes suggest they had for the freedom that followed abolition.[55] But it is important nonetheless to register the rapidly increasing currency of images of African Americans in the eyes of US information officers in the postwar period signaled by the reemergence of this photograph from the archive.

Given its infrastructure for distribution, and collaboration with UNESCO providing access to an ostensibly neutral global messenger, it might appear that the US was well placed to present its case to the world. But if, in the early 1950s, the US government thought it could counter criticism from within and without with a narrative of steady racial progress, it would soon become clear that the challenge would not be so easily met. Six years after the special issue on "The American Negro," *Courier* published an issue on "Racism." A cursory glance through the magazine is all that is needed to confirm that the US was no longer in full control of the message; the former issue appears positively anodyne by comparison. The cover carried the word "RACISM!" in a large blood-red font applied in the style of a horror film poster, accompanied by a statement from the Executive Board of UNESCO that linked a resurgence of anti-Semitism with the racism of apartheid South Africa. The selection of photographs went further in the analogies it drew. The issue opens with a widely reproduced photograph from the Stroop Report on the liquidation of the Warsaw ghetto showing a young boy with his arms in the air, and stood behind him an SS Trooper holding a submachine gun gazing unperturbed into the camera. This photograph is followed on subsequent pages with photographs of bodies strewn across the road in Sharpeville, South Africa, following the police massacre of sixty-nine anti-pass protestors, young African American children being escorted into school by federal troops in Little Rock, Arkansas, and race riots in Notting Hill, London. And if decolonization is not represented visually, it is nevertheless referenced by the editors who caution against seeking racial explanations for the failings of newly independent states.[56] The exception that proves the rule of diminished US influence is a small photograph, supplied by USIS, appearing later in the issue, which shows Robert Brooks, "a little Negro boy," in an integrated US classroom. It gives the impression of a half-hearted effort to offset the challenging message conveyed by the principal visual juxtapositions. The mutual association between anti-Semitism, apartheid, and segregationist racism in the US was, unsurprisingly, controversial, even if the call to member states to address racial violence and hatred "within their territories" offered a concession to the realpolitik of the new world order. No doubt it confirmed what was an established view of the organization in some quarters—UNESCO activities were already banned from schools in some US states—but it also signified something else. Where in the early postwar years UNESCO had been a "handmaiden" of US foreign policy, it was now on its way to

becoming a forum for "intensifying and successful opposition to the US government's anti-racist pretensions and neocolonial policies."[57] This is not the place for a history of US relations with UNESCO, but two things were now clear: first, the US would not have things all its own way as it sought to project its image across the globe; and, second, an engagement with the question of race was as hazardous as it was necessary.

The overlapping forces of the Cold War, postwar anti-racism, and decolonization presented a complex field of operation for US foreign policy and international public diplomacy. "Discerning the precise, subtle, and intricate connections" between these three is, Jason Parker argues, one of the challenges for international histories of the Cold War.[58] This is no less the case for photographic histories of the period. Establishing a sense of periodization at the intersection of histories of photography and US foreign policy and public diplomacy is not an easy task. There are two arguments I want to make here. First, while the high point of photography's utopian promise, as embodied in *The Family of Man* and some of UNESCO's early exhibitions, may indeed have been short-lived, the presence of ideas around race and anti-racism in these visual discourses gave them greater longevity. For Hazard, in his study of UNESCO, postwar anti-racism began in 1945 and lasted through the end of the 1960s.[59] It was a period that saw the coming together of civil rights and anti-colonial activism with the challenge to forms of biological determinism, in the context of the US struggle for global hegemony and the emergence of the UN and associated organs of world government. This periodization fits very well with the concerns of this book. In contrast to histories that have emphasized the brevity of the postwar photographic moment, I argue here that the engagement of photography with anti-racism, civil rights, and decolonization means that this period should be seen in longer perspective—the "Racism" issue of *Courier* might be considered as bridging an earlier and a later moment. I propose a change of empirical attention as well as argument, however. In his study of postwar photography, as many have done, Blake Stimson takes Steichen's *The Family of Man* as his starting point for analyzing the significance of the medium for attempts to reimagine political belonging. But it is the direction his analysis takes that is more significant. Stimson explores photography as an artistic and intellectual endeavor always at one remove from the grounded political struggles of the era. From Steichen, he goes on to consider Robert Frank and the Bechers. It is on this basis that he is able to contrast the concrete political successes of anti-colonial and civil rights movements with the failure of photographic projects; the former, he argues, "had workably particular concepts of nation to offset and implement the unworkably general abstraction of human rights or 'humanity itself' or freedom or enlightenment, whereas the latter remained an airy modernist universalism."[60] As an alternative, rather than move from *The Family of Man* into an avant-garde history of the medium, I propose following a

route that cleaves closer to the politics of the period, delving into settings where the medium served explicitly political ends and was inevitably compromised by political considerations and diplomatic sensitivities. No longer at a remove, it is instead thoroughly entangled with politics. Yet, at the same time, I wish to retain a sense of the space the medium offered for political imagination. USIA photography is one such setting. Of course, it is only one, and a very specific one at that, but it is warranted since USIA sponsorship of *The Family of Man* leads not into the space of the modernist gallery but directly into the offices of government communication agents in Washington and their regional staff across the world. Parenthetically, I want to note one caveat to a periodization that would see the end of postwar photographic anti-racism in the late 1960s, when realpolitik moderated African criticism of the US record on racial injustice, once African nations had themselves achieved independence and sought to protect their own national sovereignty from external criticism. It seems at least arguable that it is not until the ending of apartheid in 1990 that the project initiated during this period can really be considered complete. It is beyond the scope of this book, but it is worth noting that the UN remained an important locus for anti-apartheid photography through the 1970s and 1980s.

Photographic historians and critics of this period have tended to view the photographic humanism and universalism of *The Family of Man* as nothing more than an expression of US ideology in a Cold War struggle between the two superpowers, and its global tour as a form of neocolonialism, underlined by corporate sponsorship from the likes of Coca-Cola. There is some truth in this assessment, whether one sees its presentation as naive or disingenuous. More significant, however, is the tendency to treat the exhibition's global tour as a one-off event, the first and last word in US photographic diplomacy. It was not, as I intend to demonstrate in this book, and least of all in relation to African nations, few of which were independent at the time it toured the continent. As the 1950s turned into the 1960s, the use of photography by USIA evolved in concert with the challenge of civil rights at home and decolonization abroad, even as communism continued to be perceived as the central threat and the frame through which everything else must be seen.

Parker's efforts to unravel the complex threads that were woven together in US public diplomacy in this period are enormously helpful to contextualize an understanding of USIA's photographic engagement with Africa. In brief, his argument is that in terms of race it may be useful to consider two Cold Wars, "an early one characterized by Race repression, which gave way to a second one of Race liberation."[61] In symbolic terms, though not immediately in practical politics, the Asian-African conference at Bandung, Indonesia, in 1955 represented a pivotal point. This would be underlined over subsequent years by the Suez crisis, events at Little Rock, and

Ghanaian independence. Where in the early postwar years, the exigencies of the developing Cold War meant the US administration closed down the space for progressive change at home and maintained its allegiance to colonial powers abroad, increasingly from the mid-1950s this strategy seemed to put the US on the wrong side of history. If it did not precipitate a moment of "conclusive epiphany,"[62] the historical analogy between Third World anti-colonialism and its own revolutionary foundations, articulated by President Sukarno at Bandung, nevertheless soon came to seem like sound international politics. As African American Congressman Adam Clayton Powell, who had been in Bandung, told Secretary of State John Foster Dulles and President Eisenhower at the end of 1955, "colonialism and racialism must be eradicated as quickly as possible in our foreign policy. . . . The timetable for freedom was no longer within our control—Bandung had stepped it up, and we [had] to move fast."[63] There is more to be said about the ways in which attitudes toward African independence shaped US public diplomacy on the continent, but the important point for the moment is that USIA photography would soon be charged with engaging Africans as modern subjects and political actors, rather than framed by an idea of abstract humanity. Despite strenuous effort, this is something that can barely be discerned in *The Family of Man*, if it can be discerned at all.

I want to end this section with a brief look at a counterpart to *The Family of Man*, one that has not registered in photographic histories of the period. *A World on the Move: A History of Colonialism and Nationalism in Asia and North Africa from the Turn of the Century to the Bandung Conference* was published in an Indonesian edition in 1954, and then updated and published in English in 1956.[64] It is a "picture album" illustrated by 675 photographs culled from various archives, photographic agencies, and museum collections, supported by text written by two historians at the University of Amsterdam, and, in the English edition, a foreword by Dr. Supomo, Indonesian ambassador to the United Kingdom. In terms of its design and reproduction it falls short of the standards set by the catalog to Steichen's exhibition, or indeed Henri Cartier-Bresson's photographic study of China published the same year, to which one reviewer compared it unfavorably.[65] But it speaks to the photographic moment with which I am concerned in this book, though in quite a different register than more prominent examples. Unquestionably, there are limits to its political imagination. The framing of an Asia "'awakening' from a 'sleep' of several centuries" conveys a predictable paternalism, as does the "sense of duty" that its Western authors claimed to guide their endeavors; nevertheless, there was at least an acknowledgment of the position from which they sought to contribute to "world history." The ideological commitment to nationalization and modernization as remedies to the "technical, social and political backwardness" of the non-Western world was explicitly stated. In that

analysis, however, they would have had much in common with many new and aspiring national leaders, as they would in the assessment that it was necessary to "liquidate colonialism" to achieve national development.[66] Indeed, a review in the journal of the US-based Association for Asian Studies, accused the authors of "favor[ing] the current dogmas of Asian nationalism," "endorsing too much loose emotionalism on the part of Asian politicians," and "undervalu[ing] the Western contribution."[67] This critique was echoed in the *Bulletin of the School of Oriental and African Studies* in London.[68] But it is the effort to establish a postcolonial mode of picturing the world that is of most interest here. In the preface, the publishers explicitly positioned the book in opposition to a colonial photography "dealing exclusively with customs, religions, raw material, flora and fauna, agricultural products, and the countless folkloristic aspects, presenting Asia as an interesting land for wealthy tourists, enterprising young people, and scholarly and art-loving field workers." Instead, they wished to present an image of "a continent with a great history of its own, inhabited by peoples with a character of their own, a will of their own, and a profound desire for political and social expression of their own." Furthermore, they proposed the assembly of a visual archive as a necessary adjunct to the restoration of colonized regions to their place in history, hoping that in place of "scanty and improperly cared for" photographic collections, the book would stimulate "a systematic large-scale investigation," bringing together material that was "extant but hidden and scattered . . . including, without doubt, a great deal of material in private hands." The compilation's visual repertoire included photographs of the people of Asia and North Africa as victims of exploitation and refugees of conflict, as well as beneficiaries of modern housing and health care, but also without doubt as political actors. For at least one reader of the time, the juxtaposition and serialization of these elements conveyed a powerful political message. Responding to a page containing multiple images of "Cheap labour!" and showing construction laborers, tobacco sorters, and cotton workers in China, India, and Thailand, Cowan makes the following observation: "To include three different photographs of coolies dragging a road roller may strike a Western reader as a tiresome reiteration of the fact that Asia provides cheap labour. It ought also to bring home to him the strength of Asian resentment at the way in which that labour has been used by Western enterprise. The real value of this book lies in the clear picture it will give to Western students of the way Asians *think and feel* about 'colonialism.'"[69]

The opening and closing photographs of the book might be regarded as a political call and response. The frontispiece carries a photograph depicting a plain wall on which has been daubed the slogan, "Justice & Freedom for <u>All</u> Nations," an act of protest and a political demand (fig. 7). The closing photograph shows the conference hall at Bandung, with delegates seated in rows and an array of national flags providing the

Fig. 7 *A World on the Move*, 1956 (frontispiece). Photographer unknown.

backdrop to the main platform. The caption notes that "the flags of free and not-yet-free nations demonstrate the end of an era—that of Western supremacy in Asia and Africa. Not all the countries represented at Bandung have their flags flying at United Nations, where the nations of the world are gathered together. But their time will presently come." The image recalls Steichen's inclusion of a photograph of the UN General Assembly in the closing section of *The Family of Man*. Here, however, the message is historicized rather than universalized, a point that was echoed in the comparison with Cartier-Bresson's book on China: "Cartier-Bresson is an artist *par excellence*. His approach is individual and subjective. He goes there and sees with his own eye and the eye of his camera, and because he sees deep and straight his subjectivity has universality."[70] For Christopher Rand, it was precisely the claimed universality

of the photographer's vision that elevated it above the compilation of *A World on the Move*. Whether universality should be the aim of such photographic endeavors was never doubted. Yet if the photographers and officials at USIA looked to *The Family of Man* and to the cadre of international photojournalists such as Cartier-Bresson for inspiration, I want to suggest that they nevertheless had to trim their sails to catch the winds of change that were blowing across Asia and Africa, and in doing so owed just as much to the thinking that informed *A World on the Move*.

In the early to mid-1950s, when US public diplomats first began to think seriously about the significance of race to their engagement with overseas audiences, African decolonization had barely begun and civil rights activism in the US had yet to cohere into a movement. It is the conjunction of these two developments over the next decade and a half and the significant part they played in shaping US diplomatic photography that I intend to turn my attention to in the chapters that follow. But it is important to realize that USIA photography was neither created nor seen in a vacuum. The photographs that issued from Washington were from the very beginning in dialogue with the photographic history and context that I have sketched here. As they arrived in USIS posts across the globe, they met audiences who often had access to a wealth of photographic imagery circulating as part of visual economies that were both local and global.

––––––––

At the core of this study is what I have termed a photography of relations. In part, this is dictated by the material, a collection in which the relational and performative qualities of the medium come to the fore. But it is also a methodological choice, one that has consequences for the way in which I have approached the research and for how the photographs are interpreted. My intention is not to displace questions of representation entirely but rather to extend attention beyond the image, back toward the circumstances of its making, and forward toward its circulation. I have been assisted in this direction by a body of photographic scholarship, emerging from anthropology, that treats the photograph as a "relational object." As Elizabeth Edwards puts it, such an approach requires "an engagement with the whole social dynamic of photographs over space and time, in which photographs become entities acting and mediating between peoples."[71] This means attending not simply to what photographs depict but equally to the occasion and manner of their staging, and the routes along which they travel. Based largely on the study of photography as a dimension of cross-cultural encounters in colonial or postcolonial contexts, this scholarship places greatest emphasis on the photograph as an image-object, or even a vital substance,[72] that mediates social relations between individual actors. Although I am less concerned here with the individual photograph in the hands of an interlocutor, given that my focus is at the level

of state image production and distribution, the insights of this work are, I suggest, transferrable to other contexts where the mobility of images and the ways in which photography can serve as both index and agent of relations are a central concern. This methodological perspective enables a shift in attention, away from state photography as propaganda or instrument of disciplinary power, which has occupied a considerable volume of photographic scholarship, toward a more complex understanding of its operation as a tool of soft power and diplomacy—in other words, relationship building.

The photography I am concerned with here is relational in at least three important senses, one or more of which may be in play in any image or setting. First, it is centrally concerned with picturing relations, or more precisely, picturing new relations in the process of formation during a period of decolonization. The USIA collection provides a unique, if very selective, lens through which to observe this cultural historical moment. A significant proportion of the collection is devoted to showing relations, usually positive and friendly, between different groups, Africans and White Americans, Africans and African Americans, African Americans and White Americans, and, much less frequently, Africans and Native Americans. Second, many of the photographs not only "show" relations but also provided the occasion for their performance and affirmation, and a way of making them visible to others as an invitation to share in a larger project of diplomatic relationship building. Each photographic event represented a small attempt to imagine and perform a new kind of relationship, however awkward, clumsy, and at times crass the results might appear. The theme of Africans and Americans "getting to know one another" permeates many USIA photographs. They present an emerging world order in microcosm and serve as visual refutation of accusations that the US was an inherently racist society. In his study of USIA output, Sönke Kunkel uses the notion of "contact points"—"representational interfaces that allow individuals from one society to engage with another society (and its actions) without actually having to travel there"—drawing on Mary Louise Pratt's notion of "contact zones" but absent of its emphasis on spatial proximity.[73] Here, however, I want to reinstate the fuller sense of the concept. In much USIA photographic output, physical presence and intimate proximity not only provide the occasion for image-making, as encounters that must be negotiated, but are also thematically central. Third, the photographs were circulated as tokens of relations. This applies in both a narrow sense, for example, the gifting of photographs of a visit to the US to an important guest on their departure, and in a wider sense, meaning the circulation of photographs across the world as an invitation to a collective project of building relations between peoples. In this latter respect, photographs are objects of the political imagination. Photographs, as has been argued for literary print media, "afford the opportunity for individuals to imagine themselves as members of larger than face-to-face solidarities"

and, consequently, "of choosing to act on behalf of those solidarities."[74] At this historical moment, of course, the "solidarities" on offer were global as well as national. Photography was one medium through which newly independent African nations and their citizens were drawn into globally competing visions of the future. In this sense, the circulation of photographs needs to be understood as expressive of political agency. USIA invested in a major program of activity for the continent in which photography served to imagine capitalist, consumerist, and democratic futures for Africa, modeled in its own image. USIA photographs depicted African visitors to the US as they toured US institutions of government, observed democratic politics in action, and were introduced to modern consumer products and lifestyles. The photographs were subsequently circulated to African countries as vouchers of an available future to be redeemed. In parallel, and competing, fashion the Soviet Union, too, sought to engage citizens of African nations with an alternative imagined future, and likewise African-Soviet photographs abound.[75]

This is not, I hope it goes without saying, to advocate for the future that was imagined in the space opened by USIA photography but simply to argue that it must be reckoned with alongside other projects of transnational imagination in the postwar period. I have described this formation as a "Cold War" imagination deliberately, to signal both the overall framing and its political limits. Central as it undoubtedly was, however, the Cold War imagination was not solely shaped by the contest between the two superpowers. USIA had equally to engage with questions of race and decolonization as it sought to project an image of the future that would be capable of attracting the allegiance of the elites of newly independent nations. In doing so, it can be seen to overlap with other forms of political imagination, most significantly those associated with civil and human rights agendas, and with decolonization. The Cold War imagination, as I use the term here, had both to compete with and accommodate to these alternative imaginaries from the 1950s on. For a period, the racial logic that underpinned transnational solidarity between civil rights activists in the US and anti-colonial and anti-apartheid movements abroad was perceived as a powerful challenge, even if it met significant resistance at home, including among African Americans, and ultimately fragmented.[76] USIA's extended engagement with civil rights photography was an implicit recognition of the strength of this imaginative framing at a particular historical moment, accompanied by an effort to contain it within an illustrated narrative of American democracy.

At the same time, the photography under consideration here was in competition with photographies born of a decolonial imagination that, as Jennifer Bajorek has argued, enabled "African photographers, their subjects and their publics to reimagine and remake colonial histories and experiences" and in turn "gave rise not simply to new

and distinctly African relationships to colonial modernity, but to a distinctly African vision of what might come after it, and of what had, perhaps, already exhausted it."[77] In the context of this study, with the exception of a small proportion of the photographs made in country by local employees, the camera remained firmly in the hands of US photographers. This was no decolonial photography; more arguably it was neocolonial. The work of Bajorek and others, however, serves as an important reminder that the US projection of soft power across the continent through the agency of the photographic image did not encounter an empty cultural field, even if its infrastructure for the production and dissemination of visual materials far exceeded the capacity of local actors on the ground in many of the countries in which USIA operated. From the beginning of its involvement with Africa, USIA was engaged in an effort to understand and imagine its African audiences. Its image of the continent and its peoples may often have been oversimplified, or misaligned with reality, but it was nevertheless part of an ongoing negotiation with competing imaginations. Understanding this complex field of operations and how it was navigated is central to this study.

The research presented a twofold methodological challenge: to locate and contextualize, first, photography, and then, Africa, in the archive. As Phu, Noble, and Duganne have observed, studies of the cultural Cold War have tended to concentrate on discrete cultural forms—abstract painting, jazz, literature—that lend themselves to case studies of the promotion of US culture and values to overseas audiences.[78] There were occasions when photography was accorded this kind of independent status in US cultural diplomacy. For example, the African American photographer and filmmaker Gordon Parks was the subject of several features as an artist in his own right, and there was an ongoing valorization of Edward Steichen's career. And there were multiple instances of self-consciousness around the medium and its capacities for communication and cross-cultural understanding.[79] But photography was at the same time a much more diffuse and pervasive presence in the public diplomacy of the period, operating across multiple sites, at times acknowledged as a medium of expression, but in many others deployed, rhetorically at least, as a neutral carrier of information, a record of people and events, or simply an adjunct to other activities, presented as such without reflection or comment. The illustrative function of photography was reflected in the organization of the master file of still pictures, a series of individual photographs indexed by personality and subject that functioned as a picture library on which the organization could draw for its visual production and in response to specific image requests. This cataloging is retained in the archive and continues to serve the needs of those interested in US history and foreign policy. From the perspective of this study, however, the organization of the master file obscures the principal object of investigation. In addition, while the final visual products, illustrated pamphlets, published

photographs, posters, and so on, are significant for the approach taken here, they do not allow one to penetrate beneath the surface, to access the conceptualization and organization of the photography on which the public diplomacy effort relied. Instead, it was the "staff and stringer" and "picture story" files that were central to the research process, and around which this study pivots. The staff and stringer files typically contained a mix of negatives, work prints, contact sheets and occasionally request sheets, caption notes, and correspondence—the remnants of the original photographic assignment. The picture story files contained series of photographs with text and captions packaged for distribution, short photo-essays one stage on from the assignment files but nonetheless prior to any specific published use. The files were often frustratingly incomplete, in some cases only negatives or contact sheets without any further information, or text but no corresponding photographs, and the indexing by title meant that identifying relevant material was challenging. Nevertheless, they provided insights into photographic working practices at a stage before the formation of specific visual messages, not available either in the master file or in the published outputs. It was possible to get a sense of the individual photographic assignment, its scale and scope, and, in some instances, the ideas that lay behind it and the photographer's interpretation, especially where this differed from or went beyond a shooting script. I have then attempted to correlate this close examination of photographic assignments with the broader policies within which they were anticipated to function, the mediation of the photographs as they were used in specific publications or exhibitions, and the circuits through which they were distributed. This necessitated engaging with the vast USIA and Department of State document collections, wherein there is no easy mechanism for identifying material relating to the many diverse uses of photographs. For reasons of conservation, photographic prints and negatives have tended to be separated from the textual documents that would have surrounded them in their contexts of use, requiring an effort to reconstruct these connections. Among the most interesting documents here were the reports of the USIS country offices, where occasionally one gains a fascinating view onto the presence of photographs in the African contexts for which they had been created. This material makes it possible to consider not only the careful scripting of images and picture stories but also the cultural and pedagogical work that photography was expected to perform as it was inserted into the visual culture of cities across Africa in the form of magazines, posters, pamphlets, and window displays. The ambition has been to bring to this study of photography the interpretive qualities of historical ethnography.

Locating Africa in the archive is no less of a challenge, conceptually and practically. One might argue that if "Africa" emerges from the archive as a coherent entity at all, it is as an imaginative projection of US public diplomacy. In that sense, this

is not an African archive. The photographs were primarily, although not exclusively, made in the US for distribution in Africa. The continent and its peoples, therefore, were inevitably refracted through a US lens. In many cases, the photographs enact a double refraction—Americans looking at Africans looking at America—within which "the African" risks becoming merely an empty frame through which to project US values. As US politicians and diplomats became conscious of the need to engage the decolonizing world, they drew on a limited knowledge of the continent. Prior to the mid-1950s, public diplomacy efforts in Africa had concentrated on European colonial elites, with indigenous populations viewed as difficult to reach and often character- ized in racist terms. A 1954 study of operating assumptions, for example, cited a USIA employee on the challenges of engaging "the guy with the loincloth in the jungle" and reported crude and patronizing understandings of visual preferences that merely repli- cated colonial attitudes—"People in Asia like color."[80] In this early period, there was a tendency to treat the continent as a single territory, requiring a single approach, with correspondingly lazy and self-regarding assumptions about the identification of Afri- cans with the plight of African Americans in the US. Public diplomacy was far from static during this period, however, and as US officials began to deepen their engage- ment with the continent and to take seriously the prospect of independent African political leadership superseding colonial rule across the continent, it was clear that such unsophisticated conceptions could not hold. The Africa of the US imagination came under pressure and was reshaped in response to a complex cultural and political land- scape. As the number of USIS offices expanded and public and cultural affairs officers disseminated materials in specific country or regional settings, they developed a more grounded and nuanced appreciation of local audiences, even if misinterpretation and misunderstanding remained a significant feature of diplomatic relationships. Wher- ever possible, I have attempted to tease these encounters out of the archival records and consider how they contributed to the formation of US photographic diplomacy on the continent.

On a practical level, the effort to study photography as it was deployed by the US government across an entire continent might seem ambitious to the extent of being foolhardy. The rationale is twofold. First, the mid-1950s through the late 1960s was a period in which Africa began to be accorded a prominent position on the US foreign policy agenda. In the first instance, it did so precisely as a continent, an open, largely unknown, imagined space of Cold War contest with the Soviet Union. In the years that followed, the US diplomatic engagement with independent African countries and their peoples became, of necessity, more attuned to country-specific issues and dynam- ics. This transition and the ways in which photographic diplomacy was shaped in the process are a central concern. Furthermore, the conjunction of African decolonization

with the US civil rights struggle had implications for the ways in which USIA communicated with the continent. The racial logic that saw an inevitable affinity between Africans and African Americans may well have been a flawed basis for policy, and subject to modification in particular country settings and over time, but it undoubtedly played a significant part in USIA visual output. The engagement with Africa had a discernible influence on the representations of race in the US that are now extant in the archive. In this context, one might even argue that Africa is too narrow a focus, in that USIA visual production around race was not exclusively targeted at African audiences but during this same period might be understood as an attempt to speak to the emerging postcolonial world.

The second reason for framing the study as continent-wide is that the principal focus is at program level, by which I mean the centralized conception and production of visual material for distribution overseas. Much of USIA's photographic production had a modular structure, wherein materials produced in Washington would be distributed to multiple sites in the knowledge and expectation that they would be adapted for local uses. Some material was deemed of value to all USIS posts across the world, other material was distributed regionally—for example, to all African posts—and yet other selected material would be sent only to a specific list of country offices. Visual materials were occasionally produced in response to specific requests from country offices, but this was only a small proportion of the total output. The Washington-based Africa Branch was the source of many requests for visual material, which it felt would appeal to more than a single country. USIS African offices also received material from more general output, in relation to the US space program, for example. To conduct research in the still picture collections in the US National Archives is to start at the center, with the photographic material produced in Washington, and only subsequently to trace its distribution across the continent, reading the country records attentively for echoes of its local reception. Reading the archive in this way is to invite juxtaposition. One finds material on Francophone West Africa adjacent to Anglophone East Africa. North Africa received some of the same material that was distributed to sub-Saharan Africa, but also other material that was not. South Africa was on some occasions treated as a special case, but not uniformly or consistently. Rather than dwelling only in one location, I followed lines of inquiry that led back and forth across the continent in an effort to grasp a broader sense of the program, while also paying attention to points where USIA photographic output became grounded in a particular location. The argument for this approach does not obviate the practical and intellectual challenges it presents. There is inevitably a risk of trading depth for breadth. I hope, however, to have mitigated the worst risks by retaining a critical attentiveness to how Africa was being constructed in the archival records, and through careful

contextualization of those examples where the local reception of USIA materials was at issue.

Finally, a brief observation on the continuing archival presence of these photographs. If it seems misplaced to frame this collection as part of an African photographic archive, then the idea can nonetheless serve as a provocation. Western archives and collections contain many African photographs that "have spent very little time in Africa itself, beyond an often brief sojourn within the continent," existing in a state of dislocation.[81] Yet this need not be a permanent condition. Photographs can speak to the present and the future, as well as about the past, and the photographic archive can be a place of new narratives and new connections. Consider, for example, the artist Maryam Jafri's critical re-presentation of photographs from the archives of postcolonial "independence days," which share both content and historical time with the images in this study.[82] The African lives of the USIA photographs disseminated on the continent and the responses they prompted are largely beyond the scope of this project. Yet I hope in some small way that this study can return these images to light and movement and in doing so provide an impetus for future Africa-based studies that explore in greater depth the settings in which the photographs discussed here were made meaningful, or not, and that bring them into dialogue with African photographic histories more firmly grounded on the continent.

In the next chapter, I turn my attention to the place of photography and visual production in the formation of the US information programs in the early postwar period and the Africa program as it took shape in the 1950s and 1960s. Subsequent chapters take a thematic rather than chronological or country-based approach, examining those themes—international cooperation, racial integration and civil rights, and transnational friendship—that predominated in the photographic output for Africa. In the final chapter, I turn to the USIS offices on the continent, the network of distribution points for photographs arriving from the US and themselves sites of visual presentation through exhibitions and window displays, in order to understand how photographs and picture stories created in the US became a part of urban African cultures.

Photography, Public Diplomacy, and the Africa Program at the United States Information Agency

In October 1967, then USIA director, Leonard Marks, wrote a short piece for *Industrial Photography: The Magazine of Photography at Work*, entitled "Photography a Vital Asset." Describing the mission of the agency, he pointed out that "creating and nurturing mutual understanding among nations is a delicate and difficult process. When attempted in the face of ignorance or distrust and over the barrier of cultural differences, the process becomes incalculably more difficult." Photography, he argued, was one means by which this challenge could be met: "We look to photography and the men and women who are the creative artists in the field for ideas, techniques and products that will help in the complex and exciting task of communicating the substance of America to the world."[1] This appeal by Marks was indicative of the symbiotic relationship that existed between the agency and the creative and communication industries in the postwar period. This chapter examines, first, the context in which photography came to serve as a "vital asset" for the agency. There has been much commentary on the USIA's sponsorship of the global tour of *The Family of Man*, which Nicholas Cull describes as "a remarkable piece of cultural diplomacy."[2] Yet, notwithstanding the importance of this exhibition, it is evident that photography had a far more extensive role across the agency's public diplomacy activities. The chapter then turns to the Africa program as it developed from the early postwar period through the 1960s, and the ways in which photography was deployed to reach African audiences in newly independent nations.

The story of postwar US government photography is one of administrative upheaval and uncertainty in combination with an underlying continuity of purpose, which would be reinvigorated and reshaped from the early 1950s. The end of the war heralded a period of insecurity for the US government information program and its personnel. With the cessation of hostilities, the Office of War Information (OWI) was quickly closed and its "mighty global apparatus of advocacy and cultural projection" transferred to the Department of State, where it would remain, somewhat uncomfortably and subject to constant restructuring, until the establishment of USIA as an independent agency in 1953.[3] The level of activity that had peaked during wartime was cut back substantially, with personnel reduced from eleven thousand to just three thousand by 1946.[4] By 1948, the information program was faced with the "near-elimination of all . . . picture activities" and being "forced to abandon all but a very small contract" for the supply of commercial visual material.[5] For a period, in the mid to late 1940s, it seemed that the continued existence of a coordinated program was in doubt.[6] Without the justifying rationale of conflict, questions began to be aired publicly about the legitimacy and cost of overseas operations. The challenges came from several directions. As commercial picture agencies continued to expand their international operations there was tension around the increasing overlap between their own distribution networks and those operated by INP, and its successor, the Press and Publications Service (IPS). Indeed, the executive order that relocated the information program from the OWI to the Department of State explicitly stated that government output should not be in direct competition with US commercial media organizations.[7] Media organizations were equally concerned that their output would be tarred as propaganda, affecting both credibility and commercial prospects.[8] Ostensibly, this presented significant restrictions to operations. INP was committed to the "widespread exhibition of the documentary photograph to delineate all phases of the United States, and what goes to make it," and viewed the medium as "a highly effective weapon in correcting conscious distortions of this country's aims and activities."[9] But in their negotiations for the supply of pictures for 1949 they were faced with various geographical restrictions. For example, International News Photos allowed unrestricted use of images in INP displays, filmstrips, and field-based publications but restricted supply to foreign publications to Eastern Europe, the Middle and Far East, and Latin America, where they had begun to establish significant markets. Associated Press (AP) went further, claiming that their operation now extended across the globe and that, therefore, it was no longer necessary or desirable for any of their news pictures to be distributed via the US government. Jack McDermott, INP Division Chief, expressed his frustration at this response: "It is difficult to challenge with precision Mr. Stratton's implication that AP

pictures cover the world, but it is certain that there are many small or large regions of the world which do not see them, and many thousands of publications which have no access to them . . . it may be true that, for commercial reasons, AP cannot afford to supply photographs to the Department, it does not follow that there is no need for picture distribution."[10] The context of the Cold War would eventually create the political space for USIA to develop programs that were more extensive than might be envisaged in the light of the position taken by AP here, but the challenge from commercial press agencies nevertheless underlined the need to establish a distinctive mission.

The extent to which the INP operation was identified with a wider media environment and the tension between this and its political accountability surfaced again a few years later in an internal study: "The problem, in a nutshell, is this: is too much of the Publications Branch in New York?" and "How much of it, if any, should be moved to Washington?" The study's author argued that New York was the better location given its proximity to the press and publishing industry, and not least for photography where "a dozen or more sources are often needed to give a single picture story proper ideological content, documentary quality, liveliness, and suitability to the readership involved."[11] New York, it was argued, was home to many specialized agencies with "collections of exceptional value to the publications program," for example, Pix, Inc.'s coverage of India and Black Star's "pictures relating to the life of the Negro in the United States." Washington-based agencies, on the other hand, dealt mainly with news photographs, a marginal proportion of the Branch's picture purchases. The report also argued that personal contacts with the network of freelance photographers on which they might draw for assignments was better maintained from a New York base: "The Picture Unit has built up a string of out-of-town and travelling photographers," many of whom "are in the habit of apprising the office's picture editor of their travel plans and assignments." Despite the cogently and passionately argued case, however, over the next few years the center of gravity would shift significantly to Washington, underlining a closer alignment with foreign policy.

As well as financial and organizational challenges, the content of overseas information programs and the political allegiances of staff came under the spotlight. Laura Belmonte provides a striking example of the level of scrutiny to which overseas output was subject. In 1951, in response to a request from the USIS office in London for a picture story on "Home Life in the USA," the IPS Photographic Branch selected what they believed would be an appropriate family, with two children, who were active in the community and regular churchgoers. When the subjects of the story were identified in a piece in the Washington *Evening Star*, however, officials were immediately challenged on the couple's suitability for representing American values. A caller to the Department of State pointed out that this was a second marriage for both the man

and the woman, and furthermore, the former "does not even have a war record." The story was pulled, lest it provide material that could be used by Soviet propagandists to present the US as "a country of moral degenerates."[12] This was just a single instance of a broader climate of hostility and suspicion toward the overseas information programs, which had their origins in the Roosevelt era. The Photographic Branch that had transferred to the Department of State at the end of the war originated in the FSA under Roy Stryker, itself often subject to political challenge, before becoming part of the OWI in 1942. In the mid-1960s, USIA was comfortable enough with its history to have a feature article on the agency acknowledge that it still used the old FSA lab and OWI processing facilities.[13] In the immediate postwar period, however, this legacy was less helpful in convincing legislators of the legitimacy of its activities. As Justin Hart observes, the accusation that the information program sought to re–create the OWI within the Department of State was "the most damning criticism of all."[14]

Senator Joseph McCarthy, whose investigations of alleged communist infiltration into the US government and public life reached fever pitch during the 1950s, had overseas information programs on his list of targets. Early 1953 was a genuine moment of peril for the organization, as the integrity of its staff was impugned and its activities represented as communist subversion. The investigations had a damaging impact on operations and staff morale. As Wilson Dizard put it, in "the black days of the spring of 1953, the organization sagged and groaned to a halt."[15] Despite the assaults on its integrity, however, the idea of an information agency weathered the political storm and emerged on the other side. From a photographic perspective, it is worth a brief comparison here with the New York-based Photo League, which emerged in the mid-1930s as part of the same documentary moment that gave birth to Stryker's project at the FSA. In the postwar period, however, its fate was rather different. In 1947, it was declared to be a communist front organization and blacklisted by the Department of Justice, precipitating its eventual demise in 1951. Despite promises of support from Edward Steichen, who would become such a favorite of US government photography under USIA, when the pressure was on, this support did not materialize.[16] The photography that survived under the auspices of the Department of State did not do so unchanged of course. The photographic operation that reemerged as part of USIA was quite different from that which had existed at FSA in the prewar years. It was more constrained by political considerations—not least around issues of race and civil rights—more conservative in its outlook, and photographers would not have the same degree of autonomy as had existed for a period under Stryker. It was nevertheless both more complex and extensive than is usually acknowledged.

One of the most significant features of US government photography in the postwar period is that even as it continued to look at America, it did so now in order to engage

with a world in which it had become a global power. As Archibald MacLeish observed in 1945, mass communications had "made foreign relations domestic affairs."[17] If there were many who would have liked to close down US overseas information operations, or simply starve them of funds, there were countervailing factors that worked in their favor. In the immediate postwar years, their contribution to democratization efforts in occupied Germany and Japan provided positive examples of support for foreign policy objectives in peace time.[18] More important, however, was the growing appreciation that overseas information operations would be critical in efforts to counter the Soviet Union in the rapidly developing Cold War. The establishment of the Truman Doctrine as the central plank of US foreign policy was followed in Congress by a significant piece of legislation sponsored by Karl Mundt and Alexander Smith. The United States Information and Educational Exchange Act, passed in 1948, provided a legislative basis for information and cultural programs as a permanent feature of US foreign policy. The objectives of the Smith-Mundt Act—"to promote better understanding of the United States in other countries, and to increase mutual understanding between the people of the United States and the people of other countries"—provided the guiding principles around which US information and cultural programs would be developed.[19] The legislation was followed by the launch of Truman's "Campaign of Truth" as a flagship program, which aimed to move from a passive presentation of the US to overseas audiences to a proactive and vigorous effort to counter the ideological challenge presented by Soviet communism. The operation at the Department of State was first restructured into the IIA, and then, after it had weathered the assault by Senator McCarthy early that year, in August 1953 it was established as an independent agency, USIA.

———

After eight uncomfortable years at the Department of State, the creation of USIA as a separate entity gave new focus and standing to the information and cultural programs. Although it would always remain subject to the political weather, for the length of the Cold War, USIA provided the framework for US informational, cultural, educational, and exchange programs and their implementation through an expanding network of USIS posts overseas. Significantly, USIA had no mandate for communicating government policy to domestic audiences, and the materials it produced were prohibited from being distributed within the US.[20] Although items surfaced periodically in ways that caused controversy for the agency, the program was conducted largely out of sight of the general public in the US, which, with a degree of caution, gave it license to depict issues of civil rights and racial integration in ways that would not have been possible for domestic audiences.

USIA took its foreign policy direction from the Department of State but was responsible to the president through the National Security Council, established in 1947 to advise

on major foreign policy issues.[21] In October 1953, Eisenhower provided the agency with a formal statement of mission. Its central purpose was "to submit evidence to people of other nations by means of communication techniques that the objectives and policies of the United States are in harmony with and will advance their legitimate aspirations for freedom, progress and peace."[22] The agency was tasked with "explaining and interpreting" US government policy, "unmasking and countering hostile attempts to distort or to frustrate" US aims and objectives, "delineating . . . aspects of the life and culture of the people of the United States" that promoted greater understanding of US objectives, and, most significant in this context, "depicting imaginatively the correlation between US policies and the legitimate aspirations of other peoples in the world."

USIA was not the only government agency responsible for the export of soft propaganda around the globe. As revealed in 1966, the CIA had long been covertly funding cultural initiatives to counter communism, especially in postwar Europe where it sponsored the extensive activities of the Congress for Cultural Freedom.[23] The directors of both agencies sat on Eisenhower's new Operations Coordinating Board. The CIA was primarily engaged in covert forms of propaganda, whereas USIA's approach was considerably more overt. But despite this division of labor, and the insistence of its first director, Theodore Streibert, that there should be a "firewall" between them, there were many shades of gray and at times their operations were closely coordinated.[24] USIA also had authorization for the production and distribution of unattributed materials, though this was used somewhat cautiously and often viewed as a risk to the agency's credibility.[25]

The emphasis on counterpropaganda in the agency's mission was of signal importance in underpinning the case for funding in the climate of the early Cold War, but, at the same time, the weight given to imaginative engagement with foreign publics, together with the reference to communication techniques, ensured a central place for creative media production. As Schwenk-Borrell points out, USIA recruited "reporters, interpreters, writers, designers, film-makers, artists and public relations experts."[26] The grounding of the USIA approach in the creative documentary and journalistic treatment of "the facts" was made clear in a Basic Guidance paper produced just a few years after its foundation. "Every effort should be made," it stated, "through imaginative use of facts, through highest-quality standards of editing and presenting material, and through skillful use of art, humor, local interests, and fresh, creative techniques, to make our unfolding of the facts attractive as well as understandable." The document contrasted the US approach with that of their Soviet counterparts: "The communists can never reveal themselves for what they really are. Instead they must constantly obscure the truth and create illusions. Our strength lies in precisely the opposite direction."[27] This approach relied on faith in the fundamental rightness of the American model: "All

the deepest motivations and desires of human beings are such as to drive them away from communism and to identify them with us." Even a willingness to acknowledge "unpalatable facts," such as the racial conflict at Little Rock, Arkansas, when seen "in their proper proportion and setting," was understood to lead to the same conclusion.

USIA's stability and increased funding provided a platform on which to build an extensive program of public diplomacy in response to the exigencies of the Cold War and the changing world order. Before turning to the agency's operational structure, and the place of photography within its programs, however, it is worth pausing for a moment on the notion of "public diplomacy." The term itself was not common currency in the 1950s when USIA was formulating its mission. Indeed, as implied in the title of Wilson Dizard's history of USIA—*Inventing Public Diplomacy*—the agency played a part in establishing its contemporary sense as "the process by which international actors seek to accomplish the goals of their foreign policy by engaging with foreign publics."[28] According to Cull, the term "took off" precisely because it fulfilled a need on the part of USIA to find a better way of articulating its activities, an "alternative to the anodyne term information or malignant term propaganda: a fresh turn of phrase upon which it could build new and benign meanings."[29] But as Cull also describes, the term encompassed an expansive range of activities that have a long history in modern statecraft: listening, advocacy, cultural diplomacy, exchange, and international news broadcasting.[30]

USIA was engaged in the full range of these activities: extensive and regular surveys of public opinion within the countries where it operated, including a series of "World Surveys" during the 1960s; advocating for particular policies, for example, through the dissemination of major presidential policy statements; the export of US culture, most notably the high-profile jazz tours; the support of educational and cultural exchange programs; and a regular fast news service through its wireless bulletin, as well as slower media in the form of pamphlets and posters. Moreover, the medium of photography played a role in each of these areas. It circulated the image of US presidents, along with their policies, and featured in exhibitions where photography was simply the medium of communication as well as those such as *The Family of Man* where it was presented as a cultural form in which the US led the world. Photo-essays presented various educational and exchange programs, and photography was also part of USIA's regular news services. Even "listening" to how foreign publics responded to photographs or picture stories was part of the program. Photography was not the only medium to which the agency turned to fulfil its aims of course, nor even in some areas the most important. The revitalized Voice of America (VOA) program had perhaps the highest profile and the most extensive reach, and there was a significant film program.[31] Nevertheless, photography was a vital medium that featured across the range

of USIA activities. The diverse purposes it served, often as a taken-for-granted part of the public diplomacy toolkit rather than a cultural form, make it challenging to study, since it cannot be identified with a discrete program in the same way as radio or film. Yet its value deserves to be better understood.

Although USIA was subject to reorganization several times and the name of individual sections changed over time, the underlying structure remained relatively stable, comprising a series of media services on the one hand, and the division of the world into regions on the other. The operation was overseen by a director and several offices, including one responsible for Policy and Programs and another for Research and Evaluation. In addition to VOA, known within USIA as the International Broadcasting Service, the media services included IPS, the Motion Picture Service (IMS), and the Information Center Service (ICS). IMS was responsible for the film program, including newsreel packages such as *Today* produced for distribution in Africa, and would later incorporate a television service. Photography was primarily located in IPS, where the Photographic Branch was responsible both for production as well as processing facilities, acquisition from outside agencies, and maintenance of the Photographic Library, an indexed master file of prints and negatives selected from those produced and acquired in the course of its work and subsequently available to service future image requests. The Photographic Branch worked closely with the Publications Branch, which produced regular illustrated magazines. The Photographic Branch also responded to requests directly from regional offices and supplied material for displays organized by the Exhibitions Division within ICS, which was responsible for the libraries and information centers maintained at many of the USIS overseas posts. The latter were important sites for the dissemination of USIA photographs across the world, and I will return to their presence in Africa in a later chapter.

Through the late 1940s and early 1950s the Photographic Branch had undergone a process of transition, from the more autonomous setup that had existed under FSA and OWI to the tighter operation more closely related to foreign policy that emerged at USIA. A list of picture story assignments scheduled for a six-month period in the spring and summer of 1950 gives a sense of the activity during the early postwar period.[32] There were assignments to cover visits by the President of Chile and the Premier of Pakistan, but the list is overwhelmingly dominated by stories of American life. There were stories on the port city of New Orleans, economic growth in the south, Travelers Aid in Chicago's Union Station, and Cleveland Community Theater. Considerable attention was given to rural America, with stories on a Maine fishing village, the start of the wheat harvest in Texas, a visiting public health nurse in Kentucky or Alabama, and farm families ("good American types") including an Alabama farm family—"preferably one which formerly sharecropped and now owns its farm." And

to modern life, stories on labor relations, congressional primary elections, tourists in national parks, drive-in movies, modern department stores, and the "daily lives" of American women, were intended to "show how their activities join in Democratic life." This last story was described as a "top project for Germany." There was a small scattering of stories with an international focus—an international trade fair in Chicago, an International Boy Scouts Jamboree, and a foreign student summer project—and, in reflective mode, there was a story proposed on "visual education in schools." Many of these assignments were developed over time as extended picture stories, in some cases with input from multiple photographers. The script for a story on skilled labor, entitled "Fifty million skilled workers," identified sixty-nine different types of photographs to be made, covering not only different forms of work, from miners and steelworkers to bakers, bus drivers, and pilots, but also the workplace environment, union organization, recreational facilities, Labor Day parades, and ending in the home as the demonstration of living standards achieved—"They work hard and live well under a full measure of freedom"—and images of children to indicate the promise of the future.

The photographers whose names were listed against the proposed stories had a considerable degree of autonomy, as can be seen from their individual itineraries. Several were working for the agency as writer-photographers. Tom Parker, who had previously worked for the War Relocation Authority, and was assigned to several elements of the labor script, planned to spend up to ten days traveling from Washington to Chicago, through Indiana and Ohio, searching out appropriate locations, stopping in Evanston to carry out another assignment on a department store, and then spending a minimum of four to six weeks shooting labor photographs. He then anticipated heading west via Mooseheart, Illinois, and Boys Town, Nebraska, where he was planning to photograph two children's homes, to arrive in the national parks in early June for the tourist season. Jean Speiser, a former photographer and editorial assistant at *Life* magazine, would spend much of May and June in New England, first photographing the proposed fishing village story in Maine, and then in Bingham where she was to photograph a community pooling resources to build a local hospital.

Texas-born photographer Carolyn Ramsey photographed human interest stories on a Texas fruit farmer, the Gatlinberg Fair, and a small town whose main business was producing Christmas trees. She also picked up the Alabama farm family story, the racial dimension of which was now stated more explicitly. The assignment was based on a piece published in the illustrated magazine *Collier's* in July 1949, entitled "It Happened in Mississippi," which reported on two Black sharecroppers who benefitted from government loans enabling them to buy their own farms. The story was planned for publication across four to six pages in *Amerika*, distributed in the Soviet Union.[33]

The insights provided by these detailed itineraries and shooting scripts are valuable of course, but they should not distract attention from the ways in which government photography was undergoing significant transformation. Even before the formation of USIA as an independent agency, Truman's "Campaign of Truth" led to greater centralization of the US propaganda message, and what one document referred to as a "sharpening" of its pictorial output. The romantic idea, associated with the FSA period, of the photographer traveling across the country responding to what he or she saw and creating photographic images and narratives would hold considerably less truth in the years to come. The model that dominated USIA production was often more akin to that of a commercial illustrator producing work in response to a closely specified brief and with little involvement in the rest of the process. It is important not to lose a sense of the practice of photography. As Nick Natanson points out, "Political motives notwithstanding, USIA's commitment to the still photographic medium was as rare as it was long-term," not least its development of the central file "in the very decades when most other agencies were abandoning the notion of a photo file that would serve anything more than immediate publication needs," and "providing work and international exposure for dozens of talented young freelancers across the country," in addition to staging high-profile photographic exhibitions.[34] But one should recognize nonetheless that the photographer was only one component in a vast international operation, whereby photographs were multiplied and distributed across the world. The output of the Photographic Branch was certainly extensive, forming a key source for what was conceived as a "constant flow of truthful information to all parts of the world." At the beginning of the 1950s, INP estimated that ten thousand foreign newspapers and periodicals and one hundred thousand foreign government officials, editors, and other opinion formers were receiving informational materials through USIS offices in around one hundred different countries and territories. "The visual medium," it was argued, "dramatizes the US story for huge audiences abroad" and "conveys truths and refutes lies in convincing, long-remembered form." An INP document sheds light on the perceived relationship between form and audience:

> Photographic display material is adapted to many audiences—in mass-produced poster form for rural dwellers and youth, in impressive portable displays for circulation to worker groups and higher-level students, and in dramatic exhibits for influential city audiences. To the literate, photographic material conveys a sharp, visual impression; an illiterate can grasp its message without words or by looking at it while someone else reads him the captions. Photographs printed in leading foreign newspapers magazines reach government and other leaders; plastic printing plates used by smaller publications reach a broad range of

workers, farmers, and businessmen in provincial areas. Filmstrips have great impact on youth and in labor organizations.

Exhibitions consisting of forty to sixty enlarged and mounted photographs on a specific theme were produced at the rate of around one a month in editions of two hundred fifty and sent overseas for display at venues such as schools, museums, and libraries. Posters with around six to nine captioned photographs each were produced in editions of sixty thousand every two weeks; captions were translated into multiple languages, or in some case left blank to be added locally. Feature photographs for distribution to foreign newspapers and magazines were sent out at the rate of around fifteen thousand prints weekly. Ready-to-use, lightweight plastic plates were distributed to small rural and provincial publications that could not afford the cost of engraving their own. Output averaged fifteen thousand plates covering twelve different subjects each week, with an estimated 75–100 percent usage. Filmstrips, an updated version of the magic lantern show considered to be particularly effective with illiterate audiences, comprised a slide sequence and written lecture notes. These were produced at the rate of around three titles a month, with nine hundred prints of each servicing six thousand projectors, including models powered by kerosene for rural areas. Visual production was spread between the US, where the "home-base creates and distributes longer-range displays and exhibits, filmstrips, press photos and plastic plates for selective distribution by the missions"; Regional Production Centers (RPCs), which enabled faster distribution of large print runs of materials on a regional basis; and local missions, where staff were able to "create tactical posters on urgent current issues, using native artists or selecting INP or local photos for local impact."[35] With the exception of filmstrips, these different forms of photographic output would continue to be produced in volume by USIA throughout the 1950s and 1960s. The case of filmstrips is an interesting one, and I discuss some examples below, though for the moment it is worth noting that the pedagogical form of the filmstrip, which arguably had colonial associations, was soon felt to have outlived its usefulness to the mission of US public diplomacy.[36]

Although the commitment to the medium of photography remained constant, there were two significant trends that influenced the agency's visual output over the longer term. The first of these was the understanding of audience. Even in the early documents there was a declared imperative for greater targeting of communications. Over time this would become a constant refrain, accompanied by a relentless search for efficiency. In virtually all areas, the consequence was that no longer would there be the same effort to reach mass audiences espoused in the early postwar period. Instead, the principal focus was on those in positions of power and influence, alongside educated youth. This was particularly the case in Africa. The second trend was away from

the predominance of "Americana"—human interest stories on the American landscape and its people—in favor of what a later report referred to as a "sharpened . . . political accent" to the agency's output. In other words, a greater focus on global political issues, as well as the democratic institutions of the US. Americana, it was argued, should only be used "when it is essential as a means of suggesting a method of action in other countries."[37] The agency should "not get sidetracked into activities that derive from the American fetish of wanting to be liked," one commentator urged, describing photographic coverage of US national parks as "relics of the (hopefully) discarded theory that admiration of scenic splendor somehow transfers into understanding of foreign policy."[38] These developments became especially important as the agency began to turn its attention away from Europe to the rest of the world.

The US information and cultural programs inherited by USIA mapped their operations onto the Department of State, dividing the world into four regions: Europe, Central and South America, the Far East, and the Near East, the latter encompassing South Asia and Africa. In the immediate postwar years, the reconstruction of Europe and combating the Soviet Union along the fault line between East and West took priority over other regions. The budget and staffing for Europe dwarfed that of all other regions put together. But the Korean War, and the emergence of anti-colonial and postcolonial nationalisms across the world had begun to challenge a Eurocentric perspective. Information officers became increasingly aware of the importance of the non-European world to US foreign policy. A 1952 survey of field posts in the Near East region offers a preview of the concerns that would preoccupy the visual program over the coming years, as it sought to move its operation into new areas.[39]

Harry Casler, then chief of the Display Section of the Photographic Branch, flew out to Manila in early January and made his way back westward stopping at USIS offices in Hong Kong, Saigon (Ho Chi Minh City), Bangkok, Singapore, Colombo, Karachi, New Delhi, Bombay (Mumbai), Cairo, Beirut, Damascus, and Tehran, arriving back in Washington via Europe in mid-March.[40] His report gave a candid assessment of the photographic operation in the countries he visited, and also reflected wider concerns at program level. With respect to the latter, his recommendations echoed concerns being expressed elsewhere, posing the question of whether it should aim to "positively project the story it knows best (the American way of life)," or instead contribute to "the American effort in psychological warfare, which necessarily must so often use a negative approach." His conclusion was that the status quo was untenable: "The program appears to be talking out of two sides of its mouth simultaneously which . . . results either in a confused message or an unintelligible mumble." He argued, too, that the approach needed to be nuanced in relation to specific country contexts; the program "can no longer delude itself that materials usable in one country can be

applied with the same effectiveness in another country." Rather than "flooding" field posts with material, much of which went unused, either because it was not appropriate or simply because the post lacked the personnel who understood its value, Casler proposed an immediate switch to "a qualitative rather than quantitative concept," or as he more colorfully put it, "the deer-rifle instead of blunderbuss technique." Giving substance to its case, the report outlined some of the visual sensitivities that needed to be observed. Anti-communist material was "completely unacceptable" in India, as were images of the conflict in Korea or indeed of the US military. The only exception to this "sweeping ban" were photographs of prisoners of war being cared for by the UN, medical units, and "reconstruction or rehabilitation pictures." In Karachi, on the other hand, anti-communist material was welcome, though photographs of Israel were not. And "as a general rule," no photographs that included both Indians and Pakistanis should be sent to either country. Furthermore, the report recommended that the information service take greater responsibility to inform overseas audiences "not only about the activities of Americans and peoples of the Free World, but also of progressive activities within their own countries." The issue of race was important across the Indian subcontinent and there was a plea for a wider range of material from which to select. The report noted sardonically that "Ceylon is no exception to having the impression that there are only two Negroes in the US and neither of them is very dark"; the reference was to Ralph Bunche and Edith Sampson who featured heavily in output during this period. Field posts needed photographs of Americans who were "pictorially obvious as of non-white origin," and who would be accepted as more representative of the African American experience: "Credible pix of Negroes, plain people going about their daily lives as Americans, effortlessly mixed in our pictorial output without straining to make a point of intermingling." Across the Near East, there was noted a general perception of the US as "starkly lacking in culture," which the program was implored to put resources into disabusing, even if it may not be easy to sell as a priority to politicians in Congress who controlled the budget. This was a perception held more widely than the Near East, of course, and one can often sense how it stung US information officials.

At an operational level, Casler provided a critique of photographic personnel and facilities, all of which "offered vast room for improvement"; in some cases, "facilities were installed in a closet and operated by a semi-trained local employee working with highly inadequate equipment." He made the case for the local adoption of a model of photographic organization akin to that in Washington, where a centralized photo-morgue was created "to serve as a mother lode," maximizing the value of material distributed to field posts and enabling a quick response to specific picture needs. The report stressed the need to appoint more personnel with experience in picture editing, who would be able to "make much capital use of images." Equally significant was

the "dire need for specialists who can produce documentary photo stories in publishable pictures and text," with many posts wishing to have US photographers assigned to them, or at least available at short notice. This might seem one item too many on an extended Photographic Branch wish list, but Casler noted that Larry Gahn had begun to play something of this role in Southeast Asia. One of Casler's key proposals was that the use of visual material should be recognized in individual Country Plans, the "hard charter" defining the mission in that country. He saw this as a mechanism for ensuring that Public Affairs Officers (PAOs) "feel compelled to give . . . attention to still visual exploitation." Finally, Casler reflected on a question with both operational and strategic import. The expansion of the US information program beyond Europe had given rise to the question of whether another RPC was required to service the Near East—the Far East was serviced by one already established in Manila. Cairo had been mooted as a possible location, and so Casler set out the pros and cons, contrasting its favorable location for distribution with the risks posed by political instability, described in the report as "emotional outbreaks so often resulting in wanton destruction of property." The following year USIA opted instead for Beirut.

At this moment in their history, US information and cultural programs had not penetrated Africa much beyond offices in the North of the continent, a limited engagement with majority populations in French and British colonies in East and West Africa, and a long-standing relationship with Liberia. As the push for decolonization gathered pace, this would need to change.

—————

At the close of the Second World War, activity on the continent of Africa was significantly scaled back. North Africa, which had been an important theater of informational as well as military operations, was no longer a strategic priority, and with most of the continent still under colonial rule, there was little demand for an expansion of US cultural and information activity in the wider region. Earlier efforts by the outward-looking Division of Cultural Relations to locate officers in Accra, Cairo, Leopoldville (Kinshasa), and Lourenço Marques (Maputo) had not come to fruition and in a tightening fiscal environment were dropped.[41] Extensive wartime radio broadcasts were substantially reduced with Arabic and Afrikaans output cut altogether, leaving only English. And the closure of the USIS libraries in Cape Town and Johannesburg in 1947 left only two branches, in Algiers and Cairo. A small visiting student program with Liberia continued, but this added little to the overall picture. From this low base, over the next decade, there would be a gradual growth in activity and the establishment of several new field posts, but as Peter Koffsky described, this was "slow, unspectacular work," which did not have great success with "economy-minded appropriations committees."[42]

In this initial period there was considerable caution in the US cultural and information operation vis-à-vis their colonial allies in the region, evident in a series of country papers from 1950.[43] In British East Africa, the first priority for the program was to "reaffirm our long standing friendship with the African, the European and Indian populations." Yet the different weight accorded to the colonial and subject populations was explicit. White settlers and colonial officials were expected to be the most important target group "for some time to come," with African and Indian leaders "who are gradually achieving positions of responsibility in the fields of education, government, trade and commerce" a second priority. The broad mass of the population, with low levels of literacy, was listed only as tertiary target. In French Equatorial and West Africa, the order of priority was broadly similar, with "colonial officialdom itself" regarded as the primary target of US output. Only in the Gold Coast (Ghana) were literate Africans regarded as the highest priority audience. In both East and West Africa, the reports noted suspicion concerning the ultimate goal of US programs. In British East Africa, there was a perception among the colonial settler population that the US was trying "to promote among native peoples ideas of independence and breaking away from Great Britain." And in French-speaking colonies, they were regarded "as everything from tools of American anti-colonialism to forerunners of United States economic or even military imperialism." As a result, US information officers were at pains to convince both White settlers and colonial officers that their support for the "progress of African peoples" was consistent with a "desire for the increased strength and stability of the metropolitan governments."

The Country Plans stressed the importance of working with and through colonial authorities, and to some extent White settlers, toward the "orderly progress of African peoples." There is evidence of cooperation and the sharing of visual materials between US and British officers. For example, the director of the Colonial Film Unit in Uganda is cited on the value of the US produced film *Hookworm* in persuading the African population in the Western Province to present themselves for medical treatment. The network of US missionaries in the region also provided an important outlet for US books, periodicals, films, and filmstrips. Relations with French colonial officials were rather cooler, and hence the US program was more constrained in its operations. Following the arrival of a PAO in Dakar in May 1950, and the opening of new offices in July, there was a very measured approach to engagement with sections of the local population, lest they upset the French colonial authorities. Engagement with the majority African population in the region was "definitely discouraged" by the French. Hence, during the program's initial period it was recommended that "contacts with indigenous African students . . . should not be sought after . . . unless the proper French authorities approve." Even in the Gold Coast, where a PAO had been in post since October

1949, with the territory on a path to self-government and the population in "a receptive state of mind," there remained lingering suspicion on the part of British colonial officials as to US motives.

Yet, despite this caution, it is evident that information officials were beginning to consider indigenous Africans as an emerging audience, both educated elites and the broader population, underpinned by a belief that the US had a key role to play in the future of the continent. It was argued, for example, that "the native population of British East Africa must be reached by every means possible in order to assist them in their economic, social, cultural, spiritual and political development," and that this could "only be achieved in desirable depth and speed with large American cooperation." In the Gold Coast there were considerable grounds for optimism; the country was regarded as "fertile territory for assisting the African non-self-governing areas in their development as a healthy and well-educated democratic people whose reliance and respect will thus be turned toward the West." Photography and film were viewed as central to the task of reaching out to African audiences. Despite issues of distribution, the British East Africa report ventured that the "literate African leader's relative lack of knowledge of the United States, together with the space, coverage and printing limitations of the African vernacular press, and the African's general suspicion of the European including his press, favor the film and filmstrip as the number one medium for this group." The number of filmstrips on loan had already increased from fifty to one hundred thirty, limited primarily by the number of schools that were equipped with projectors rather than the supply of visual material. Continued expansion of the program at USIS Nairobi and "the link between literate and illiterate or semi-literate Africans, for whom a general visual approach is probably most effective" suggested that it would not be long before visual media became the primary means of targeting literate Africans.

If educated Africans were regarded as a higher priority, it was clear nonetheless that efforts were made to reach beyond an urban educated elite. In this regard, US information officers often held racist and patronizing views on the capacity of African audiences to understand complex media texts; views that differed little, if at all, from those of colonial officials.[44] For such groups, it was argued, "Only the simplest and most obvious audio-visual techniques . . . will be of value." In Francophone contexts, where the US operation was less developed, rural audiences were to be targeted only with "simple films on health, agriculture, irrigation, and sanitation." Like their British counterparts, US information officers saw the need to inculcate in African audiences a proper approach to modern media consumption: "While there appears to be a light disciplinary problem on the part of children and some illiterates on some occasions of non-intelligibility of sound track, this is said to be completely offset when

the showing is preceded by an indoctrination and explanatory session, and the program integrated to include both documentary and entertainment films." No doubt in this early period cooperation between US and British officials was underpinned by a shared understanding of the task of communicating to African audiences.[45]

Given the priority accorded to filmstrips, it is worth briefly considering some examples that were in circulation. Reviewing a catalog from the beginning of the 1950s, it is clear that output was dominated by a mixture of narratives of American life and landscape, from railroads to cowboys to small town doctors, along with accounts of science and development, such as the peacetime uses of atomic energy or the transformation of the Tennessee Valley, and explanations of modern media and US democratic institutions. There were a relatively small number of internationally focused filmstrips—for example, on the work of the UN, the war in Korea, and US involvement in postwar reconstruction in the Philippines. Few of the filmstrips would have been made with African audiences in mind, and the continent appeared as the subject of just two out of a listing of 257: *Toward Better Health for Liberia* and *African Fibers Make American Brooms*.[46] The latter was cited in the British East Africa report as being of considerable value for the program in Kenya. That both African filmstrips were focused on Liberia reflected the longer-standing relationships the US had built there, as well as, quite possibly, the presence on the ground of an accomplished African American photographer, Griff Davis, who had traveled to the region as a journalist before working for the US government.[47] The first provided an account of the US public health mission in Liberia, funded under the Point IV program, the foreign aid and technical assistance program initiated by President Truman. The photographs present a narrative of development and healthcare modernization, through the construction of new hospital buildings, the installation of water purification facilities, the training of healthcare practitioners, and the inculcation of modern attitudes to health through exercise, nutrition, and hygiene. The narrative ends with photographs of a mobile clinic as it travels from village to village across the country. This, however, was not an instructional filmstrip but rather a public relations piece setting out the impact of the program and, therefore, most likely directed at those in positions of influence in other countries in Africa and elsewhere, where such programs could be developed, as well as at those who it was felt needed convincing of US goodwill toward Africa. It is notable, however, that US benevolence was understated visually, even if it was clear in the accompanying commentary. The second image in the sequence is a portrait of Liberian President William Tubman seated at his desk, establishing the program as his initiative. Moreover, there is evidence of a racial sensitivity in the selection: White figures are almost entirely absent from the photographs and Black Africans are shown in all the key roles, in the classroom, in the laboratory, and in the operating theater (fig. 8).

Fig. 8 "In the third and last year students assist in the operating room and in the hospital." *Toward Better Health for Liberia*, ca. 1950. USIS Filmstrips, 1942–1952, RG306, NARA. 306-FS-250-33.

The second filmstrip tells the story of piassava, a strong fiber produced by palm trees in the coastal regions of Liberia, which was exported to the US for the manufacture of brooms. As the commentary put it, "As we look at the pictures, we will see how the raw material of one country becomes the finished manufactured product of another." The narrative style of the commentary is quite different than in the healthcare example, addressing its audience directly as the putative producers of the raw material—"When you see bundle after bundle of piassava swing into the hold of a ship, do you ever say to yourself, 'I wonder what happens to piassava after it leaves this country?'"—or their children—"Some of you have watched your fathers and brothers cut the branches, trim the fronds and prepare the long strands of fiber for market." The assumption must be that, even if it served a purpose for other USIS programs on the continent, this filmstrip was prepared for local distribution. The images and commentary move between a form of industrial education and an education geared toward

cultural and economic understanding, while positioning Liberia in a neocolonial relationship with the US as a producer of raw materials for export (figs. 9 and 10). In a section on "Trimming," for example, the commentary gives precise instructions: "Trim both ends of each bundle so that all the fibers will be the same length. Your exporter will tell you what length he needs." Despite this ostensibly instructional mode, it seems doubtful that the filmstrip was used for training piassava workers. More likely, one aim of the filmstrip would have been to foster attitudes necessary for its African subjects to see themselves as efficient modern workers participating in international trade with the US, a message that would have been more widely applicable.[48] Reinforcing this point, the end of the script elevated the status of the work to a national project: "Now that we know how to prepare piassava, let's show our friends how to cut the branches, trim the fronds and prepare the fiber. Last year Liberia exported 2,500 tons of piassava. Perhaps we will produce three times as much this year."

In its visual and narrative structure, there is an implied equality to the presentation, with the Liberian cutters, trimmers, and dock workers on one side of the Atlantic balanced by the broom factory workers, housewives, and street cleaners on the other, an indication no doubt of the US desire to mitigate perceptions that it was exploitative in its economic relations with the continent. The selection contains one photograph, however, that undermines the message of mutuality it sought to present (fig. 9). A well-dressed White man, with a cigarette casually held in his mouth, stands noting down the weight and grade of each bundle of fibers prior to export. The young man in the foreground who has presented the bundle gazes downward, avoiding looking at the exporter, whose decision will determine the economic value of his labor. To the left and right of the frame stand, respectively, a woman and child, and a slightly older man. They look somewhat anxiously or inquisitively toward the camera; maybe they, too, are hoping for a favorable price. The image captures a moment of transaction and the power relations that lie at its heart, betraying the idea of equality between the two sides of this photographic narrative, and making it starkly visible in racial terms. If at the time the filmstrip was produced such a photograph could be passed over without comment by US information officials, this would soon cease to be the case. In many ways, this was precisely the kind of image that USIA photography was later to set itself against.

US information programs provided a range of educational materials in support of the foreign aid and technical assistance program. As these two examples begin to suggest, however, the ambition went beyond simply following colonial models in the search for efficient means of instructing indigenous populations in modern approaches toward healthcare or agricultural production. Rather, the US program might be understood as operating on two intersecting dimensions: first, the provision of materials that

Fig. 9 "... an exporter grades the fiber and weighs each bundle. When he is ready to ship the fiber, he notifies the Department of Agriculture and Commerce." *African Fibers Make American Brooms*, ca. 1950. USIS Filmstrips, 1942–1952, RG306, NARA. 306-FS-276-19.

supported the cultural, political, and, in the language of the period, "psychological" modernization perceived as necessary for the evolution of African countries toward self-government; second, the development of a visual and news media infrastructure and audience, at local, national, and regional levels, by opening countries up to US commercial media where possible, or by substituting for them in their absence. The former was heavily dependent on the latter, but the latter was itself an end as well as the means. The US saw visual media literacy and access as crucial to modernization, because it was one of the central forms of modernization. The production of numerous filmstrips on subjects such as *Making a Movie*, *Public Opinion*, *News in the Making*, and *Education through Sight and Sound* demonstrate the point. Before the phrase became popular, it was clear that US information officers understood that the medium was the message. In French West Africa, the Country Plan was clear that one aim of the program was audience building, or as they put it, to "condition an attitude of receptivity" that would enable wider acceptance of visual media in the future, as an effective channel for reaching the indigenous population. The recommendation that the

Fig. 10 "Here the bundles are unloaded into slings and lifted to the hatch hold of the ship. The Farrel Lines' *African Glade* is taking this shipment of piassava from the Port of Monrovia to the United States." *African Fibers Make American Brooms*, ca. 1950. USIS Filmstrips, 1942–1952, RG306, NARA. 306-FS-276-22.

use of visual materials "should be directed towards the end of stimulating their consciousness of a world external to their natural environment" was clearly cultural and psychological in ambition, albeit underpinned by racist assumptions.

US information officers were aware that education and development, and what they perceived as an opening up of Africa to the world, came with its own risks, not least since the US was only one of the actors in this arena. In Nigeria, for example, it was observed that "the general eagerness for educational and social advancement makes them [the local population] excellent targets for any information program—Russia's as well as ours." Frank Gerits has argued that this set up a certain ambivalence or circularity between the education and propaganda elements of the US program in sub-Saharan Africa. Through education the US believed it was engaged in "producing citizens . . . who were more interested in world events," which inevitably included the treatment of racial minorities in the US. The information program needed, therefore, "to repair the damage to the US image that its own education program inflicted."[49] As early as 1950, this was evident in East and West Africa, where the US program was

seen as compensating for a lack of commercial US news and media. Into this vacuum had begun to flow material representing "considerable distortion" of American life, particularly related to "problems of race relations and US economic penetration of Africa." The issue was felt to be particularly acute in Francophone Africa, where "fears and suspicions" of the US were amplified by an active communist press pursuing an anti-American line and regularly reporting on lynching and segregation. Furthermore, it was argued, "the insularity of their [the educated African elite] French education has prevented their acquiring any real understanding of American culture and the American character." Exchange programs were already directed to countering negative perceptions of the racial situation in the US: two visitors from East Africa were treated to a tour of the southern states, "in order to gain first-hand information on the Negro problem in the South." The broader point Gerits makes, however, is that the emphasis on information and propaganda has come to obscure the role of education, which he argues was more central to the US information and cultural programs in Africa, especially during the Eisenhower administration.[50]

Gerits makes a distinction between public diplomacy as it was deployed in Europe, and "cultural assistance," defined as "the use of cultural resources, such as education and film, to accelerate the modernization process," in Africa.[51] His argument is that in the African context, under Eisenhower, the program was directed primarily toward "psychological modernization," in order to prepare African populations for self-government, rather than engaging in a propaganda war with the Soviet Union. He makes the methodological point that by relying on the reports made to Congress by USIA directors, historians have echoed a little too readily a line that was shaped to appeal to politicians who controlled the budget, rather than examining more carefully evidence of the programs themselves. This nuanced account is helpful to the analysis here and supports the argument for an understanding of photography as more than simply a medium of propaganda. The filmstrip program, for example, precisely fits this model of cultural assistance. However, photography was not just a resource to be deployed in the service of modernizing goals but was itself being enrolled in the US project of producing postcolonial citizens. As the evidence above begins to suggest, the program in Africa not only was concerned about the political and ideological content of its visual output but also paid attention to forms of visual communication, as part of the modernizing process.

In his recent analysis of *The Family of Man* exhibition, Fred Turner argues that, setting aside the critique of its ideological content, one can see in its mode of display the search for a form of mass popular education appropriate to the cultivation of a democratic populace. The exhibition was "less a vehicle for a single message than a three-dimensional arena in which visitors could practice acts of mutual recognition,

choice, and empathy—the core perceptual and affective skills on which democracy depended."[52] Turner was referring to educated Western audiences, but it seems pertinent to ask to what extent the US deployment of photography in Africa embodied similar ideas and visual practices in its pursuit of a democratic future for the continent shaped in its own image. While US information officials evidently thought of African audiences differently, often in ways that were patronizing or simply racist, there is also a sense that some of them understood this, too, as a project of development and modernization, one in which it was expected that over time African audiences would become more discerning and critical viewers demanding more sophisticated visual products, and more persuasive forms of argument. In this respect they differed from their colonial counterparts.[53] It is perhaps unsurprising in this context that the filmstrip program did not last beyond the 1950s.[54] The ideological content of US visual output was without doubt important, and would continue to attract attention, not least because this was the easiest aspect of the program for politicians in Washington to grasp, but any account of USIA photography in Africa has to pay attention to its deployment within the context of a broader program.

————

Given the low priority accorded to Africa and the cautious accommodation with colonial powers in the region it is unsurprising that growth in the information program during the first half of the decade was limited. In 1953, there were just thirteen field posts in Africa, with only Egypt, Ethiopia, Liberia, South Africa, and an unstaffed post in Angola, outside of British and French colonial territories. Only two more would be added over the next five years: Somalia and the Federation of Rhodesia and Nyasaland (Zambia and Zimbabwe, and Malawi).[55] The continent, however, was on the cusp of historic transformation. The US soon recognized that it needed to be seen to oppose colonialism if it was not simply to stand by while movements for national independence in Africa turned decisively to communism. The Department of State understood that "communism had successfully identified itself with nationalism in Africa because of European colonialism"; its response was to argue that by breaking with colonialism it was possible to direct the national aspirations of African peoples toward a model of US democracy.[56] In short, the continent was there to be won or lost. Africa had begun to assume a new importance for US foreign policy. For the information program, the early period of "complacency" was followed by "considerable convulsion," as its operations in Africa rapidly gathered pace.[57] This contrast can be seen, for example, in reports from South Africa, a country whose strategic importance to the US would soon be at odds with its political and symbolic significance for the continent. In June 1955, the ambassador signed off a dispatch by stating that "happily," as far as the South African government and White population are concerned, the objectives of the US Ideological

Program have been "largely attained." He was apparently unconcerned with the Black majority population, described as "backward, illiterate, not politically conscious, and not concerned in internal or external political matters," a conclusion that seems almost willfully ignorant of the new generation of Black political leaders who were beginning to mobilize the majority population and make their voices heard internationally. Just three years later the view from South Africa was rather different, pointing to the "rapidly growing importance (and explosive potentials) of Africa to the United States," and arguing that it was incumbent on the Department of State and USIA to provide the resources for "a more imaginative and enlarged USIS program" for the country.[58] At the same time, the US was undergoing its own political convulsions and events on the domestic front were becoming a prominent dimension of foreign policy. The *Brown vs. Board of Education* decision of 1954 alongside growing civil rights activism meant that race would be a complicating factor in its evolving relationship with Africa, and the image of US democracy was itself at stake.

More aware than most of the changing context, US information officers became increasingly keen to signal their support for African independence. In 1956, "intensive publicity" was given to an anti-colonial resolution proposed by a group of US congressmen.[59] In 1957, when Ghana became the first country in sub-Saharan Africa to achieve independence, Vice President Richard Nixon attended independence celebrations, where he was photographed by Griff Davis in casual conversation with Martin Luther King. The image no doubt portrayed a helpful message for local purposes, even if it was not suitable for distribution in the US.[60] USIS Accra produced a full-color calendar for the occasion (fig. 11). Opening with a portrait of Eisenhower and a statement welcoming Ghana to the "family of independent nations," the photographs presented a narrative of collaborative economic development and shared values. A photograph of a ship docking in New York, for example, served to illustrate US-Ghana trade relationships, not least in cocoa for which the US was a major customer.[61] Other photographs included a US Northwest landscape, a paramount chief in the Northern Territories, cocoa production, the US Declaration of Independence, the Chief Justice of Ghana's Supreme Court in full robe, and Kwame Nkrumah signing papers at his desk.[62] Following the independence of Guinea in 1958, its first president, Sékou Touré, was given similar visual treatment by USIA in a pamphlet, published in French, to mark the occasion of his visit to the US the following year, entitled *Bases d'une Amitié Durable*.[63]

Beyond these one-off publications, however, USIA was beginning to develop a sustained visual media program specifically targeting African audiences. In June 1954, USIS Accra published a "special edition" of *American Outlook*, an English-language publication.[64] It carried a cover story on the Supreme Court school segregation decision,

Salute

TO GHANA INDEPENDENCE

FROM PRESIDENT DWIGHT D. EISENHOWER

" On behalf of the people of the United States of America, I wish to extend to the Government and people of Ghana, congratulations on the occasion of your joining the family of independent nations. We have watched with particular admiration the manner in which you have attained your independence, for it shows the good fruit of statesman-like co-operative effort between the Government and people of Ghana and the Government and people of the United Kingdom. I am sure that this same spirit will characterize Ghana's relationship with the free world, including the great and voluntary association of nations, the British Commonwealth. " In extending these good wishes, I speak for a people that cherishes independence, which we deeply believe is the right of all peoples who are able to discharge its responsi- bilities. It is with special pleasure, therefore, that we witness the establish- ment of your new nation and the assumption of its sovereign place in the free world. " In sending you these greetings, I am conscious of the many years of friendship which have characterized the relations between our two countries. We are proud that some of your distinguished leaders have been educated in the United States. We are also proud that many of our most accomplished citizens had their ancestry in your country. We are pleased that trade between our two countries has deve- loped to the benefit of both countries. But most importantly, we revere in common with you the great and eternal principles which characterize the free democratic way of life. I am confident that our two countries will stand as one in safeguarding this greatest of all bonds between us."

★★

		MARCH				
1957						**1957**
SUNDAY	MONDAY	TUESDAY	WEDNESDAY	THURSDAY	FRIDAY	SATURDAY
					1	2
3	4	5	6	7	8	9
10	11	12	13	14	15	16
17	18	19	20	21	22	23
24/31	25	26	27	28	29	30

UNITED STATES INFORMATION SERVICE

Pagan Road, P.O. Box 2288, Accra, Ghana. Phone : 4694-5

Fig. 11 *Salute to Ghana Independence*, 1957. Master File Copies of Field Publications, 1951–1979, Box 124, RG306, NARA. [Declassified Authority: NND022120.]

illustrated by a photograph that foregrounded an African American child. From 1955, *Outlook* was published monthly with an initial print run of around one hundred thousand copies for distribution primarily in English-speaking West Africa but reaching as far afield as Sudan, Ethiopia, Tanganyika (Tanzania), and the Somali Republic (Somalia) (fig. 12).[65] Although only published on low-quality newsprint, it soon adopted a highly photographic design and layout, often with a photo-essay on the center pages designed as a pull-out and suitable for use as a poster. The year 1957 saw the launch of *Today*, a newsreel specifically for African distribution and with a strong emphasis on the development and independence of African nations. *Today* was shown in theaters, USIS offices, and through mobile film units. By 1959 it was being shown in over two hundred theaters in nine African countries.[66] In 1960, *Outlook* was joined by *Perspectives Americaines*, a French-language equivalent published out of USIS Leopoldville with distribution to Senegal, Cameroon, Tunisia, Ivory Coast (Côte d'Ivoire), Congo-Brazzaville, and Togo (fig. 13). At the same time, *Outlook* began to produce an additional supplement targeted at students. By the end of the decade, the Beirut RPC, established in 1953, would enable significant expansion in high-quality printed output for distribution across the continent. The first USIA magazine for Africa—*Al Hayat Fi America* (*Life in America*)—appeared in 1959. Printed in Beirut from material supplied by Washington, *Al Hayat* targeted Arabic-speaking audiences. USIA would soon see the need to develop an equivalent illustrated magazine for sub-Saharan Africa, as a memo from then director Edward Murrow reveals: "One thing we need in Africa is a good slick picture magazine in English and French devoted largely to African affairs and only incidentally to the US message."[67] When it was launched in 1965, the USIA magazine for Africa—*Topic*—was targeted almost exclusively at an educated elite and especially at students (fig. 14).[68] And as Murrow's comments imply, the form was every bit as important as the content; its readers were to be left in no doubt that they held in their hands "an exceptional publication, designed for an exceptional audience . . . as colorful in make-up, layout, and the use of photographs and text as the finest American commercial publications."[69] Similarly, where African posts had once received copies of a worldwide photographic poster series—*World Photo Review*—by 1962 a continent-specific monthly series had been initiated, consisting of six to twelve photographs selected in Washington to reflect US policy priorities and printed at the Regional Service Center (RSC) in Beirut.[70] Initially published in English and French as *The News in Pictures*, the series was soon expanded to include Arabic and Swahili versions, began to benefit from color printing, and changed its title to *Pictures in the News*, a subtle shift of emphasis that underlined the significance of the visual form (fig. 15). There was also capacity for country-specific poster series. *Pictorial Review*, for example, was published in a dual-language version—English and Amharic—for Ethiopia,

including several posters focused on the US Military Assistance Program, subject matter that was relatively atypical for USIA posters. In addition to printed material, USIA began to produce photographic exhibitions for distribution to African posts, and by the early 1960s ICS was sending out small, themed displays on a monthly basis. In little over a decade, the US visual media operation in Africa was transformed from the use of colonial-style filmstrip presentations on development topics to the production of high-quality visual products, some printed in full color, that would not have looked out of place in the US.

The context for this rapid expansion of the visual and media program in Africa was twofold. First, toward the end of the 1950s there was widespread recognition that the US was behind the game in its engagement with the continent. Second, the lack of a developed visual media infrastructure in many African countries placed additional pressure on USIA to step into the gap. In 1957, the year of Ghana's independence, as USIA faced financial constraints, Africa was the only region not to see a reduction in its budget.[71] Two years later, with many more countries on the cusp of independence, Eisenhower set up a Committee on Information Activities Abroad (the Sprague Committee). Its report recommended "a drastic and prompt upward revision of all plans, estimates and preparations for information activities" in Africa, where, it argued, "the pace of political developments has outstripped our informational preparations."[72] In 1960, as seventeen African countries achieved independence, Africa became a separate USIA "area operation," with the appointment of the first Assistant Director for Africa, Edward V. Roberts, who had joined the Department of State after working for United Press in Europe (fig. 16). Although the approach under the incoming president would be different, Kennedy was equally committed to USIA expansion on a rapidly decolonizing continent. Indeed, he was seen by many, including in Africa, as personally identified with, and committed to, the continent.[73] The early years of the decade saw an increase in the budget for Africa of around 30 percent, and substantial growth in the number of offices and personnel. By 1963, there were fifty-nine posts in thirty-three countries, and between 1960 and 1964 nearly four hundred employees were reassigned to Africa, many from Europe. Operations in the former imperial centers were "raided" to staff the Africa program, as Koffsky put it.[74] During this initial period of expansion, USIA aimed to have an active presence in each country as quickly as possible. This was both a matter of respect, according equal treatment to each new nation, and a pragmatic response to difficulties of facilitating operations across an extended area, given a lack of transport and communication infrastructure. It was also an implicit admission that USIA did not yet have a clear idea of where information operations would be most needed or effective. There was evidently still much work to be done to understand the worldview of what were referred to as "emerging peoples."[75]

American Outlook

CONTENTS

Vol. 4, Number 2 February, 1958

Americans Ponder: "What Can I Do To Prevent War?"

— SEE PAGES 6 AND 7 —

Fig. 12 *American Outlook* 4, no. 2, 1958. Master File Copies of Field Publications, 1951–1979, Box 89, RG306, NARA. [Declassified Authority: NND022120.]

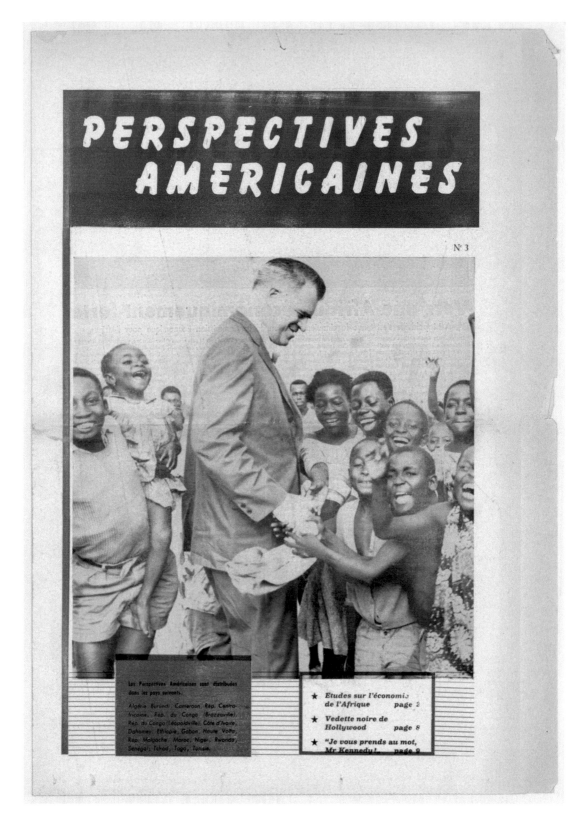

Fig. 13 *Perspectives Americaines* 3, 1963. Master File Copies of Field
Publications, 1951–1979, Box 242, RG306, NARA. [Declassified Authority:
NND022120.]

Fig. 14 *Topic* 1, 1965. Issues of "Topic" Magazine, 1965–1994, RG306, NARA. Cover photograph by Susan Wood. Reproduced courtesy of the photographer.

PICTURES IN THE NEWS

S.S. HOPE SAILS FOR GUINEA

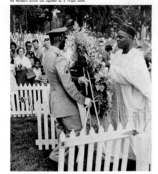

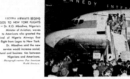

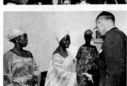

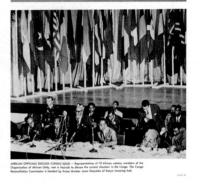

Fig. 15 *Pictures in the News*, 1965. Master File Copies of Field Publications, 1951–1979, Box 425, RG306, NARA. [Declassified Authority: NND022120.]

Fig. 16 / opposite USIA Overseas Posts, Africa, January 1, 1961. Subject Files, 1953–1999, Box 209, RG306, NARA. [Declassified Authority: NND36854.]

The limited visual media infrastructure of many newly independent countries in Africa placed a burden on USIA operations that had not existed in Europe. In early 1961, President Kennedy tasked Carl Rowan, then Acting Assistant Secretary for Public Affairs, to prepare an analysis of the press in Africa.[76] The problem, as Rowan framed it, was that "freedom in Africa is endangered, because the vast majority of Africans are ill-prepared to make choices at a time when they must make decisions that affect not just Africa but all of mankind." This was not simply a matter of education, however, though Rowan certainly acknowledged the need to support literacy programs, but equally one of information; there would be no point in "teach[ing] them to read without providing reading material." In Africa, the US perceived "a glaring information vacuum," which it was concerned communist bloc countries were rapidly moving to fill. If, as Gerits argues, Africa was not the site of a significant Cold War propaganda battle during this period, there was nevertheless anxiety about the support and training being provided by communist countries to the development of media and communications on the

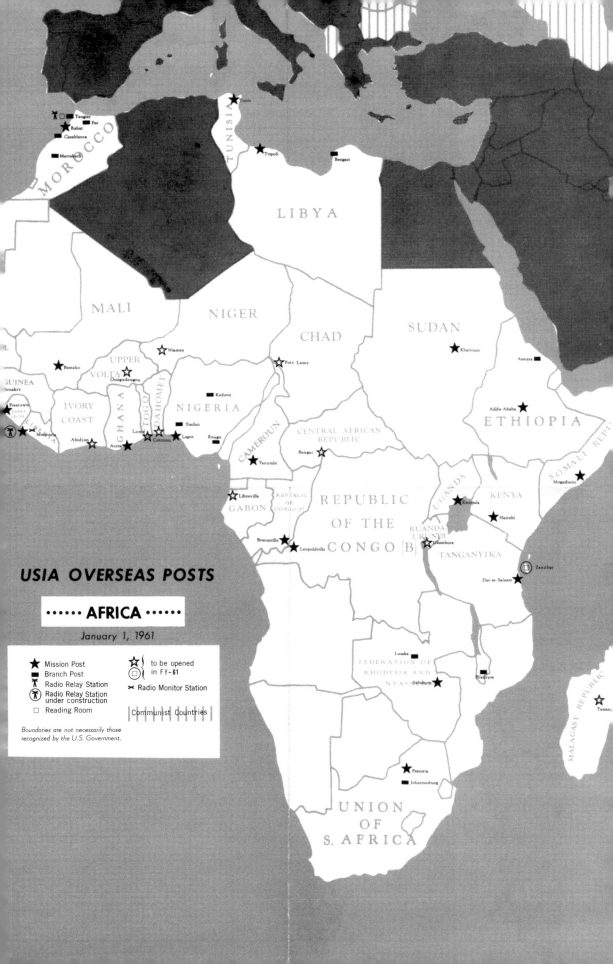

USIA OVERSEAS POSTS

······ AFRICA ······

January 1, 1961

★ Mission Post
■ Branch Post
⚊ Radio Relay Station
⊗ Radio Relay Station under construction
☐ Reading Room

☆ to be opened in FY-61
✕ Radio Monitor Station

| Communist Countries |

Boundaries are not necessarily those recognized by the U.S. Government.

continent, with potential long-term consequences.[77] The report noted, for example, that in an effort to reduce French influence, the government of Mali had welcomed the arrival of the Czech News Agency in Bamako to help it set up its own press service, and in Guinea it was observed that East German faculty had established a school of journalism.[78] Rowan suggested offering the assistance of some US educators to the latter initiative, as a way "to test the realness of Sekou Toure's desire for 'neutrality.'" In light of these developments, and the absence of Western countries stepping into this opening, the US was concerned that the prospects for some newly independent African nations remaining neutral were "rather dim." USIA's plans for the continent appeared "too little too late." Support for the penetration of US commercial media operations in Africa was viewed as important but only a partial solution, not least as their coverage of the racial situation in the US, while preferable to that put out by the Soviet news agency TASS, "tends to be pretty lurid and pays little attention to the constructive developments in this field."[79] Rowan's report made the case for a "bold but feasible" program, "to ensure that sub-Saharan Africa does not lose it freedom." The proposals included encouraging more African correspondents to be posted to the US, working with amenable newspaper owners, and assisting those African correspondents already there, many of whom it noted were "insecure and quite unsophisticated in getting to see the busy people they need to see if they are to write meaningful articles." Another idea floated in the report was for USIA "to arrange discreetly to have two or three competent Africans set up a small news bureau at the United Nations." If they could avoid being "'tainted' as stooges of the West," then "many African newspapers might be eager to use their reports." There was also a call for expansion in the coverage of Africans in the US, especially students, for distribution to USIS field posts, a recommendation that would give rise to a significant volume of photographic coverage over the coming decade.

In January of the following year, Edward Murrow visited the continent to see for himself. On his return he took the argument to the House Committee on Appropriations, where he pointed out that in Africa there was "an insatiable curiosity about the West in general and the United States in particular," and that without further funding, operations would remain "ill-housed, inadequately staffed, unable to meet a demonstrated need."[80] Like Rowan, he observed with concern that the Soviet bloc "took advantage of widespread African desires to improve their own mass media to serve both educational and informational needs," in order to "penetrate a strategic area of African society." He noted that this substantial infrastructural support was often provided at a loss, in pursuit of long-term political objectives. He referred specifically to the East German–built Patrice Lumumba Printing Plant in Guinea, with "a capacity far greater than Guinea's domestic publishing needs," as well as a contract for East Germany to

build another printing plant in Ghana.[81] There was also considerable debate on the extent to which African offices should be staffed by African Americans. In his appearance before the US Advisory Commission on Information, Murrow stated his intention to increase the proportion of African American officers serving in Africa, and the following year was able to report that the numbers had nearly doubled.[82]

Murrow's visit certainly gave impetus to the development of the Africa program. At the same time, it was accompanied by a review of the agency's operations and a greater emphasis on precision and efficiency. Where just a few years previously the response to decolonization was to open offices as fast as possible to ensure a presence in all newly independent countries, under Murrow there was a move toward defining more clearly the target audiences for USIA output and emphasizing the impact of the program, not merely the geographic coverage. This meant concentrating efforts on reaching the often Western-educated elites in positions of power and influence, and students—both groups that could be targeted with English- or French-language materials. Although USIA did produce African language materials, only Swahili and Arabic were added to the large-volume output, with more local publication by USIS field posts in other African languages. Murrow defended the predominance of French and English as key to the audiences they were trying to reach and argued that this should not be seen as disrespectful to "native African culture."[83]

The emphasis on educated youth was another dimension of the Africa program that took shape under Murrow's leadership. In 1963, Murrow's deputy, Donald Wilson, defended the priority given to students and young people, arguing that they were "the main centers of unrest" and the most susceptible to communist influence.[84] Given the less developed media landscape in Africa, the focus on the educated and primarily urban population enabled the agency to concentrate its resources and downgrade its earlier efforts to cultivate mass audiences. Prior to his visit to Africa, Murrow had expressed reservations about the comprehensive approach to coverage at a national level that accompanied the early years of decolonization, putting it rather bluntly: "I doubt . . . posts in Mauritania or Upper Volta [Burkina Faso] will greatly influence the course of future events in Africa." "We may be able to cover the waterfront," he argued, "but we can't cover all of Africa." He even posed the question of whether it might be sensible to "eliminate or drastically reduce" the operation in South Africa in order to spend the money more effectively elsewhere.[85] The search for efficiency and the emphasis on making each part of the USIA program count would be a constant refrain over the years ahead. Nevertheless, it was clear that the agency was establishing a significant program in Africa.

As importantly, by the early 1960s those involved with the information program in Africa had begun to develop a more sophisticated appreciation of the continent and its

peoples, even in one report sarcastically referring to the need to address "those hapless 'others'" who lacked such knowledge, presumably a reference to politicians in Washington.[86] Although hardly free from prejudice themselves, they understood that many of those in Africa they were trying to reach saw the world less in terms of East-West than North-South, "not between democracy and communism but between the haves and the have-nots," and as a consequence would resist efforts to position African nations as "pawns" in the Cold War. They understood African engagement with the Soviet bloc was part of a strategy of "diversifying its dependence." They recognized that African opinion viewed the Soviet Union as anti-colonial and anti-racist, and that, therefore, the US strategy of presenting communism as a form of "red colonialism" was destined to fail in Africa.[87] They understood that African nations appreciated Soviet support at the UN to end colonialism, and resented US policies on apartheid, Congo, Algeria, and Portuguese colonialism, and the failure to eliminate racial discrimination at home. They understood the appeal of China as a nation that had "successfully thrown off foreign white control or exploitation," and whose "bootstrap" operation offered a model for rapid development in Africa. Most importantly, perhaps, they understood the resentment toward "the belittling attitude of the world toward the African," and the "disparagement" of African culture.[88] While they were inevitably the "prisoners" of US foreign policy, they believed that their output should "continuously" reflect "the African claim to dignity, racial equality, national prestige and sovereignty, international standing, and political independence-plus-economic viability," and "within the confines of policy" that USIA should "assert support for African unity."[89]

Not all shared this understanding of the continent of course, and those "hapless others" would continue to have their say, but the main terms of the debate that would frame US operations in Africa during the 1960s were set. In the chapters that follow, I want to turn to the photographic output for Africa that developed in this context, as it responded to events in Africa and in the US, including the attention given to international collaboration and friendship as African nations took their place as actors on the world stage, and to civil rights and racial integration. The photographic material produced for the continent and the thinking that lay behind it offer unique insights into the way in which the US understood and sought to build its relationship with postcolonial Africa.

"Toward a Better World"

Africa, the United Nations, and the
Photographic Diplomacy of Decolonization

A young African man elegantly dressed in a dark robe with long white sleeves, adorned with a flowing lion's hair headdress and a flywhisk hanging from his wrist, stands reading from a sheaf of papers. Closely grouped around him are several others in similar dress: one clutches by his side a roll of papers, perhaps waiting for his chance to speak; another stands at the rear holding his finger aloft in an effort to gain attention; and slightly behind, looking over his shoulder is an older man, neatly, if slightly awkwardly, attired in a Western-style suit and pith helmet. Directing his camera up at the man speaking, the photographer has chosen a low angle from which to document the scene, emphasizing its theatricality. This is a photograph of a performance, and it is through photography that the performance will travel beyond the continent and across time (fig. 17). Moreover, it is the public performance of a political act. The man is reading a petition to the UN. Among the concerns of the petitioners are the "slow rate of progress," "the restitution of alienated lands," and "high prices, low wages, inadequate schools or medical service."[1] The photograph's arrival at USIA, however, meant the attenuation of any political weight the performance may have carried. One of the earliest photographs from Africa to appear in the master file, it is asked to stand for the continent in its entirety; the photograph is indexed under the heading "African petition to the United Nations" and referenced to the category "Inhabitants-Africa." No further information on either the location or the petitioners is provided. The numbering indicates that the photograph entered the collection in 1953, but there is no indication of

Fig. 17 UN Trusteeship Mission to the British Cameroons, Bamenda, 1949.
Reproduced courtesy of the United Nations. UN Photo 7505074.

when it was taken. Nor do we know the name of the photographer. Obligingly, however, the index card records that it is a copy negative sourced from the UN.

The photograph, it turns out, was made in late November 1949, during the visit of a UN Trusteeship Mission to the British Cameroons. The location is given as Bamenda, a province in the western highlands bordering Nigeria, now part of the North-West Region of Cameroon; the UN caption refers to the central character as a "Chief." Although the index card transcribes almost word for word the information recorded by the UN, these details of identity and location were omitted. It is not clear what motivated US information officers to request the photograph for its central file, though it seems possible they first came across it in a pamphlet published by the UN Department of Public Information in 1952—*Looking at the United Nations*—where a cropped version appeared in a section on West Africa.[2] Nor is it clear what specific purposes USIA officers thought the photograph might serve. The only indication is a stamp on the reverse of the copy print recording its distribution to all areas in early 1957. For the UN, the photograph functioned as an illustration of the Mission visit, part of an institutional record demonstrating the work of the Trusteeship Council. Yet this, too, can be understood as part of a process of abstraction and decontextualization, which the photograph's entry into the USIA file completed.

Reading the report of the UN Mission alongside the photograph, one can observe how it compresses and contains its subject.[3] The narrative account of the Mission's journey paints a rather different picture of their arrival at meetings, such as those organized by the workers of the Cameroons Development Corporation (Tiko), the Bakweri Land Committee (Buea), and the Cameroons National Federation (Kumba), where they were greeted by "placards and banners" making political and economic demands: "Cameroons Want Direct Government by UNO or Independence," "Bakweri Demand Return of Their God-Given Lands," "Bakweri Want Right of Free Speech to UNO and No Victimization," "We Want More Employment for Ex-Servicemen," "Give Bonus to These Men Who Fought for World Democracy."[4] If the Mission photographer recorded these scenes, they do not appear to have made it into the public record. In their stead, aside from the reference to alienated lands—German colonial possessions seized by the British government in Nigeria at the outset of the Second World War and subsequently leased to the Cameroons Development Corporation under British Trusteeship—the demands noted in the caption accord with a narrative of development and modernization, asking for better schools, healthcare, and "progress." While it is impossible to know the specific content of the petition that is being delivered in the photograph, the section on the visit to Bamenda province records that although inhabitants of the region "were strong in their demand for more education, better communications, better and more adequate health services, and greater economic development," the "main

task" there was to examine a petition on polygamy. Traveling to the village where the elderly Fon of Bikom resided, described as "like a visit into the Africa of Stanley and Livingstone," the Mission noted sympathy with what was somewhat euphemistically referred to as the "feeling of unwarranted interference" in local customs. The "annoyance" felt by the Africans was "not wholly unjustified" in the Mission's view.[5]

Polygamy aside, the conclusions drawn in the report were largely benign, presenting a picture of British administration as enlightened and beneficent. The Mission commended a number of developments instituted by the administration and accepted at face value the ultimate intention to return the land to the people, sharing the view that "the indigenous population of the Cameroons is not yet competent to obtain, unaided, the maximum benefit from the plantations."[6] Furthermore, they were "agreeably impressed by the exercise everywhere of free speech," noting that even in the presence of colonial authorities, "Africans did not hesitate to express their opinions."[7] Where the administration was falling short, the tone was one of gentle encouragement. Responding to the claim that a minimum period of forty years would be required to transfer control to the local population, the report suggested that "it should be a positive and publicly stated objective to reduce that period by as much as one-half."[8]

The figure in the photograph, whose specific demands the caption writer did not see fit to record, can be understood as a product of the postwar imagination that had shaped the UN. In Seth Center's terms, he is "a fictional petitioner—'Trust Territory Man'—from the 'heart of Africa'"; he was "not a radical or a revolutionary, but a 'humble and modest man' of 'practical mind' interested in the educational, social and agricultural development of his lands."[9] But his presence on the world stage would be short-lived As decolonization rapidly altered the composition of the UN, the figure of the African petitioner would soon be replaced by images of a more assertive anti-colonialism. Compared with the iconography of liberation struggles and independence celebrations, the act of petitioning has barely registered in visual histories of decolonization.[10] Nevertheless, the image also serves to illustrate the changing relationship between photography and the performative politics and public diplomacy of the postwar period. The decision to acquire the photograph for the USIA file can be interpreted as a sign that US information officers were beginning to grapple with the presence of Africans in the politics of the postwar world order and sought new ways to visualize African participation in global affairs. It is no surprise that they turned first to the UN. In its coverage of the global south through the 1950s and into the 1960s, USIA was "strongly and consistently pro-UN," which was unsurprising given US influence in shaping the organization of the world into nation-states under its aegis.[11] The place of the UN in the evolving photographic output on and for Africa produced by USIA provides an important starting point. But it is also important to recognize how

rapidly decolonization of the continent created new subjects and publics for US visual diplomacy, necessitating a reorientation away from images of Africans as chiefs and petitioners to ones that show them as political leaders on a world stage. This chapter traces the evolution of the photographic program as the agency embraced African leaders and diplomats from newly independent nations on their arrival in the US. Significantly, developments in USIA photography during this period were not simply a matter of changing photographic content but equally represented an evolving awareness of the medium as a dimension of visual public diplomacy.

———

It was through the frame of the UN that Africa first became visible in the US program of photographic diplomacy. At the outset, admittedly, the continent was marginal to US concerns. As Parker points out, it was the Korean War that had focused US attention on its relationship with the global south and provided the impetus for a concerted propaganda effort.[12] But, beyond the immediate conflict, the framing had greater longevity and strategic value, as US information officers sought to craft a message that would appeal to the wider non-European world. Placing the UN center stage—symbolized in photographs of its foundation beneath the proscenium arch of the San Francisco Opera House—enabled the US to present itself as distinct from European imperialism, committed to multilateralism, and supportive of the aspirations of colonial peoples for independence within a framework of international governance. A filmstrip produced in 1950, following the outbreak of the conflict in Korea, and simply entitled *The United Nations*, serves to illustrate the visual repertoire of this early moment.[13] The presentation opens with an image of the new UN complex in the process of construction, the iconic Secretariat Building standing proud on the shore of New York's East River bathed in the sunlight of a bright, clear morning. What follows is an illustrated lecture on the history and structure of the organization. US Secretary of State Edward Stettinius is shown signing the UN charter at the 1945 San Francisco conference against a backdrop of national flags, followed by a closer shot of President Truman. The emphasis of the visual narrative then shifts from the commitment of US leaders to that of its ordinary citizens. A tightly framed photograph showing a crowded auditorium demonstrates, the viewer is told, the wholehearted support of the American people, hundreds of whom came to the temporary headquarters at Lake Success to listen to debates. Subsequent photographs picture a school classroom, where US youth are educated about the UN, a Citizens' Committee planning for UN Day, and massed crowds witnessing Truman laying the cornerstone of the new Secretariat Building in October 1949 (fig. 18).

The viewer is then taken on a visual tour of the locations of postwar reconstruction and emerging Cold War conflict. UN observers at the Greek border watch over

Fig. 18 Cornerstone laying ceremony, United Nations Day, October 24, 1949. Reproduced courtesy of the United Nations. UN Photo / Albert Fox 7771349. A cropped version appears in *The United Nations*, 1950. USIS Filmstrips, 1942–1952, RG306, NARA. 306-FS-242-8.

Greek children made homeless by "Communist guerrilla raids"; Ralph Bunche mediates in Palestine in 1948; a Buddhist temple in Seoul is decked out with a banner welcoming the UN Commission; and, in a rare moment of visual humor, two observers are pictured crossing above a river in wooden crate, set against a backdrop of the mountains of Kashmir. There is a short sequence on the Trust Territory of the Pacific Islands, where visiting representatives of the US Congress are pictured consulting islanders on forms of government. Interspersed throughout are photographs that illustrate the business of the Security Council, the Economic and Social Council—Eleanor Roosevelt is pictured holding up a poster-size version of the Universal Declaration of Human Rights—and the International Court of Justice, as well as the day-to-day work of the Secretariat. The filmstrip then proceeds to feature the work of the specialized agencies, supported by US funding, coordinating their resources to fight hunger, disease, and ignorance, as it is framed in the caption accompanying a photograph of a UNESCO

Fig. 19 "Egyptian cholera epidemic . . . when the World Health Organization (WHO) makes a request for vaccines, blood plasma, or other medical and emergency supplies from the United States are rushed to the place they are needed." *The United Nations*, 1950. USIS Filmstrips, 1942–1952, RG306, NARA. 306-FS-242-45.

literacy project in the Maribal Valley, Haiti. In this familiar visual narrative of modernization and development, Africa makes a single appearance: a photograph of cholera vaccine being loaded onto a plane destined for Egypt (fig. 19). Yet this is an image of US largesse rather than African experience. "Today," the caption states, "when the World Health Organization makes a request for vaccines, blood plasma, or other medical or emergency supplies from the United States are rushed to the place they are needed."

The filmstrip concludes with a sequence of three images that return the narrative to Korea and the immediate Cold War context. The photographs show the US and UK representatives, hands raised in favor of adopting of UN Security Council Resolution 83—condemning the actions of North Korea and calling on member states to assist South Korea and "restore international peace and security"—seated next to the Yugoslavian representative, who voted against; the empty seat of the Soviet Union, which had boycotted the Security Council since the beginning of the year; and three

flag bearers—"The blue and white UN flag, which had been carried in Greece, in Kashmir, and in Palestine, now flies in Korea . . . between the flag of the United States and the flag of General Douglas MacArthur, Commander-in-Chief of all United Nations forces in Korea." This last photograph was made at a ceremony at Command Headquarters in Tokyo, where MacArthur was presented with the UN flag on July 14, 1950.

Africa's marginal presence in the filmstrip—it was so abstracted as a beneficiary of UN assistance that neither the continent nor its people need actually be pictured—provides a baseline from which to measure the rapid emergence of the continent as a focus of US interest and visual representation in the years that followed. Yet the selection of Egypt to feature in the filmstrip is intriguing. No doubt inadvertently, it points to a tension beneath the surface of the visual narrative, for Egypt was present in the history of this moment not only as the recipient of medical aid but also as a nonpermanent member of the Security Council, which along with India chose to abstain on Resolution 83. The abstention was of little consequence to the military action in Korea and was rendered invisible in the framing of the selected photograph, which instead censured Yugoslavia. It would not be long, however, before both Egypt and the continent of Africa would come more clearly into view.

In spite of the fact that US output "downplayed" the role of political representatives of "actual such 'peoples,'" as noted above with respect to Egypt, the emphasis on the UN underpinned a public diplomacy strategy intended to reach out to Africa and Asia.[14] As the decade progressed, Africa would become increasingly visible. *The World Counts its UN Blessings*, a picture story from 1955, marked ten years since the founding of the UN. The narrative asserted that it had "wrought miraculous changes in the lives of uncounted millions of people," enabling them "to build a better future."[15] It was distributed to all regions, to be used in connection with either the week-long celebrations in June or UN Day in October, or to commemorate more country-specific occasions such as charter ratification or admission to the UN. The images work both symbolically and indexically—that is, at a national level—to illustrate themes of health, peacekeeping, education, technical assistance, and modernization. Here, Africa is represented by the independent nations of Libya and Liberia. The former is described as "a godchild of the United Nations" and illustrated by a photograph of Dr. Rascovich, an economist with the UN's Food and Agriculture Organization (FAO), observing Libyan sheep being loaded for export. "FAO experts," the caption states, "are assisting Libya in developing her sheep industry and advising her on marketing problems." In Liberia, the viewer is presented with photographs of young men engaged in the hard, physical labor of forest clearance (fig. 20), and an intimate mother and child pairing. The visual humanism of the imagery is echoed in the caption text: "Mothers and fathers in every land strive for a world in which children may enjoy happiness, health,

Fig. 20 "Workers clear a wooded area to permit construction of a road through a dense forest in Liberia." *The World Counts its UN Blessings*, 1955. USIA "Picture Story" Photographs, 1955–1984, RG306, NARA. 306-ST-222-55-6937.

peace and freedom. Even now millions like this Liberian mother can count their UN blessings and look with faith and hope toward a better world." At the same time, the narrative reinforces the organizational underpinnings of this visual promise.

USIA continued to promote the UN through its photographic output across the decade and well into the next. In 1957, the agency again produced a picture story celebrating the twelfth anniversary of its founding, when it was able to acknowledge the admission of six new members, among them Morocco, Tunisia, Sudan, and Ghana.[16]

Furthermore, one of the photographs portrays local leaders in the Trust Territory of Somaliland in the act of imagining future independence as they contemplate a drawing of the Somali national flag (fig. 21). At times the coverage of the workings of the UN tends toward a banal humanism, earnestly picturing the organization as a small community. *Preparing for a Big Session* (1958), which describes the UN as the "Parliament of Mankind," is focused on the "housekeeping" needed ahead of a session of the General Assembly.[17] The photographs include workers cleaning the windows of the Secretariat Building, recording and translation equipment being tested, and UN guards examining boards of delegate photographs in order that they are familiar with "who is who—and where from," and "in their spare time, sharpen[ing] hundreds of pencils." The following year *A Day at the UN General Assembly* pictured delegates exchanging views, relaxing in the lounge and voting, and visitors queuing in line for tickets to observe a meeting.[18] Later examples include *Gifts to the United Nations* (1960), on the donated art and decorative works that adorn the UN headquarters, and *Growing up with the United Nations* (1964), documenting the work of the UN International School in New York.[19] These children, the caption claims, "are unconsciously helping to create international harmony."

Fig. 21 / opposite "The Chief Cadi and Dean of Cadis look at a drawing of the Somali national flag." *Spotlight on the United Nations*, 1957. USIA "Picture Story" Photographs, 1955–1984, RG306, NARA. 306-ST-413-57-20530.

Fig. 22 Le Kef, Tunisia. *What Lies Ahead for Refugees*, 1960. USIA "Picture Story" Photographs, 1955–1984, RG306, NARA. 306-ST-618-60-1130.

In 1960, to mark World Refugee Year, USIA issued the picture story *What Lies Ahead for Refugees*.[20] The visual narrative emphasized the humanitarian goals of "alleviating suffering" and providing hope for a better future, while the selection and captioning made clear that those pictured were predominantly refugees from communism, in Hungary, Tibet, Berlin, Albania, Korea, and Vietnam. The final image in the sequence pointed in a different direction, however. Its iconic composition portrays a group of Algerian men, women, and children queuing at a milk distribution center across the border in Le Kef, Tunisia, where the League of Red Cross and Red Crescent Societies was providing aid in conjunction with the UN High Commissioner for Refugees (fig. 22). The figures in the photograph were escaping the anti-colonial war against the French in Algeria; in the words of the accompanying narrative, they were a "consequence of postwar conflicts from which new nations emerge." Although the picture story does not indict or even name colonialism, the inclusion of this image nevertheless signifies how the changing political geography of Africa existed as a tension

beneath the surface of this kind of humanist narrative. Representations of unnamed humanitarian victims of an unspecified conflict were unlikely to have discomfited the Eisenhower administration, which supported the French in Algeria, but other interpretations were possible. Already in the US, Kennedy, then a senator, had spoken out in support of Algeria's war of independence.[21]

Even as USIA continued to produce photo-essays presenting the UN as the world in microcosm and lauding its efforts as a bringer of peace and harmony where there was conflict, food aid and medical assistance where there was hunger and disease, and as a force for modernization and development across the globe, new demands were beginning to be made of its photographic diplomacy. Increasingly, the image of Africa as a continent populated by unnamed beneficiaries of aid and technical assistance began to be complemented by representations of specific leaders and individuals. The opening photograph of a 1957 picture story entitled *Independence Day Around the World* shows Kwame Nkrumah holding his arm aloft, proclaiming Ghanaian independence in Accra.[22] In distinctly diplomatic language, the caption speaks of the climax of "an orderly program of evolution from colonial rule," though the accompanying notes undermine the harmonious message, suggesting that "local political or other antipathies may suggest discretionary elimination of certain photographs in the enclosed set." This evolving repertoire also began to turn its attention to those arriving in the US to work at the UN. A picture story from 1958—*UN Trains Youth in International Relations*—depicts participants in an intern program designed to "provide a nucleus of informed young people who on return to their own countries speak on the work of the UN from the viewpoint of their own personal experience."[23] Yilma Hailu from Ethiopia is pictured with his UN mentor looking at a map marked with pins to represent technical assistance projects being carried out across the world (fig. 23). This image of a young Black African student accompanied by an older White, male figure, the embodiment of paternalism, is an early example of a genre that became more prevalent across USIA coverage in the years that followed. Here, it is important to recognize the changing understanding and use of photography signified in the practice of recording the names of the individuals who appeared in USIA photographs. For images of ordinary Africans this was almost entirely without precedent.

The image of Africa that emerged in the late 1950s in picture stories such as the one featuring Hailu, might be understood, in part, as a visual expression of "Eisenhower's paternalism," to borrow a term from Gerits.[24] The emphasis was not simply on foreign aid or technical assistance to African countries but on "psychological" development toward democratic governance. For Eisenhower, this was necessary preparation in order to avoid the hazards, as he saw it, of premature independence.[25] Photography seemed especially suited to carry this message, perceived to communicate through emotional

Fig. 23 "James E. Folger (right), of the Technical Administration Board of the United Nations, shows Yilma Hailu, intern from Addis Ababa, Ethiopia, where UN technical assistance projects are being carried out in many parts of the world." *UN Trains Youth in International Relations*, 1958. USIA "Picture Story" Photographs, 1955–1984, RG306, NARA. 306-ST-509-58-14262.

engagement with human experiences and relationships. But the continent was running ahead of Eisenhower's, and USIA's, vision. In his speech to the UN in 1960, itself the subject of a USIA photographic assignment, Eisenhower called for Africans to be provided with "the mental tools to preserve and develop their freedom"—he "wanted to use the United Nations as a superintendent who could provide education, enshrine liberal internationalism, and in that way manage a continent that had acquired its independence too soon."[26] The immediate context for the speech, however, was the Congo crisis, which within a few months would lead to the assassination of its first prime minister, Patrice Lumumba.[27] It was rapidly becoming clear that the continent would not conform to the US-defined model of orderly progress under UN stewardship that Eisenhower would have preferred and USIA photography had begun to picture.

The visual humanism of *The Family of Man* was undoubtedly influential on the USIA photographic program. While Steichen's exhibition continued to tour the world, however, it became clear that its utopian vision was no longer adequate to the political demands being placed upon the medium, even if there remained at the very least a residual attachment to its imagery within the agency's photographic section, if not a more enduring commitment to its visual philosophy. The attempt to merge this approach with a more detailed documentary record of UN programs and political developments in specific countries was reaching its limits. An extended photo-essay produced at the beginning of the 1960s illustrates the contradictions of this moment for the photographic program.

That Man Shall Walk Free on the Earth, produced around 1961, comprised sixty-one photographs from sources including USIA files, the UN, *Life* magazine, photographic agencies such as Black Star, and Steichen's exhibition.[28] The card-mounted prints in the archive suggest it had been prepared for filmstrip production, although there is no accompanying script, and by this date USIA had largely moved away from filmstrips. The number of images indicates a level of ambition that was not typical of the picture stories of the period, which tended to use between ten and twenty photographs. It is possible therefore that this was an experimental project created in-house, an ambitious failure that never reached an external audience. The selection draws on the visual humanism of *The Family of Man* at its most lyrical: a mother holds her child aloft in the breeze as *koinobori* (Japanese carp windsocks) fly above their heads; a woman stands alone holding her arm aloft in triumph or pain; an African man gazes into the distance as he beats his drum; women stand praying on a hill as dawn breaks over the mountains beyond.[29] These poetic images punctuate others intended to illustrate the development and assistance programs of UN agencies: children at a high school in the mountains of Guatemala enjoy milk provided by the United Nations International Children's Emergency Fund; a villager in Calabria learns to write; and, pictured in dynamic modernist imagery, the Kariba Dam is under construction in Southern Africa, and locally trained technicians install telecommunications in Ethiopia, connecting Addis Ababa with provincial towns (fig. 24). Unusually for USIA, the sequence includes humanitarian photographs of children suffering the consequences of malnutrition in sub-Saharan Africa.[30] But it is with respect to the complex politics of this historical moment that the utopian frame no longer seems able to bear the weight of the photographic content.

Midway through the photo-essay there is a sequence of four consecutive images recording political developments in the Trust Territories of British and French Togoland. No other location receives similar treatment. Ostensibly, the images represent democratic governance and orderly progress toward independence: they show a political

Fig. 24 Addis Ababa, Ethiopia, 1958. Reproduced courtesy of the United
Nations. UN Photo / JH 7513625. A cropped version appears in *Man Shall
Walk Free on the Earth*. Photographs Collected for the Presentation "Man
Shall Walk Free on the Earth," ca. 1953–ca. 1960, RG306, NARA. 306-WF-53.

rally, petitioners at a Trusteeship Committee hearing, people voting, and UN elec-
tion observers. Yet one has to wonder if the USIA staff constructing the sequence
understood at all what they were looking at, or even felt that such understanding was
required. No general viewer could have been expected to grasp the complexities of the
situation from the photographs alone. Moreover, no textual narrative could possibly
have made sense of it for them given the order in which the images were presented.
The first photograph, taken on the eve of elections in April 1958 in French Togoland
(Togo), records a crowd singing at a rally in Lomé of the *Mouvement de la jeunesse togo-
laise* (Juvento), the militant youth wing of the anti-colonial nationalist party *Comité*

Fig. 25 "Crowd singing the party song at the rally of the Juvento party on election eve in Lomé," Togoland, April 1958. Reproduced courtesy of the United Nations. UN Photo / Todd Webb 7469259. A cropped version appears in *Man Shall Walk Free on the Earth*. Photographs Collected for the Presentation "Man Shall Walk Free on the Earth," ca. 1953–ca. 1960, RG306, NARA. 306-WF-27B.

Fig. 26 UN Fourth Committee Hearing, December 1, 1955. At left are (left to right): A. K. Odame, A. A. Chamba, and S. G. Antor, petitioners representing the Togoland Congress. Across the desk from them are A. I. Santos (left), representing Juvento, and S. Olympio, of the All Ewe Conference. Reproduced courtesy of the United Nations. UN Photo 7420683. The image appears in *Man Shall Walk Free on the Earth*. Photographs Collected for the Presentation "Man Shall Walk Free on the Earth," ca. 1953–ca. 1960, RG306, NARA. 306-WF-28.

de l'unité togolaise (CUT) (fig. 25).[31] (The elections would be won by CUT, setting the territory on the path to independence.) This is followed by the image of petitioners at the UN in 1955, representing groups under both French and British administration, including the Togoland Congress, who campaigned for unification of the territories, and Juvento (fig. 26); then a photograph from 1956 of UN observers at the plebiscite that saw British Togoland elect to become a region of the Gold Coast; and finally, an image of a polling station in the 1958 elections. Furthermore, by the time the photo-essay was created, Togo was an independent nation under the leadership of Sylvanus Olympio of CUT and the Togoland Congress had failed in their campaign. Indeed in the sequence as presented they had already failed; British Togoland had become a region of Ghana and was an ongoing source of tension between the two nations, and Juvento had split from CUT and were reportedly plotting against Olympio—it might be regarded as historical visual irony that the Juvento seat at the UN meeting is unoccupied.[32] By January 1963 Olympio would be dead, assassinated in a coup d'état. One could argue that this level of complexity was irrelevant to the simpler message that USIA sought to convey, but that is precisely the point. It is not merely that information officers could or should have done a better job but that, faced with a deeper engagement in Africa, as elsewhere in the Third World, the photographic format and its universalist message would inevitably collapse. One can imagine uninformed Western publics reading the Togo sequence as a narrative of democratic stewardship, as was most likely intended, but the agency was now also charged with producing materials for Africa. Had the photo-essay been distributed in Ghana or Togo its interpretation would have been something else altogether.

Although the agency would continue to frame picture stories and assignments around the work of the UN well into the 1960s, running in parallel was a significant expansion in photographic coverage of Africa outside of the UN frame. UN photography also changed direction during this period, as decolonization resulted in pressure to revise the picture of gradual progress in the trust territories in favor of a more forthright condemnation of colonialism and support for anti-colonial and liberation struggles.[33] For both the UN and USIA, there was a need for more sharply political forms of diplomatic photography. With respect to Africa, USIA would need both to engage directly with a new generation of leaders as they arrived in the US and to consider the messages their visual coverage conveyed as it was distributed across the continent.

In her reading of *The Family of Man*, Ariella Azoulay comments on Steichen's selection of a photograph of the UN General Assembly for its closing sequence. She asks the viewer to "imagine him browsing through multiple available photographs of the UN in order to select the one in which the marks of nationality and sovereignty, as well as the presence of state leaders, slowly shrivel in order to make room for an image of

a general assembly of citizens."[34] The image is offered in support of her thesis that the exhibition "wishes to move the weight of nation, religion, and national politics into the background, turning them into components of a civil existence they cannot fully master or organize."[35] This may indeed be true; however, I want to suggest here that the image of the UN General Assembly might be better understood as fundamentally ambivalent, if not in Steichen's mind, then at least in the broader context of USIA photography. Whether or not African leaders, like the Steichen of Azoulay's reading, imagined a world order without nation-states as Gary Wilder argues, the nation-state was nonetheless the political form in which they secured freedom from colonial rule.[36] It was as leaders and citizens of independent nations that Africans arriving in the US became subjects of USIA photography, and it is the agency's multiple small acts of image-making that responded to this changed world in an effort to imagine and order the future to which I now want to turn.

––––––––

The protocol for photographic coverage of official visits by foreign leaders was well established by the mid-1950s, when this form of visual diplomacy was extended to African heads of state.[37] At this time, the practice was to produce a bound album of photographs, delivered after the event as a gift to the visitor. A duplicate copy was subsequently presented to the country ambassador by the USIA director and relevant area director, where possible in a formal ceremony, and additional photographs were circulated for placement in the local press of the country concerned.[38] Mohammed V, the pro-Western King of Morocco, was the first African head of state to be accorded this treatment by USIA in November 1957.[39] The album included a routine series of photographs following the monarch's itinerary, from the airport reception and motorcade through Washington to Blair House to more human interest aspects, including a visit to Disneyland. However, important as this highly personal dimension of photographic diplomacy was as a marker of respect and goodwill, the bespoke creation of an expensive commemorative album intended as a "handsome addition" to the visiting leader's personal library meant that circulation was highly circumscribed.[40] Here, therefore, I want to cast the net more widely to include not just the customary treatment of stage-managed set piece events but also the day-to-day photographic coverage of African leaders and political representatives as they arrived in the US. The number of US information offices on the continent was expanding rapidly, and alongside publishing and exhibition programs for Africa they created demand for a regular flow of images that spoke to African publics about their relation to the US in the context of global politics.

Africans were no longer abstract figures located in the imagined elsewhere of the continent, with whom interaction was mediated by the technical experts of UN agencies, but rather the political representatives of peoples whose views were now seen to

matter in ways they previously had not, peoples who were now present in the midst of the US political landscape. It is important to register what this meant for photography. Photographing important visitors might be viewed as simply an adjunct to standard diplomatic protocol, drawing on a relatively limited repertoire of formulaic photo-opportunities; however, this misses the novelty of the situation on two levels. First, as Kunkel argues, this was a period in which politics was increasingly mediated through images in the emergence of what he terms a "picture state."[41] Second, African nations were new entrants into the international political arena and, therefore, there was much to be worked out and much at stake for both sides in how they were pictured in relation to the US. Moreover, this was not simply a change of visual content but required an altogether more performative and relational conception of the medium. Photographs of African leaders in the US continued to have a representational or documentary value, as witnesses to historical and political moments, but at the same time they were themselves embedded in the making of those moments, a part of the diplomatic and political process. Photographic protocol, so often obscured in documentary uses of the medium, became central. Reading the archival record, this comes through clearly in the attention given both to the naming of individuals in the photographs and the timeliness of the latter's travel from the US to Africa. Where creators of earlier photo-essays cared little for the specific identities of African subjects, it suddenly became important to "caption completely, with . . . first and last names and home town and country," to cite a request for Dar es Salaam.[42] In place of the abstract utopian time of the visual humanist narrative, these were now images of the moment and considerable weight was placed on their timely dissemination to African field posts, often expressed as a desire for photographs to arrive before the persons depicted returned home.[43] USIS field officers in Tananarive (Antananarivo), for example, were pleased to report that following the US visit of President Tsiranana they were able to produce a pamphlet featuring both presidents on the cover in time to be able to hand a copy to him at the airport as he arrived back in the country. The picturing of Africans and Americans in the same frame was testament to their coevalness in a way directly counter to prior representations of the continent, even in photographs such as the aforementioned image of Somaliland leaders contemplating the flag, which captured a moment of imagining the nation to come, a visualization of the "imaginary waiting room of history."[44] These images traveled not simply as documents but as tokens of friendship between nations. To some extent, they operated as extensions of personhood intended to underpin claims to connections of substance between national leaders and their peoples.[45]

This dimension of the photographic program unfolded cautiously at first. As noted earlier, Ghanaian independence was marked visually through its inclusion in USIA

photo-essays and the production of a full-color calendar picturing Eisenhower and Nkrumah and the shared political values and economic interests of the two nations.[46] When Nkrumah made his first official visit to the US in 1958, photographs of the trip quickly made their way back to Ghana for publication in *American Outlook*. The August-September edition carried a photograph on its front cover of Nkrumah presenting a signed copy of his autobiography to a young African American boy from North Carolina, George Mason Miller, celebrated for his prodigious knowledge of the UN and his ambition to serve as a US ambassador (fig. 27). In light of concerns about Nkrumah's relationship with figures in the civil rights movement who saw Ghana as a beacon of hope and somewhere they could escape the oppression of the US, this was a deliberate attempt to picture an altogether less threatening relationship with African Americans.[47] The agency chose this image over those of Nkrumah being greeted by large crowds in Harlem.[48] Inside the issue, Nkrumah's visit was carried over six pages: the photographs show him being greeted by Eisenhower at the White House, addressing the House of Representatives, visiting the Lincoln Memorial, on the television show *Meet the Press*, at the New York Cocoa Exchange, and meeting, among others, Vice President Richard Nixon, Secretary of State John Foster Dulles, and UN Secretary General Dag Hammarskjöld.[49] The visit, Nkrumah is quoted as saying, "is a manifestation of the warm feeling of friendship that exists between the United States and Ghana." The photographs were intended to return to Ghana as testament to this friendship, locating its leader within the warm embrace of the US and UN toward new African nations. The following year, the visit of Sékou Touré of Guinea would result in a USIA pamphlet, the first for an African leader, that celebrated the friendship between the US and newly independent Guinea in similar terms. *Bases d'une Amitié Durable* was produced in French and reflected the higher production values that were beginning to be emphasized in output for Africa. By 1960, photographic diplomacy was being extended beyond official visits to convey a more informal and ongoing relationship between leaders. The same day as Eisenhower gave his speech at the UN, he was photographed with Nkrumah at the Waldorf Hotel in New York, and the following morning he was back at the hotel being photographed with Sylvanus Olympio in his suite, where the latter presented him with an album of Togoland stamps (fig. 28).[50]

At the same time, however, the administration remained sensitive to the views of colonial powers on the continent. When Julius Nyerere arrived in the US in late 1954 to lobby the UN Trusteeship Council on behalf of Tanganyikan independence, his visit was restricted to twenty-four hours and he was not permitted to go beyond eight blocks from the UN.[51] Even later in the decade, African nationalist leaders of countries that had not yet achieved independence were rarely able to get meetings with high-ranking officials from the Department of State. When Kenneth Kaunda of Northern Rhodesia

An OUTLOOK exclusive:
Eisenhower At The United
Nations General Assembly
Page . . . 4

American Outlook

" Basically, we seek the same
fundamental objectives..."
Dr. Kwame Nkrumah
Speech to U.S. House.

Volume 4, Number 8 Registered as newspaper at G.P.O. Aug.-Sept. 1958

A boy, a book and a leader. Dr. Kwame Nkrumah, Prime Minister of Ghana, autographs a copy of his autobiography for 13-year-old George Mason Miller, who was one of the first non-official Americans to meet the Prime Minister during his three-day stay in Washington, D.C. Dr. Nkrumah invited the youngster, who is studying history at Columbia University, to visit Ghana. For the picture-story of Prime Minister Nkrumah's July 23 to August 2 visit to the U.S. at President Eisenhower's invitation, see pages 7—12

Fig. 27 *American Outlook* 4, no. 8, 1958. Master File Copies of Field Publications, 1951–1979, Box 89, RG306, NARA. [Declassified Authority: NND022120.]

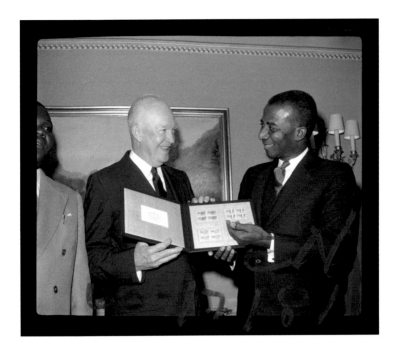

(Zambia), Joshua Nkomo of Southern Rhodesia (Zimbabwe), and Nyerere visited in 1959, Joseph Satterthwaite, Assistant Secretary of State for African Affairs, made it clear he did not wish to meet them personally, "out of deference to the British."[52] It is surprising, therefore, to find at least one official photograph does exist of a meeting between Satterthwaite and Nyerere. Gerits notes that this kind of meeting "irritated the settlers and the British, because they believed it gave the Africans an inflated sense of self-worth."[53] The photograph's existence supports the view that the visual diplomacy of this moment represented a "cake and eat it" strategy, moving between a desire to be "on the side of the natives for once," very much welcomed by US cultural and information officers, and a wish to avoid offending its European partners.[54] The multilateral framework of the UN provided the best means of navigating between these alternatives. Even the less formal photographs of Eisenhower meeting Nkrumah and Olympio in their hotel suites were framed within the context of the fifteenth session of the UN General Assembly. Yet behind the glossy pamphlet that celebrated Touré's visit sat Eisenhower's cautious approach to providing support for nations he regarded as unprepared for the task of independence, and his paternalistic emphasis on the expansion of cultural and educational programs rather than economic assistance. In spite of the photographs, this remained a worldview "riddled with colonial ideas."[55] Within a few months, however, Eisenhower's paternalism would be replaced by a rather different approach, and with it a wider responsibility for photographic coverage of US-Africa relations.

The Kennedy administration's attitude to Africa, and the extent to which it represented a change of substance or only of style, is a matter of debate among historians, but there is little doubt that personal diplomacy with African leaders came to assume a more significant place under the new president. In part this was a matter of numbers, as there were simply more independent African countries—seventeen gained independence in 1960 alone—but it also reflected a growing perception of the continent's importance, not least in the context of the Cold War, as well the increasing international prominence of racial injustice in South Africa and the US, which would emerge as subtext to the agency's visual output. Moreover, Kennedy's was a presidency more suited to and mindful of the importance of image. This much was evident prior to his election to office. Muehlenbeck relates the story of a US student volunteer who traveled to Guinea as part of Operation Crossroads Africa in 1960 and was struck by the presence of photographs from the previous year of Kennedy, then chair of the Senate Foreign Relations Subcommittee on Africa, meeting with Touré in Disneyland, highly prized and proudly displayed on the walls of dwellings in villages way beyond the capital of Conakry.[56] Despite the resources that went into the USIA pamphlet of Touré's meeting with Eisenhower, it was the image of the young president-to-be, and his message of support for new African nations, that had resonated on the continent.[57]

———

As African politicians, diplomats, and visitors began arriving in the US from the late 1950s onward, the photographic attention they attracted grew commensurately. In the early 1960s, there was regular, almost daily coverage of Africans of varying levels of seniority meeting with their US counterparts in economic, educational, and cultural spheres, as well as in the realm of politics and diplomacy. This was not simply curiosity at the arrival of new visitors in town but rather a deliberate policy of attending to US-Africa relations and picturing them for circulation on the continent. The task was not as straightforward as US information officers might have wished, however. The presence of Africans in the US revealed a propensity for international relations to become entangled with the domestic politics of race in ways that threatened to disrupt efforts to court the continent's leaders. African visitors found themselves caught up in the highly charged racial dynamics of US society, and the racism they experienced became an increasingly high-profile embarrassment. In addition to feting African leaders, photographic diplomacy would often find itself on the back foot, called to serve the work of repairing relationships in the face of the damage caused by the racist attitudes of its own citizens.

In rapid succession new African nations began establishing embassies in Washington and sending delegations to the UN in New York. As they did so, many of their diplomats struggled to find adequate housing in the capital and were frequently turned

away from restaurants refusing to serve Black customers of whatever nationality or status, notoriously so along Route 40 between Washington and New York. In 1961, when African diplomats at the UN threatened to leave if their grievances were not addressed, providing grist to the Soviet mill as it sought to build support among African nations for a proposal to move the international body out of the US altogether, it was clear that the problem threatened political consequences. In response, the Kennedy administration founded the Special Protocol Service Section (SPSS) under the leadership of Pedro Sanjuan at the Department of State, with authority to investigate racial incidents involving foreign diplomats.[58] This is not the place for a history of the SPSS, but there are important parallels and points of convergence between what was happening at the SPSS and USIA's photography of African visitors. In short, they were responding to different facets of the same diplomatic problem. Rather than address the issue of African visitors in isolation, as had been the natural instinct of the Department of State—prompting accusations that it was creating Potemkin villages—Sanjuan sought to link racial discrimination toward Africans to the struggle for equality for African Americans. This was a connection many others were making too, from a range of political perspectives, and one that would influence USIA's photographic coverage. It was becoming clear that racial injustice at home had a detrimental impact on foreign policy in the context of Cold War; this was an argument that Sanjuan pursued, extending the reach of the SPSS beyond African diplomats to students and, more controversially, to African American government workers.[59]

This provides the necessary context to interpret the release by the White House of an official photograph of President Kennedy meeting with the chargé d'affaires of Sierra Leone, William H. Fitzjohn, in the Oval Office in April 1961, just a few weeks into his presidency. The meeting had been arranged following an incident in which Fitzjohn had been refused service in a Maryland restaurant.[60] The photograph gave visual form to Kennedy's personal apology, enabling it to travel as testament to the restoration of respect due to a leading African diplomat. More proactively, the SPSS used the interest of the illustrated press to bolster its efforts to desegregate the restaurants along Route 40. In an article in *Life* magazine, Sanjuan was pictured as the "patient peacemaker" negotiating with restaurateurs.[61] The piece included a photograph of two African students "wearing their national dress" being served by a White waitress. The SPSS campaign coincided with a series of demonstrations along Route 40 by the Congress of Racial Equality, and although there were no direct connections between the two campaigns, the interests of civil rights activism and international public diplomacy were at a point of convergence. USIA monitored the output of the illustrated press and on occasion repurposed material from *Life* for international distribution. Although there is no evidence that it acquired these specific photographs, officers would certainly have

recognized the value to its field posts of photographs of Africans receiving hospitality in an American restaurant. Moreover, the agency would have been keen to move the debate off the back foot, represented by the image of the Kennedy apology, and onto the front foot, characterized by narratives of progress and positive photographs of international cooperation and racial integration. The prevalence and form of African visitor assignments and picture stories were inevitably shaped by these circumstances. Not only was there heightened sensitivity to the representation of race in the minds of those who commissioned and produced photographs of Africans in the US, but also the photographs need to be understood as a means through which politics and diplomacy were pursued.

It is important not to overstate the domestic angle, however. As the government deepened its engagement with many African countries and expanded its cooperation and exchange programs, the opportunities for photographic assignments on US-Africa relations multiplied exponentially. From 1960 on, the collection includes a growing number and range of photographs of African visitors. The hand of visual diplomacy was extended not only to national leaders on official visits to the capital and at the UN, or new African ambassadors being greeted by Secretary of State Dean Rusk or Assistant Secretary of State for African Affairs G. Mennen Williams, but to politicians at many levels. Photographers were assigned to record the visits of, among others, the Nigerian Foreign Minister, the Nigerian Minister of Education, the Dahomean Minister of Agriculture (Benin), the Governor of Cairo, the President of the National Assembly of the Ivory Coast, the Ugandan Minister of Health, the Minister of Works and Housing of Nyasaland (Malawi), and Nigerian parliamentarians. Typically, these were single-image stories, picturing the African guests and their hosts shaking hands or sitting and talking informally with a globe or map visible in the background. Several assignments made use of the African art, as well as an ivory tusk, that Williams happened to have in his office for just such photographic occasions. But assignments were not limited to office greetings. The Dahomean minister, for example, was photographed on a visit to Puerto Rico being shown the benefits of agricultural development, including an abundantly stocked farmers' cooperative store.[62] The shooting instructions stressed the relational dimension, requesting that the photographer should ensure at least "one American in every picture," along with the now customary request to "caption with names and titles of all." Philippe Yace of Ivory Coast was photographed on a visit to a Chevrolet plant in California, where he was pictured in the driver's seat of a new Impala just off the assembly line, experiencing first-hand the benefits of US capitalism (fig. 29).[63] And Nigerian Foreign Minister Jaja Wachuku was photographed on a visit to NASA, where the coverage had direct strategic relevance to the siting of a US tracking station in Kano and a US ship based in Lagos harbor as part of the latest

Fig. 29 "President of National Assembly of Ivory Coast—Mr. Yace visits G. M." (Photographer: Bill Brunk), November 2, 1962. Staff and Stringer Photographs, 1949–1969, RG306, NARA. 306-SS-6-11435-24.

Syncom satellite communication program (fig. 30).[64] President Kennedy and Vice President Johnson had only a month previously participated in a relay conversation with the Nigerian prime minister via this system. In other cases, visitors were pictured in more relaxed settings. For example, the Governor of Cairo was photographed alongside Bob Hope at a football game, where he had brought along his own camera to record the outing.[65] Coverage also extended to many business and cultural figures. The singer Miriam Makeba appears in the collection, as does South African anti-apartheid cleric Beyers Naudé. There are photographs of African dance groups performing at World's Fairs, and an Ivorian sculptor visiting an Indian pueblo in New Mexico. These photographs would travel as individual news images for inclusion in the agency's African-produced illustrated press, for use in the monthly poster series or as one-off posters for local distribution such as one on the "Niger Goodwill Visit" of December 1962, as well as for display at USIS offices and distribution to amenable African publications.[66] It is important to note, too, the careful management of the photographic record. The protocols of diplomatic image-making may seem so well established as to be beyond explanation, however, like any highly structured cultural encounter they are anything but. Many of the photographed scenes were scripted and, in some cases, carefully choreographed in advance. The shooting instructions often went into a remarkable level of detail, even if this did not rule out altogether a degree of creative improvisation on

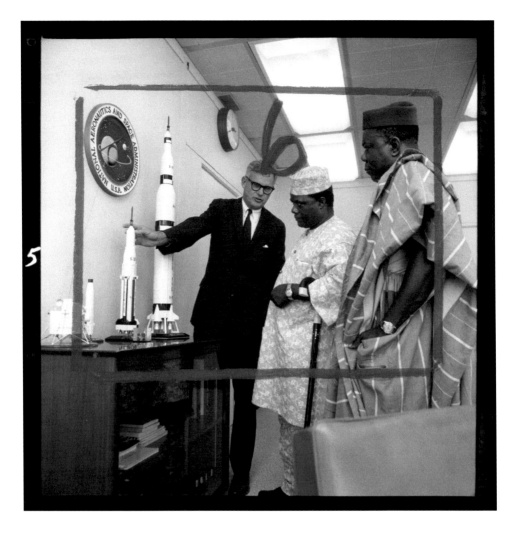

Fig. 30 "Foreign Minister Jaja Wachuku of Nigeria meets with NASA
official. Dr Robert C. Seamans, associate administrator of NASA shows the
foreign minister a model of the Saturn moon rocket. Man closest to camera
is Julius M. Udochi, Nigerian Ambassador to the US." "Nigerian Foreign
Minister Visits NASA" (Photographer: George Szabo), October 21, 1963. Staff
and Stringer Photographs, 1949–1969, RG306, NARA. 306-SS-31-1465-5.

the part of the photographer or the role of photographic subjects in influencing the
shape of the visual record.

Two examples from the first few months of the new administration illustrate the
political accenting of Africa-focused photographic assignments and reflect the change
of tone toward the continent. On April 15, 1961, the White House hosted a recep-
tion to celebrate Africa Freedom Day for the first time since it was established three
years earlier. Two days after the event, the USIA's deputy director wrote to the presi-
dent proudly detailing the speed with which his speech had been distributed on the

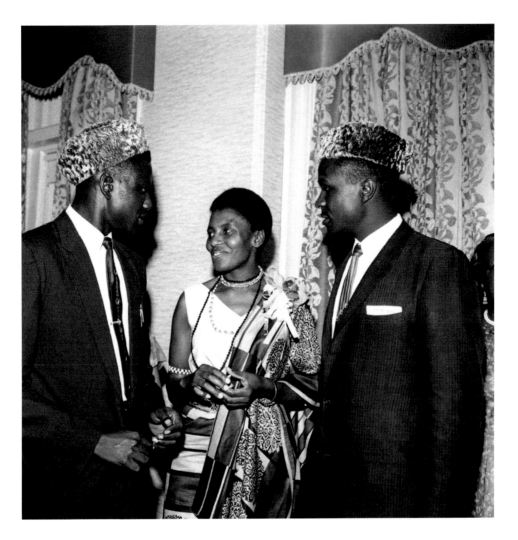

Fig. 31 "Miriam Makeba at Africa House" (Photographer: George Szabo), June 28, 1961. Staff and Stringer Photographs, 1949–1969, RG306, NARA. 306-SS-2-8960.

continent and the extent of the visual coverage. USIS posts in Africa received 1,500 prints of twenty-seven photographic subjects from the reception and 231 prints of a group photograph showing the president with African ambassadors and "other African personalities."[67] Notably, South African representatives were not invited, and in Pretoria the event was interpreted as parading unequivocal support for Black Africa.[68] The South African government would have been no more sanguine about the decision of USIA to assign a photographer to a reception in honor of the popular South African singer Miriam Makeba in June (fig. 31).[69] The shoot consisted of just a couple of rolls of medium-format film, but it reveals something about the broader approach

at USIA to the problem, and opportunity, apartheid South Africa presented for visual diplomacy. The photographs show Makeba greeting guests and engaging in informal conversation, along with group portraits. Several frames have been marked for selection, although the captions are missing from the archive file making it difficult to identify the guests. They appear to be mainly Africans, signified by the wearing of "traditional" dress, with others in Western-style suits or dresses, and it seems likely that several African Americans were among the invitees. An accompanying note indicates that the request came from Jim Pope, an African American who worked in the agency's recently established Africa Branch.

Although the file refers to "Miriam Makeba of the Union of South Africa," by 1961 the South African government had revoked Makeba's passport, and she was effectively in exile and on her way to becoming an international anti-apartheid campaigner, as well as actively involving herself in civil rights campaigns in the US. The value of the photographic coverage to USIA was that it enabled the agency to appeal to African audiences who opposed the apartheid regime in South Africa without significant damage to its relations with Pretoria on a political level. The openness of photographs to multiple interpretations served these ends well. While ostensibly the story reflected the recognition of a cultural figure who was popular in the US, for many African audiences the photographs were intended to signify the performance of solidarity between newly independent African citizens, African Americans, and a representative of those oppressed by the racist regime in Pretoria. The US presented itself as the welcoming host to this meeting. The commitment to equality and a narrative of steady progress on racial justice, which formed a core part of the message to Africa, had no appeal for the apartheid government in Pretoria, however, and so the Kennedy administration pursued its own "cake and eat it" strategy, combining public criticism of the apartheid regime with private reassurances.[70] Although US foreign policy was complicit in keeping the National Party in power, the rhetoric and accompanying photographic output sought to appeal to the administration's new friends in Africa.[71] It seems likely that photographs from this event arrived in the USIS offices in South Africa, though whether or to what extent they were distributed would have been a local judgment. The South African field post was on occasion quite sensitive to the views of the National Party government, which as John Stoner observes often "failed to perceive accurately that there was little substance behind the rhetorical shift toward a more vigorous anti-apartheid stance," and at other times seemingly less so.[72]

———

Under Kennedy, the agency no longer limited its photographic coverage to the leaders of African nations that had achieved independence. The earlier deference to the interests of colonial powers was no longer necessary or desirable, at least not to the same

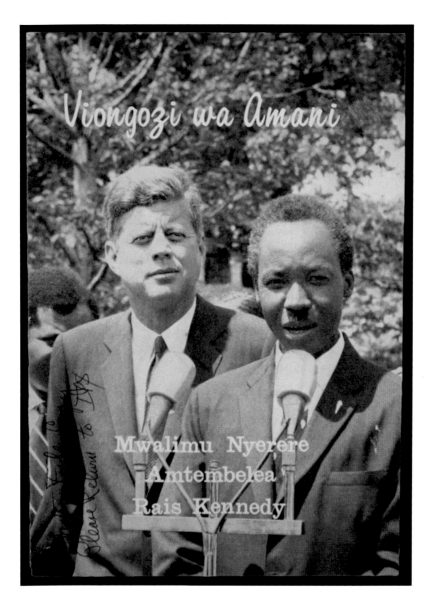

Fig. 32 *Viongozi wa Amani: Mwalimu Nyerere Amtembelea Rais Kennedy* (Leaders for Peace: Mwalimu Nyerere visits President Kennedy), USIS Dar es Salaam, October 1963. Master File Copies of Field Publications, 1951–1979, Box 268, RG306, NARA. [Declassified Authority: NND022120.]

degree, and this was reflected in USIA's visual output. This is especially evident in the coverage of visitors from Southern Africa, where the US sought to gain enough diplomatic capital to offset the reality of its continued support for the regime in Pretoria. Julius Nyerere of Tanganyika was one leader with whom Kennedy developed a particular rapport.[73] He was also one of the earliest African visitors to the White House, while he was still in negotiation with the British to secure independence. The visit took place in July 1961 when Nyerere was in the country for a meeting of the UN Trusteeship Council. USIA coverage included images of Nyerere being greeted by Kennedy and Mennen Williams on the White House portico.[74] It also extended to a separate meeting with the Secretary of Commerce, Luther Hodges, where the pair were captured

seated in casual conversation, visually signifying US support for economic develop-ment following independence as well as friendship between equals. The achievement of Tanganyikan independence later that year was marked by an image of Nyerere being carried aloft on the cover of *Perspectives Americaines*. When Nyerere visited as the new president of Tanganyika two years later, a visit he framed as about self-determination, the visual coverage was intended to further underscore his status and friendship with the US.[75] The USIS office in Dar es Salaam designed and produced a pamphlet in Swa-hili to commemorate the visit (fig. 32). Among photographs of Nyerere being greeted by US and UN dignitaries was a filmic portrait of him coolly wearing sunglasses, set against the New York skyline, signifying a broader appeal based on American culture alongside the fundamentals of political and economic support for the new nation.[76] According to the USIS report to Washington this was a "prestige publication . . . to capitalize on the goodwill emanating from the Tanganyikan president's visit." Five thousand copies were printed for Tanganyika, two thousand for Kenya, two hundred each for Zanzibar and Kampala, and one hundred for Leopoldville, for distribution to government officials, youth leaders, student groups, secondary schools, community centers, government offices, and business groups. A special presentation was planned to coincide with the premiere of a film of the visit—*A Voice from Africa*—with Nyer-ere and members of his cabinet in attendance.

The visit of Kenneth Kaunda in May 1963 attracted considerable agency attention too, with seven separate assignments covering his engagements in New York and Wash-ington over five days (fig. 33). At the time, Kaunda was Minister of Local Government in a coalition in Northern Rhodesia, the year before he would become the first presi-dent of an independent Zambia. Only a few years earlier he had been imprisoned by the British colonial government for his political activities, before going on to lead civil disobedience campaigns.[77] He had visited the US previously, in 1960, when he met with Martin Luther King. In common with much USIA coverage from this period, the photographs convey a sense of futurity, the promise of independence, and the devel-opment and modernization that US support was envisaged to guarantee. Among the events covered was a private lunch reception hosted for Kaunda by Kenneth Holland, president of the International Institute of Education, at which he was photographed with Holland and US ambassador to the UN Adlai Stevenson viewing a large archi-tectural drawing of the future Center for International Education due for completion in 1964. The following day Kaunda was photographed at the UN, first on his own and then standing and talking with his compatriot Solomon Kalulu (later a minister in Kaunda's government). It is worth noting, however, that the photographs at the UN were made before a private lunch with UN Secretary General U Thant at which pho-tography was not permitted, and it was requested that no photographs were made of

a dinner with "financers and philanthropists" organized by Chase Manhattan Bank. Little more than a year before Zambian independence, Kaunda's presence at the UN signified a future that was under negotiation, even if the visual record of that negotiation needed careful management. Intriguingly, Kalulu was the subject of a separate assignment a few days later, where the photographer managed to capture a more aesthetically satisfying image of his subject set against the UN buildings, taken from an elevated position on a balcony of the Carnegie Endowment Building.[78] The circumstances of this assignment are unclear, but it is intriguing to speculate whether Kalulu may have been able to influence the photographic record to reflect his own ambitions, or alternatively, if his US hosts were hedging their bets on potential future leaders.

Coverage did not neglect the smaller territories in the region. The agency assigned photographers to record meetings between Mennen Williams and a government minister from Nyasaland, the leader of the Swaziland Democratic Party, and the paramount chief of Basutoland, the latter image capturing the pair together with a US flag flying in the background (fig. 34).[79] Nyasaland and Swaziland (Eswatini) were both British protectorates, and Basutoland (Lesotho), an enclave within South Africa, was a British crown colony. The distribution notes refer to Basutoland as "a gathering point for African nationalist exiles from South Africa" and it was suggested therefore that the photograph would be of value to field posts in Accra (for use in *American Outlook*), Lagos, Salisbury (Harare), Kampala, Nairobi, and Dar es Salaam. South Africa was included on the list, though it was pointed out in parenthesis that "they can throw away if they want."

Alongside South African apartheid, domestic racial problems in the US continued to be present as subtext to agency picture stories. As images of racial violence and civil rights struggle in the US began to circulate internationally, sometimes aided in their African distribution by the Soviet Union and China, US information officers were mindful of the need for counterimages of harmonious Black-White interactions that responded to criticism on the continent. Photographs of Attorney General Robert Kennedy, then in the midst of handling the civil rights disturbances unfolding in the southern US states, standing alongside African leaders, might be understood as speaking implicitly to this situation.[80] Furthermore, the agency began to extend its coverage to the interactions between Africans and African Americans. In late 1963, USIA's Jim Pope traveled with a Kenyan delegation to the UN on a visit to Atlanta where they were photographed with Martin Luther King and Senator Leroy Johnson, Georgia's first Black senator in over fifty years.[81] The request specified that all photographs should include Senator Johnson and that the images should be "well animated." The American Negro Leadership Conference on Africa (ANLCA), formed in 1962 to influence US policy toward Africa, also attracted the attention of USIA. Its meetings would

Fig. 33 "Kenneth Kaunda of Rhodesia and Secretary Williams" (Photographer: George Szabo), May 22, 1963. Staff and Stringer Photographs, 1949–1969, RG306, NARA. 306-SS-13-722.

Fig. 34 "Basutoland Chief at the State Department" (Photographer: Jack Lartz), February 27, 1962. Staff and Stringer Photographs, 1949–1969, RG306, NARA. 306-SS-3-10071.

provide an opportunity for the agency to gather images of direct engagement between African and African American political leaders perceived as useful for circulation to posts in Africa.[82] While straightforward photographically, the message agency coverage of the 1964 meeting was intended to convey was nonetheless significant. As the request sheet put it: "Interest in this conference is high in Africa since it is evidence of the solid interest in the continent among Americans of African descent." The direct and personal connections that the photographs made visible and portable was central to their value: "Photos of prominent Americans, white and Negro . . . with African

participants or observers would be useful to all posts in Africa." A combination of formal and informal photographs was intended to speak to the idea of cordiality between Africans and Americans, White and Black, as well as formal political alliances. Accompanying the detailed instructions was the offer of an additional member of staff to assist the photographer should this be required, a further indication of the understanding of photography as a matter of careful staging. Among those pictured at the event were James Farmer, Dorothy Height, Martin Luther King, A. Philip Randolph, Carl Rowan, Roy Wilkins, and Whitney Young, along with Adlai Stevenson and Dean Rusk. African delegates included Simeon Adebo, Nigerian ambassador to the UN, Okon Iden and Isaac Moghalu, also of Nigeria, and Alphonse Okuku, brother of Tom Mboya of Kenya.[83]

Despite this extensive coverage, however, sentiment toward the Kennedy administration in Africa was far from universally positive. USIA research noted that "Africans viewed the youth, vigor, and idealism of the new US Administration with admiration and high expectancy," yet at the same time acknowledged that it was continually necessary to offset criticisms prompted by its "domestic racial troubles" and events such as the murder of Congo's Patrice Lumumba.[84] The latter was more or less coincident with Kennedy's arrival at the White House and prompted accusations from Kwame Nkrumah that he was personally responsible, with photographs of lynchings reproduced in the Ghanaian press making the connection to domestic racial injustice. The Ghanaian censors even blocked Kennedy's inauguration film in March 1961 shortly before Nkrumah became the first foreign head of state to visit the White House, albeit this visit opened a more positive chapter in their relationship.[85] Moreover, USIA was acutely conscious that following his murder the Congolese leader had achieved "symbolic stature" in Africa such that "few African leaders can now afford to publicly denounce Lumumba or not to espouse certain of the goals associated with him," which the Soviet Union had moved quickly to exploit by producing the film *Proud Son of Africa* (1961) for distribution on the continent and renaming the People's Friendship University for Lumumba.[86] It is hardly surprising then that the agency deployed the resources of visual public diplomacy in an effort to bolster the standing of his successor, Cyrille Adoula, preferred for the role because of his anti-communism and given a helping hand by the CIA.[87] Following his visit to the US in February 1962, Adoula was the subject of a USIA pamphlet, *Adoula Speaks to the World* (fig. 35).[88] Drawing on a range of photographic assignments from the visit, the pamphlet promoted him as a leader of substance, quoting extensively from his statements about humanity, African independence, and national unity, and picturing his status among US and world leaders. Photographs show him together with President Kennedy, Mennen Williams, U Thant, Adlai Stevenson (standing in front of a portrait of George Washington),

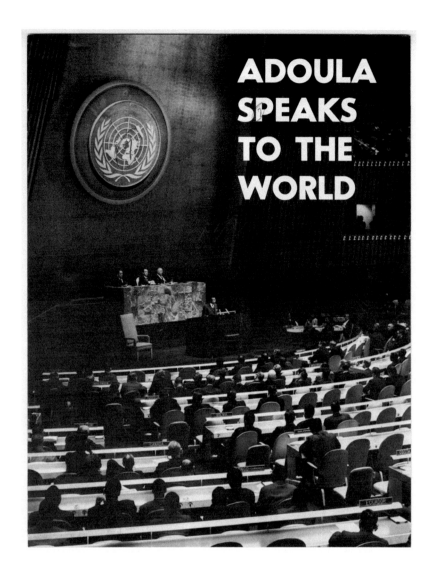

Fig. 35 *Adoula Speaks to the World*, 1963. Photographs Assembled for Pamphlet Production Relating to U.S. Political, Economic, and Cultural Life, ca. 1957–ca. 1995, RG306, NARA. 306-PAM-1-430.

Ralph Bunche, Eleanor Roosevelt, and Afro-Asian delegates to the UN. As if to signal his Cold War political alignment, a somewhat awkward-looking photograph was chosen to show his meeting with the Soviet delegation. The pamphlet presented him in human terms: he was photographed in an affectionate pose with his wife, meeting "fellow-Africans" at the airport, entertaining in New York, being interviewed on television, and together with his wife waving farewell as they boarded the plane to depart. The glossy, illustrated pamphlet was only the tip of an extensive media strategy for the country. According to Gerits, the illustrated paper *Perspectives Americaines* launched the previous year, along with weekly newsreels in French, Lingala, and Swahili, "had nothing to do with winning friends for the United States or the exploitation of the American way of life," rather they had one single purpose: "to legitimize

Adoula's leadership."[89] It is a moot point whether all agency staff viewed their efforts in quite such narrow political terms, and the debates run through the documents of the period, but it is evident that USIA photography reflected focused objectives in specific countries alongside broader goals.

Beyond the more overtly political pictures, USIA sought to extend its photographic coverage to softer cultural dimensions of the African presence in the US, including visiting dancers from Burundi and Sierra Leone, the latter described as expressing "the mysticism of African tribal life."[90] As one assignment indicates very clearly, the point was not so much the dances themselves but the relational picturing of Americans enjoying African cultural forms: "The picture should show both the performers and the audience reaction . . . keep in mind that we will use only one photograph, so the one picture has to include all the ingredients—recognizably-African elements, plus American crowds."[91] Many of the lighter or more human interest stories were decidedly gendered. The activities of the wives and daughters of the almost exclusively male cadre of African leaders and dignitaries frequently provided the occasion for less serious coverage. "Margaret Kenyatta at Disneyland" is one such example, promising an almost archetypal encounter with US culture.[92] Kenyatta was in the US in her own capacity as a political figure, but it is doubtful that the USIA would have taken the same interest were it not for the fact that she was the daughter of then prime minister and soon-to-be president of an independent Kenya, Jomo Kenyatta. In the months leading up to independence there was a clear political interest in presenting the US as a welcoming and hospitable host for Kenyan visitors. Interestingly, the photographic dimension of the visit seems to have been something of a diplomatic tussle between Bill Brunk, a press photographer keen to get the story, and Kenyatta, who "felt very ill at ease with the cameras around" and sought to minimize the photo opportunities. This is one of the few occasions where the archive sheds some light on how subjects themselves sought to shape the photographic record. As Brunk's notes record: "Miss Kenyatta objected strenuously to photo coverage of her at Disneyland, and only permitted pictures at the Indian Village." As a good press photographer, however, he was undeterred: "I made most of the shots with 100mm lens so that I wouldn't be obvious, and shot what I could." In many respects, this approach was atypical for USIA diplomatic photographs, which were usually carefully choreographed and collaborative affairs. Among the candid photographs Brunk managed to capture with his longer lens were photographs of Kenyatta on the "Jungle Boat Ride" and entering the submarine ride in "Tomorrowland," both offering somewhat stereotypical symbolic potential. The former hints at a dimension that appears in several USIA visitor stories, where there is a sense of playing back traditional notions of African culture to African visitors, either directly or via American viewers of performances. The less surreptitious photographs

included Kenyatta in the Indian Village talking to Chief White Cloud (fig. 36) and posing, at her request, with him and his performance troupe, as well as viewing the performance of a Navajo bird dance. The latter offers an intriguing reversal of the World's Fair photographs of Americans enjoying African performances. Why the Indian Village was the setting in which Kenyatta felt most comfortable being photographed one can only speculate. The photographs were marked for distribution to Accra and Leopoldville, as well as Nairobi, suggesting they were considered for publication in *American Outlook* and *Perspectives Americaines*, as well as for local use in Kenya.

Kennedy's assassination did not bring an end to USIA's program of photographic diplomacy in Africa, rather the range of picture stories would continue to expand through the mid-1960s

Fig. 36 "Margaret Kenyatta—Africa (Kenya) at Disneyland" (Photographer: Bill Brunk), August 10, 1963. Staff and Stringer Photographs, 1949–1969, RG306, NARA. 306-SS-24-1156.

and in some ways became more sophisticated, including a greater use of high-quality color printing, but it did mark the end of a first enthusiastic phase. Kennedy's image, if not always an appreciation of his policies, had become established on the continent in ways that must have gone beyond the agency's expectations, even if personal views may well have amplified reports that appear in the archival record. In October 1963, just days before Kennedy's death, Edwards Roberts, the agency's Assistant Director for Africa, proudly relayed the comments of an editor who had participated in USIA journalism seminars over the summer: "I found, on the whole, that Africans think President Kennedy is the greatest white man who ever walked upon the earth, thanks to his civil rights message with which USIA blanketed Africa just before we arrived."[93] Shortly after the assassination, the agency commissioned research on the reaction of foreign publics to the news. The mood in Africa was one of "shock and concern." Given "the high regard for Mr. Kennedy and his special interest in Africa," it was reported, "the assassination produced a wide-scale emotional reaction which has not been dissipated."[94]

Photography is a medium existentially linked to the celebration of new life and to the continuing presence of the dead. In Kennedy's case, it appears this is no less true in the context of photographic diplomacy. In August 1963, Mark Lewis, the PAO in Ghana, wrote to Washington enclosing a photograph of a baby in his mother's arms.[95] The child's parents had written to USIS Accra a few months previously from Kumasi to say that they were naming their child John Kennedy Adjei. Invited to call at the USIS office, they arrived with gifts of two live chickens, two dozen eggs, an "enormous" pineapple, oranges, and yams. In return for being photographed, they were presented with a large print of the president. The USIS photograph of the child was sent to Washington and distributed to the local Ghanaian press.[96] Conversely, the agency saw in Kennedy's assassination an opportunity to develop the theme of racial integration in the US for its African audiences. An assignment sheet, issued by Mary Lyne of the IPS Africa Branch on December 10, requested photographs be made of African American servicemen in the ceremonial guard at Kennedy's grave in Arlington Cemetery in the weeks following the funeral.[97] The "program value" of the coverage was stated as, "to show Negro participation in Kennedy funeral and at Arlington." The request was for "two special photos," showing "two different situations at the grave." The first was to be "an integrated picture showing a Negro and white serviceman at the head and foot of the Kennedy grave, making sure to show the eternal flame." The second, a picture of First Lieutenant George Forrest who would be the officer in charge at the gravesite. A feature was to be centered around Forrest, who had been assistant officer in charge of the Capitol funeral coordination. The branch already had a full interview with him and therefore this latter image was essential to the story—"We definitely need a picture of the lieut. . . . Be sure to get a good close-up." The request sheet suggested that the photographer "picture him in an activity that arises naturally in the course of his duty—perhaps receiving a wreath from a man-in-the-street visitor at the tomb or perhaps from a dignitary if any happen to be there." The racial dimension of the assignment was explicit: "We would like him with a white serviceman for the integration angle if you cannot get him with a visitor or visitors (we prefer the latter)." The resulting photographs follow closely the scripted request. Lt. Forrest is shown saluting Kennedy's tomb accompanied by a fellow Black serviceman, then talking at the edge of the fenced area with a White private, and, finally, standing guard over the grave with visitors paying their respects in the background (fig. 37). The assignment was relatively simple—to photograph a US soldier at Kennedy's grave—yet the detailed coordination and the careful attention to the choreography of the scene as one of racial integration, set within the national story, reveals a deepening of the agency's attention to the representation of race at this moment. Equally important, it demonstrates the extent to which the perception of Kennedy as both a friend of Africa and an advocate of civil

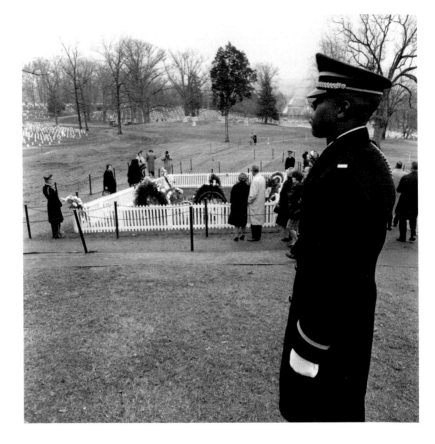

Fig. 37 "Negro Serviceman and Lieutenant in Guard at Kennedy Grave at Arlington" (Photographer: Jack Lartz), December 13, 1963. Staff and Stringer Photographs, 1949–1969, RG306, NARA. 306-SS-35-1683-Sheet.A-Frame.5.

rights meant that even after his death he was regarded as a valuable asset for the agency in presenting their message on the continent.

Within a few months, USIA had produced the picture story *When the World Mourned the Death of a President*.[98] In Africa, a Senegalese boy was pictured gazing up at a photograph of Kennedy displayed on the window of the USIS office in Dakar (fig. 38), and a Sudanese taxi driver was shown standing beside his car, carrying a portrait of the president on the front grill draped in black cloth (fig. 39). Moreover, the arrival of African leaders to pay their respects at Kennedy's grave in Arlington Cemetery would continue to feature in USIA assignments in the months and years ahead.[99] In late 1963, a Guinean delegation, the Kenyan Minister of Home Affairs, the Nigerian Foreign Minister, the Princess of Morocco, and Kenneth Kaunda were all photographed at the temporary gravesite surrounded by a white picket fence (fig. 40), and as late as 1968 the agency was still recording the visits of political representatives of African nations for distribution on the continent. The US chief of protocol Angier Biddle Duke had once observed that "to prove true sovereignty, a new nation's leader must run up the new flag, take the oath of office, and visit with President Kennedy."[100] It appears this was no less true after his death.

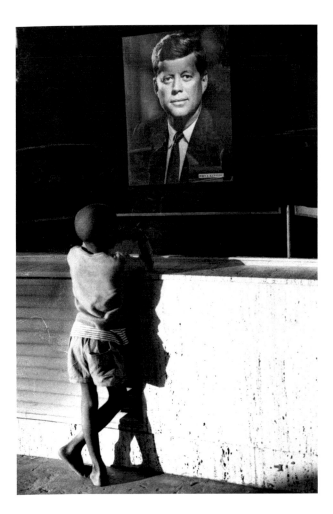

Fig. 38 "In Africa, a Senegalese boy stopped and gazed at the president's picture in the window of the American Center at Dakar." *When the World Mourned the Death of a President*, January 1964. Foreign Post Photographs and Articles, 1955–1965, Box 1, RG306, NARA. 306-PSC-63-6179.

The coverage of African leaders visiting Kennedy's grave suggests an appreciation on the part of USIA that the dead president's image continued to have a value on the continent that the new administration might do well not to abandon entirely. President Johnson did not enjoy the same level of recognition or respect in Africa as Kennedy, nor did he express the same personal interest in the affairs of the continent. On his taking office, USIA research acknowledged the challenge they faced, observing that "reservations" among Africans concerning Johnson's southern background "induced a deep initial pessimism about the fate of civil rights."[101] As Erina Duganne has argued, however, Johnson was attentive to the public political value of photography and from the very moment his presidency began, when he was pictured alongside Jackie Kennedy taking the oath of office on Air Force One, he sought to manage his image in the eyes of the US public.[102] It is no surprise, therefore, to find that USIA continued to develop its photographic coverage of relations with Africa under the new president. Nor is it

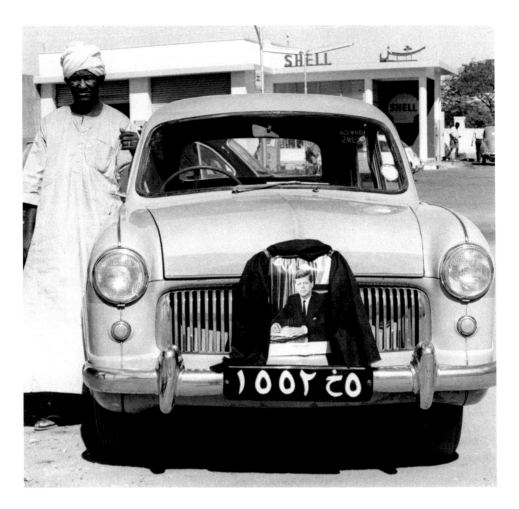

Fig. 39 "In Khartoum, a Sudanese taxi driver displayed a photograph
draped in mourning, on the front of his vehicle." *When the World Mourned
the Death of a President*, January 1964. Foreign Post Photographs and
Articles, 1955–1965, Box 1, RG306, NARA. 306-N-63-6181.

surprising, given the significance of civil rights within his legislative agenda and its perceived importance to African views of the US, that the association of President Johnson
with the passing of the Civil Rights Act of 1964 and the Voting Rights Act of 1965 was
central to USIA visual output during this period, as I will turn to in the next chapter.

The agency continued to expend considerable effort on material that conveyed "the
President's personal interest in Africa," both locally and in Washington.[103] The USIS
field office in Bujumbura, for example, put a photograph of Johnson shaking hands
with Mwambutsa IV on the cover of an illustrated pamphlet in Kirundi based on coverage of the monarch's visit to the US in May 1964 (fig. 41).[104] Among the images inside
was one of Mwambutsa paying his respects at Kennedy's grave, establishing a sense of

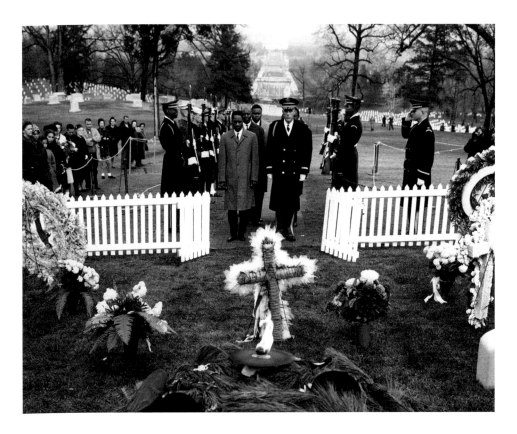

Fig. 40 "Guinea group at Kennedy grave" (Photographer: George Szabo),
December 12, 1963. Staff and Stringer Photographs, 1949–1969, RG306,
NARA. 306-SS-35-1681.

continuity with the previous administration, along with photographs of the Burundi
dancers discussed earlier. In Washington, the arrival of President Maurice Yaméogo of
Upper Volta—the first state visit by an African leader during Johnson's presidency—
was felt likely to "attract the attention of all of Africa" with potential for "a most favor-
able impact on US-African relations." Yaméogo was described as one of the "firmest
friends" the US had on the continent, an anti-communist, and a supporter of the US
position on Congo. He was one of the "moderates" that the administration wanted to
encourage to "assert themselves more vis-à-vis such radicals as Ben Bella, Nasser, and
Nkrumah."[105] The visit was expected to be "a relaxed occasion" with the president able
to identify with "a man whose country resembles Texas." Yet, at the same time, it was
understood to require careful visual management in the light of domestic concerns. As
preparations for the state visit in late March 1965 were being put in place, images of
racial violence against civil rights marchers by Alabama state troopers on the highway
between Selma and Montgomery were circulating across the world's media. "In view
of the racial climate," National Security Council advisor Rick Haynes recommended

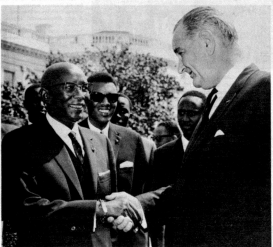

Fig. 41 *Mwambutsa IV Visits America*, March 1965. Master File Copies of Field Publications, 1951–1979, Box 291, RG306, NARA. [Declassified Authority: NND022120.]

UMWAMI MWAMBUTSA IV MURI AMERIKA

Prezida Lyndon Johnson asanganiye Nyen'Ingoma y'Uburundi imbere y'ingoro ya Presida wa Amerika italiki ya 19 y'ukwezi kwa 5 mu gisagara ca Washington, D.C.

MU KWEZI KWA GATANU N'UKWA GATANDABU
1964 NYEN'INGOMA MWAMBUTSA IV, UMWAMI W'UBURUNDI
YARAGIYE MURI AMERIKA IGIHE BUGURURA MURI NEW YORK
IKIBANZA ABANYAFRIKA BAMENYESHEREZAMWO
IBIHUGU VYABO MW'IHURIRO RY'AMAKUNGU RYABAYE
MURI ICO GISAGARA. YARATUMIWE
KANDI NA PRESIDA WA AMERIKA AGIYE KUMARA
IMISI MIKEYA MURI WASHINGTON. UMWAMI
NA PRESIDA BAREREKANYE UBUGENZI BW'IBIHUGU VYABO.

that "negroes be included in the US group going over to receive Yaméogo and Company."[106] He was also concerned that the arriving dignitaries should be briefed on the demonstrations then taking place outside the White House, which included civil rights demonstrators protesting against the brutality in Selma as well as counterprotests by supporters of Nazism carrying racist placards. Haynes explained: "The Voltan party should be prepared to see and understand the sit-ins and pickets in front of the White House—a sight which will be conspicuous from their Blair House residence." Not everyone felt that the leader of a small African country deserved such ceremonial treatment, however. In a meeting with Haynes shortly after the event, a US journalist expressed the view that Johnson had put on a "big show for some small fry," speculating that it may rather have been done to "impress American Negroes," a charge that was only partly correct.[107]

From the perspective of US-Africa relations, and certainly as far as visual diplomacy was concerned, one of the most significant set piece events of Johnson's presidency was

a reception for African ambassadors and chiefs of mission held at the White House in May 1966 to celebrate the third anniversary of the founding of the Organisation of African Unity (OAU). The reception had been suggested as an opportunity to "reaffirm" US interest in the continent at a time when "relations with African countries north of the Zambezi" were "the best they have been in some time."[108] The suggestion was supported by Johnson's National Security Advisor, Walt Rostow, who saw a threefold value in the event.[109] First, it would "appeal to a vast audience of Africans on that continent as well as to Washington-based African diplomats," thereby providing an opportunity for USIA "to underscore your interest and project your image in Africa." Second, the event could help to "build up a reserve of good will among African governments," on which the administration could draw as it sought to deal with "hard problems," including South African apartheid, the Rhodesian crisis, and the South West Africa mandate case. Third, the event would provide an occasion for Johnson to express publicly his confidence in Joseph Palmer II, the new Assistant Secretary of State for African Affairs, "thereby strengthening his hand in dealing with his African 'clients.'" Johnson's remarks at the event were, in the words of his press secretary Bill Moyers, intended to "lay the foundation of a Johnson doctrine for Africa," and the part of the speech dealing with self-determination and racial inequality was expected to "splash big headlines" across the world, except in "outposts of injustice" such as South Africa and Rhodesia.[110] Johnson described as "repugnant" those places on the continent that continued to maintain White minority rule, adding that the US had "learned from lamentable personal experience that domination of one race by another leads to waste and to injustice." The event had two further targets. While Moyers acknowledged the importance of the speech for foreign policy, he thought it would have domestic value for its impact on the "civil rights people"; it was, as he put it, "a cheap way to keep them quiet on at least one issue." It also came just ahead of a trip to South Africa by Robert Kennedy, where it was anticipated that he would "try to get ahead . . . on the question of political liberty for Negro Africans." Johnson's remarks were seen as preempting this possibility: "I think it would be wrong for us simply to offer economic assistance and material aid while Kennedy trots off making hay on the intangible issue of the rights of man." USIA nonetheless made ample use of coverage of Robert Kennedy's trip in its African output.[111]

In light of the perceived diplomatic and propaganda value of the event, USIA mobilized its resources to secure substantial visual coverage for African distribution. In addition to photographs for *Topic*, the recently launched magazine for Africa, the agency proposed a color film, noting that "with many of the Ambassadors in national costume, the reception lends itself to color filming."[112] In total, USIA suggested that a media team of eighteen people would be required. The agency worked closely with

the official presidential photographer Yoichi Okamoto to arrange the placement of the president and guests in a planned group photograph to be staged in the Blue Room.[113] Among the visual products was a wall-size color poster printed in Arabic, English, French, and Swahili versions for distribution as part of the African monthly series *Pictures in the News* (fig. 42).[114] The poster was headlined with a quote from Johnson's speech—"A Unity of Purpose that Transcends Two Continents"—and included photographs of the construction of an aluminum smelter powered by the US-supported Volta River dam project in Ghana, African students receiving language training in Vermont, and a satellite antenna in Nigeria, pictured with a boy riding on a camel silhouetted in the foreground. But it is the approach to portraiture that is most fascinating. The main image is the group portrait made with Okamoto's assistance in the White House, with President Johnson seated alongside Dr. Ousmane Socé Diop, Senegal's ambassador to the UN, in the foreground and the rest of the African diplomats in a semicircle behind them.[115] Although there is no record of discussions with the visitors over the photographic arrangements, for public diplomacy purposes, no less than for the president's African guests, it would have been important to visually acknowledge their political status. The pairing of Johnson and Diop, who had been designated Dean of the Delegation, allowed for this without the former appearing too paternalistic or failing to signal his own status vis-à-vis the larger group, although the painted portraits of former presidents that adorn the wall behind the guests might be thought to signify a somewhat paternalistic framing. (The image selected for reproduction seems to show Johnson anxious to get up from his seat, frustrated perhaps at the time taken to stage the photograph.) Then, in the panel below, reproduced in black and white and presented in a three-by-seven grid format are twenty-one identically staged photographs showing Johnson shaking hands with each of the African ambassadors, from Algeria to Upper Volta, while presenting them with a book on African art in US museums and private collections. It is reasonable to assume that the agency's creative staff did not alight on the use of a grid in order to make an artistic reference to the work of Bernd and Hilla Becher.[116] Rather, the format provided a unique visual solution to the problem of representing the diplomatic act of gift giving while according equal respect to all of the African leaders present.[117] The choice of a book intended to "increase the understanding and the appreciation of [Africa's] rich cultural heritage," as Johnson put it, reprised the familiar strategy of staging American interest in African culture. In many respects, then, this poster exemplifies the paradigm of USIA's African diplomatic photography that had been initiated under Kennedy and consolidated during Johnson's presidency: performative, attentive to issues of political prestige and protocol, and straining to convince Africans that the US had a genuine knowledge of and affinity for the continent and its peoples. This message was then offered as a gift back

Fig. 42 "A Unity of Purpose that Transcends Two Continents," *Pictures in the News*, 1967. Master File Copies of Field Publications, 1951–1979, Box 425, RG306, NARA. [Declassified Authority: NND022120.]

to their representatives in visual form. The medium was valued less for its affective and narrative potential than for its ability to affirm political and diplomatic relations.

It is interesting to compare the OAU poster, a high-water mark of US-Africa diplomatic photography, with an example that reversed the direction of travel. In late 1967, Vice President Hubert Humphrey embarked on a tour of nine African countries.[118] In contrast to the detailed requests that typically accompanied assignments for staff photographers, the archive contains just one sheet with a few instructions typed in capitals and headed "FOR EACH COUNTRY": "HHH WITH NATIVES . . . TOUCHING FOLKS," "ONE WITH HEAD OF STATE OF HIGHES [*sic*]," "ONE GOO PHOTO [*sic*]," "ONE GOOD COLOR EACH COUNTRY." Richard Saunders, who worked across the continent for USIA, was the photographer assigned to the visit, with local USIS photographers present in several locations. The images included Humphrey being greeted by crowds at the airport in Abidjan and by children in Tunis, meeting with his various African hosts, and on a walkabout with Mobutu Sese Seko in Congo. The latter was likely from the tour of a United States Agency for International Development (USAID)-assisted housing project, where "crowds gave us an enthusiastic welcome as we drove in Mobutu's open car, greatly overshadowing an earlier minor incident in which a small number of Communist-organized students sought to embarrass the visit."[119] But it was on the tour of Tema,

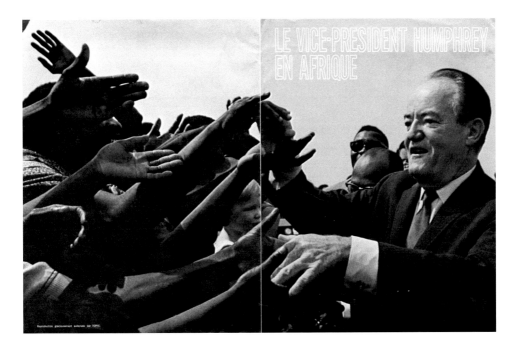

Fig. 43 *Vice President Humphrey in Africa*, 1968. USIA Files, Box 11, LBJ Library.

Ghana, that Saunders felt he had met the brief: "I hope here you'll have the type of thing you looking for—people with hands up, spontaneity. In some cases I don't think they realized it was the Vice-President, but they really gave him quite a welcome."[120] This was precisely the kind of image desired: a photograph of Humphrey touching the outstretched, disembodied arms of a crowd provided the wrap-around color cover for the illustrated publication produced in French and English to celebrate the visit and extend its public diplomacy value (fig. 43). It is hard to know how to read this emphasis on intimacy with unidentified Africans, not least in the light of the formality and attention to naming that had become established practices in the agency's coverage. It has some of the qualities of conventional political campaigning imagery, yet in an African context along with the reference to "natives" it would seem to carry colonial overtones.[121] Perhaps the agency had yet to pay the same attention to the way it pictured ordinary Africans on the continent as it had to the current and future leaders that arrived in the US, after all these much more than the citizens of African nations were the target audience. Maybe it was also expressive of a desire to be looked up to in Africa as the agency gave space to the visual imagination of America's global leadership role, at the same time displacing the imagery of protests against US policies on the continent. Moreover, there are striking similarities between this image and one of

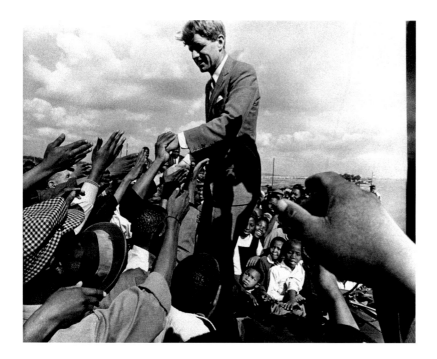

Fig. 44 "Robert Kennedy in Africa," *Topic* 12, 1966. Photographs Assembled for "Topic" Magazine Coverage of Political, Economic, and Cultural Life in the United States and Africa, 1965–1990, RG306, NARA. 306-TMP-12-2.

Robert Kennedy on his visit to South Africa in 1966, which ran over a double page in *Topic*, suggesting that this was the visual template agency staff had in mind (fig. 44).[122] The narratives that surrounded the perceived image of the Kennedys in Africa, which at times take on an almost mythical quality, may well have become something of a touchstone for the agency. In all these respects, like many of the photographs discussed in this chapter, it reveals more about the way the US used photography to imagine its relations with Africa than it can ever tell about the continent or its citizens.

———

As photography lent substance to the connections between US and African political leaders, so too it enabled the former to establish a visual presence in Africa.[123] When USIA requested a photograph of President Kennedy reading his statement on Algerian independence, or when his portrait was reproduced alongside that of Milton Obote on the cover of a pamphlet on the occasion of Ugandan independence, the image conveyed something of the president's person to the continent.[124] Moreover, the medium was understood to have a kind of diplomatic agency. Ahead of a trip by Mennen Williams to the continent in 1965, the president's press secretary, Bill Moyers, requested that Johnson take a few moments out of his schedule for a simple "step-in-step-out" photograph with him for distribution "all over Africa."[125] The image was intended to show Johnson "working on problems other than Latin American and Asia," but more significantly Moyers believed that it would "enable Williams to arrange much more than he might otherwise." Photography enabled the president to bestow some of his

Fig. 45 "Tunisian President Habib Bourguiba receives a color photograph (of his return from exile to a tumultuous welcome in 1955) from Director Marks at Blair House. The photograph was taken by Frank J. Scherschel who was then with *Life* magazine. He is now Photo Laboratory Branch Chief in the Agency's Press and Publications Service." *USIA World* (June 1968). Leonard H. Marks Papers, Box 14, LBJ Library. The photograph of Marks and Bourguiba was made by Joseph Pinto. 306-USW-Box.3-Folder.D-June 1968-P91.

political prestige on Williams in the expectation it would open doors that may otherwise remain closed. To what extent the medium delivered on this promise is impossible to judge; nonetheless, it is clear that photography had become established as a significant facet of diplomacy. Diplomacy without photography was, in this sense, unimaginable.

By the later 1960s, the agency's growing collection of photographs on African subjects and a certain confidence in approach created the conditions for moments of reflexivity in its photographic coverage. The visit of President Habib Bourguiba of Tunisia provided two such occasions. The first can be seen in an image of Bourguiba with USIA Director Leonard Marks at Blair House receiving a large, framed color print of his "return from exile to a tumultuous welcome" in 1955, when he led the country to independence (fig. 45). The color image had been made by Frank Scherschel, then working for *Life* magazine, who had since become the head of the photographic laboratory at USIA. It was reproduced in the agency's internal publication *USIA World* as part of a photographic roundup of activities involving leaders in the global south.[126]

Fig. 46 "Le Miroir Photographique," published in *Le President Bourguiba aux Etats-Unis*, 1968. USIA Files, Box 5, LBJ Library. 306-SSD-Box.32-Folder.M-26.

The second made its way into a pamphlet produced by the USIS field office after the Tunisian president's visit in May 1968. Among the images of the visit was a photograph of Bourguiba seated at a table, again with Marks and accompanied by agency photographer Richard Saunders, browsing through the latter's photographs of the Tunisian president (fig. 46).[127] It carried the caption "Le Miroir Photographique," intended no doubt as a comment on Bourguiba viewing himself, yet at the same time reflecting the now self-assured place of diplomatic photography in USIA's Africa program. In the next chapter, I want to consider USIA photography as a mirror in another sense, as the agency turned the camera on US society in order to imagine and shape its relationship with Africa and the world.

"A Pleasant Mixture of Negro and White"

Photographing Civil Rights as Democracy in Action

One of the stranger stories about the information program in Africa to attract press attention back in Washington concerned portraits of George Washington and Abraham Lincoln exhibited at the USIS offices in Leopoldville in the Democratic Republic of the Congo. The piece, carried by several Washington papers over the last weekend of March 1963, reported that the local population felt USIA had gone too far in presenting portraits that depicted Washington and Lincoln "as Negroes."[1] Given that these were "two of the most respected white men," Congolese respondents took the view that rather than try and garner favor with Black Africans through this unusual act of mimicry, "the propagandists would do better to use them to enhance the black man's respect for the white race." USIA Director of Research Lowell Bennett expressed his incredulity. The Office of the Assistant Director for Africa "knows nothing of such stupidity," Bennett stated, and "agrees with us that it is just about inconceivable that USIS would deliberately contrive Washington and Lincoln to appear colored." There were no accompanying images to confirm or refute the description. Bennett went on to speculate that the USIS office may have hired a local artist to paint the portraits, and that as a result of training and background the artist had depicted the two presidents with "Negroid features." This was "only conjecture," he admitted, and further enquiries were being made to ascertain the facts of the matter.[2] If there was any literal truth in the story, then Bennett's hypothesis seems the most likely explanation. But I am less interested here in its truth or otherwise and more in what the report might reveal about the perception of race in the USIA Africa program. Bennett suggested that

the very idea was as all but "inconceivable," yet, regardless of any actual portraits, their presence in this account is testament that this was not the case, a point that applies whether the Congolese viewers interpreted them in good faith or, alternatively, with an element of mischievous or ironic humor. And the point would apply too, albeit from a different perspective, even if the story had been fabricated by USIA information officers in an act of self-deprecation.

In setting the context for this chapter, it is useful to take a moment to reflect on this example and its possible interpretations, each of which offers an insight into the thinking of the different parties involved in this moment of visual public diplomacy. While Bennett did not take the story at face value, it is striking that he could not bring himself to rule out altogether the possibility that staff at USIS Leopoldville had deliberately "Africanized" their historical subjects. That the story was only "just about" inconceivable seems to leave the door open. It is possible to discern in his hesitation the fear that just conceivably, staff in the field had been overenthusiastic in their interpretation of their mission; that they had "gone native," taking with them esteemed symbols of American leadership. To put it another way, whether or not the story as presented was true in any straightforward sense, the anxiety it provoked was real enough. There was evidently something more at stake than the simple truth or falsity of the account. Permeating US engagement with the continent during this period was an assumption that Africans simply wanted to be more like Americans. As Lawrence Rogers put it in his report from the later 1960s: "Capitalism, communism; east, west; black, white; civil rights; poverty . . . these are abstract concepts totally lost on almost all Africans who just want to know . . . 'How do you get to be like an American?'"[3] The portrait story is remarkable because it reversed this assumed direction of mimesis in US-Africa relations. The tradition of "blackface" had long been used to mimic African Americans of course, but the context here carries none of the derogatory or racist connotations associated with that genre. Instead, the anxiety provoked by this story points to the idea that engagement with Africa was a risk to the integrity of (White) American identity. USIA was indeed trying hard in Africa. This included distributing numerous photographs and picture stories depicting the success of African Americans in public life and presenting the US as a harmonious, racially integrated society; increasing the number of African Americans on its staff for the continent, predicated on the idea that racial identification would reap diplomatic benefits; and encouraging the US Air Force to make its Black pilots more visible on African flights—to "make vividly convincing in flesh and blood a point we're trying to make in disembodied words and pictures."[4] In that respect, the story might be understood, in the USIA context, as a moral tale about the perils of trying too hard.

Looked at from the Congolese perspective, on the other hand, the story presents an intriguing illustration of how the US mission was interpreted by its intended

audience. Whether or not Congolese viewers believed the US had deliberately "Africanized" Washington and Lincoln, the story suggests they understood something fundamental about the agency's efforts to win over African audiences and were reflecting this truth back with either sincerity or humor. Since Bandung, if not before, the US had seen rhetorical potential in identifying independence movements in Africa and Asia within the same tradition as the American Revolution and reflected this in its appeals to nascent African nations and their leaders. The appearance of George Washington, therefore, can be viewed as a visual manifestation of the conceptual linkage that African audiences were already being invited to make. Lincoln's presence was complementary and reflected his commemorative construction and mobilization as a symbol of racial emancipation and equality contained within the idea of America.[5] Displayed in an African context, the portraits set up a three-way identification between American political traditions, national independence movements in Africa, and civil rights in the US. At the very moment when the civil rights struggle erupted as a major challenge for the USIA visual program on the continent, the idea that the portraits were intended as a genuine appeal no longer seems far-fetched; on the contrary, they take on a symbolic significance. It would appear, however, that the audience remained somewhat skeptical. In reflecting back their interpretation, it seems that the Congolese respondents were offering a critique of the US program and its appeal to Africans on the grounds of racial identification.

There remains the final possibility that the entire story was a fabrication, but even if this was the case the analysis offered above is hardly less relevant. On the one hand, if the story was a hoax directed by USIA officers in the field at their Washington-based superiors, then it suggests not only an awareness of the racial dynamics at play in their propaganda work in Africa but also the believability of the idea that they might indeed overstep certain limits, on which the effectiveness of the joke rests. On the other hand, if the story had a more malign source and was intended to discredit agency operations in Africa, portraying them as beyond the pale, a hypothesis that has a certain credibility given it was passed to the US press, then it further highlights the extent to which concerns around the use of race in US propaganda on the continent were more widely shared. Bennett would have been well aware of the vulnerability of USIA to attacks on the domestic front and no doubt his anxiety was informed in part by the political damage such stories could cause.

Setting aside the actual events or motives, this intriguing, almost comical story crystallizes certain ideas around the USIA program that was beginning to be shaped by and for Africa at this moment—most importantly, the idea that the engagement with Africa had consequences for the image of the US, and vice versa. Racial injustice had long been recognized as a thorn in the side of US public diplomacy, but from the

mid-1950s, as African decolonization gathered pace and the civil rights movement took on new momentum, it presented an unprecedented challenge. The Washington and Lincoln portrait story broke just days before Martin Luther King's Southern Christian Leadership Conference (SCLC) launched its campaign against segregation in Birmingham, Alabama. This chapter examines the ways in which the agency responded, incorporating the campaign for civil rights and racial integration into the narrative of US democracy that it presented to the world. The shape this coverage took was, at least in part, a response to its mission in Africa. As it sought to project its message across the rapidly decolonizing continent, the agency was compelled to deepen and extend its engagement with the representation of race in the US.

Several recent studies have turned to the photographic archive of the US civil rights struggle to challenge the received image of the period. Looking beyond the established canon of civil rights photographs, scholars have drawn attention to hitherto neglected or underrepresented perspectives and provided insights into the selectivity that has shaped the image of the period in the public imagination. Martin Berger, for example, reads the canon of civil rights photography for what it reveals about the prejudices and anxieties of the editors, publishers, and curators whose decisions set the pattern for the subsequent public visual record.[6] Drawing on material produced and published by Black photographers and editors, he demonstrates that the received history of the period is not the only story that could have been told. Berger argues that the repertoire of photographs that framed the visual imagination of this period was dominated by images of African Americans as passive and lacking agency: "dignified black schoolchildren silently suffering the jeers of unruly mobs, well-mannered black students at lunch counters weathering the abuse of mirthful white crowds, and stoic protestors buckling under the assaults of water jets and police dogs."[7] Moreover, this vision "performed reassuring symbolic work" for northern, White liberal audiences.[8] African Americans appeared most often as nonthreatening victims, seeking the intervention of White authorities; "only infrequently do they [the photographs] illustrate African Americans delivering impassioned speeches, organizing voter-registration drives, running for office, educating younger generations, or advancing legislative reforms."[9] It is not that such photographs were never taken, simply that the dominant image derived overwhelmingly from mainstream White press coverage. The consequences of this selectivity were political. Depictions of African Americans as victims "encouraged white sympathy" without threatening White viewers' sense of security, thereby fostering support for civil rights legislation. At the same time, this way of representing the struggle constrained the ability to imagine more fundamental change: "the photographs impeded efforts to enact—or even imagine—reforms that threatened white racial power."[10]

Berger presents an engaging argument regarding the circulation of civil rights photographs domestically in the US, and their potential to be co-opted to a reformist political imagination without fundamentally challenging the racialized distribution of power. The question examined here, however, shifts the angle of view from the domestic to the international, asking how the US responded through its overseas visual program to the global circulation of photographs of racial violence and civil rights protest. Many of the same images of racial violence in places like Birmingham and Selma that dominated the US mainstream press were distributed through international news agencies and amplified by Soviet propagandists indicting the US government and White society. These graphic photographs of racial violence were understood at the time to have a damaging impact on US foreign policy, and can be seen to provide an external impetus to the passing of civil rights legislation.[11] For Berger, the photographs' impact on how the US was seen in the world accentuated a sense of national shame, without fundamentally altering the dichotomy between Black victimhood and White power and responsibility.[12] Attention to the USIA archive allows a slightly different picture to emerge. The focus is not the archive of press photographs, White or Black, but the program of photographic production the agency initiated around civil rights. The response at the top of government may simply have been to wish images of racial violence would go away, and to hasten legislation that it was hoped would have the desired effect. For the overseas information program, however, earlier hopes that the story would simply disappear had long since evaporated. The question, therefore, was how it could be framed within a more affirmative narrative. While Berger's interpretation might well have held true for audiences in many parts of Europe, it clearly did not apply in newly independent African countries. In order to supply material to overseas posts, therefore, USIA created its own photographic record in response to this political moment. Moreover, where Berger argues that the process of selection operated at an unconscious level—"Few reporters and editors were sufficiently attuned to the dynamics of race to articulate the link between scenes of black agency and the anxiety of whites"—the context for the production and selection of material by USIA could not have been more different.[13] The photographs made and distributed by the agency did not evolve in a plural media setting, where an intuitive sense of audience preferences and expectations could operate to filter material, but rather were carefully scripted and packaged to target specific audiences. As USIA began to take seriously its efforts to reach African audiences, there is no question that the dynamics of race and agency were the focus of deliberate and self-conscious attention.

———

By the end of the 1950s, events in Little Rock had concentrated minds at USIA on how it presented progress toward racial equality and integration. This led to a significant

expansion in the production of photographs and picture stories, the construction of which was sharpened by an awareness of the need to communicate with audiences in Africa. A desire to represent the US as a racially integrated society permeated USIA photography, but it is also evident that many picture stories expressly intended to illustrate the theme of integration were the result of specific requests from the Africa Branch, or in some cases individual African field posts. At this point, however, the leadership of USIA did not consider it necessary for the agency to produce its own photographic coverage of civil rights protests or conflicts over desegregation. They saw no propaganda or informational benefit in doing so and left it to national and international media outlets. A planning paper produced in 1958 to consolidate the guidance developed in the wake of Little Rock articulated the position unambiguously. It set the task of countering coverage of racial protests and violence by putting "the problem in perspective" and providing accounts of "real progress already made and in process." Noting the "special kinship" many populations in the postcolonial nations of the global south felt toward African Americans, agency output was to emphasize "the gains of non-white Americans, both as individuals and in integrated situations." While "realistically reflect[ing] existing obstacles to integration," the overall tone should evince "a note of confidence in continued progress."[14] The agency was conscious of the fact that "pictorial evidence of violence had a substantial impact upon audiences abroad" and created an "appetite" for further coverage. But the response to incidents such as the murder of Emmett Till and the formation of White Citizens' Councils, which "had begun to mar the favorable picture"—in retrospect a shocking level of understatement—created since the *Brown* decision, was simply to "redouble its efforts . . . to convince the people of other nations of the real progress being made." The guidelines stated unequivocally that segregation was to be depicted "only when the evidence of progress clearly outweighs any adverse impact of segregation," and that output across all areas should place the "major emphasis upon interracial cooperation."

At the beginning of the 1960s, the treatment of the campaign for civil rights in agency output differed little from the pattern set in early pamphlets such as *The Negro in American Life*.[15] It stressed the twin importance of education and legislation, and the visualization of civil rights activism was limited to formal portraits of leaders of moderate African American organizations, such as the National Association for the Advancement of Colored People (NAACP). Walter White, then head of the NAACP, appeared in *The Negro in American Life* (described in the caption as a "crusader for Negro rights"), as did Elmer Henderson, a Black lawyer who had launched legal action against segregation on train dining cars.[16] African Americans exercising the right to vote were represented only in the abstract, by an image of an unnamed woman described as a "literate voter"—the "greatest contributor to Negro progress"—as if literacy was

the only obstacle to obtaining the vote, and tacitly accepting that the test of literacy was a legitimate requirement for democratic participation. An updated version of this pamphlet published in October 1960—*The Negro American: A Progress Report*—did not go much further. Despite the fact that grassroots actions such as student sit-ins were widespread that year and acknowledged in the pamphlet text as having taken the lead in pressing for integration, they did not feature in any of the illustrations. Ironically, the discussion of the protests in the text was juxtaposed with an image of an African American debutante ball.[17] The pamphlet included just two photographs directly referencing civil rights: the first, an image of Marian Anderson performing at the Lincoln Memorial, was over twenty years old; the second, of an unspecified rally, also at the Lincoln Memorial, had a caption that stressed the integrated nature of the gathering and declared that "the right of peaceful assembly is a cherished heritage." It may not have been an emphatic statement, but the latter was nevertheless a new kind of image for USIA, which had hitherto been reluctant to include even images of nonviolent collective protest.[18] Events of the early 1960s were beginning to put pressure on the basic tenets of the agency's approach to civil rights and change the propaganda calculation.

As the agency's Africa operation became established, there was soon a regular flow of reports back to Washington on African opinion. High on the list of topics that USIA began to gather information on was how African populations were reacting to the ongoing racial strife in the US. Among the items Edward Murrow, Kennedy's choice as the new USIA director, would find on his desk when he arrived in January 1961 was a report on Ghanaian press coverage of riots that followed an attempt to desegregate Georgia University.[19] USIS Accra reported that the *Ghanaian Times* and *Evening News* continued to "play up" the attacks by White students, linking events to the Ku Klux Klan and including a photograph of Black student Charlayne Hunter "being jeered and taunted." A handwritten note on the archived copy of the memo posed the question, "the hottest so far?" It may not have been hot enough to keep Murrow's attention for long, however. A few months later racist violence would again make headlines in Africa and across the world, when civil rights activists set out on interstate buses from Washington to test the enforcement of anti-segregation legislation in southern states. The Freedom Rides and the violence with which they were met generated a vast amount of coverage in Africa. USIA staff speculated that it may have exceeded that in the US.[20] In late May and early June, press reports began to arrive in Washington and the Office of Research and Analysis that compiled analyses of reaction worldwide.[21]

African coverage of the violent attacks that greeted activists on their arrival in Alabama, which generated compelling images of buses ablaze and mob violence, provided mixed messages for US information officers. On the one hand, it was plain that the

events had damaged the US in the eyes of the continent and "left a deep impression upon African opinion about racial inequalities," and while editorial comment may have been "surprisingly light," "its tone is increasingly bitter." In Accra, the government-owned *Ghanaian Times* opined caustically that "surely the Negro problem on the earth as well as the plight of oppressed peoples in Africa and elsewhere demand much more serious attention and consideration than the sending of a man to the moon." The press in White majority countries used the opportunity to renew accusations of hypocrisy. In Angola, for example, the *Diário de Luanda* claimed that there was no "American scientist of note, Republican or Democrat, Protestant or Catholic, who does not consider the Negro being (to be) inferior to the white (man)." In what might be viewed as a rebuttal to one of the agency's preferred propaganda images for Africa, the editorial went on to state that when "an Adlai Stevenson . . . is obliged nowadays to shake hand with some Nkrumah, he does it only under the strict political necessity of the world in which we live. He is hypocritical and sells his soul to the devil." On the other hand, USIA officers may have been reassured by an editorial in the *Ashanti Pioneer*, described as "helpful," noting that it "appears that many decent minded Americans are working tirelessly to find a permanent solution to all forms of racial troubles in America." The wording could almost have come direct from a USIA press release, and perhaps it did.

Most concerning for US information officers would have been coverage pointing to implications for political and diplomatic relations in Africa, notably the association between the US and colonialism and the specific analogy with apartheid South Africa. In Conakry, the state-owned *Horoya* ran a sketch imagining a dialogue between an American and a South African traveling to New York: "No, my dear Yankee, we are cast in the same mold—Be sure and let your United Nations diplomats know this. . . . Before they start weeping over the fate of the Bantous they had better start right now to save those millions of black Americans."[22] "On balance," one report concluded, "it must be assumed that in many parts of Africa American prestige has been impaired with regard to a problem of growing importance to the peoples of Africa." Yet the US could take comfort in evidence suggesting the geopolitical consequences were minimal: "There is no evidence that adverse racial incidents have caused any nation to align itself against us, even in Africa."[23] What none of the reports did, however, was draw out implications for USIA's own coverage.

Two specific observations seem pertinent to USIA's visual program. The first was recorded in a telegram from Lagos. Noting that USIS background material "appears have had quieting effect local editors [*sic*]," its author added the following comment: "Little emphasis bi-racial nature of Freedom Riders."[24] The second appeared in one of the summary reports. Despite the negative impact, it suggested, "Africans have been

given an object lesson, perhaps for the first time since Little Rock, of the Federal Government's determination to enforce anti-discrimination statutes."[25] The agency does not seem to have drawn any immediate conclusions from either point. The observations were more significant than anyone realized at the time, perhaps. But they contributed nonetheless to an emerging set of ideas that was beginning to circulate in relation to civil rights and the program for Africa. At the same time reports on press coverage of the Freedom Rides were arriving in Washington, Carl Rowan, an African American journalist recently recruited by the Kennedy administration, was preparing remarks for regional conferences of US Embassy personnel in Nigeria, Cyprus, and India.[26] Setting his speech in the context of the Tunisian blockade of Bizerte, an attempt to force the French from their last naval base in the country, and comments from a leading Tunisian editor critical of the US for its commitment to a "fraternity of white men" over national self-determination, Rowan underlined the challenge racial injustice presented for US efforts to distance itself from colonialism. Recalling Bandung, he cited Nehru on the mood of Africans and Asians who were "sick and tired of white men sitting down in Paris or Geneva or London or Washington to decide the affairs of Asians and Africans" and pointed out that for many colonialism and racism were two sides of the same coin.[27] Moreover, he stressed that in the coming months the challenge would not lessen: "There are going to be freedom rides and sit-ins and kneel-ins and sleep-ins and some forms of protests against segregation that you and I have not yet dreamed of." No longer was it satisfactory to claim that "we have a problem but we are making progress." The matter was more urgent.

Prefiguring an emerging USIA script, Rowan encouraged his audience to ensure the populations in the countries where they worked understood that "were it not for the fact that the American Negro has far more education, economic strength and political power, the freedom rides and other demonstrations would not be taking place." Moreover, he argued that it was "absolutely essential that we make Asians and Africans realize that racial strife in the United States is not simply a matter of Negroes against white people," and that it was the task of his audience to point out that "going to jail in those freedom rides are white students as well as Negroes." The civil rights protests of 1960 and 1961 had put USIA on the back foot in Africa, and if Rowan's remarks are anything to go by there was a growing sense that the response needed to be stepped up. The issues converged around the question of agency and its representation. In order to escape the colonial framing of the racial struggle in the US, it was no longer acceptable to represent equality as something that would be achieved in good time, when Whites were willing to grant it, and it was equally important, indeed "essential," Rowan realized, that the campaign for civil rights was not presented in stark racial terms. In other words, the integration of the civil rights struggle itself was central to the message the

agency needed to present. Rowan's phrasing is telling. His point was not that African Americans were willing to go to jail to secure their rights but that Whites were willing to do so too. The "object lesson" for USIA from its coverage in Africa was that given the way events were unfolding it could not leave it to the international media to ensure that the federal government gained credit for civil rights progress. The agency's presentation of the US government needed to align it more explicitly with the struggle for civil rights as a form of democracy in action. For USIA to retain a hold of the narrative, presenting civil rights as a matter for legislation and education alone would no longer suffice, rather it was necessary to "embrace the notion that active, non-violent dissent was an integral sign of the nation's fundamental health."[28]

If this much can be read back into the documents of 1961, it should be acknowledged that it was not necessarily clear at the time, and the agency's civil rights coverage would always remain contested, internally as well as externally. Furthermore, President Kennedy was hardly unequivocal in his support for direct action such as that instigated by the Freedom Riders and tried to use his influence with an older generation of civil rights leaders to calm protests, always mindful of the votes of Southern Democrats in Congress.[29] USIA had no explicit mandate for change. One can, however, detect examples that appeared to test out the direction ahead. In June 1962, a photographer was assigned to cover the swearing-in of Luke Moore as a US marshal, for Rufus Wells of the Africa Branch.[30] Moore was the first African American to hold such a position since Frederick Douglass, which may have been justification enough, but the photographs of him being congratulated by Robert Kennedy connect the story back to the role of federal marshals in Alabama the previous year, while also pointing to the future. A month later, in another assignment for Wells, a photographer covered Martin Luther King speaking at the National Press Club in Washington.[31] Significantly, King was pictured with Angier Biddle Duke, Chief of Protocol at the Department of State, visually illustrating the connection between civil rights and discrimination against African diplomats in the US.

King was now beginning to appear regularly in USIA output. The same year, for example, he was included in the 1962 pamphlet *Distinguished Young Americans*, the only African American.[32] He was pictured in a single photograph, showing him meeting with a group of African American women. The text was carefully worded, referring to his commitment to nonviolence and the capacity to "bring cohesiveness out of the bitter factionalism among the Negroes themselves." There was a recognition here that it would be both necessary and possible to incorporate King into the narrative the agency wished to present. Any closer attention to direct action was still largely out of bounds however.[33] There was still uncertainty within the agency as to how far coverage should go in engaging with civil rights protests.

The latter half of 1961 through the summer of 1962 represented a period of "considerable progress and . . . relatively little violence."[34] But it was not to last. In late September another civil rights crisis created international headlines, this time at the University of Mississippi, commonly known as Ole Miss. After a protracted legal battle, James Meredith, a former army veteran, had won the right to enroll at the university, setting the stage for confrontation with the state's governor Ross Barnett, an ardent supporter of segregation. In the face of Barnett's intransigence, the president and attorney general directed a contingent of US marshals to provide Meredith with protection as he arrived at the university on September 30. That same evening, after Kennedy had made a televised address to explain his actions to uphold the law, a riot broke out as White protestors attacked the campus. Two people were left dead and many more injured. The following day federal troops were sent in to establish order and facilitate Meredith's enrollment. The events at Ole Miss brought home to Kennedy the depth of opposition to civil rights progress in the southern states. The lesson for USIA, however, came in the responses carried in the international press, where coverage of events had made a "positive impact" and generated "strong praise" for the president.[35] US ambassador to the UN Adlai Stevenson reported that "friends of the US and most particularly those in Africa [are] delighted at strong response of [the] president to challenge in Mississippi."[36] Federal intervention against bastions of White supremacy was welcomed by African populations and provided a narrative that was helpful to the agency's message. As an internal memo observed, a "general expectation" that the US government would intervene "to tip the scales in favor of integration" was becoming a "powerful element in foreign reaction."[37] More importantly, this was accompanied by a growing perception that public opinion in the US favored integration and supported government intervention—"the two are beginning to be equated, at least implicitly." The memo made two further important observations. First, that foreign publics saw in the increasing urgency of African American demands for civil rights not so much a result of "an improved climate for progress" within the US but the influence of external factors such as African independence. Second, there was increasing awareness of the "alternatives posed for Negroes in the varied leadership and methods offered by Dr Martin Luther King and by the extremists like the Black Muslims." This latter point especially may have given USIA officers reason for careful consideration of the value of King's image to the information program.

As a footnote to the Ole Miss crisis, it is worth noting that there had been a certain prescience in the photographic assignment on Luke Moore's swearing-in as a US marshal. The photographs of Meredith being escorted onto campus did not include any Black marshals, a deliberate decision given the likelihood of escalating tensions further, but it was Moore who was drafted in to supervise Meredith's protection after

Fig. 47 "Attorney General Robert Kennedy and James Meredith" (Photographer: George Szabo), May 27, 1963. Staff and Stringer Photographs, 1949–1969, RG306, NARA. 306-N-63-2519.

his enrollment. Whether any USIS field officers in Africa were aware of this fact and exploited the earlier photographs to offset the sense of White authority and Black passivity conveyed by mainstream press images is not clear, but it is an intriguing prospect held out by the archive. It is evident that at least some USIA officers were alert to the significance of the Meredith case for the evolving presentation of civil rights to overseas audiences, and the value of pictures as well as words in establishing ownership of the agenda. In May 1963, the agency sent one of its photographers to document a meeting between James Meredith and Attorney General Robert Kennedy at the latter's office in Washington (fig. 47).[38] The story was treated as "fast news" and the image of the two of them in conversation circulated to all USIS offices. For several African posts, the image of Kennedy shaking hands with Meredith would have provided another example of visual triangulation; just four days earlier he had been photographed in his office greeting Kenneth Kaunda of Northern Rhodesia.[39] By this time, however, another civil rights crisis had once more sent graphic images of racial violence around the world.

When they chose Birmingham, Alabama, to launch the next phase in their campaign against racial segregation, Martin Luther King and the SCLC not only understood that things may turn ugly but also recognized the impact images of White violence had on the wider struggle. They were not to be disappointed. At the beginning of May 1963, protests in Birmingham provoked a vicious reaction from local police under the leadership of Eugene "Bull" Connor. The photographs of high school students targeted by high-pressure fire hoses and attacked by police dogs are the most shocking and memorable images to emerge from this period of direct action. Once again USIA sought to gauge the damage to its image abroad.[40] Its assessment was not wholly negative, describing the coverage as "light to moderate"—a phrase more suited to a weather report than brutal police violence—and editorial comment as "scanty." The African media paid more attention than most regions. Press commentary in Ghana was described as "critical and caustic." The pro-government *Daily Graphic* focused attention on the president's leadership, arguing that it was "time for Kennedy to act promptly to stamp

out this racial persecution." In East Africa, *Mwafrica* pointed out the contradictions in US policy: "helping South Africa secretly while announcing to the world that she opposes segregation." The identification of Kennedy with civil rights evidently carried risks as well as benefits. Elsewhere, there were only occasional "sensational" headlines and photographs "marring" what was otherwise "surprisingly moderate and balanced coverage." The report authors were in no doubt, however, that "pictures of police brutality, particularly the use of police dogs, has militated strongly against the US image." Although the Soviet Union had been slow to exploit the incidents, over the weekend of May 11–12, they "began to hit high 'C' . . . particularly in output to Africa," depicting government failure to protect African Americans' civil rights as "evidence of colonial-mindedness."[41] An internal report on press coverage was not the place for policy recommendations, but it is nonetheless worth noting that the summary concluded federal intervention was "likely to be met with approval."

————

The events in Birmingham meant the case for a more forthright approach was now overwhelming, even if the agency was constrained by the need to follow rather than lead government policy on civil rights. A memo composed in late May by William Gausmann, head of the agency's unit on minorities affairs and well connected to civil rights organizations, set out the picture for the coming months and the challenge for the information program.[42] While Alabama was likely to "remain front and center" for the next few weeks, the situation was "boiling" in a number of cities. It was anticipated that an "upsurge" in the South would have a significant impact in the North, leading to protests against segregation and inequality in housing and employment. To compound the issues the administration had to contend with there was the rising radicalism of the Black Muslims, poised to become the "left-wing of the Negro thrust" and threatening to "take the non-violence out of non-violent direct action." This put further pressure on King and his fellow leaders to make gains. Agency output, Gausmann maintained, must hold to the guidelines it had begun to establish over the past couple of years, communicating the commitment of government to the same objectives as civil rights organizations. The task was twofold: to supply "a continuing flow of hard evidence" of change, and to respond, "constructively and convincingly" to "headline making explosions." There would be "more devastating photos and more critical analytical articles," he acknowledged, arguing that the former would be most significant for "mass opinion" and the latter for elites. And in a comment that could be taken as damning of much of the agency's integration output to date, he pointed out that "police dogs in Birmingham cannot be dismissed by pictures of bi-racial playgrounds in Manhattan," though he conceded they might be "partially answered by photos of actual desegregation moves in Birmingham and other Southern cities." As

an aside, Gausmann mentioned that Kennedy had not been pleased by the suggestion from James Baldwin, repeated by Martin Luther King, that he "personally push the university door-barring Governor aside in Alabama"—a reference to George Wallace who promised to literally block the entry of two Black students to the University of Alabama. Yet perhaps this proposed photo-opportunity was not entirely lost on USIA, since the scene of Wallace moving aside at the behest of federal authorities appeared in one of the first agency films on the civil rights struggle.[43] The media programs, Gausmann concluded, "must dispel the dismay of educated overseas audiences," "demonstrate our appreciation of the difficulties," and "show the broad front . . . along which the battle for progress is being fought." To underline the importance of the task ahead, each of the media divisions was asked to put forward plans for review and to designate officers responsible for the civil rights programs.

The agency was not far into the planning process when its program for civil rights coverage received a significant boost. On June 11, following the success of federal intervention at the University of Alabama, President Kennedy once again made a televised address to the nation.[44] The speech marked a significant moment. It went beyond the earlier framing of civil rights as a matter of law and politics, referring to it instead as a "moral issue." Kennedy addressed his remarks to the urgent crisis faced at home, where "fires of frustration and discord are burning in every city," and to the country's leadership in the "worldwide struggle" for freedom. Whether he was genuinely moved to moral action by the scenes of racial violence and injustice or merely concerned with the consequences for foreign policy is a moot point. The agency's leadership in Washington and its field officers immediately understood the value of Kennedy's intervention for the Africa program. Donald Dumont, US ambassador to Burundi, wrote to Acting Director Donald Wilson from Usumbura (Bujumbura) to share his view that the speech would be significant.[45] Echoing Dumont's reaction, Wilson's reply described the speech as "some kind of a turning point on a road that has been too slowly travelled." Many similar responses received from Dumont's overseas colleagues, he stated, "indicate we have opened the door to understanding and sympathy by many of Africa's and the world's leaders."

Wilson felt that the agency had been "handed a most useful tool." The president's public commitment to civil rights established "a bridge of credibility," which would underpin future claims of progress and had the potential to "lessen the shocks of future outbreaks of violence in the minds of Africans." The agency wasted no time in disseminating the text of Kennedy's address and seeking to consolidate and build on the momentum it had provided. By many accounts this concerted push was highly effective in identifying Kennedy with the civil rights cause in Africa, linking it to the struggles for national independence in which many of the African elites targeted by

USIA had participated.[46] John McCormally, a reporter for the Kansas-based *Hutchinson News*, who had participated in a USIA journalism seminar in Africa that summer, was emphatic: "I found, on the whole, that Africans think President Kennedy is the greatest white man who ever walked upon the earth, thanks to his civil rights message with which USIA blanketed Africa just before we arrived."[47] Kennedy's acclaim was not universal of course. The Ghanaian press, for example, expressed some skepticism of his ability and commitment to deliver meaningful change, since racism was the "hand-maiden" of the capitalist system.[48] Notwithstanding such criticisms, however, for many of those engaged in shaping the agency's output Kennedy's speech was taken as an endorsement of the more proactive approach to civil rights coverage that was beginning to crystallize, and served to give it further impetus.

A sense of the debates going on within the agency's media production divisions can be gleaned from internal communications during the summer of 1963, among them a memo sent from the International Television Service to Edward Murrow, "continuing the dialogue" on race in USIA output from earlier meetings.[49] Strikingly titled "Race and Revolution," it had been composed by Robert Ehrman, recently moved from the Africa office to take up a policy role. The memo was forwarded by Murrow to Thomas Sorensen, USIA Deputy Director of Policy and Planning, on the day of Kennedy's speech, prompted perhaps by the meeting he had with the president on civil rights that afternoon.[50] Murrow added the following covering note: "The attached . . . has much to commend it. If you agree, let's proceed." Ehrman and his colleagues argued the agency's approach should be positioned in "the context of America's unfinished revolution." It is worth quoting from the document at length: "The bulk of the world's people is trying to change the status quo, not to preserve it. So are Negroes and their white supporters in America. We should strengthen and exploit this identification wherever possible. The denial of Negro rights is probably the most critical, certainly the most unfinished part of America's unfinished revolution. We should show that it *is* being finished, that it *does* involve a struggle, and—implicitly—that we realize there is no fundamental progress *without* a struggle" (emphasis in original). The connection drawn here between the civil rights struggle in the US and liberation from colonial rule achieved or still being sought in much of the global south anticipated Kennedy's civil rights address. But perhaps most remarkable is the language of the document, using words like "revolution" and "struggle," little more than ten years after the height of McCarthyism. It demonstrates just how rapidly thinking had developed at USIA. In "picturing" the efforts that were being made to change US society, it proposed that "in addition to the vital role of the Federal government," agency output should acknowledge that "other elements of our society—public, private, and individual—are also pushing the fight for equality." And that it was important to show "the

many Negroes and whites working together on the problem," in order "to avoid the false image of a solid mass of anti-segregation Negroes pitted against a near-solid bloc of pro-segregation whites." These two themes were, it has to be said, already becoming familiar. But it went further, arguing that: "In reporting efforts to wipe out discrimination through legal, legislative and educational means, we would also recognize the catalytic function of militancy—notably direct action in the form of non-violent protest and demonstration. (Militancy is part and parcel of the US tradition and US progress. American women, for example, went to jail to win the right to vote. Militancy, then and now, belongs to America's unfinished revolution. In this sense it has meaningful appeal to many overseas.)" The view expressed in the document was just one perspective, and there were many competing voices within and without the agency, but it nonetheless indicates the extent to which at least some of those involved the agency's media production operation were prepared to embrace a more radical vision of America and deploy their creative skills in its service.

The more radical and innovative ideas did not have things all their own way of course, and other documents, as well as some of the output, give an insight into competing perspectives. Indeed, one can discern a strong recidivist tendency at the agency, which often asserted a preference for coverage that was as anodyne as it was upbeat. In July 1963, IPS, where photography was located, was subject to criticism from a USIA committee set up to monitor output on civil rights.[51] The nub of their complaint was that IPS output was too negative in tone. The response from IPS Director Ray Mackland was spirited and fulsome—appended were several pages of coverage to counter the claims of the committee.[52] Describing the report as "intemperate," "erroneous," and "ill-advised," Mackland went on to rebut the committee's points one by one. In their own internal review of the Birmingham coverage, he noted, "police dogs" and "fire hoses" appeared on just two occasions; and, he asked rhetorically, if the distribution of a total of 104 photographs on civil rights to all posts in May and June, in addition to post-specific "target pictures" and photo-essays on integration at Little Rock and the University of Alabama, "is not coming to grips with the problem, what are the committee's suggestions?" But most scathing was his critique of the committee's underlying assumptions. "Emphasis on the positive often tends to relative dullness," he pointed out, and "no one story of virtue even greater than has thus far been shown will dissipate the effect of the head-on clash in Birmingham. It will take many pictures of less-exciting sweetness and light subjects to dent the impact of the single shot of flesh-tearing police dogs." In summary, he argued, "in this cumulative, comprehensive program we shall continue to report the increasing instances of symptomatic tokenism but, even more important, to provide effective meaningful material on the theme of the President's TV address and message to Congress. . . . Integration is

not a case in which USIA can live on either—pardon the expression—whitewash or semantic acrobatics. If, as I infer, the committee is proposing a completely Pollyannaish attitude, I do not believe it is any longer necessary for us to grasp at thin straws to prove that things are better than they are." Mackland was articulating with some force an internal critique of agency output that had gained traction in the early 1960s. At the same time, perhaps, his rebuttal can be read as an expression of the frustration of many of the photographers, picture editors, and writers working at the agency who wanted to use their skills to respond more authentically to the situation in the country as they saw it and felt that Kennedy's speech had given them permission to do just that. Mackland concluded the memo by asking Murrow's permission to distribute his response to members of the IPS task force on civil rights and other staff in the division, in order to address the "morale sag" caused by the committee report. A handwritten note in the margin indicates that Murrow agreed.

————

By the summer of 1963, civil rights protest was firmly on the agenda at USIA. It was only from this point on, however, that it became subject to more extended visual narrative or documentary treatment. Shaped by internal debates, the agency's media divisions sought to craft a perspective on events that acknowledged civil rights as a struggle but positioned the federal government at its heart, pursuing a civil rights agenda with passion and determination. Cull makes the point that anyone solely reliant on USIA sources for information on the civil rights movement in the US would be left with "the impression that the hero of the civil rights era was the federal government which came to the aid of the distressed black citizens."[53] Nowhere would this observation have been more pertinent than in Africa. Although urban African audiences certainly had access to mainstream media reporting of events in the US, as well as Soviet, Chinese, and nonaligned outlets, USIA was an important media player on the continent and its message there had significant reach. There is no better exemplar of Cull's point about the centrality of the federal government than the first of the agency's scripted picture stories to reflect its more concerted approach. *Protectors of Civil Rights for All Americans* is remarkable for including just a single African American in its seven photographs.[54] This might suggest it was not primarily targeted at Africa, where integrated imagery was rapidly becoming obligatory, though like most picture stories it was distributed to all posts. The photo-essay introduced a cast of White characters, centered on Robert Kennedy, at the heart of a coordinated campaign to ensure the enforcement of civil rights legislation across the country—it has the quality of the opening sequence of a film or television series, familiarizing the audience one by one with the protagonists in the narrative. The US Department of Justice, it states, is the "nerve center of the Federal Government's fight to end racial discrimination"; its "dedicated

staff keeps a close watch on racial developments, and is prepared to go on short notice to scenes of racial disturbances." Among those depicted were Assistant Attorney General Burke Marshall—"a quiet, scholarly man of 40 . . . [his] personal mediation was instrumental in reaching the agreement that ended the Birmingham, Alabama, racial demonstrations"—his aide John Doar, shown reasoning with an African American protestor in Jackson, Mississippi—"Mr. Doar goes wherever racial demonstrations occur and works to settle disturbances by peaceful means"—Assistant Deputy Attorney General Joseph F. Dolan, pictured in an animated pose as he "forcefully explains to a State police officer in Huntsville that any demonstrations must be handled in an orderly and equitable manner," and two of the department's lawyers, Ramsey Clark and Louis Oberdorfer—"both grew up in the South and understand southern attitudes on race relations." The photo-essay's signature image condenses the central message (fig. 48). Deputy Attorney General Nicholas Katzenbach is pictured in the act of adding another small flag to a map of the US bearing the title, "Public Facilities Desegregation Progress since May 22, 1963." The Department of Justice, it implies, is akin to a military command center. The sequence closes with an image of Robert Kennedy in conversation with his brother at the White House, signifying support for the campaign at the highest level. The picture story provides an illustration of how, as it began to grapple with the international prominence of the civil rights protests, the agency saw its task as complementing international media images; not providing a counternarrative but rather weaving an account of events that secured the place of the federal government as a key civil rights actor in the international imagination. In addition to Robert Kennedy, photographs of Katzenbach and Doar were already in circulation through international press agencies. Katzenbach had been central to the desegregation of the University of Alabama, and the image of him facing down Governor Wallace at the university entrance would have been widely reproduced. Doar, on his part, had been one of the two US marshals pictured in the press escorting James Meredith onto campus in Mississippi.[55] The picture story served to appropriate these public images of confrontation for a visual narrative of federal leadership in the campaign for civil rights, while at the same time humanizing the "heroes" at the Department of Justice. Equally, this picture story could be read as a more or less direct response to a poster produced by the Student Nonviolent Coordinating Committee (SNCC)—"Is He Protecting You?"—which Leigh Raiford argues signaled "the organization's increasing lack of faith in the Justice Department to use its power . . . on behalf of African American protestors."[56] The photograph on which the poster was based had been made by Danny Lyon on the campus of the University of Mississippi during the 1962 confrontation.[57]

Not all USIA photographic coverage that summer would project the same positive message of progress as the Department of Justice picture story. The agency's established

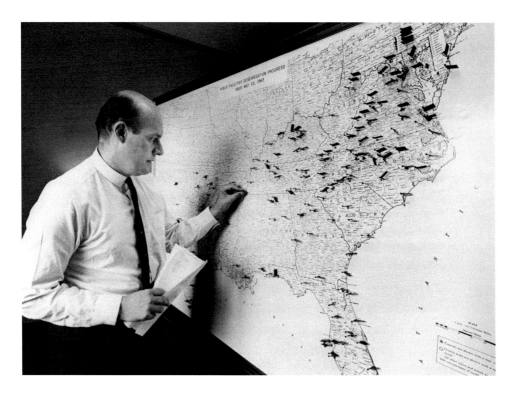

Fig. 48 "Deputy Attorney General Nicholas Katzenbach checks a map of the United States showing progress in the desegregation of lunch rooms, hotels and other public facilities since May 22, 1963." *Protectors of Civil Rights for All Americans*, 1963. USIA "Picture Story" Photographs, 1955–1984, RG306, NARA. 306-ST-819-63-4064.

injunction against reporting anything more than the barest facts of the deaths of African Americans at the hands of White supremacists was at least partially lifted when the morning after Kennedy's civil rights speech, Medgar Evers was shot and killed outside his home in Jackson, Mississippi. Evers was a military veteran and an NAACP activist who was involved in the campaign to desegregate the university and investigated cases of lynching, including that of Emmett Till. Following the assassination, his body was brought to the John Wesley African Methodist Episcopal Church in Washington, where it was viewed by mourners over two days before the committal at Arlington National Cemetery on June 19. USIA sent one of its staff photographers to cover the funeral.[58] The archive file does not contain any notes on distribution, but it is clear from the images marked for selection that the event was to be interpreted as a moment of national tragedy and collective grief on the part of Black and White Americans. One contact sheet contained over half a dozen frames in which the photographer captured the faces of mourners as they stood outside Fort Meyer Chapel listening to the service, flanked by two members of the Third Infantry Honor Guard, one Black and

one White (fig. 49). At the graveside, the photographer captured the grief of the murdered man's wife, Myrlie Evers, and daughter Reena, viewed through the US flag and the casket, as well as a tightly framed shot of Myrlie Evers clutching the flag retrieved from the now-lowered coffin close to her body (fig. 50). The latter image was marked for printing. The graveside sequence also included an image of the two children that powerfully captures a sense of bewilderment and anger beneath a surface composure (fig. 51); this image does not appear to have been selected.

Several other photographic assignments in the weeks following Kennedy's speech began to fill out the coverage of civil rights. Robert Kennedy's office had by now become a regular beat for agency photographers. In late June, Kennedy was photographed there again, this time with a visiting group of African American children from Georgia. The file contains no details of the occasion for the visit, but it is worth noting its triangulation with the photographs of James Meredith and Kenneth Kaunda in the same location just a few weeks previously. Again, this was a picture request for the Africa Branch.[59] And in July, USIA sent a photographer to document Roy Wilkins, NAACP Secretary, testifying before the Senate Commerce Committee on the Civil Rights Bill.[60] But the central civil rights event that summer from the point of view of the agency's photographers and filmmakers was to be the March on Washington for Jobs and Freedom in August.

USIA immediately understood the value of the March on Washington for the vision of civil rights progress it now sought to project around the world and was prepared to invest significant time and resources in the production of a film directed by James Blue, as well as extensive photographic coverage. While Blue's film was primarily focused on the day of the march, the photographic record documented some of the earlier meetings in Washington, reflecting the organization behind the scenes, in addition to several photo-essays carefully prepared from photographs made on the day. The early-phase assignments appear intended to convey two messages. First, they emphasized that the march was a collective democratic exercise with responsibility distributed on both sides. The coverage offered an illustrated lesson in the management of a peaceful demonstration, the duty of those in positions of power to facilitate public protest, and the responsibility of protest organizers to work with them to ensure it was conducted in an orderly manner. Second, they showed that the protest was integrated and representative of a majority of citizens, Black and White, who supported the civil rights cause. On August 5, for example, an agency photographer was dispatched to the NAACP offices in the capital to photograph a meeting between the local director, Edward Hailes, and Lieutenant Owen Davis of the Metropolitan Police Department.[61] The single-shot story shows the two men, both African Americans, seated around a desk discussing plans laid out before them. Unremarkable in photographic terms, the

Fig. 49 "Evers' Funeral in Arlington Cemetery" (Photographer: Jack Lartz), June 19, 1963. Staff and Stringer Photographs, 1949–1969, RG306, NARA. 306-SS-16-849-Sheet.A.

Fig. 50 "Evers' Funeral in Arlington Cemetery" (Photographer: Jack Lartz), June 19, 1963. Staff and Stringer Photographs, 1949–1969, RG306, NARA. 306-SS-16-849.

Fig. 51 "L and R, are the two Evers children Darrell, 9 and Reena 7." SS-16-849, "Evers' Funeral in Arlington Cemetery" (Photographer: Jack Lartz), June 19, 1963. Staff and Stringer Photographs, 1949–1969, RG306, NARA. 306-SS-16-849-Sheet.A.

Fig. 52 A. Philip Randolph, "March on Washington meeting with Murray
and Senators" (Photographer: Jack Lartz), August 7, 1963. Staff and Stringer
Photographs, 1949–1969, RG306, NARA. 306-SS-23-1104.

assignment nonetheless indicates the kind of record of the march that the agency's Photographic Branch thought it appropriate to construct. Two days later, another agency photographer was at a meeting between US congressmen and senators and A. Philip Randolph, one of the organizers of the march.[62] Randolph was photographed speaking and answering questions in an animated manner in front of an assembly of politicians supportive of civil rights legislation (fig. 52). The photographer sought to make the most of the relatively routine setting by an extended series of close-ups of Randolph gesturing as he spoke and shots from behind the platform that capture him haloed by a bright light as he stood in front of the crowded room, visualized as an example of African American leadership commanding the attention and respect of legislators. The same day a third meeting was deemed of sufficient interest for USIA coverage.[63] The photographs appear to document a gathering of local organizers briefing volunteers who would be present on the day of the march. The point of the assignment from the agency's perspective, however, would seem to have been the integrated nature of the volunteers; the film envelope carried the subject heading "integration." Photographs of the assembled group were taken from several angles, and there are a small number of photographs of individual interactions between Black and White volunteers, as well as an engaging sequence of a young White woman as she passes self-consciously in front of the photographer (fig. 53).

Fig. 53 "March on Washington Meeting" (Photographer: George Szabo), August 7, 1963. Staff and Stringer Photographs, 1949–1969, RG306, NARA. 306-SS-23-1111.

On the day of the march, USIA had a significant number of people on the ground in Washington, with film, television, and radio crews as well as photographers. Africa Branch staff were well represented, with Rufus Wells and James Pope both present, as well as Africa area television producer Ken Boles.[64] In addition to single images for distribution to field posts as fast news, several packaged picture stories were prepared for distribution after the event. To facilitate timely dissemination, the first of these—*Why They Marched*—had been constructed and dispatched in advance, and required only the addition of a lead photograph, which field posts were to slot in when available.[65] It was suggested that they "select an overall elevated shot of the mass rally from the news photo coverage of the march provided by IPS." As a photo-essay it is relatively atypical for USIA, first, because it featured photographs of civil rights protests, including a couple in which no White activists were

Fig. 54 "Demonstrators picket in front of a school board office protesting segregation of students." *Why They Marched*, 1963. USIA "Picture Story" Photographs, 1955–1984, RG306, NARA. Reproduced courtesy of St. Louis Post Dispatch / Polaris. 306-ST-818-63-4118.

Fig. 55 "An integrated classroom symbolizes the goal of the marchers in the area of education." *Why They Marched*, 1963. USIA "Picture Story" Photographs, 1955–1984, RG306, NARA. 306-ST-818-62-6212.

visibly present; second, because it adopted a "before and after" approach, presenting, in the visual narrative at least, protest as the cause of change, with no visual reference to federal authorities. In this respect, it offered an alternative to *Protectors of Civil Rights*. The Series A images pictured the "peaceful demonstrations techniques and pressures used throughout the US to speed-up full integration and eliminate discrimination," whereas those in Series B "typify the goals demonstrators hope to achieve," while asserting that "these goals have been attained—often voluntarily— in many parts of the country." The images covered the domains of schooling (figs. 54 and 55), housing, employment, leisure (figs. 56 and 57), and religion. These local protests, the text explained, had "expanded in numbers and spirit" into the March on Washington, which was presented as their culmination. The effect was to draw

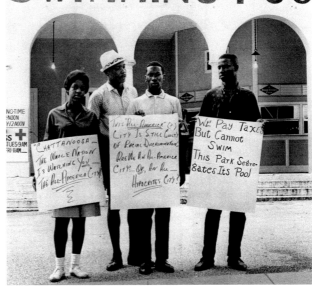

Fig. 56 "Picket lines and sit-in demonstrations, such as this group picketing a public swimming pool, have been set up in front of theatres, recreation parks, restaurants, hotels and other places serving the public, but restricting their services on the basis of race." *Why They Marched*, 1963. USIA "Picture Story" Photographs, 1955–1984, RG306, NARA. 306-ST-818-63-4115.

Fig. 57 "Teenage boys plan a water game. Through voluntary changes by proprietors many public facilities are available to all." *Why They Marched*, 1963. USIA "Picture Story" Photographs, 1955–1984, RG306, NARA. 306-ST-818-63-4116.

the multiple local struggles into a single unified narrative. Looking at the picture story now, it is striking that in most cases the images of protest are linked to a specific location, identifiable either from the protestors' placards, or through the source notes on the reverse of the archival prints—a swimming pool in Chattanooga, a new housing development in Bergen, New Jersey, the school system in St. Louis. In contrast, the integrated pairings remain abstract, unnamed places, creating an effect that

disrupts the intended message. The former draw one back into a historical narrative of civil rights protest, a capacity absent from the latter.

Two further picture stories produced from the volume of images created on that day shifted attention from the causes and ambitions that motivated the organizers to the humanity of the marchers. *Faces of the March* pictured the "cross-section of Americans" assembled in Washington and "the feelings of some of those who participated."[66] The photographs were intended to convey the "deep fervor and the quiet dignity" of participants and the racially integrated nature of the march: "These were neither whites nor Negroes who were marching today but Americans having a common background, a common goal, a common faith in the future of democracy." The sequence included a portrait of an NAACP worker at a moment of relaxation, and another of a group of participants looking beyond the frame, listening to speeches (fig. 58). In addition to its thematic emphasis on integration, the latter seems to comment self-reflexively on the relationship between media consumption and democratic participation: "Cameras, pennants and transistor radios, young and old, men and women; the Civil Rights March in Washington was a true reflection of the depth of democracy in America." It was an invitation to the story's overseas viewers to reflect on the circulation of information in the postwar world. The second picture story was entitled *Goodwill marks the Washington March.*[67] The short journalistic text bears some similarity to the voice-over of Blue's film: "Americans, Negro and white, converge on Washington . . . to take part in a historic demonstration for civil rights. They came by plane, train, bus and on foot. . . . They left for home feeling they had opened a new phase in the struggle." The photographs emphasize the humanity of participants through action and interaction. One "adventurous demonstrator" parades his enthusiastic support from high in a tree, waving his placard at the crowds below. Three of the five photographs in the sequence show interracial interaction, as participants "share a placard to shade them from the sun," pin badges on fellow marchers' arms, or assist each other to fit their armbands. A later memo from Ray Mackland to Edward Murrow could have been referring to these picture stories when he described "the effort to show American democracy in action and to point up with pictorial obviousness, but no blatant text emphasis, the bi-racial character of the March on Washington."[68]

There was certainly "pictorial obviousness" to the agency's representation of civil rights as a cause supported by Black and White people working together. Viewed in retrospect, in the archive, the photographs of interracial pairings take on a relentless, almost numbing quality across the output from this period. The lightness and sentimentality that accompanied the picturing of fraternity between Black and White Americans seems absurd, even contemptuous, given the violence and brutality that had preceded the civil rights protestors' assembly in Washington and that they would

Fig. 58 "Cameras, pennants and transistor radios, young and old, men and women; the Civil Rights March in Washington was a true reflection of the depth of democracy in America." Photograph by Rowland Scherman. *Faces of the March*, 1963. USIA "Picture Story" Photographs, 1955–1984, RG306, NARA. The two boys in the foreground are Seymour and Mickey Silberstein, young brothers of the photographer's girlfriend. Reproduced courtesy of the photographer. 306-ST-821-63-4526.

face again once they returned home. USIA might again, with some justification, be accused of staging a racially integrated Potemkin village, packed and shipped in the portable medium of photography for reassembly abroad. Yet the scenographic metaphor is only partially applicable. Photography is a complex documentary medium, and the instrumentality of the context did not preclude the possibility of images that exceeded its limits. In the task of imagining an interracial society, agency staff and photographers found themselves on occasion keeping company with those who sought to act on such utopian imaginings, practicing interracialism as part of experimental community projects. It is intriguing to discover that in the summer of 1963, exactly one week before the March on Washington, Joseph Pinto was assigned to photograph an integrated day camp in rural Maryland.[69] The archive contains frustratingly little information on the setting, identified as Camp Hope Valley, or the worldview that motivated its organizers, but for a brief moment perhaps it connected USIA photography to a tradition that at its edges was inspired by more radical social critique than the agency could ever countenance.[70] The photographs Pinto made there of interactions between

Fig. 59 / opposite "Integrated Day Camp. Camp Hope" (Photographer:
Joseph Pinto), August 21, 1963. Staff and Stringer Photographs, 1949–1969,
RG306, NARA. 306-SS-25-1173.

Fig. 60 "Integrated Day Camp. Camp Hope" (Photographer: Joseph Pinto),
August 21, 1963. Staff and Stringer Photographs, 1949–1969, RG306, NARA.
306-SS-25-1173.

young Black and White children, girls and boys, sharing equally in the work of pick-
ing corn and hanging out washing, and the pleasure of eating and singing together,
display a genuine tenderness (figs. 59 and 60).

Equally, the photographs need to be seen in the light of what was possible for a
government agency, as well as the cultural resonance of the imagery at the time. Hav-
ing viewed the first cut of James Blue's *The March*, in early 1964, an advisory commit-
tee on information policy took the view that it should not be distributed; the scenes
of interracial interaction, specifically a young Black man and a young White woman

seated next to each other on a bus, were deemed too controversial. None of the photographs in the picture stories above risked a sexualized reading, though such images were undoubtedly available: the image of the young woman at the volunteer meeting above, for example. Furthermore, the committee felt there was a risk that "unsophisticated" African viewers might conclude that the film "confirms the Communist propaganda that at all levels in the United States Negroes are cruelly and violently oppressed."[71] African viewers were not so unsophisticated as US politicians assumed of course.

The criticisms cut both ways. James Forman's observations on the March on Washington, written a few years after the event, can usefully be read alongside the USIA coverage. Forman, who played a leading role in SNCC, was conscious that "liberal and conservative forces" recognized the propaganda value of civil rights protests, properly contained, to foreign policy, and saw in the march, and especially the charismatic presence of Martin Luther King, a vivid demonstration of "how peaceful change was possible within the American system." His most telling observation, however, concerned the consequences for the movement. While the march and its visual representation offered evidence of peaceful protest, the effect was "to stifle manifestations of serious dissent and to take the steam out of the black anger then rising in the South . . . fancy productions like the March on Washington tended to 'psych off' local protest and make people feel they had accomplished something . . . when, in fact, nothing had been changed."[72] It is telling that Forman appears to conflate the march itself and its visual representation in USIA productions, which it should be remembered were exclusively for international distribution. Whether or not agency coverage had the effect Forman describes, it was certainly the case that the visual narratives were intended to consolidate a sense of change achieved.[73]

There were alternatives to the USIA depictions of the march, however, and one should keep open the question of whether or for whom photographs of the event may have had an effect different from that described by Forman. Leigh Raiford draws attention to a photograph by Danny Lyon adapted for a SNCC poster that was intended to amplify rather than dissipate the energy of the movement. The image of a Black man in the crowd with his arm raised "resonates with the immediacy of their demands and reverberates with the exuberance of being in church."[74] Nor does reading the photographs in the context of the US civil rights movement exhaust all possible meanings. There seems little doubt that the images would have been interpreted differently on the continent of Africa, just not in the unsophisticated manner envisaged in Washington. At the time of the march, the Black South African photographer Ernest Cole would have been working on his extended project on the oppressive apartheid regime. Cole visited the USIS offices in Johannesburg regularly and studied in its library, and so would almost certainly have seen agency images of the march. It is possible that he

shared something of Forman's interpretation, but he will also have drawn a connection to the situation in South Africa and the parallel struggle against apartheid.[75]

———

The March on Washington was undoubtedly a high point in the agency's coverage of civil rights, and Blue's film was regarded as a propaganda tool of real value, particularly for audiences in sub-Saharan Africa and India. The most interesting photographs the agency produced in relation to the civil rights movement, however, resulted from a handful of smaller-scale assignments made in 1963 and 1964. Outside the spotlight that had inevitably accompanied such a major event in Washington, it seems that there was greater license to explore a different perspective on events and push at the boundaries of the agency's public diplomacy mission. In August and September 1963, photographers working for USIA documented Black civil rights activists from southern states being hosted by White supporters in the North, first in Kings Point, Long Island, and then in Bethesda, Maryland. The latter event was reciprocated when a group of Bethesda residents paid a return visit to Danville, Virginia. It does not appear that there were any direct connections between the two assignments, suggesting the motivation was likely to be thematic: a deliberate, if tentative, effort to deepen the coverage of Black-White relations in the context of civil rights, moving beyond the superficial or staged picturing of equality toward a documentary exploration of forms of cross-community solidarity. In this respect, these two assignments can be seen alongside the photographs of the integrated day camp in Maryland discussed above. The photographs are not typical of agency output, nonetheless they point to the possibilities of this moment.

The events at Kings Point are outlined in a short piece from the *New York Times*, a clipping of which was retained in the archive file. On Sunday, August 4, ten Black students who had been attacked and arrested during civil rights protests, one or two only recently released from prison, arrived "to spend a week as guests of white families."[76] The visit had been arranged by the Medical Committee for Civil Rights, a recently formed, southern-based organization committed to desegregation in healthcare and providing medical support to injured protestors, in collaboration with the community-based Great Neck Committee for Human Rights and Roslyn Committee for Civil Rights.[77] Funds had been raised by the families in Kings Point and Great Neck to cover the cost of travel. The group were SNCC members aged between sixteen and twenty-three from Birmingham and Gadsden, Alabama; Tampa, Florida; and Jackson and Greenwood, Mississippi. Among them were Bernard and Colia Lafayette, both longstanding civil rights activists—Bernard had been among the Freedom Riders—and Mary Lee Lane, all three of whom were on the staff at SNCC.[78] Bernard Lafayette, the article explained, had a fresh wound on his head, received while trying to register voters in Selma; Colia Lafayette had been among those photographed in

Fig. 61 "White Families Entertain Formerly Jailed Negro Demonstrators" (Photographer: I. Burt Shavitz), August 12, 1963. Staff and Stringer Photographs, 1949–1969, RG306, NARA. 306-SS-23-1118.

Birmingham being knocked off her feet by the jet from a high-pressure fire hose; and Mary Lee Lane had spent twenty-six days in the Mississippi State Penitentiary as a result of trying to register to vote. These were not the typical subjects of USIA's upbeat coverage of progress toward equal rights.

The file contains scant documentation beyond the press cutting, some caption information, and a sheaf of contact sheets, so the precise circumstances of the agency's engagement are unknown, though the story appears to have been a commission from USIA features editor Shirley Kahn. The photographs were made by Burt Shavitz, a freelance photographer whose images appeared in the mainstream press and magazines such as *Life* and *Time*, including widely reproduced pictures of Malcolm X.[79] His photojournalistic connections would have brought him into the ambit of the agency's photographers and editors, but Shavitz happened to have grown up in Great Neck, and so it is possible he was already aware of events there. The file also contains several press photographs by Jim Ware of the *Birmingham Post-Herald* showing demonstrators being targeted by fire hoses, suggesting that the intention may have been to create a photo-essay using the photographs from Birmingham alongside those made at Kings Point. Shavitz's photographs provide a remarkably intimate and relaxed record of the visit, many of them made in the living rooms, bedrooms, kitchens, and gardens of the hosts (fig. 61). It is evident that hosts and guests were comfortable in the presence of the camera. The subjects of the story are seen at an informal reception on arrival and at a picnic given by the Great Neck Committee for Human Rights, as well as in various parts of the house and garden, in conversation, reading the newspaper, watching television, eating together, playing ball, and "singing freedom songs." Bernard Lafayette appears on crutches in several shots, his lower leg in plaster (fig. 62), and is pictured "discussing integration problems with local teenagers." The photographs offer a view of grassroots involvement in civil rights that was rare for the agency, and some

Fig. 62 "White Families Entertain Formerly Jailed Negro Demonstrators"
(Photographer: I. Burt Shavitz), August 12, 1963. Staff and Stringer
Photographs, 1949–1969, RG306, NARA. 306-SS-23-1118.

distance from the approach embodied in stories centered on the federal government
and the Department of Justice.

The photographs of the Bethesda-Danville exchange are missing from the staff
and stringer files unfortunately, but a couple of images from the master file suggest
that the coverage there would have been similar in many respects to Kings Point. The
two available photographs were made when the White residents of the suburb of Ban-
nockburn, Bethesda, were hosted by Black families in Danville; the White families had
hosted their African American guests on the eve of the March on Washington. The
images show their arrival in Danville and, separately, a group of teenagers who had
participated in the march "relax[ing] in a field with their Danville hosts, singing free-
dom songs" (fig. 63).[80] The Bethesda-Danville exchange was also the subject of a short
film segment for USIA's *Today* newsreel, produced for distribution across Africa.[81] The
connection on this occasion appears to have been a White activist from Bethesda who
had been arrested and jailed for eleven days in Danville when she traveled there in July
following the violent response of the authorities to civil rights protest in the city. As in
the Kings Point photographs, the agency's film coverage emphasized relaxed interac-
tion, showing guests and hosts swimming, playing, singing, and eating together. It is
interesting to note, too, that in Danville, the agency was beginning to create a record

Fig. 63 "Danville, Virginia: civil rights teenagers who marched on Washington relax in a field with their Danville hosts, singing freedom songs," 1963. Photograph by Edwin Huffman. Master File Photographs of US and Foreign Personalities, World Events, and American Economic, Social, and Cultural Life, ca. 1953–ca. 1994, RG306, NARA. 306-N-63-4574.

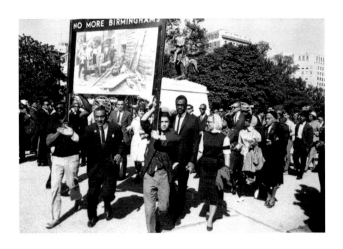

Fig. 64 "Sunday March in Sympathy Birmingham Bombing" (Photographer: Edwin Huffman), September 22, 1963. Staff and Stringer Photographs, 1949–1969, RG306, NARA. 306-SS-29-1380.

that overlapped with the photography pursued at SNCC by Danny Lyon. Lyon had photographed in Danville that June, and among his images are a few more intimate studies, such as one of Black and White activists singing together and another of James Forman and Dottie Miller shot in a domestic interior, alongside the images of protests and the violence with which they were so often met.[82] In its representation of civil rights, USIA sought to convey a message of nonviolent protest working in step with the support of the federal government toward social and legislative change. Undoubtedly, this was a message that sought to constrain ideas about more radical social transformation, primarily to persuade its audiences in Africa and elsewhere of the virtues of the American democratic model and its good faith toward people of color. Yet in Kings Point and Bethesda it documented instances of genuine interracial solidarity, absent of the guiding hand of federal authorities; utopian perhaps, lacking an analysis that would satisfy many certainly, but not merely a public relations exercise. What place these images deserve in the historical presentation of civil rights is a moot point, but their absence is nonetheless worth some reflection.

Documenting the civil rights movement was never a central task for the agency, and assignments such as those above would remain the exception. There were no photographers working regularly in southern cities and USIA left coverage of protests largely to local and national press and activist organizations such as SNCC, sourcing material from the former if needed. But the events of the summer of 1963 had broadened its purview beyond "sweetness and light." As indicated by the decision to cover the funeral of Medgar Evers and the protests that followed the bombing of the 16th Street Baptist Church in Birmingham, Alabama, if violence was not represented directly, it had nevertheless become an absent presence in USIA photography (fig. 64).[83] Nor would Danville be the last time that the agency decided that grassroots activism was within its scope.

As Johnson was steering the civil rights legislation initiated by Kennedy through Congress, plans were underway for a voter registration drive in Mississippi in the summer of 1964. The Mississippi Summer Project, also known as Freedom Summer, was initiated by the Council of Federated Organizations (COFO), a coalition of national civil rights organizations. The plan was to bring large numbers of volunteers, mainly young White college students and graduates from the North, into Mississippi to facilitate voter registration and to teach in Freedom Schools. The structure of the project was not without controversy. Several activists in Mississippi opposed the project and feared the impact of an influx of college-educated White volunteers on the morale of the grassroots organization being built in the state. Yet it was acknowledged that the presence of White volunteers changed the dynamics of the situation, drawing attention from the media and the federal authorities, and bringing in funding that would simply not be there were it only Black activists putting their bodies on the line. As local activist Lawrence Guyot observed, there were significant benefits in "bring[ing] the wives, daughters, sons, nephews of the Binghams who were in Congress, the Rockefellers, into the Freedom Houses of Mississippi."[84] Wesley Hogan describes it as an "agonizing irony" that just at a moment when local Black leadership and organization was beginning to emerge, a number of those in SNCC felt that "only national publicity and federal intervention could sustain the movement in the face of the white terrorist response."[85] Nevertheless, the benefits were considered to outweigh the risks, so the decision was made to proceed, and the project took shape under the leadership of Bob Moses, a key figure in SNCC and codirector of COFO.[86] Inevitably, the racial dynamics remained a constant source of debate, but as James Forman recalled, the project retained a clear focus on Black leadership. Volunteers had to agree to serve under Black area directors.[87] In the summer of 1964, as the project was beginning to get underway, USIA made it the subject of a photographic assignment. The coverage was limited certainly, but as the first and possibly the only time that the agency commissioned its own photographs of a grassroots civil rights organization it was nonetheless significant. Moreover, the likes of Bob Moses and James Forman had not previously received any attention.

The Mississippi Summer Project began in June 1964 with an orientation program for its volunteer recruits run at a campus in Oxford, Ohio. It was this aspect of the project that USIA decided to cover, commissioning a local photographer.[88] The agency did not send or commission any photographers to document activities in Mississippi. Why they chose to commission the photographs is a matter of speculation. The project had attracted the attention of the media and the Johnson administration; the latter sent Allen Dulles to talk to the organizers and assess the possibility of

federal government assistance.[89] John Doar from the Department of Justice also traveled to Mississippi and Ohio, though the extent to which he offered any reassurance in the light of the risks faced by local activists and volunteers is debatable.[90] But those meetings alone would not have been sufficient reasons for the agency to require photographs. Most likely, it was the interracial character of the program that attracted its interest; in that respect it fulfilled the organizers' expectation that the presence of White students from the North would attract national attention and recognized the value for its own message overseas. As Carl Rowan, now USIA director, had urged in relation to the Freedom Riders, it was essential to the agency's civil rights message in this period that Whites were prepared to suffer alongside Blacks. If anything, however, the stakes were now higher. As James Forman put it, with rather more symmetry than Rowan: "There is no need to be apologetic about this particular matter. People laid down their lives. . . . The only people killed were not black; there were white people killed. The only people killed were not white people; there were black people killed."[91] The fact that there were White volunteers prepared to risk their lives was not something that the agency would state explicitly, but it was nevertheless an unspoken subtext to the photographs. The message for African audiences was that the White majority supported civil rights for African Americans and were prepared to share in the struggle to achieve equality.

The orientation program was intended to prepare volunteers for their work in Mississippi, including giving them "a full and accurate picture of the risks involved in their work."[92] They listened to talks from the organizers and civil rights workers from Mississippi, were taught about the history and geography of Mississippi, and role-played different scenarios that they might face in the field, from answering reporters' questions—"Are Negroes staying with white boys and girls?"—to dealing with the police—"If a police [sic] stopped you and asked you to get into his car, what would you do?"[93] The agency file contains only a handful of photographs and no significant documentation, so it is not possible to assess the full range of activities recorded or the assignment brief. There are no photographs documenting practices of nonviolent self-defense and the kind of self-possession such training was intended to instill, a theme that was well represented in the images of the program made for the organizers, as well as elsewhere in the work of Danny Lyon for SNCC, and that Berger claims is legible in the photograph of Walter Gadsden in Birmingham, Alabama.[94] Whether or not such images had been part of the complete USIA set is unclear. The photographs that remained in the file, however, speak to two themes: interracial interaction and leadership. Predictably perhaps, there are photographs of Black and White volunteers and organizers standing holding hands and singing freedom songs. One such contact print, however, has James Forman circled in blue ink, an indication that for the agency this was more

Fig. 65 "Jane Steidmann and Fred Miller sorting books." "Mississippi Orientation Program" (Photographer: Harlan Johnson), July 10, 1964. Photographs from Staff and Stringer Photographic Assignments Relating to US Political Events and Social, Cultural and Economic Life, 1964–1979, RG306, NARA. 306-N-65-1304.

about the individual than the collective. The file also includes a strikingly tender portrayal of shared political activism (fig. 65). The image shows two volunteers sitting amid piles of books they are tasked with sorting: Jane Steidemann, a young White woman from Missouri, who would work that summer in a Freedom School in Clarksdale, and Fred Miller, an African American from Mobile, Alabama.[95] The books lend an intellectual air to the exchanged glances between the two, yet at the same time, Miller's body language as he listens to his female colleague brings one back to the impact of racial dynamics debated at the outset of the project. It is evident that a photograph of this kind readily served the agency's international message of interracial solidarity and collaboration; the reality of violence exists only in the context, from which the images seem to float free. Yet, at home, the romantic overtones of the image would almost certainly have been more controversial, risking the very violence that it seems to deny.

The small set of images also speaks to the question of Black leadership, signaling that the agency may have begun to think about whether figures such as Bob Moses, James Forman, and Bayard Rustin should have a place in its output. All three feature in the photographs. Forman and Moses, especially, represented a different kind of Black leadership than USIA had hitherto featured, involved more in local organizing than seeking out the spotlight (figs. 66 and 67). In light of the agency's heavy use of Martin Luther King in the early 1960s, it is interesting to read the reflections of one Freedom Summer volunteer: "Bob Moses . . . presents a striking contrast to the Martin Luther King type which too often tends to be our image of the Negro leader. He is not concerned with oratory and bombast—rather his speech is quiet, slow, and thoughtful."[96] Rustin, on the other hand, was a controversial figure even within the movement. Despite his role in the March on Washington, he had not featured significantly in the agency's coverage compared with Martin Luther King and A. Philip Randolph. Interestingly, Moses would be the subject of a photo-essay in the first issue of *Topic* the following year, which included several photographs of him in Mississippi made by Danny Lyon during his time at SNCC, licensed to USIA through Black Star.[97] The piece also included photographs of Moses at the Democratic National Convention as part of an unsuccessful effort to unseat the Mississippi delegation elected on a racial franchise.[98]

There is a risk in trying to draw too many conclusions from a single photographic assignment, not least one that in many ways was an exception to the rule, but the intersection between USIA and the Mississippi Summer Project is nonetheless thought provoking. It suggests that for a brief moment photography provided a space of proximity, if not alignment, between a political movement on the ground seeking to challenge the racial structure of society and at least some of those whose task it was to picture that society for audiences overseas on behalf of the federal government. SNCC more than any other civil rights group understood the importance of photography. Like USIA,

Fig. 66 Robert Moses. "Mississippi Orientation Program" (Photographer: Harlan Johnson), July 10, 1964. Photographs from Staff and Stringer Photographic Assignments Relating to US Political Events and Social, Cultural and Economic Life, 1964–1979, RG306, NARA. 306-SSA-1-3455-4.

Fig. 67 James Forman. "Mississippi Orientation Program" (Photographer: Harlan Johnson), July 10, 1964. Photographs from Staff and Stringer Photographic Assignments Relating to US Political Events and Social, Cultural and Economic Life, 1964–1979, RG306, NARA. 306-SSA-1-3455-4.

they produced posters, pamphlets, even filmstrips, and distributed images to get their message across and raise funds, as well as, quite unlike USIA, using photography as a medium to document incidents of violence. Moreover, SNCC photographers drew inspiration from the FSA, in whose darkrooms USIA films were still developed, and Elizabeth Martinez, who headed up SNCC's New York office and was responsible for photographic exhibitions and publications, had previously worked both at the UN and for Edward Steichen.[99]

In this light, it is worth noting that in September 1964, just a few weeks after USIA dispatched a photographer to cover the Freedom Summer orientation program, a group

of SNCC activists left for a tour of Africa, among them James Forman, Bob Moses, and Julian Bond, the organization's communications director.[100] In Guinea, Bond was confronted with the images of African Americans that had been the mainstay of USIA output on civil rights and integration to date, displayed in the windows of USIS centers. It caused him dismay: "There were all these pictures of Negroes doing things, Negro judges, Negro policemen, and if you didn't know anything about America, like Africans would not, you would think these were really commonplace things. That's the worst kind of deceit."[101] Evidently, the agency's Freedom Summer photographs had yet to make their way to Conakry. And when Moses came across his profile in *Topic* on a visit to Africa the following year, he felt that he had been used, along with those who had died in Mississippi.[102] There were some, like Mackland, who hoped the agency could look beyond "symptomatic tokenism" to more meaningful coverage of US society, but ultimately the context within which they worked severely limited what was possible. Yet if the agency's output often tended toward "rub[bing] out the work of civil rights leaders . . . at the national and grassroots level," as Schwenk-Borrell argues in relation to film, the photographic archive nonetheless remains a place from which it possible to retrieve at least some of what was lost in production.[103]

———

As Freedom Summer volunteers headed south to Mississippi from Ohio, events in Washington would once more alter the context in which the agency's photographic program operated. On July 2, 1964, Johnson signed into law the Civil Rights Act. It would be followed a year later by the Voting Rights Act of 1965. This is not the place for a historical assessment of what was and was not achieved by these pieces of legislation; it is indisputable, however, that they became central to USIA's message on civil rights progress, eclipsing the handful of photographs of grassroots initiatives that had entered the agency's collection the previous year. In his weekly report to President Johnson at the end of June 1964, Carl Rowan outlined the worldwide campaign that would be "set in motion" the moment he signed the act. In addition to coverage on VOA and a television roundtable, photographs of Johnson signing the act were set to be "air-expressed abroad."[104] Just a few weeks later, Rowan was able to report the positive impact in Africa.[105] African reaction to the passage of the bill was described as "highly favorable." It found approval from many African leaders at the OAU summit in Cairo. Sékou Touré of Guinea interpreted the passage of the act as a "great victory" for African Americans. Gamal Abdel Nasser of Egypt, on his part, sought to align the development with the racial struggle on the continent—"We can complete the siege around South Africa and Rhodesia . . . one of the promising signs in this connection is the adoption of the civil rights bill in the US"—albeit the connection between the civil rights bill and "the advance of African liberation" received "sparse play" in

the African media. Rowan observed that African leaders would be keeping a "watch-ful eye" on events to see if the US lived up to the promise of the bill, but the positive response appeared to be a cause for satisfaction. He did point to one small blot on the horizon, however. Riots had broken out in Harlem that week after an African American boy had been shot and killed by a policeman. Early reports in the Nigerian press expressed dismay; a significant volume of coverage was expected to follow and could "set in motion a severe adverse reaction that will erode much of the benefit that we had hoped we would achieve with the civil right legislation." It was an early warning of the direction the narrative on race in the US would take over the next few years.

USIA followed the immediate coverage of the signing of the 1964 act with exten-sive output designed to consolidate the gains that accrued to the federal government as result and, importantly, to cement Johnson's identification with civil rights. Where the agency had continued to trade on the value of Kennedy's image in Africa in the wake of his assassination, there was now a concerted effort to realign the civil rights message with the new president. Earlier in the year Johnson and Rowan had agreed to make "Racial and Ethnic Progress" USIA's top media priority.[106] Over the next few years, the agency published heavily illustrated copies of Johnson's major speeches on civil rights, separately and in a collected volume entitled *The Road to Justice*, along with a number of highly produced pamphlets such as *For the Dignity of Man* and, later, *We Shall Overcome*.[107] On its publication, Jack Valenti, Special Assistant to the President, wrote to US Ambassador to the UN Arthur Goldberg and Assistant Secre-tary of State for African Affairs G. Mennen Williams, recommending they pass mul-tiple copies of *The Road to Justice* to African representatives at the UN and African ambassadors in Washington.[108] There were also initiatives in African field posts that sought to build on the material coming out of Washington. A report from Nairobi following Johnson's speech in March 1965, made in the wake of the violence against civil rights demonstrators in Selma, Alabama, described it as "a turning point in offi-cial Kenyan view toward President himself and to a certain extent toward US policy Africa" and indicated that the post would be "further exploiting" it locally through a poster and pamphlet in Swahili.[109] The text was illustrated with photographs of John-son giving speeches and in conversation with African American civil rights leaders—James Farmer, Martin Luther King, A. Philip Randolph, Whitney Young, and Roy Wilkins—interspersed with images of racial integration in schools, colleges, employ-ment, housing, and so on.[110] In short, it reasserted the agency's dominant visual rep-ertoire about integration established over the preceding years. The pamphlets appear to have had more creative license and included several images of the March on Wash-ington and the Selma to Montgomery March—though not the violence that accom-panied the first Selma march—but Johnson nevertheless remained central and the

visual message was one of significant progress. Visually and graphically the approach was more sophisticated, but the pamphlets nonetheless carry a sense of returning to the earlier, more abstract message of progress, now incorporating peaceful demonstration as part and parcel of the democratic process. The threat to the narrative of democratic progress posed by the violence that erupted in Birmingham in 1963 appeared to have been contained, even as it continued in Selma and elsewhere.

Occasional assignments that offered alternative perspectives on events do appear in the archive, but it is hard to determine where such photographs appeared, if indeed they ever did. For example, over a few days in March 1965, USIA staff photographer Jack Lartz made a series of photographs of demonstrations in response to the attack by state police on the civil rights march in Selma. On March 9, he photographed demonstrators picketing the White House with placards that read "Shame!" and "Bloody Sunday in Selma."[111] Intriguingly, the photographer appears to have experimented with the low-angle perspective on the demonstrators that would feature in one of the later iconic Selma photographs.[112] In the background of one of the photographs, however, one can see a camper van driving past carrying on its front the message "White America Awake," and on its rear, "Hitler Was Right! White Man Fight." A few days later, Lartz was back outside the White House, this time photographing a counterdemonstration by a handful of American Nazis wearing military-style outfits with swastika armbands and carrying placards with racist messages such as "Black Freedom Means Rape" (fig. 68).[113] The same day, Lartz also photographed a larger demonstration against the violence at Selma in Lafayette Park.[114] The last of the three may have fitted into the USIA narrative of peaceful protest, but it seems unlikely the agency would have distributed imagery of right-wing extremists to any of its field posts.

USIA continued to center its coverage of civil rights leadership on Martin Luther King, Roy Wilkins, and a handful of others. In 1964, for example, Roy Wilkins was the subject of an extended photo-essay that seemed to follow the earlier directive to humanize African Americans for the agency's African audiences.[115] In addition to being depicted as NAACP leader, Wilkins was shown relaxing at home with his wife in their New York apartment. The image projects a cultured middle-class identity: Wilkins with his wife in their library reading the newspaper. The caption describes him as "a man who mingles rebellion and reasonableness"—the ideal kind of man for USIA. After his profile in *Topic* in 1965, Bob Moses did not make any further appearances in agency output, and neither did James Forman. Having briefly included these grassroots civil rights leaders, the agency reverted to type and tended to use either images expressive of the charismatic leadership represented by King, or more conservative depictions of civil rights leaders in Washington looking every bit a part of the political mainstream. The archive contains numerous images of King and others meeting with the president,

Fig. 68 "American Nazis Picket the Pickets at White House" (Photographer: Jack Lartz), March 14, 1965. Photographs from Staff and Stringer Photographic Assignments Relating to US Political Events and Social, Cultural and Economic Life, 1964–1979, RG306, NARA. 306-SSA-9-4542.

some of which appeared in the post-1964 swathe of pamphlets. Where SNCC actively sought to present an image of "group-centered leadership . . . in which all stand, pray, and work side by side" as a self-conscious alternative to King's leadership of SCLC, the latter was more readily appropriated by USIA.[116] Cull suggests that following his criticisms of the war in Vietnam, as well as some of the disclosures from the FBI about his private life, the agency cooled somewhat on King.[117] Nonetheless, he continued to be the subject of photographic coverage, and in some senses the agency still turned to him as a bulwark against alternatives that were gaining ground in their appeal at home and abroad.

While Malcolm X was on his second visit to Africa of 1964, Mark Lewis, then assistant director for Africa, wrote to Carl Rowan to express his concern at the attention he was receiving. He had been introduced by the Kenyan Minister of Health as "the real leader of the civil rights movement." Lewis's recommended response was that the agency persuade King to make his own tour of the continent.[118] Just a week later, Lewis wrote to Thomas Sorensen about the impact Malcolm X was having in East Africa: the ambassador in Kenya was said to be "particularly disturbed" and his colleague in Guinea was asking for advice on "the most effective way to inoculate Sékou Touré against Malcolm X."[119] His request was for the agency to make a more concerted effort to counter his influence, including citing "derogatory remarks" he was alleged to have made after Kennedy's assassination.[120] In the margin of the archive copy of the letter to Rowan is a handwritten note on the announcement of King as the winner

Fig. 69 Yolanda and Dexter King. "Recognition Dinner Honoring Martin Luther King," March 15, 1965. The event took place at the Atlanta Dinkler Plaza Hotel on January 27, 1965. The file date indicates when the photographs entered the USIA collection. Photographs from Staff and Stringer Photographic Assignments Relating to US Political Events and Social, Cultural and Economic Life, 1964–1979, RG306, NARA. Reproduced courtesy of Black Star Publishing Co. 306-SSA-9-4545.

of the Nobel Peace Prize. It is no surprise that the agency saw value in promoting the award in its output. When a dinner was organized in recognition of King in Atlanta in early 1965, USIA commissioned coverage from Black Star.[121] The photographs of the dinner at the Atlanta Dinkler Plaza Hotel include a sensitively observed sequence of Yolanda King in the audience looking at her father through binoculars, which serves as a visual commentary on his remoteness and the costs to his family of his political commitment (fig. 69). The captions seem to reinforce the point: "Dr. King seemed, as always, rather unemotional—almost cold—perhaps somewhat physically drained as a result of his strenuous activities in Selma, Alabama's voter drive." But perhaps the most revealing comment might stand as a summary of USIA civil rights photography. Recording that the guests at the event were "approximately 50% white and 50% colored," the accompanying notes stated that among the selection were "several frames of the crowd and segments thereof—with emphasis on the pleasant mixture of Negro and white." It is no longer so hard to see where the confusion over the racialized representation of Washington and Lincoln in the Congo, with which I began the chapter, may have arisen. USIA paid a final tribute to King's contribution to its program after his assassination, producing a high-quality illustrated pamphlet (fig. 70).[122] Subtitled *Man of Peace*, it painted a portrait of the King of the agency's imagination and its dreams; no longer able to disrupt that narrative with sexual indiscretions or comments on Vietnam, he was presented as an orator, a politician, a preacher, a leader of nonviolent demonstration, and a family man.

———

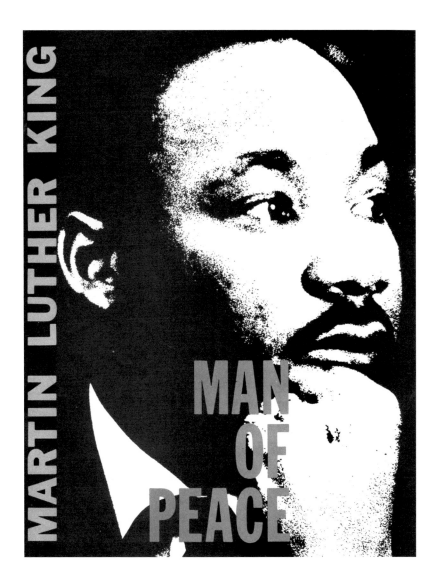

Fig. 70 *Martin Luther King: Man of Peace*, 1968. Leonard H. Marks Papers, Box 46, LBJ Library.

Having passed the Civil Rights Act (1964) and Voting Rights Act (1965), there was a sense for USIA that the civil rights story had reached some kind of conclusion. It now had a substantial volume of material it could offer field posts.[123] The eruption of violence in US cities in the latter part of the decade would require a different kind of response, one that did not lend itself to photography in the same way as had, for a brief moment, the civil rights movement. Besides, when it surveyed residents of Nairobi and Lagos in November 1964, the agency was pleasantly surprised to find that although the riots had marred news of the Civil Rights Act to some degree, "the total gain in favorable opinion was not erased."[124] When the agency collated press reaction to events in Selma the following March, they came to a similar conclusion. Rowan observed that despite the prominence in words and pictures of "the uglier scenes," reactions

were "far less adverse . . . than has been observed in previous racial incidents." He put this down principally to Johnson's "uncompromising stand," but he also felt that perhaps the agency had "played a significant role, not in trying to hide the ugly aspects of this struggle, but in explaining all its aspects, making sure the negative is presented in proper perspective."[125] Moreover, in gauging response to the recent disturbances in US cities, the agency was reassured to find that a substantial majority "opposed the use of violent methods by Negroes to gain equal rights," even if there was less opposition in countries such as Kenya that had experienced violent anti-colonial struggles.[126] The response to Black Power that this engendered was to attempt to defuse and deflate its representational resonance, to place the emphasis on "the moderation of the majority of black Americans . . . black American economic progress . . . growing black political influence in the mainstream."[127] In an issue of *Topic* summarizing 1966—"The Passionate Year"—in photographs and text, the term was presented as both divisive and confusing—it "generated more noise than change, more heat than light."[128] The Los Angeles neighborhood of Watts, which had been the scene of a violent uprising the previous year, appeared in the selection of photographs, but in the celebratory form of an anniversary parade, led by Sargent Shriver, director of Johnson's flagship "War on Poverty," waving at crowds from a car adorned with the words: "Sargent Shriver: The Man Who Has Done More for Urban Minorities than Any Other Man in this Country." It was time, some believed, to shift the emphasis away from race.

Although voices maintaining that a preoccupation with race in the agency's output was unwarranted had been present from the very beginning, from the mid-1960s it was increasingly clear that the argument was going their way. By late 1965, with Leonard Marks installed as the new USIA director and bringing in a new set of priorities, "Racial and Ethnic Progress" had been replaced at the head of the list by Johnson's vision for "The Great Society."[129] To further complicate matters, the agency was now centrally involved in "psychological operations" in Southeast Asia as part of the Joint United States Public Affairs Office. In the summer of 1963, in the wake of Kennedy's civil rights address, some at the agency had begun to think more openly about how they should respond to the crisis, allowing the language and imagery of struggle into its representation of race in US society, even momentarily contemplating the relationship between "race and revolution." Two years later it was clear that this space was rapidly closing. USIA had not completely balked at the equation between civil rights and African liberation in the early 1960s, even on occasion seeing some benefits to the comparison, but the parallels being drawn between Black Power and Vietnamese insurgency were utterly inimical to US information policy.[130] A report from 1966 noted that although unfavorable views of the racial situation in the US were widely held, this had "comparatively little effect on general opinion of the US," posing the

question: "Does the racial issue as a propaganda problem preoccupy us more than the facts warrant?"[131] The answer, the authors suggested, was "probably Yes. . . . It seems probable that we have crossed some sort of watershed in foreign judgments and perspectives on the racial issue in the US." The report drew a number of conclusions for the future direction of coverage. First, it stated not only that African American leadership and the civil rights movement should be given less attention but also that its role in bringing about change should be de-emphasized, lest the agency's output seem to "suggest that what has occurred or is occurring in the US is a successful War of People's Liberation." Moreover, progress should be presented within the "framework of normal American life, rather than within the civil rights movement"; coverage should describe "a pattern of acceptance," rather than "a separate social movement." Most directly, "the emphasis should be taken off 'struggle'"; other media could be left to "carry all the drama and the violence," and by contrast the agency "should avoid . . . the black-and-white treatment" in preference for "the low key, mulatto." A later policy note written in response to the civil unrest that spread across US cities in the summer of 1967 echoed these recommendations, directing posts to stress that "only a tiny minority" of African Americans had participated in these protests, and that the majority "utterly deplore such tactics."[132] At the same time, posts were "discouraged from reporting extreme views or descriptions of the situation as 'civil war' or 'revolution.'" The agency was reverting to its earlier approach of emphasizing a long-term narrative of steady progress, with an accent on programs initiated by Johnson's administration. Even claiming that the prospect of change had "stirred interest and hope among the underprivileged where previously there had been only passivity and despair"; "paradoxically," it was suggested, "the improvement in the Negroes' condition in recent years has contributed to the bringing about of violence." Such observations aligned with an effort to present the issue as one of poverty rather than race, the challenge of "social discrimination" following on the achievement of legal equality.[133] The agency's program for Africa reflected these changes. Where civil rights had been viewed just a few years earlier as a key feature of output for the continent, a policy note from October 1968 did not use the term or make any mention of race in the US, other than a single reference to the importance of representing government efforts to "assure equal rights" and to "improve the lot of disadvantaged Americans."[134] Ironically, the move away from coverage of civil rights and racial conflict in output to Africa reflected a maturing in the agency's engagement with the continent, less focused on presenting an image of the US to its imagined African audiences, and more attentive to economic and political developments on the ground, albeit still underpinned by racist assumptions.

———

I began this chapter with the story of an apocryphal image, an image in which Blackness and Whiteness, African and American, had become confused, and which, I suggested, might be understood as expressive of US anxiety about what was at stake in its engagement with Africa. I want to end by juxtaposing an alternative image, similarly present in the archive only in textual form. In early June 1963, Thomas Sorensen, deputy director of policy and planning, was sufficiently anxious at the prospect of another case of mistaken identity that he decided to undertake some advance planning for the eventuality. In a short memo, he notified Edward Murrow that he had tasked a member of agency staff to consider "what we might say or do if an African student becomes involved in a civil rights disturbance this summer."[135] His primary concern was expressed in visual terms: "Photographs of an Alabama Negro being hit by a White cop caused us great problems abroad; a photograph of a Nigerian student being manhandled could be disastrous." No such photograph ever appears to have been taken, but its imagined presence in the archive provides a striking illustration of the extent to which the agency sought to manage the relationship with Africa through photography. Yet, at the same time, it signifies an awareness that the medium always risked slipping out of reach. Perhaps, too, it acknowledged the fragility of the image of integrated America the agency had created, always at risk of being displaced by counter-images of solidarity between Africans and African Americans in their struggle against White supremacy and colonialism.

"Africans at the Wax Museum"

Photography and International Friendship

In September 1964, three African students studying at Howard University—Jonathan Ajeroh and Gilbert Ola Ogunfiditimi from Nigeria, and Jacob Quaye from Ghana—along with Lieutenant Colonel Belachew from Ethiopia were photographed visiting the wax museum in Washington.[1] In carefully staged photographs, the African visitors were inserted into several tableaux representing moments in the history of the US, or more specifically its founding as a nation: the signing of the Declaration of Independence, Betsy Ross making the first US flag, and George and Martha Washington receiving the Marquis de Lafayette at Mount Vernon. As an acknowledgment of African American scientific achievement, the visitors were also invited to engage with the waxwork of George Washington Carver, a prominent botanist and teacher at Booker T. Washington's Tuskegee Institute. The resulting images are rather curious, if not downright strange. Stranger still, however, is that this small photographic project was not the outcome of any personal or idiosyncratic pursuit, or mischievous behavior by these museum visitors, but a tightly scripted USIA assignment. The photographs were meticulously planned and executed, with advice offered by White House photographer Yoichi Okamoto. They were prepared for distribution across Africa through the network of USIS cultural and information centers and agency publications (fig. 71). For their African audiences, they were part of the agency's wider effort to foster the imagination of a new world of international relations after colonialism. In this light, the juxtaposition of moments in the founding of the US with citizens of newly independent African nations takes on an instructive quality, offering a historical analogy—the

A Talk With Martin Luther King

By Fletcher Martin

This story was written for the Chicago Sun-Times when Dr. King was only 29. He had begun to build a foundation of philosophical belief that would help him gain the respect of men over the world. Now at 35, Dr. King has won the Nobel Peace Prize. This coveted honor would seem to indicate that his country and the world recognize and applaud his true worth in the important field of human relations.

In the Reverend Martin Luther King Jr., of Montgomery, Alabama, the Negro American has the most dramatic leader since Booker T. Washington. In less than two years, the young Baptist preacher has risen from relative obscurity to become the leading spokesman for the aspirations of his people.

Martin Luther King is a rather short man, somewhat sensitive about his waistline — "I've put on five pounds in the last few weeks." In a room full of people, his presence is not especially worthy of notice. Then you hear him speak, and the words work a kind of magic:

TO BED HUNGRY

"I am concerned not only about milk and honey flowing in the streets of heaven, but about people on earth having to go to bed hungry; not only about the mansions of gold in heaven, but the hundreds of thousands forced to live in slums here on earth — slums that damn; social and economic conditions that condemn. Any religion that ignores the material well-being of the people is unrealistic, an opium."

You soon learn that he preaches in the Southern tradition of resounding rhetoric. He builds to his climax in a crescendo of impassioned words that overwhelm the listener with the depth of his convictions.

His friends say Martin King's convictions captured the imagination of his followers in Montgomery in such a way that some Southern Negroes attach religious significance to his leadership role.

UNHURT IN FALL

This view was best expressed before a shouting crowd in Montgomery at the height of the successful 1956 bus boycott by an elderly woman who knew King since childhood.

When Martin King was 6, he was playing on the second-floor hallway of his home in Atlanta, Georgia. As he leaned over the upstairs railing, he suddenly lost his footing and plunged head-first some 20 feet to the ground floor and then catapulted through an open cellar door to the basement.

The boy got up and walked away unhurt.

The woman at the church meeting, recalling the incident, determinedly ruled out mere luck for his not being killed. She said: "The Rev. King didn't come to any harm because the Lord was saving him for us. The Lord picked him long ago to do the job he's doing right now—leading us out of this wilderness of race prejudice."

MAN OF THE HOUR

At 29 Martin Luther King is the Negro's acknowledged Man of the Hour. Across the South — Nashville, Atlanta, Birmingham, Jacksonville, Dallas, Durham, St. Louis — Negro leaders march behind his banner. In areas where implementation of the U.S. Supreme Court's decision outlawing segregation in public schools has been stymied, his advice is sought on means of accelerating it. In hard core states where the high court's edict is defied, Negroes seek out Dr. King for words of wisdom and action

The minister is representative of young Negroes who are Southern-born but Northern-educated. For many of them the combination has meant a break with the views of their parents; for all of them it has meant an attack on some of the traditions of their communities. It was such an attack—on segregated bus seating — that brought Rev. Dr. King into prominence.

SIDE BY SIDE

Negroes and whites now ride side by side in Montgomery public buses. But the Alabama clergymen recalled that "most of the results of the boycott have been intangible. Most important, I think it has given Negroes of Montgomery a recognition of the powers of unity."

During the interview, the Baptist preacher told this reporter that many white people in the South favor ending segregation but they are fearful of ridicule from friends and even members of their families, who view race segregation as 'an ordained way of life.'

The Rev. Dr. King laughed as he told the story of one white parson who placed his argument against integration in the form of Aristotelian syllogism, reasoning: "Man is made in the image of God, as everybody knows. God, as everybody knows, is not a Negro; therefore, the Negro is not a man."

The Rev. King said: "Thank God, that is not the dominant opinion in the South. It is inevitable that the South — along with the rest of the nation — will move toward the conviction that race segregation is morally wrong. We must believe this because we are a moral people."

NON-VIOLENCE

The minister spoke of militant non-violence "as a possible strategy for the Negro in his fight for just treatment."

"The spiritual power that the Negro can emit to the world comes from love, understanding, goodwill and non-violence. It may be possible for the Negro, through adherence to nonviolence, to so challenge the nations of the world that they will seek an alternative to violence," the minister said.

From these struggles, the Rev. King said he sees a new Negro emerging. "Living under the condition of segregation many Negroes lost faith in themselves," he said. "Many came to feel that perhaps they were inferior. This is the ultimate tragedy of segregation. It not only harms one physically, but it injures one spiritually. It scars the soul and destroys the personality. It inflicts the segregator with a false sense of superiority, while leaving the segregated inflicted with a false sense of inferiority."

It is the Rev. Dr. Martin Luther King's goal in life to do everything humanly possible to keep this from ever happening to his people again

A MIGHTY WELCOME — Hundreds of persons were at the John F. Kennedy International Airport, New York City, to welcome the inaugural, flight of the Nigerian Airways from Lagos to New York. Included on the passenger list of the historic flight was a team of Nigerian dancers who came to the United States for the purpose of performing to mark the occasion.

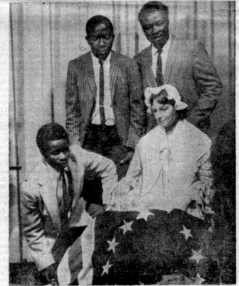

AT THE WAX MUSEUM—Three African students enrolled at Howard University, Washington, view a plastic figure depicting Mrs. Betsy Ross as she made the first American flag. The Wax Museum in the nation's capital is one of the favorite spots for visitors. The students are, from left, Gilbert Ogunfiditimi, of Western Nigeria; Jacob Quaye of Accra, Ghana; and Jonathan Ajeroh of Okigwi, Eastern Nigeria.

Fig. 71 "Three African students enrolled at Howard University, Washington, view a plastic figure depicting Mrs. Betsy Ross as she made the first American flag." From left: Gilbert Ola Ogunfiditimi, Jacob Quaye, Jonathan Ajeroh. Photograph by Joseph Pinto. *American Outlook* 12, no. 11, 1964. Master File Copies of Field Publications, 1951–1979, Box 295, RG306, NARA. [Declassified Authority: NND022120.]

immortalized American past and the embodied African present brought together in the images projects the promise of African futures contained in the American present. Although whether the African visitors in the photographs interpreted their performance in that way may be open to question—the playful manner in which Belachew offers tea to the wax figure of Martha Washington and attends to George Washington's jacket suggests a more irreverent interpretation. Absent from the picture, however, as regular US visitors to the museum would have noticed, was a more troublesome sign of African presence in the American past. In order to facilitate the photographic shoot in a way that suited the purposes of its commissioners, and was sensitive to its subjects, the museum had kindly agreed to "remove completely" the figure of a slave from the tableau of George Washington's porch at Mount Vernon. The word "completely" here signals a certain degree of anxiety, and the perceived need not simply to move the slave figure so as avoid its appearance in the photographs (a matter of representation) but to put it out of the sight of the visitors altogether, lest it offend (a matter of diplomatic etiquette).

In an earlier chapter, I discussed the photography shaped at USIA to engage the arrival of African politicians and diplomats in the US. But as the wax museum assignment demonstrates, the agency's photographic coverage extended beyond high-profile visitors to Washington and New York and embraced many less prominent Africans on cultural and educational visits. It is to these photographs I want to turn here. African students were the subject of numerous assignments and picture stories, a level of attention that was determined by several factors, among them the extent to which civil rights protest was seen to demand a visual response from USIA. It is no surprise that the agency's need to project positive narratives about integration and Black-White relations in the US would influence the ways in which it pictured African students. The anxiety around race that preoccupied the agency during this period inevitably shaped its output for the continent. Picture stories on African students in the US might be seen as just another way of talking about integration and civil rights to an international audience. But the significance of African students for USIA photography cannot be explained by this alone. After the elites leading newly independent nations on the continent, educated African youth were next on the list of priority targets for all aspects of the agency's Africa program, since it was "sophisticated youth," they reasoned, who were "most likely to be of influence in the future."[2]

Education was central to Eisenhower's view of Africa and its postcolonial future, aligned with an approach that had heavily paternalistic overtones.[3] Its importance only increased under the Kennedy administration, albeit from a different ideological standpoint. As James Meriwether points out, Kennedy had first recognized the political publicity value of student exchange programs during the 1960 election campaign. When

Tom Mboya of Kenya failed to convince the Department of State to provide support for East African students to take up scholarships in the US, Kennedy saw an opportunity to make "an oblique play for the black vote."[4] The Kennedy Foundation provided support for the East African student airlifts, thereby, as Meriwether puts it, "bolstering at little cost a weak record on civil rights with a strong stance on African issues."[5] Yet the presence of African students in the US had value beyond its perceived appeal to African American voters. For USIA, education provided an ideological bridgehead into Africa. As a report from 1961 observed, "African interest in American education provides an opening wedge for projecting other selected aspects of American life and culture" and it was through African students in the US that this opportunity could be exploited.[6] Under Edward Murrow's leadership, the agency appointed a youth and student affairs officer, and during his 1962 visit to Africa he even arranged for a contingent of Ghana Young Pioneers, Kwame Nkrumah's political youth movement, to tour several US cities, generating "substantial still photo coverage."[7] Although an unlikely target, given that the organization was "somewhat Marxist in concept," the agency noted optimistically that many of the Pioneers were pro-American and had participated enthusiastically in a recent US trade fair in Accra. More broadly, an analysis of the African press prepared for Kennedy in the early months of his administration included the recommendation that USIA should "devote considerably greater attention to Africans studying in or otherwise visiting the US" and "greatly expand" its coverage for African placement, "especially of students."[8]

The agency duly obliged, and from the early 1960s photographs and picture stories on African students became a central theme in USIA output. *American Outlook* ran a student supplement with a column on "African Students in the News" and regular photographic features, along with student-focused pull-out posters, as did *Perspectives Americaines*. It was 1965 before the agency finally launched its African magazine *Topic*, but it is clear that officers in the field saw an increasing need for high-quality print and visual products for a youth and student readership.[9] Despite the views sometimes expressed in Washington, field officers would have been well aware that the agency's images and publications had to compete with the sophisticated photographic and media cultures emerging in many urban centers on the continent, where there was widespread engagement with photography.[10] Although the archive offers very few insights into the responses of African readers of *Outlook* and *Perspectives Americaines*, any interpretation has to recognize the wider internationalized postcolonial public sphere in which they existed, and indeed played a part in constituting.

In part, the attention paid to students was driven by Cold War competition for influence among African youth, who were seen as receptive to communism and were the object of Soviet attention through comparable information and exchange programs.

While the agency might have taken some satisfaction from surveys suggesting that Africans "prefer to study in the United States rather than in the bloc," they nonetheless put considerable effort into countering influences perceived as unhelpful among those educated elsewhere, not least in Francophone countries.[11] In Chad, for example, students returning from study in France, where it was felt they were "subject to leftist and openly communist persuasion," were viewed as a key audience for the USIS field office in Fort Lamy.[12] Similarly, in Ivory Coast, field officers sought to counter the exposure of students to "coverage of practically every example of racial discrimination" in the French press.[13] Moreover, field officers recognized the need to present a positive vision of the future to young educated Africans. In Niger, the Country Plan for 1961 paid close attention to those "Young Turks" educated abroad who were dissatisfied with the current ruling elite, to whom they felt superior "by education and knowledge": "It is essential that we reach, know and attempt to carefully cultivate this group in the endeavor to convince them, too, that the application of moderation and democratic process will bring about both national development and their own personal advancement more surely than radical commitment to other ideologies."[14] Meanwhile, in Kenya, the publicity surrounding the student airlift generated "a constant stream of prospective students approaching USIS" for support.[15]

In contrast to the formal visits of significant figures, where diplomatic protocol dominated, there was a greater creative license for the agency's coverage of these less distinguished visitors. As the curious story at the wax museum attests, the coverage encompassed a wider range of activities and locations and expanded to include more informal interactions between Americans and their African guests, including in private domestic settings. The photographs that resulted might be understood as forms of visual promise and invitation. The temporal relation between the American past and African futures signified in the wax museum was accompanied by a spatial relation of images, people, and ideas as they flowed back and forth across the Atlantic through the mutually reinforcing circuits of exchange programs and USIA media distribution networks. As if to make this very point, when the photograph of the students standing beside the wax figure of Betsy Ross was reproduced in the November 1964 issue of *Outlook*, it was paired with an image of the inaugural Nigerian Airways flight from Lagos to New York.[16] A Nigerian dance group was pictured disembarking at John F. Kennedy airport, marking the occasion as simultaneously one of cultural exchange and entry into the modern world of international travel, or even modernity itself. (Both images sat beneath a piece about Martin Luther King following his award of the Nobel Peace Prize.) It is worth observing, too, that the photograph of a modern passenger airplane brings the agency's visual repertoire into relation with the much-discussed genre of West African studio photography, where jet aircraft were a popular addition to the painted backdrops

of modern cityscapes, alongside props such as radios and televisions.[17] USIA no less than African studio photographers sought to engage the popular imagination, even if its model of the postcolonial future was already more clearly circumscribed.

————

A photograph published in the October 1961 edition of *Perspectives Americaines* provides a symbolic point of entry into USIA's photographic coverage of those ordinary African citizens, or soon-to-be citizens, who arrived on its shores (fig. 72).[18] Captured from behind, a man and a young girl, quite possibly his daughter, stand together on the deck of the SS *Irpinia* gazing toward the Statue of Liberty as it comes into view. He is dressed in a smart Western-style suit, his African identity elegantly signaled by a close-fitting hat or kufi; she wears a bright white dress and a ribbon in her hair. He was one of 180 students arriving on the *Irpinia* from several African countries on extended scholarships. Pictured below were other passengers, African and French, shown engaged in a game of chess and joyfully dancing the Virginia reel. The image extended an invitation for postcolonial Africans to imagine their future and that of their children in American terms.

As US cultural and educational programs for Africa expanded during this period, often hand-in-glove with private philanthropic organizations, the photographic coverage quickly moved beyond the symbolic toward something akin to a menu of opportunities for aspirant African youth committed to national development. The output modeled the essential components of modernization, development, and statehood for its audiences on the continent. African students were shown studying science and engineering, construction, local and national government, the postal system, policing, and healthcare. Timothy Olu Farinre, an electrical engineering student at the University of Pennsylvania, for example, was the subject of an assignment for *Outlook* and *Perspectives Americaines*.[19] The request sheet makes clear that the photographs were intended to portray the technology element of the story—"in electrical engineering or other laboratory; close-up or medium close-up with lab equipment to right or left"—as well as the college context—"in dormitory room; reading or writing at desk; three-quarter or profile"—although the photographer chose instead to picture him relaxed, lying on the bed listening to a reel-to-reel tape. It also signified visually the aspirational quality of studying in the US—"outdoor pose, close-up, full-face, with sky background behind head . . . prominent architectural feature." Interestingly, the request provided technical advice, with all of the various poses accompanied by a reminder for a "light background behind head" and "plenty of light on face." Christopher Tolo from Kenya was the subject of a comparable assignment at a Los Angeles construction company while studying at Harbor College.[20] Posed on site, he was photographed consulting blueprints, watching concrete being poured, and conferring with his supervisor, who

DES ETUDIANTS AFRI-CAINS ARRIVENT AUX ETATS-UNIS

L'un des groupes les plus importants d'étudiants africains qui jusqu'à présent se sont rendus aux Etats-Unis, quelques 180 jeunes gens, arriva récemment par bateau à New York pour une période d'études de quatre ans dans les principales universités américaines.

Les étudiants profitent d'un programme étendu de bourses d'études, dans le cadre duquel quelques 300 étudiants de divers pays d'Afrique seront inscrits dans les universités américaines au cours de la présente année académique. Huit mois de planning et de sélection approfondis par des éducateurs africains et américains ont précédé l'arrivée des étudiants. Le projet est sous le patronage du Programme d'Etudes pour Africains des universités américaines auquel se sont joint tout récemment le United Negro College Fund et le Cooperative African Scholarship Program.

L'Institut Africain-Américain a la direction du projet. L'Institut est une organisation financée par des sources privées qui veut favoriser l'établissement de liens plus étroits entre les peuples d'Afrique et les Etats-Unis.

Presque 150 universités américaines collaborent à ce programme de bourses d'études qui accorde à chaque étudiant quatre années d'études, toutes dépenses défrayées, dans le domaine de leur choix. Les frais sont partagés : les universités qui font partie du programme, portent la charge de l'enseignement, le gouvernement américain paie les frais de subsistance, les gouvernements des pays d'où viennent les étudiants, prennent à leur charge les frais de voyage tandis que la Carnegie Corporation, elle aussi financée par des dons privés, et l'Institut Africain — Américain accordent des dons spéciaux pour l'administration du programme.

Ci-dessus, 2 passagers africains du SS Irpinia contemplent la Statue de la Liberté, symbole bien connu de la liberté américaine.

Ci-dessus, sur le SS Irpinia, un étudiant nigérien et un étudiant français, jouent aux échecs au cours de la traversée qui transporta 180 étudiants vers 4 années d'études aux Etats Unis.

Une des plus grands contingents d'étudiants à visiter les E.U. (plus de 180 sont partis sur le SS Irpinia pour faire 4 annes d'études boursières aux Etats Unis ; Ci-dessus un africain fait tourner sa partenaire française dans le Virginia Reel, une danse folklorique très populaire en Amérique.

Fig. 72 *Perspectives Americaines*, October 1961. Master File Copies of Field Publications, 1951–1979, Box 215, RG306, NARA. [Declassified Authority: NND022120.]

happened to be the owner of the company. In a similar mode, John Idakwa, also from Kenya, was shown in the language laboratory at Howard University, looking over the master control panel, and posed standing beside a large globe in conversation with Ernest Wilson, Director of Foreign Students, repeating a familiar motif.[21]

In addition to students on funded scholarships, coverage included many employees of newly independent states on short training programs. A visiting group of clerical staff from East African postal and telecommunications services were photographed on a tour of the US Post Office, being briefed on the IBM tabulator and in the criminal detection laboratory.[22] Four doctors from Ivory Coast were photographed meeting with the program director of the Office of International Health (fig. 73).[23] Here, the request sheet advised that the doctors would be escorted to a nearby consulting room "where they will observe a nurse giving a shot of some kind in the arm of a patient," although this particular setup seems to have eluded the photographer. Instead, they were shown looking at an "American sterilizer" with "cyclomatic controls." The instructions specified "an integrated picture" and asked "that the photographer please get left to right identification." Again, it is hard when viewing these photographs not to draw parallels with the contemporaneous genre of African studio photography, with domestic signifiers of modernity such as radios and telephones exchanged for sophisticated medical devices, postal sorting equipment, and language learning technologies. In this light, the agency's visual program might be seen as an effort to Africanize the image of these technologies and implant them within local state and governmental imaginaries through the circulation of photographs on the continent. That is not to say USIA neglected modern consumer items or private enterprise, however. In a predictably gendered assignment, visiting Congolese women were photographed entering a "Better Homes" store in Los Angeles where their American hosts introduced them to the latest in kitchen appliances.[24] At the time, the story would have been resonant of the 1959 "kitchen debate" in Moscow, between Nixon and Khrushchev, on the respective abilities of capitalism and communism to deliver modern consumer products and labor-saving devices for the home, replayed here for African audiences. A group of Nigerian entrepreneurs were the subject of an assignment on an outing to Prince George's Shopping Mall (a short distance from where the photographs are now archived) as part of a USAID-funded training program.[25] They were photographed viewing soft furnishings, the latest fashions, and abundant produce in the supermarket, where they discussed "the pricing and weighing of watermelon" and "the packaging of frozen french fries." The Nigerian PAO who had requested the story emphasized the "outstanding reputations" of these guests in Nigeria, and advised that coverage would be most useful "if it is given heaviest play at the time they are observing their US counterpart industries," which would also "make for more diversification"—racial, presumably.

Considerable attention was given to students of government and politics. Peter Echaria and Leonard Kibinge, both of whom would subsequently become important figures in Kenya's diplomatic service, were the focus of several assignments in the spring and summer of 1963.[26] The request came from USIS Nairobi, with the Africa Branch seeing feature story potential. The pair were photographed sitting in on a meeting of the House Foreign Affairs Committee, as well as on training placements in Hamden (Echaria) and Milford (Kibinge), Connecticut, where they were introduced to the operations of different facets of city government. Images record them viewing city records, observing the data

Fig. 73 "Ivory Coast Doctors visit International Health and PHS" (Photographer: Ollie Pfeiffer), May 18, 1964. Staff and Stringer Photographs, 1949–1969, RG306, NARA. 306-SS-48-3207.

processing and billing equipment in the finance department (fig. 74), and being shown the latest city fire engine. The special feature, entitled "Kenyans Prepare to Solve Problems in Diplomacy," focused on their time at the American University in Washington—a visual lesson in international cooperation and diplomacy. Pan-African unity was among the topics discussed. In the early classes, debates had "occasionally reached incendiary levels," the reader was told, but over time the students of many nationalities became "more accustomed to discussing even the most sensitive issues with calm detachment," underscoring the lesson the picture story was intended to convey. Apparently, the highlight was a television debate sponsored by the Association for Higher Education, "because of the national dress of its 'cast,' and their lively, knowledgeable rapport with their instructor." The text also noted that Echaria and Kibinge would be spending ten days at the UN, connecting this story to the wider context of internationalism that often framed USIA output for Africa.

Another favorite of agency coverage was police training. An assignment from August 1963 documented police officers from Tunisia, Niger, Central African Republic, and Gabon attending a training course on "Police Operations and Criminal Investigations" at an academy in Washington.[27] Their participation was sponsored by the Office of Public Safety (OPS). Like all such picture stories, it presented a positive narrative of Africans as the beneficiaries of this development program for audiences in

Fig. 74 "In the IBM data processing division of the Department of Finance, Leonard Kibinge is shown has [sic] taxes are assessed and collected and how the city pay roll is prepared. Left to right are Jay M. Etlinger, Milford Director of Finance, Mrs. Anita Croteau, IBM operator and Mr. Kibinge." "Kibinge of Kenya trainee in town government" (Photographer: Al Mathewson), August 1, 1963. Staff and Stringer Photographs, 1949–1969, RG306, NARA. 306-SS-22-1090.

their home countries, and for those in other African countries who might aspire to take up similar opportunities in the future. The photographs show the African officers being introduced to the academy's "Basic Principles of Learning" and instructed in fingerprint identification. In an amusingly reflexive image, four of the students surround the instructor, Mr. Fleming, for a lesson "in the operation of still cameras for use in criminal investigations" (fig. 75). The following month, the same agency staff photographer, Joseph Pinto, was back at the academy to photograph participants from the United Arab Republic (Egypt), where again an important aspect of the experience deemed worth recording was an introduction to the "latest in camera equipment."[28] Several years later another staff photographer returned to photograph Mohamed Hashi Jama, a Somali police inspector who happened to be the main youth and sports contact for USIS Addis Ababa.[29] In a letter to Jim Pope of the agency's Africa Branch, the USIS Regional Youth Officer pointed out that Jama was influential for their program and he would therefore "appreciate some thought being given to photographic coverage of his activities in classroom and in the physical training hour. This, I tell you, could be useful for Somalia press and USIS exhibit." In a gesture toward local sensitivities, the request sheet indicated that "persons concerned should be told that pix are for release by USIS to the press in Africa." Notwithstanding the positive and lighthearted sense of camaraderie and engaged learning that the photographs from these assignments convey, however, one should note that the OPS was involved in building less transparent alliances. One of its purposes was to train and equip local police forces in Africa, Latin America, and Southeast Asia to fight against communist subversion, and it worked closely with the CIA, serving as a source of recruits for counterinsurgency operations.[30]

Fig. 75 "African Policemen and Others attend Police Academy"
(Photographer: Joseph Pinto), August 14, 1963. Staff and Stringer
Photographs, 1949–1969, RG306, NARA. 306-SS-23-1135.

At the same time as providing visual confirmation of the valuable education and training these visitors received, photographers were directed to portray their African subjects in human terms. Providing a human touch to the assignment on the construction student, for example, the owner's young son joined him and Tolo for one of the photographs. Similarly, Echaria and Kibinge were photographed relaxing in the company of their hosts, chatting informally and sharing a meal (fig. 76); they were accommodated in the homes of several residents during their stay. And the Nigerian entrepreneurs were pictured "intrigu[ing] and enchant[ing]" children they met at the mall. In an apparently fortuitous connection, given US satellite installations in Nigeria, one of the girls with whom they were photographed happened to be wearing an

Fig. 76 "Kibinge of Kenya trainee in town government" (Photographer: Al Mathewson), August 1, 1963. Staff and Stringer Photographs, 1949–1969, RG306, NARA. 306-SS-22-1090.

"I'm a little astronaut" T-shirt. The imperative to provide a rounded picture of African visitors' experiences placed particular emphasis on relationships with their American hosts. A picture story on a young Ghanaian student, Emmanuel Boye, who was working at Bell Telephone Laboratories appears at first sight as a visual narrative expressive of US leadership in satellite technologies and the participation of Boye as a junior partner in this scientific endeavor.[31] Boye is pictured gazing with admiration at the replica of the Telstar satellite displayed at Bell Labs (fig. 77).[32] Yet, as important to the narrative is the relationship between Boye and older White male figures with whom he was photographed. The text cites his "pride in working with engineers and scientists" at Bell and in particular Mr. Lambeth Montfort whom he praised for his supervision. The text pointedly notes he conveyed this "during a long distance telephone conversation," presumably back to Ghana. But supervision was not the only reason for Boye's gratitude; the reader was told that Montfort had "loaned him a bicycle to go to and from work and also to have a means of transportation on weekends." Boye is pictured standing beside the bicycle along with Montfort outside the home where he was staying, visually establishing this paternalistic relationship (fig. 78). In fact, the bicycle features in two of the seven photographs selected for printing, signifying its attraction as metaphor for mobility as well as the contrast it provided to the sophisticated communication technologies that Boye was engaged in studying. It signifies a certain modesty and diligence in relation to the invitation of modernity, ostensibly attributed to Boye but by extension projected as an appropriate attitude on the part of African nations.

African exchange students were frequently pictured with their American colleagues in both formal and informal settings. An assignment on George Kalu, an economics major from Nigeria at the University of Wisconsin, provides a sense of the range of

Fig. 77 "Emmanuel Boye of Ghana at Bell Telephone Laboratories"
(Photographer: not identified), July 10, 1963. Staff and Stringer Photographs,
1949–1969, RG306, NARA. 306-SS-18-958-1.

activities the agency wished to illustrate.[33] The request sheet detailed several settings
and asked for multiple shots of each:

(a) If possible in room or chamber where student senate meets, preferably
with one or two other members of Senate or student government;

(b) Outdoor scene on campus showing lake, or skaters or other winter activ-
ities—Kalu close-up in foreground right or left;

(c) In his dormitory room or in dormitory lounge with one or two fellow
students (if African, need identification, class, major subject, home town
and country).

Fig. 78 "Boye with Lambeth R. Montfort, Morristown, Transmission systems engineer at Bell Labs, who loaned Boye the bicycle." "Emmanuel Boye of Ghana at Bell Telephone Laboratories" (Photographer: not identified), July 10, 1963. Staff and Stringer Photographs, 1949–1969, RG306, NARA. 306-SS-18-958-4.

 (d) In dining hall, cafeteria or lunchroom.

 (e) In Student Union lobby or bookshop.

 (f) On steps of student Union or other campus buildings.

More or less formally stated, this reflects the standard repertoire for this type of exchange student assignment, along with the aforementioned attention to composition and lighting: "Caution: Please use care to ensure that in all pictures Kalu's head is against light, uncluttered background, but with plenty of light on face." The assignment was undertaken by campus photographer Duane Hopp, whose careful staging and lighting give the images an almost theatrical or filmic quality. In one image, Kalu is pictured on

Fig. 79 "George Kalu, a graduate of King's College, Lagos, Nigeria, pauses during a stroll over the snow-covered University of Wisconsin campus at Madison to chat with Gary Lutz, Milwaukee, left, and Anita Sharpe, Beverly Hills, Calif., center." "Nigerian student George K. I. Kalu at University of Wisconsin" (Photographer: Duane Hopp), February 5, 1963. Staff and Stringer Photographs, 1949–1969, RG306, NARA. 306-SS-9-121-C.

campus in front of Bascom Hall with fellow American students Gary Lutz and Anita Sharpe (fig. 79). A statue of Abraham Lincoln looms meaningfully in the background, although the somewhat odd angle of the shot lends the image a rather more enigmatic air than was likely intended. In another, he is shown with classmates chatting casually in his dormitory room and on a break at the student union cafeteria, where he treats them to coffee and doughnuts. Whatever else they signify, the images of eating together can be read as visual refutations of the lunch-counter segregation that had become a focus of civil rights protests across the US. In perhaps the strangest image of the set, Kalu is shown with fellow student Janet Holloway viewing a display of modernist sculpture in the university gallery (fig. 80). She towers over him as he squats down to touch a globe-like sculpture; they look at each other and smile. Since in the image they gaze only at each other, the comment in the caption that they found "much to

Fig. 80 "An American student and a student from Africa find much to smile
about in the current exhibit of sculpture in the Main Gallery of the Wisconsin
Union at the University of Wisconsin in Madison. Standing is Janet Holloway
of Madison; kneeling at right is George Kalu, Lagos, Nigeria." "Nigerian
student George K. I. Kalu at University of Wisconsin" (Photographer: Duane
Hopp), February 5, 1963. Staff and Stringer Photographs, 1949–1969, RG306,
NARA. 306-SS-9-121-F.

smile about in the current exhibit" takes on lightly romantic overtones, except for the
fact that the interracial dimension would have been anything other than light outside
of this imagined world of international harmony. Images from this assignment were
used in student-focused posters and the agency's African publications, and copies were
sent directly to USIS Lagos.

Not all of the assignments on African students pictured education settings directly.
In a less frivolous version of the wax museum assignment, a group of Nigerian and
Ugandan visitors were photographed at the US National Archives viewing the Decla-
ration of Independence and the Constitution of the United States (fig. 81), and outside
on the steps of the building—"one of the Washington shrines visited by many Afri-
cans"—where the agency was "more interested in getting the beauty and magnitude

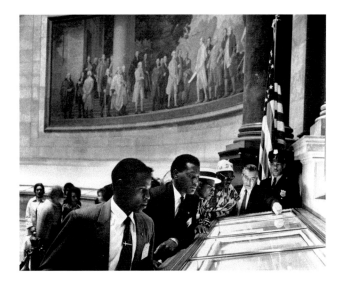

Fig. 81 "Africans visit the National Archives" (Photographer: Joseph Pinto), May 6, 1964. Staff and Stringer Photographs, 1949–1969, RG306, NARA. 306-N-65-1253.

of the building than in close ups of the Africans."[34] They were also pictured with the Director of Exhibits and Publications showing them the original document of the nuclear test ban treaty that Kennedy had signed the previous year, neatly illustrating the US commitment to peace. The agency had a very clear idea of the images that were required, providing the photographer with examples taken from the *New York Times* and the instruction to produce "something as near that as possible." Significantly, both images were required to include Africans and Americans together. They may have been disappointed with the result however, as the request sheet refers to the Africans being "in robes," whereas a majority of the group chose to arrive wearing suit and tie.

Other assignments in this vein sought to portray being in the US as simply a pleasurable cultural experience. One such example followed a group of female students from Guinea on a tour of the sights of Washington on a snowy January day in 1963.[35] The students, from Conakry, Labé, and Forecariah, were coming to the end of a six-month course at the American Language Institute at Georgetown University. The request sheet indicates the planning of this as a photographic outing, with the students organized in groups of three for different tours, with schedules and transportation provided by USIA. "In case of bad weather," it was noted, "dates will be postponed." In the event, although it was "a bitterly cold day," the city was bathed in bright sunlight. The instructions asked that the students be pictured in "typical Washington settings," and obligingly the photographs show them in front of key landmarks including the Capitol Building and the Jefferson Memorial, frequently with US flags flying in the background, inserting the African visitors once again into an American narrative of nation and democracy (fig. 82). Nevertheless, the scripting of the photographic assignment does not entirely determine its possible interpretations. Compared to the more

controlled assignment at the National Archives, there is a sense of playfulness to the way in which the African students have been photographed amid the snow-covered Washington cityscape. One almost gets the sense that photographer and students were treating the outing as something of a fashion shoot, a perception reinforced by the marking up of the file envelope with the title "GUINEA GIRLS" in red chinagraph, capitalized and underlined. Again, the photographs were for use in USIA's African publications in addition to direct distribution to USIS Conakry: a message to the people of Guinea on how well the US was treating their young citizens, and an effort to buttress the improved relations Kennedy had established with Sékou Touré since coming to office. It is possible that the story was framed in more general terms as a tour of Washington because of sensitivities arising from the use of USIA visual material in Guinea. An assignment to document Guinea Youth Day, attended by many Guinean students studying in the US, carried the following note: "USIS Conakry is extremely limited in its possibilities for placement. Photos of Guineans in an American environment are one of the few things they can use."[36] This serves as a reminder that the agency did not always have a free hand in what it distributed on the continent, often having to work within political constraints, as well as being sensitive to local cultural preferences and expectations.

In many respects, the agency's photographic output on African students amounted to a visual prospectus setting out the benefits of a US education, a point reinforced by the production of a pamphlet—*Exchange Students in the USA*—which drew on the material available through the individual assignments and consolidated the agency's key themes.[37] As the pamphlet text put it, a US college degree was not only "a passport to personal status and prosperity" but also "a precious asset in national development." The pamphlet carried the apocryphal-sounding story of young man from Nyasaland who walked four thousand miles to get a US college education, another example of a more basic form of mobility offered as a somewhat patronizing metaphor for an African attitude to the promise of American modernity.

While, inevitably, the majority of the photographs and picture stories emphasized US leadership in the fields of science and technology and the virtues of its capitalist democratic model, there were attempts to represent the future as a more collaborative endeavor, in which Americans had as much to learn from their African colleagues as they had to teach. Many of the photographs picture African students working together with their American colleagues; others show them talking to high school groups about African history, including a beautifully caught image of Boniface Offokaja describing Nigeria to an attentive group of students at Verona High School, New Jersey (fig. 83), and in one case a beneficiary of the Kenyan airlifts appears to give Foreign Service Institute students a lesson in geography.[38] The archive also includes numerous assignments

Fig. 82 "Ghana [*sic*] students tour Washington" (Photographer: Joseph
Pinto), January 29, 1963. Staff and Stringer Photographs, 1949–1969, RG306,
NARA. 306-SS-8-96.

on Operation Crossroads Africa, a nongovernmental organization that sent American
volunteer students to Africa and brought Africans to the US for training programs, in
which participants were shown collaborating on an equal basis.

In June 1962, *Outlook* ran a double-page feature on African lecturers teaching at
US universities, whose presence, the piece suggests, "signifies the growth of a healthy
cultural exchange" and "helps to satisfy the growing demand for more information
about a continent with an extensive history and a promising future."[39] They shared
the feature with editors at *Ebony* in an effort to encourage them to publish something
similar.[40] One of the African lecturers featured in the story was Eduardo Mondlane,
pictured advising a graduate student in his office at Syracuse University and described

American Outlook

VOL. 3 NUMBER 4 MAY, 1957

The Tribune Forum: Youth Finds a Way

Nigeria and Ghana Represented At U.S. Newspaper's 11th Conference

—— See Center Spread ——

The New York Herald Tribune Youth Forum gave Nigeria's Boniface Offokaja and 32 other delegates from as many countries an opportunity to learn more about America and to teach Americans more about their own nations. Here Boniface describes Nigeria for students at Verona High School in New Jersey. Delegates had some exciting—and unexpected—experiences during their three-month stay. For an account of the American visit of Boniface and Ghana's delegate, Amelia Addae, turn to Page 6.

Fig. 83 Boniface Offokaja describing Nigeria to students at Verona High School, New Jersey. *American Outlook* 3, no. 4, May 1957. Master File Copies of Field Publications, 1951–1979, Box 89, RG306, NARA. [Declassified Authority: NND022120.]

as a "superb teacher." Mondlane was soon to return to Southern Africa to become cofounder and president of the *Frente de Libertação de Moçambique* (Frelimo), making this a footnote to the photographic history of the liberation movement in Mozambique, and providing an additional layer of meaning to at least some of the publication's African readers.[41] One might even speculate that this subtext was intentional given that the feature coincided with the high point of the Kennedy administration's support for those opposed to Portuguese colonialism, and that Robert Kennedy had recently met with Mondlane. That said, in the broader sweep of USIA coverage, its contribution to the message of reciprocity, mutual understanding, and even friendship was likely more important.

————

At first glance, it might appear that the coverage of these international visitors to the US was rather routine work for the photographers concerned, the images somewhat mundane or even dull. Yet that would be to miss the genuine novelty of the genre of international relations and friendship photography the agency was beginning to elaborate. Striking confirmation of a lack of familiarity among photographers can be found in the fact that USIA felt it necessary to codify the genre visually for their instruction. Reliant as it often was on local freelancers and college campus photographers for coverage of visitors in locations around the country, the agency saw a need for something more encompassing than the individual image request to guide them. In the early 1960s, they produced a four-page pamphlet on *How to Photograph Foreign Visitors for the US Information Agency*, giving visual instructions on the "Dos and Don'ts" of this task (fig. 84).[42] A selection of photographs highlights both positive and negative attributes. The instructions range from the thematic to the technical, but the picturing of relations between Americans and their foreign guests is given greatest prominence. Thematic suggestions, for example, emphasize the importance of showing "the purpose of the visitor's trip," illustrated by a city planning student posed working on a map; the careful selection of backgrounds, in this case the Jefferson Memorial, to "help our readers abroad share the visitor's experience"; and the need to show visitors "gaining knowledge of America" in order that they have "reliable information for friends at home." The relational emphasis was conveyed through photographs of American and foreign students and tutors working closely together in the laboratory, classroom, or work setting, where it was suggested they might be pictured "solving a problem of mutual interest." Conversely, photographers were advised not to make images of visitors working alone or in national groups without Americans in the picture. Most importantly, the photographs should communicate "a sense of kinship between the foreign visitor and his American friends." Several of the visual examples illustrate the significance of mutuality and reciprocity. "If you are assigned to photograph a prominent American," one

caption exhorts, "try to show that he attaches considerable importance to his meeting with the foreign visitor"; another encourages photographers to illustrate American students "gaining knowledge of foreign cultures and customs from visitors." And a photograph of an Ethiopian student talking to secondary school students in New York visualizes the idea that "the visitor contributes something to us." Photographers were also invited to picture visitors in domestic settings, "sharing in American home life, indicating that they see us as we really are." It is "with the help of such pictures," the pamphlet suggests, that the agency will be able "to develop among its readers abroad a sense of kinship with Americans" in the service of the broader goal of "communicat[ing] to people of other countries the knowledge that Americans share their aspirations for a better life," thereby building support for US foreign policy.

In a gesture toward the wider media context in which USIA photographs were circulating, the pamphlet pointed to the need for counterimages to those that impugned the US record on racial equality: "USIA needs pictures that will help correct misconceptions abroad about racial discrimination in American schools and colleges." In its negative examples, the pamphlet paid most attention to technical and compositional concerns, asking photographers to avoid the "static 'line up'" or "clichés such as the stiffly-posed handshake, or the pointed finger," and to "watch out for black backgrounds," "distracting objects in the foreground," and people in the frame looking in different directions. Even here, however, the reminder that "dark-skinned persons require careful exposure" discloses a certain racial consciousness permeating the agency's image-making; "fully exposed bounce flash usually will give good results," the instructions advise.

If the "how to" pamphlet began to codify a repertoire of desirable images of foreign visitors in the US, it placed a central emphasis on picturing the "kinship" or friendship between Americans and the citizens of other nations. In the case of African students, the images were, in most cases, interracial, thereby serving a dual-purpose. Themes of picturing friendship and welcoming African students into American society and family life were themselves often the central thematic focus of individual assignments and picture stories. The brief for coverage of Algerian students visiting Washington, for example, after setting out a range of scenarios in which the subjects might be pictured, made the following general request: "In all of the above, the photographs should give the impression that these students have made many American friends and that they spend much of their free time in the company of these friends."[43] Quite possibly the emphasis on friendship and mutuality reflects the enduring influence of postwar photographic humanism on USIA photography as much as policy considerations. Nevertheless, the attention given to choreographing scenes of interracial interaction in order to photograph them was indicative of the agency's growing preoccupation with

How To Photograph
FOREIGN VISITORS
For The U.S. Information Agency

Select the backgrounds carefully—they help our readers abroad share the visitor's experience.

It is important to imply in your pictures a sense of kinship between the foreign visitor and his American friends, as in this fine example. In many American schools today, students from all over the world are learning from one another

Fig. 84 *How to Photograph Foreign Visitors for the U.S. Information Agency.* Master File Copies of Pamphlets and Leaflets, 1953–1984, Box 11, RG306, NARA. [Declassified Authority: NND30995.]

Fig. 85 "African students at Friends World College" (Photographer:
Raimondo Borea), August 9, 1963. Staff and Stringer Photographs, 1949–
1969, RG306, NARA. © The Estate of Raimondo Borea, courtesy Gartenberg
Media Enterprises. 306-SS-23-1114.

the micropolitics of "racial etiquette."[44] Photographs of positive interactions between
Black Africans and White Americans were highly valued. USIA commissioned a pho-
tographer to document African students at an experimental educational initiative by
the Friends World College Committee in Long Island for a planned center-page spread
in *Outlook*.[45] The curriculum included topics such as disarmament, colonialism, and
world education, but the emphasis of the photographic coverage was on the infor-
mal interactions between participants. Among the photographs selected for printing
was one of an interracial couple holding hands as they wade in the shallow end of a
swimming pool, an image with a very particular resonance in relation to desegregation
struggles (fig. 85).[46] The agency also published an *Outlook* poster on Americans sharing
their homes and schools with African students. To underscore the visual humanism
of the photographs, Auxilia Sagwette from the Central African Republic reflected on
her experience of the three months in the US: "One always hears that human beings
are the same all over the world, now I believe it."

In a number of cases, the depth and intimacy of relations between Africans and (typ-
ically White) Americans was given extended photo-essay treatment. One particularly

striking example recorded the stay of a group of students from the Central African Republic with host families in East Grand Forks, Minnesota.[47] The coverage appears to have been prepared as the basis for a magazine-style picture story, entitled "Bangui Students Visit American Homes." The five male students shown in the photographs were on a forty-five-day visit to the US, arranged by Experiment in International Living, a charity that supported a worldwide program of cross-cultural learning and exchange.[48] For three weeks of the trip, the students were staying in East Grand Forks, located in the Great Plains, with a population at the time of about thirty-five thousand, and which the text describes as "a marketing center for wheat, sugar beets, and potatoes." This part of the trip was sponsored by the Mendenhall Presbyterian Church, which facilitated the students' accommodation as "guests in the homes of various church members" and provided them with "a first-hand look at American life," as the picture story text put it.

The photographs provide a charmingly intimate portrait of African/American, Black/White interaction, illustrating the acceptance of the African guests into the White American Christian family. Henry Baya was photographed with the family of Reverend Richard Thompson saying grace before an evening meal, Jean-Marie M'Bioka was pictured sharing a meal with the Dix family, and Antoine Koya Zounda was shown participating in an evening of hymn singing with the McCleary family. The familiar theme of modern technology is featured, here set in a familial context. Ali Nestor Mamadou is pictured on the Geddes family farm bringing in a huge John Deere diesel tractor at the end of the day, an image intended to resonate with ideas of agricultural development for its audience in the Central African Republic. And there is wonderful photograph in which Mrs. Geddes "demonstrates her upright vacuum cleaner" to her African guest in the family's modern-furnished living room (fig. 86). Youth identities and pursuits are presented as a plane of shared interests irrespective of race or nationality. In a series of intimate portrayals, the African visitors and White male counterparts in their host families can be seen in the bedroom consulting a magazine together, spending the evening eating popcorn and watching television, and engaged in a game of chess (fig. 87). One fascinating image captures an African visitor with a White youth of a similar age seated astride a small motorcycle (fig. 88). The playful intimacy of the scene and the implied commonality in teenage attitudes between African and American youth visualize the idea of friendship across national and racial boundaries. Despite the vastly different contexts, the sharply dressed African youth, the motorcycle, and the use of flash bear a formal similarity to the energetic, modernist photographic imagery being produced by the likes of Malick Sidibé in West Africa during this period. At the same time, it provides a contrast to the more earnest picturing of the Ghanaian student and his pedal cycle discussed earlier. Finally, there are a couple of photographs that signify connections to the wider world. In one image, the White

Fig. 86 "Mrs. Donald Geddes demonstrates her upright vacuum cleaner for Ali Nestor Mamadou." "African students with American host families at East Grand Forks, Minnesota" (Photographer: Bud Nagle), September 24, 1964. Photographs from Staff and Stringer Photographic Assignments Relating to US Political Events and Social, Cultural and Economic Life, 1964–1979, RG306, NARA. 306-SSA-4-3725-3.

Fig. 87 "African students with American host families at East Grand Forks, Minnesota" (Photographer: Bud Nagle), September 24, 1964. Photographs from Staff and Stringer Photographic Assignments Relating to US Political Events and Social, Cultural and Economic Life, 1964–1979, RG306, NARA. 306-SSA-4-3725-No.30.

parents stand with their African guest consulting an atlas, a familiar trope in stories of this kind. In another, the male head of the household appears to guide his guest's reading of a local newspaper, *The Fargo Forum*. Intentionally or not, the front-page headline is visible in the photograph—"Malaysia Riots Flare as War Threat Grows"— an indication of the risks attendant on the failure of ethnic, racial, and national relations, and a stark contrast to the world imagined in the picture story.

Several printed sets of the photographs were distributed to USIS offices in Accra, Bangui, and Leopoldville, and further sets were sent to the USIS Cultural Center on Rue du Dragon in Paris, most likely intended to reach young people from the Central African Republic studying in France. The depth and intimacy of the photographic record and the presence of Africans in the photographs served to authenticate and give substance to the claim that the US was a sincere friend of Africa. More widely, they can be understood as counternarratives to contemporaneous imagery of civil rights abuses and racial injustice in the US—visual refutations of racial intolerance.[49]

Fig. 88 "African students with American host families at East Grand Forks, Minnesota" (Photographer: Bud Nagle), September 24, 1964. Photographs from Staff and Stringer Photographic Assignments Relating to US Political Events and Social, Cultural and Economic Life, 1964–1979, RG306, NARA. 306-SSA-4-3725-No.3.

African students in the US remained a significant strand of USIA output for the continent through the decade. As the coverage continued to picture visitors in educational and training settings, so too the agency continued to elaborate international friendship and kinship as a dimension of US-Africa relations. Africans were pictured relaxing, playing, and eating with their American colleagues, sharing the home lives of their hosts, and participating in national celebrations such as Thanksgiving. Following its launch in 1965, African visitors were regularly featured in *Topic*. An archetypal example from the late 1960s is a photo-essay entitled "Sioux City Welcomes the World."⁵⁰ The narrative relates that in 1962 the city had taken a "plunge into open-armed diplomacy" by deciding "to invite visitors as a morale-builder for the city" and "giving our children a look at the world." Teachers, journalists, labor leaders, and government officials were matched with host families and welcomed into the "real" life of the city, "with infectious enthusiasm, informality—and surprises." In this case, in

fact, USIA had repurposed for its African audiences a story first published in *Life*.[51] The original photo-essay had covered a wider range of nationalities, which the agency had narrowed to photographs of Africans and supplemented with its own version of the accompanying text. The opening photograph captures a moment of humor between Jean Bonin of Togo and his local interpreter (fig. 89), with other images depicting visitors at a folk session in the home of one of the hosts, and at stockyards where they share "cattle-fattening, slaughtering techniques." Gabriel Mwaluko from Tanzania is pictured delighting a group of children with tales of lions in East Africa, and Henry Kinalwa from Uganda is shown "skewer[ing] a sausage with Peggy Hodge" at a student picnic. In Sioux City, USIA had discovered a microcosm of the imagined world that the agency had created through photography.[52]

For USIA, as many of these assignments illustrate, the medium of photography had an almost inherent connection to ideas of international friendship and mutual understanding between nations, a connection formed in the immediate postwar years in concert with international organizations such as UNESCO. In this respect, it is interesting to see the agency promoting the idea of international friendship photography as a practice among those who were its typical subjects. In a piece from 1965, the agency featured a photo-competition to find the pictures that best illustrated "international friendship and cooperation" at US universities, sponsored by the People to People Program founded by Eisenhower a decade earlier.[53] Profiling the winning entries, which included images of a multinational cricket team in action, a classroom discussion between American students and a visiting Soviet economist, representing "the free exchange of ideas," and a moment of exchange between a foreign student and her host family, the piece notes their "valuable contributions to the cause of international understanding." Although no Africans were represented on this occasion, it was this dimension of the medium that the agency was self-consciously bringing to bear as it pictured visitors from Africa and then dispatched the photographs to be viewed by audiences on the continent.

I want to close this section with an example of cultural exchange that appears relatively infrequently in the agency's photographic collection. In August 1964, USIA commissioned a local photographer to document the visit of Christian Lattier of Ivory Coast to the Tewa pueblos of San Ildefonso, Santa Clara, and Tesuque in New Mexico.[54] The photographs of cultural exchange that dominate the USIA collection are those picturing Africans together with White Americans. In the context of civil rights, a few assignments show Africans with African Americans, but as noted earlier this in itself often represented a source of anxiety for the agency. It is unusual, however, to find examples of Africans pictured with Native Americans, nor did Native Americans feature to any great extent in the agency's efforts to present the US as an integrated

SIOUX CITY
WELCOMES THE WORLD

Photos by Lee Balterman, LIFE Magazine.

Jean Bomin of Togo and his U.S. interpreter William Carney (below) are laughing because they have been roused from bed at an improbable hour (6:45 a.m.) for breakfast in one of the world's most improbable tourist meccas — Sioux City, Iowa. Up until eight years ago, Sioux City's fame as an international crossroads ranked next to nowhere. It was a slow-moving river town of some 85,000 people who lived and worked on the vast, flat, self sufficient mid-continental prairie, where the talk was mostly of corn, weather and local politics and where "important" people from the outside world rarely trickled in.

Today the trickle has grown, if not to a flood, at least to a steady stream. Over 400 foreign visitors stop off at Sioux City each year — and they are not simply tourists but labor leaders, teachers, journalists and government officials like Bomin, Director of Togo Electric Power Development, whose trips are sponsored by all sorts of organizations from the U.S. State Department to Washington's African-American Institute. Sioux City's plunge into open-armed diplomacy was taken in 1962, when local business leaders decided to invite visitors as a morale-builder for the city and "a way *(Continued)*

5

Fig. 89 Jean F. Bonin of Togo with his interpreter William Carney, Sioux City, Iowa, May 1967. "Sioux City Welcomes the World," *Topic* 26, 1968. Issues of "Topic" Magazine, 1965–1994, RG306, NARA. Photograph by Lee Balterman. Reproduced courtesy of the LIFE Picture Collection / Shutterstock.

Fig. 90 "Mr. C. Lattier, Ivory Coast visits Pueblo Village" (Photographer: not identified), August 25, 1964. Photographs from Staff and Stringer Photographic Assignments Relating to US Political Events and Social, Cultural and Economic Life, 1964–1979, RG306, NARA. 306-SSA-2-3620.

society. Aside from this assignment, the only other example I have encountered in the archive is of Margaret Kenyatta in Disneyland's Indian Village. On his visit, Lattier was photographed with Isabel Padilla, the latter demonstrating the making of pottery for which the region is well known, as well as visiting pueblos, exploring the Puye cliffs, and seated on the steps of what is described in the caption as a ceremonial room in San Ildefonso. At the base of the cliffs, he was posed in a portrait with Cleto Tafoya wearing indigenous dress, including an elaborate headdress (fig. 90). The file contains no contextual information beyond short captions, so it is hard to understand what motivated the story or how Lattier came to be in New Mexico. His background may allow

room for some conjecture, however. Lattier was a prominent postcolonial modernist sculptor. He was educated in France and returned to Ivory Coast after independence to teach at the École Nationale des Beaux-Arts in Abidjan. According to Nzewi, his works carry "the ideological imprints of Négritude and pan-Africanism."[55] It is entirely possible that the assignment represents nothing more than a superficial form of cultural tourism staged by the agency to illustrate a neatly contained aspect of American cultural heritage for its African audiences. Yet perhaps it also captures a moment of more genuine exchange, in which this West African sculptor sought to deepen his knowledge of artistic forms by connecting with a people with whom he found himself in sympathy through a shared experience of colonialism.

———

In spite of the centrality of African students to the USIA Africa program and the multiple photographs and picture stories distributed by the agency it is remarkably difficult to find anything beyond official narratives of mutuality and friendship. The agency's photographic encounters were typically brief, one-dimensional, and scripted in advance. There are moments when the photographer appears to have captured genuine exchange or engagement between African visitors and their American hosts, but for the most part these appear in the collection only to the extent that they fitted a predefined narrative. There is very little that offers any insight into how the subjects felt about their involvement in the agency's photographic activities, or indeed how they might have wished to shape the visual record on their own terms. Did any of these visitors bring their own cameras, one wonders, and if so how did they document their time in the US?[56] One exception that only serves to reinforce the rule is a picture story entitled "I Was a Foreign Student in the US."[57] The photographer was Priya Ramrakha, an established Kenyan Indian photojournalist who had begun his career documenting opposition to colonial rule, including the Mau Mau insurgency.[58] Ramrakha traveled to the US in 1960 to study at the Art Center College in Los Angeles. It is not clear when he crossed paths with USIA or who proposed the picture story; the result, however, is rather bland. The sequence was presented in the manner of an illustrated guide for overseas students adjusting to study in the US, as might have been prepared by an office for foreign students. Each image illustrated a facet of student life—"friendship," "new experiences," "money," "communication," "isolation," "prejudice"—with extended captions elaborating advice for the new student. Readers were advised to avoid mixing only with other foreign students, to try new foods, to understand that it takes time to build deep friendships with American students despite the ostensible warmth of their initial greetings, and to contribute to the American community. They were counselled to be generous toward their American colleagues when they ask "naive questions"—"the average American college student knows even less about the

foreign student's country than the visitor knows about the United States"—and to "help educate prejudiced Americans" rather than to withdraw. The photographs contrast markedly with Ramrakha's personal and professional images of the period, which have recently become available.[59] While in the US, Ramrakha photographed a civil rights rally attended by Martin Luther King, Nation of Islam protests in New York, Malcolm X and Miriam Makeba in exile, as well as informal scenes of international student life, including a touchingly intimate image of an interracial couple sharing a cigarette that one suspects would have overstepped the bounds normally observed by USIA photographers.

Yet, despite the general picture, among the letters and documents one does occasionally catch a glimpse of the negotiations, or in some cases unease, that accompanied the photographic attention USIA paid to its overseas guests. These do not amount to much in the way of evidence, but they do occasionally disrupt the otherwise smooth surface of the image the agency sought to present. The file for one assignment, for example, demonstrates that the agency was quite prepared to erase aspects of their subjects' identities to suit a more harmonious narrative. The assignment was focused on a group of African students at Dickinson College in Pennsylvania whose enthusiasm for soccer had encouraged the college to reintroduce the sport to its curriculum.[60] The piece was published as a photo-essay in the *Outlook* student supplement, emphasizing how the African students' knowledge of the game made them central to college teams and a source of guidance for their American teammates.[61] Among those featured in the story was Artur Lambo from Mozambique, pictured coaching his colleagues. When it came to the textual information accompanying the story, while the agency was keen to acknowledge that the students were active in the Foreign Student Forum and that they were hoping to raise funds to send two students to Africa in cooperation with Operation Crossroads, they felt it necessary to edit Lambo's biography. Reference to his status as a political refugee was crossed out with part of the longer description of his background scored twice through so as to render it illegible. This it seems was an aspect of his identity that complicated the message of an otherwise upbeat story. Conversely, the archive file for another assignment provides a rare moment when the voice of the subject becomes audible. Kighoma Malima from Tanganyika was the subject of an assignment while studying at Dartmouth College; the photographs fit the standard student repertoire showing him in various settings studying and socializing with his American colleagues.[62] It is the only example I have come across that provides evidence of a student explicitly seeking to shape how he was represented. In a letter to USIA, the director of the college news service conveyed the following request: "Kighoma asked me if we could insert some additional information about his work with the Tanganyikan African National Union. It was this that occupied his time between

secondary school and beginning his college studies. I have enclosed a suggested insert to go with the story if this seems all right with you." In the light of the previous example, it seems likely that the agency would have chosen not to emphasize Malima's political work, although I have not been able to track down any published use of the photographs.

On other occasions, the archive carries traces of disquiet about the purposes the photographs served, or indeed the very experience of being in the US. A planned assignment to photograph Wilson Abutiate of Ghana and Zemedu Worku of Ethiopia at the Center for Cultural and Technical Interchange between East and West in Hawai'i was dropped because Worku was "touchy regarding propaganda aspects."[63] And it appears that one of the Ghana Young Pioneers became violent in his Chicago hotel during their tour. This was put down to a prior history of mental illness, and the young Ghanaian was hospitalized, but of course one might wonder what triggered the episode.[64] It is self-evident that Africans arriving from recently decolonized countries were not naive about the racism they might face in the US; nevertheless, it is a subject rarely broached in any of the documentation that accompanied these photographic assignments. Furthermore, it seems that the students were directed not to raise the issue. A journalistic piece reflecting on the Kenyan airlifts fifty years on notes that the "students had been warned not to say anything about racial segregation in the US or about British colonial rule in Kenya" at the risk of losing their scholarship or harming the opportunity for other Africans to study in the US.[65] Though as one airlift student who had chosen to study in Little Rock pointed out, "there really is not much difference between Little Rock and Kenya," and experience of the former may offer good preparation for contending with colonial racism on return to the latter, a statement that would have been anathema to USIA.[66]

One might ask whether anything can be discerned of the subjects' perspectives from the photographs themselves. Many of these African visitors would have encountered and participated in the sophisticated photographic cultures taking shape on the continent before traveling to the US. Performing for the camera was unlikely to be something new, and of course photography is a medium characterized by contingency and ambiguity. Despite the agency's highly scripted and choreographed approach to image-making, moments of openness remained. The photographic session with which this chapter opened may provide one such example (fig. 91). Although there is no evidence to support the interpretation beyond the photographs, I wonder if the posture Lieutenant Belachew adopted toward the wax figures of George and Martha Washington was not in fact a parody of racial deference, an indication that he understood the representational game in which he was being asked to perform a role and chose to subvert it, reinserting the troubling history of racial injustice that his hosts had sought

Fig. 91 Lieutenant Colonel Belachew interacts with the wax tableau of George and Martha Washington receiving the Marquis de Lafayette at Mount Vernon. "Africans visit Wax Museum" (Photographer: Joseph Pinto), September 22, 1964. Photographs from Staff and Stringer Photographic Assignments Relating to US Political Events and Social, Cultural and Economic Life, 1964–1979, RG306, NARA. 306-SSA-4-3720.

to remove from the picture; or, if that is going too far, then at the very least a sign that he knew there was something slightly absurd about the whole routine.

―――――

As the examples discussed in this chapter illustrate, USIA photography was dedicated to portraying a world of international friendship and mutual interest between peoples of different nations and races. Yet there was a darker side to the agency's competition for the hearts and minds of African students. While the agency devoted considerable resources to the creation of a harmonious picture of Africans studying in the US, it was not averse to distributing negative propaganda in relation to their colleagues studying in the Eastern bloc. I want to close with two examples that throw into sharp relief the agency's dominant approach. The relative absence of visual material in this type of output is striking. Where USIA produced a surfeit of positive visualizations of Africans in the US, it remained extremely wary of identifying itself with negative imagery in any context, a reflection perhaps of the predominantly humanist formation of its approach to photography, and an echo of its earlier injunction not to picture incidents of racial injustice or violence. There was also a preference for this material to remain unattributed, thereby keeping the agency's hands clean. Rather than creating its own propaganda, the agency's deployed its resources and distribution networks to amplify criticisms coming from Africans themselves.[67]

As the number of African students in the US had expanded rapidly from the late 1950s, so too had the Soviet Union opened the doors of its colleges and universities. In naming the People's Friendship University in Moscow for the murdered Patrice Lumumba it signaled the importance accorded to educational support for the continent. When members of an early cohort of African students to travel to Moscow openly criticized their hosts, the US jumped at the opportunity and it was clear that a propaganda battle had been joined. An "open letter" from three African students—Andrew Richard Amar from Uganda, Theophilus U. Chukwuemeka Okonkwo from Nigeria, and Michel Ayih from Togo—to all African governments, presented at a press conference in Frankfurt in September 1960, made a series of criticisms of the treatment of African students in the Soviet Union. In concert with the Department of State and the CIA, USIA swung into action to ensure copies of the letter in English, French, and Spanish made their way rapidly around the globe. A memorandum from that October indicates that all field posts were sent a directive "urging unattributed placement" with specific reference to the text being "surfaced" in Nigeria and Togo, and although the CIA had not been able to find "suitable attribution" to enable it to mail the letter to Africans at the UN, some copies had made their way into the hands of French-speaking delegates.[68] The letter created something of an international media storm at the time of its release, but for USIA it evidently had a longer term value. Two years later, a neatly produced, though still unattributed, pamphlet reproducing the letter was printed by the RSC in Beirut, and three thousand copies were shipped to USIS Pretoria.[69] The pamphlet contained only the text of the letter, which it was stated "requires no additional comment"; it is nonetheless still interesting from a photographic perspective. In the letter, Okonkwo recounts his anger at the manipulation of a photograph of him for propaganda purposes by the Soviet authorities. Photographed in a boxing pose by a Russian student while working out in a Moscow gym, Okonkwo's photograph was subsequently reproduced by Soviet authorities in a graphic composition against a background outline of the continent with broken chains, from which he is struggling free, sketched in on his arms, and "a white man with a whip falling back in terror."[70] Besides its message about the poor treatment of Africans in the Soviet Union, the pamphlet thereby marked a difference between US and Soviet approaches to the photographic image, one that would have confirmed the agency's conviction in the moral authority of its own approach versus communist manipulation.

The following year, in the wake of incidents involving African students in Bulgaria, a USIS field office once more sought to make capital out of troubles in the Eastern bloc. In response to racial discrimination, poor treatment, and inadequate facilities, the students had formed an All-African Students' Union. The subsequent banning of the organization by the Bulgarian authorities led to protests on the streets of Sofia;

Fig. 92 *African Students Behind the Iron Curtain*, April 1963. Master File Copies of Field Publications, 1951–1979, Box 242, RG306, NARA. [Declassified Authority: NND022120.]

AFRICAN STUDENTS BEHIND THE IRON CURTAIN

the clashes turned violent, leading to the arrest of several students and many more deciding to leave the country. Within a few weeks of the incidents gaining international press coverage, USIS Salisbury had issued a pamphlet with a print run of three thousand copies, under the title *African Students Behind the Iron Curtain* (fig. 92).[71] Its stated purpose was "to bring a wider audience awareness of the treatment of African students in Soviet bloc countries," in a context where local press coverage was "sketchy." The fact that the pamphlet was initiated by USIS Salisbury with copies distributed to offices across East and Southern Africa—Lusaka, Blantyre, Dar es Salaam, Pretoria, and Nairobi—suggests the particular importance accorded anti-communist propaganda in Southern Africa, where independence was yet to be achieved and liberation movements looked increasingly to the Soviet Union and China for political and military support. The pamphlet carried on its cover an image of three African students,

returning home bloodied and bandaged after what the caption describes as a fight at a restaurant sparked when one of them danced with a Bulgarian girl. No source is given for the photograph, and it was clearly not an image made specifically for agency use. There is no doubt, however, that when audiences on the continent encountered this image of Africans in the Eastern bloc they were expected to call to mind a very different picture of their experiences in the US, one that the agency had gone to great lengths to create.[72]

"Don't Touch Those Windows"

United States Information
Service Exhibits in Africa

In early January 1966, the USIS center in Ouagadougou, Upper Volta sent a brief situation report by telegram to USIA Washington.[1] A raft of new austerity measures announced by President Maurice Yaméogo in late December had precipitated a general strike, further adding to popular unrest fueled by a failing economy, corruption, and rigged elections. Yaméogo in turn declared a state of emergency, sending troops on to the streets of the capital. The move backfired, and rather than suppressing the demonstrations, the military decided instead to overthrow Yaméogo in a coup d'état.[2] Amid the chaos of street protests and the ousting of the president, field officers were pleased to confirm that despite crowds attacking the nearby National Assembly building and causing damage to shops in the vicinity, USIS facilities remained untouched. The report drew specific attention to the display windows, implying that they conferred a protective quality on the center: "Many of the thousands who passed cultural center during day [*sic*] shouted 'Don't touch those windows. They are our friends.'" Moreover, following the sacking of nearby buildings, "several revolutionaries stationed selves [*sic*] in front of center as protectors." In a demonstration of their willingness to adapt their visual message rapidly to local circumstances, USIS officers agreed in return to remove from the window display the photograph of Yaméogo, who had been viewed by the Johnson administration as a firm friend of the US, along with those of his wife and Minister of National Planning Edouard Yaméogo. As confirmation that all was well, the telegram signed off with the laconic message: "Center open today."

This was not the first time that the value of USIS window displays had been invoked in this way. In mid-1964, US-Burundi relations were at a particularly low point following accusations of mistreatment in the US of participants in a USAID program as well as the wider context of US involvement in neighboring Democratic Republic of the Congo. During this period USIS Bujumbura featured an exhibition in its windows of photographs of Mwambutsa IV during his recent visit to the US, where he had met President Johnson, along with images from the New York World's Fair, which had hosted a Burundi dance group. The display proved popular, with crowds still gathering to view the photographs some two months after they first went up. More importantly, however, field officers concluded its popularity served to offset the tensions, speculating that it may have explained "why no bricks were thrown at our windows during the most difficult period in US-Burundi relations. No one here would throw a brick at a photo of the Mwami."[3] Such protection was never guaranteed of course, and one can only assume that the choice of photographs later that year was rather less popular or carried less symbolic value for the local population. In November 1964, USIS Bujumbura reported that slogans such as "A bas les Américaines" and "Assassins des Nègres" had been painted on the windows of the center and the floor tiles in front of the US Embassy.[4] Either way, however, it is apparent that USIS windows were an important focus of attention for those on both sides of the glass, giving the US a presence in African urban centers.

The central focus of this book has been on the production of USIA photographs and picture stories, primarily in the US, set in the context of the domestic and international political agendas that shaped the visual program for Africa. In this concluding chapter, I want to turn to the presence of this photography in the public media spaces of late colonial and postcolonial African cities. USIA often construed newly independent Africa as a media vacuum, into which it needed to step to counter Soviet and Chinese media operations. But that was to overstate and oversimplify the case. Although varying across different countries and regions and shaped by the legacy of colonial policies, there is ample evidence that the agency was not entering an open field, not least in its own archives. To take just one example, a 1965 report from USIS Libreville noted the "penetration" of French material into the villages of Eastern Gabon; "even the smallest," it observed, "have French news photos and posters on walls or in the village chief's hut."[5] USIA media operations in Africa shared the territory with a range of other actors, including colonial and former colonial powers, newly formed African governments and political parties, competing Soviet and Chinese operations, and local print and visual cultures. The Africa program existed as part of a media ecology peculiar to each setting in which it operated. USIA may have been an important media player in many countries, but its photographs and media products nevertheless

had to attract and hold the attention of local audiences if they were to be effective. In some cases, USIA output appears to have offered little more than a staid version of vibrant local print and visual cultures, and most newly independent nations had their own information agencies and official photographers, often inherited more or less intact from colonial administrations.[6] USIS field officers were well aware of the media contexts in which they operated; after all that was their job, and they regularly shared agency materials with government information services and local and national press. The free content was no doubt appreciated by hard-pressed editors and journalists. Nonetheless, it was evident the agency was competing in a contested and rapidly evolving postcolonial visual public sphere. It is the manner in which it did so that is of principal interest here.

————

Before turning to USIS operations on the ground, I want to briefly consider how one might conceptualize the African publics they addressed. In her study of *Bingo*, an illustrated magazine published in Dakar for French-speaking West African readers, Jennifer Bajorek proposes the idea of a "transcolonial visual public."[7] *Bingo* offers a particularly apt example here as not only did it commence publication the same year USIA was founded (1953) and span the colonial and independence periods, but its founding editor, Ousmane Socé Diop, was himself featured in a USIA photograph, on a visit to the US in 1966. Drawing on Stephanie Newell's notion of a "transcolonial reading public" composed of readers who shared a common identity as subjects of the British Empire, Bajorek suggests that its visual equivalent can be observed in the patterns of photographic exchange between subjects of the French Empire evidenced on the pages of the magazine. Marking a distinction from the claims made for the importance of print culture to forms of national imagining, the point is that this public was "constituted" through the bonds of empire.[8] Moreover, Bajorek argues that in the independence period, as the magazine's contents "became more clearly aligned with consumer marketing . . . and more conspicuously pan-African," one can observe the transformation of a transcolonial visual public into an emergent decolonial one.[9] The visual presence of figures such as Malcolm X and Muhammad Ali on its pages is taken as indicative of changing political possibilities and identifications. The significance of this to an understanding of USIA's Africa program is twofold. First, it is reasonable to assume that the readership of *Bingo* overlapped with the consumers of USIA output to a more than trivial extent. It is likely the agency reached out to the editors with offers of content, not least the "profiles of black athletes, movie stars, and entertainers" that were a staple of agency output.[10] Second, the agency's photography was just as oriented to forms of political relation and belonging beyond local or national boundaries. That is not, however, to suggest there were no differences. There were,

and they were significant. To take Bajorek's example, the concerted effort made by the agency to displace the appeal of Malcolm X on the continent with the preferred image of Martin Luther King as a moderate civil rights leader, discussed in an earlier chapter, is just one indication.

In the 1950s, as the agency began to develop its operations on the continent, there was undoubtedly a degree of continuity and shared understanding with the soon-to-be former colonial powers, the British perhaps more than the French. Newell's characterization of the British officials' perspective following the Second World War would have been recognizable to their US counterparts as they began to expand their presence on the continent. They understood, she argues, that their remaining colonial subjects in Africa "must be *persuaded*: first, not to embrace Soviet forms of anti-imperialism; second, to accept a staged . . . political script towards eventual independence along Western democratic lines; and third, to become the type of consumers to sustain global free trade" (emphasis in original).[11] Persuasion was something the British had come to realize was a necessity. For USIA, however, it was always more of an innate attitude. But there was a more fundamental difference. As Gerits argues, while for the former colonial powers Africans were conceived primarily as "socio-economic subjects," the US viewed them as "potential political agents."[12] This is evident in the agency's targeting of its output at educated elites and students, current and future leaders, and visualized in numerous photographs and picture stories. It marks an important difference from the idea of a transcolonial visual public, where the colonial context precluded any recognition of the capacity for political action. By 1960, as many African nations achieved independence, the agency's approach to its audiences shifted away from the imperial notion of "modernising 'minds' through education" and "opened the door to socio-economic schemes of modernisation that targeted societies rather than mentalities."[13] The central idea was to "demonstrate" the benefits of modernization to their African audiences, a purpose for which photography was particularly well suited.[14] USIA conceived, and pictured, its African audiences as postcolonial national subjects entering a pan-African and world community of nations. This was visualized in the transformation of early photo-essays on the UN through the widespread coverage of African leaders in the US, for consumption not only in their home countries but also more widely across the continent. Yet if it is possible to discern an emergent decolonial visual public on the pages of *Bingo*, then one must acknowledge that USIA, and US hegemony more widely, cultivated a parallel and overlapping neocolonial visual public, the basis of which lay in the movement of images and people back and forth across the Atlantic Ocean and within Africa through its network of cultural centers. The agency's demonstration of the benefits of modernization placed the US at its center, as the source of knowledge, technology, consumer products, development aid, and

models of democratic governance. African futures were to be shaped in the image of American modernity. If USIA photography recognized Africans as postcolonial subjects of independent nations, it also visualized corresponding forms of political relation and belonging within a bipolar world, interpellating its consumers as neocolonial subjects in the context of US global leadership.[15] That is not necessarily to accuse the agency of acting in bad faith. For USIS officers these two things were not so far apart; as Gerits observes, "they assumed that societal norms and cultural identities would converge."[16] Not everyone shared that view.

The ways in which agency output was conceptualized by staff in Washington and field officers in Africa does not, of course, determine how it was actually received by its intended audiences. It is evident from reports sent back to Washington that USIS field officers sought to understand audience preferences and to tailor the material they presented to local concerns. In Mogadiscio (Mogadishu), for example, they tried to ensure that around a third of the photo-displays were focused on joint Somali-American affairs, and a majority of field posts did likewise.[17] The agency's market-research-style polling, however, tended to deal in generalities and focused primarily on the idea of "effectiveness," meaning the degree to which recipients agreed or not with specific agency messages. There is very little detailed archival material on the viewing practices of African audiences or first-hand evidence that illuminates how they interpreted the material they encountered. African voices, where they appear, are inevitably filtered through a US perspective, and often packaged within a message tailored for the consumption of agency heads. It would be a mistake to believe they were passive recipients, however. As Newell makes clear for colonial West Africa, despite what the British may have imagined, they were dealing with sophisticated media consumers not so easily susceptible to persuasion.[18] Furthermore, as Bajorek points out, illustrated magazines such as *Bingo* found, and to some extent depended on, a public already engaged with photography as "a means of visual, social, and political experimentation."[19] Accounting for the extant visual and media literacies encountered by agency operations in Africa poses a set of empirical questions that would need to be asked of each specific setting; nevertheless, as a basic working assumption it seems sensible to concede that to a greater or lesser degree the situation that obtained in West Africa held true elsewhere too. This is not to posit an idealized notion of resistance to US propaganda, simply to acknowledge that the multiplicity of media messages created a space within which it was possible for individuals to exercise agency, to reject or accept certain ideas, and to imagine different futures for themselves and their compatriots. Despite the legacy of colonial attitudes toward local viewing practices that lingered on in some USIA reports, this was something many agency field officers recognized.

———

USIS Information Centers, some placed in prominent central locations and the majority with display windows facing onto city streets, were at the heart of agency efforts to engage African publics (fig. 93). They were hubs of activity. In addition to window displays, they hosted small exhibitions, some shipped from overseas and others produced locally, organized events and showed films, provided access to foreign publications in libraries and reading rooms, and delivered language education. Many had photographic darkrooms to facilitate print and exhibition production, and the documentation of center activities. They also managed the distribution of agency pamphlets and publications to personal contacts and target audiences. In the mid-1960s, Michael Codel, an AP foreign correspondent based in Leopoldville, described the print shop in the rear of the USIS building as "always roaring away," noting that "we can't buy milk in Leopoldville, but the French edition of the Warren Report is abundant," though he bemoaned the lack of output in local African languages. He admitted that the distribution was a bit of a "mystery" to him: "Maybe it's because as soon as something is laid down here it is snapped up, but I see very few of these publications around town."[20] USIS offices also engaged in the unattributed or covert distribution of material, planned both locally and centrally. Codel's report referred to the positive reception of an "explanation of voting procedures" ahead of the election, as well as posters produced for the Congolese Army to be used in "the psychological warfare phase of anti-rebel activities," and USIS offices across English-speaking African countries were asked to submit distribution lists for an unattributed "anti-Chicom" pamphlet coordinated by Washington.[21] But it is the public visual presence of the US in Africa with which I am primarily concerned here.

The cultural center model was not unique to USIA. It appealed to former colonial powers and had an influence on African governments, not least in Ghana where the role of cultural activities became the subject of misunderstanding and conflict between the agency and the Ghanaian government.[22] The location and appearance of the centers was equally a matter of effective operation and prestige. On assuming the post of Assistant Director for Africa in July 1964, Mark Lewis ordered a review and instigated a series of relocations and renovations. The rapid expansion of agency operations on the continent in the early years of the decade, he noted, meant that many were opened "on a crash basis" and were simply the best that was available at the time within budget. Demurring from his predecessor's preference for locations "giving an African or local appearance" and with one eye on the competition—"the British, French, Germans and others are putting up beautiful information and cultural centers around Africa"—Lewis expressed his own view that "without looking luxurious, they should look American." He was "appalled" at the state of the center in Monrovia, and despite progress, major problems remained at Dar es Salaam, Lagos,

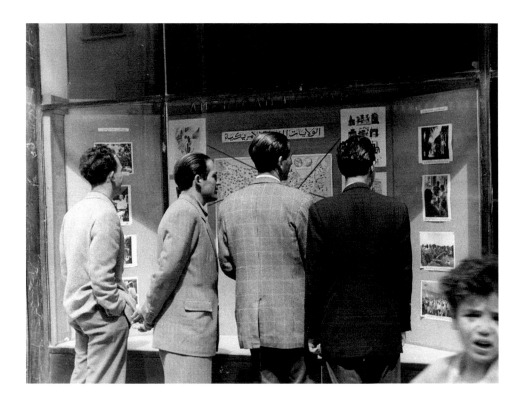

Fig. 93 Window display, USIS Morocco, March 1953. Photographs of
Information Center Service Activities in Foreign Countries, 1948–1954, Box
9, RG306, NARA. 306-CS-9H-1.

and Kampala, where he was "acutely conscious of the need for a new location and a
better looking building."[23]

The centers provided a primary context for the presentation of agency photogra-
phy. As an interface between the agency and the continent's urban populations, the
window displays had both a practical and symbolic importance. USIS Conakry, for
example, described its "choice window frontage on the city's main street" as one of its
"most valuable assets." In February 1962, in the context of eased tensions between the
US and Guinea following a new economic aid agreement, the windows carried a rap-
idly changing series of displays, including photographs of the signing of the agreement,
the Guinean ambassador at the White House, technical preflight pictures of a space
mission, a US trade fair in Ghana, the US ambassador to Mali calling in on President
Kennedy, and a conference in Lagos, as well as portraits of George Washington and
Abraham Lincoln. This selection of images was described as "only a sampling." "To sus-
tain spectator interest, USIS kept putting fresh pictures in its long sweep of windows,"
the PAO Joseph Kolarek reassured his masters in Washington, a process made more
efficient by the agency's move to send photographs already bearing French captions.

Furthermore, in relation to John Glenn's orbital space flight, he noted, "USIS was ready with its picture displays the moment Colonel Glenn hit the water." They "drew steady and impressive crowds" both African and European, including visitors from Soviet bloc countries. The agency also secured prominent visual coverage of Glenn's mission in the state-owned newspaper *Horoya*. Distribution of the agency's *Today* newsreel benefitted from this "thaw" in relations too, and Kolarek was pleased to report on his cordial relations with Guinean Minister of Information Bengaly Camara, who treated him to a drive out to see his "palatial" new home on the outskirts of the city.[24]

USIS Leopoldville was similarly well placed to insert agency imagery into the everyday lives of the city's inhabitants. Occupying a large building on the edge of "the African Quarter," its US flag and name "prominently displayed," it had around one hundred feet of window display frontage. "Shoppers going from the Great Market to the south of USIS to the retail stores," it was reported, "use the USIS parking lot as their pedestrian highway." Anyone taking this shortcut had to pass the USIS windows, and most stopped to look. At the time of Codel's report, the windows carried photographs of US ambassador George McMurtrie Godley on a trip to the lower Congo region and of the Zambian oil lift, demonstrating support for a neighbor to the south following Rhodesia's decision to cut off supplies. Both attracted "good crowds." These were among a cycle of exhibitions that included US history, space exploration, and "Negro Achievements," though it seems there was a notable lack of interest in a battle map of Vietnam. Codel's personal view was that the emphasis should be on "educational and economic advancement, especially US-Congolese AID cooperation," and his primary recommendation was that the displays should contain more photographs picturing Americans together with Congolese. He also wondered why more use was not made of USIS posters: "Other national information services are permitted to smear the walls with posters. Why not us?"[25]

Even in what field officers regarded as unfavorable locations, the center window displays provided a means of reaching local audiences. USIS Zanzibar was one such example. Moved to new premises as part of Lewis's centers review, it was now "admirably located" facing the recreation park, nearby to the Ben Bella Girls Secondary School and the Haile Selassie Boys Primary School, and on the main route into town from Mbeni Technical College, which had been supported by funds from USAID. Nevertheless, the operation had a fractious relationship with the local government. In May 1966, the PAO was expelled and the branch post closed down. It reopened a few months later, despite little improvement in relations. In the absence of an agreement for the posting of a new US officer, it was run by a local of Goan descent with guidance and support provided by the consulate and USIS staff in Dar es Salaam, who visited periodically. A report from Dar es Salaam observed that "USIS Zanzibar

speaks with but the faintest whisper, so encircled is it by hostile tensions. . . . It is a very attractive and a highly unorthodox operation, yet it is a very vital toe in a door. Given the wild character of the thugs who run Zanzibar, the large sums lavished upon it by Moscow, Peking, Hanoi, and Havana, it is a wonder that USIS is still operating at all." Censorship hampered the film program, which only attracted "neighborhood families," and the local employees, it was suggested, may all be "spies." Yet, amid this unpromising setting, the potential for using the windows stood out; the center had "four splendid display cases facing the park." Despite the banning of sports and recreation for young people during the week as a result of what was described as "Zanzibar's own little mini-Cultural Convulsion," they caught the attention of all those who passed by, whether on foot or by car: "So little of interest going on in the town, that these four precious panels are certainly scanned by every passing vehicle." These were, the report concluded, "the sole windows in the West in all of Zanzibar," and the only competition for East Germans "and the like" and the local bookstores managed by the Chinese.[26]

South Africa was perhaps the most significant counterexample to the general aim of USIA to give visibility to the US and its relations with African nations in the continent's urban centers. In Johannesburg, an early report felt that USIS was well advised to "hide its light beneath a bushel" in order to avoid causing "more harm than good by arousing the suspicions of a very suspicious government." Its library was discreetly housed on the sixth floor of a public building.[27] Though even in South Africa, there were occasions when the agency sought a higher profile for its output.

The multiple textual descriptions of window displays that featured in USIS reports to Washington were occasionally accompanied by photographs showing the displays in situ. Many pictured local audiences crowded round, giving embodied presence to the postcolonial visual publics of the agency's imagination. They represent a parallel to the audience photographs that Eric Sandeen traced across the world through the archive of *The Family of Man* tour. The genre Sandeen identifies blurred the boundary between the people in the photographs and people viewing them: "Selected viewers were brought close to the photograph, seeming, at times, to break through the plane of the image to a respectful, almost reverential communion with the engaging photographs that Steichen viewed as the world community."[28] Such photographs do appear in the USIS files, as in one example from Tunis where the viewers seem to merge into a crowded city scene (fig. 94). Whether the display's focus on traffic safety quite conveyed Steichen's sense of world community is another matter, though it may have spoken to a shared experience of urbanization.[29] But many of the photographs are suggestive in other ways. An early photograph of the center in Leopoldville shows a window display on the Tennessee Valley Authority (fig. 95). Taken at night without the presence

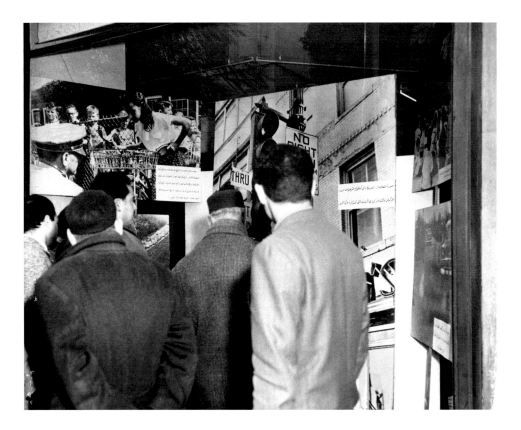

Fig. 94 "Traffic Safety Exhibit, Project 62-336," USIS Tunis to USIA
Washington, March 19, 1964. Records Concerning Exhibits in Foreign
Countries, 1955–1967, Box 37, RG306, NARA. [Declassified Authority:
NND931622.]

of viewers, the glow of electric light from the large rectangular windows illuminates
the pavement in front of the center.[30] Although it lacks a figure seated inside to com-
plete the scene, it is nonetheless reminiscent of an Edward Hopper painting of the city
at night, and as such it locates a sense of American modernity on the African conti-
nent, echoing the modernization and development on offer in the exhibition. By far
the majority of these photographs, however, are taken from a little further back, cap-
turing crowds or small groups of viewers from behind as they gaze at the window dis-
plays. What exactly they are looking at is not always easily discernible, suggesting the
point is less the specific display than the act of viewing itself. At one level, the images
serve simply to evidence the popularity and informational value of these small exhibi-
tions to USIA leaders and politicians in Washington, a visual demonstration of value
for money. For example, a photograph of "an ordinary crowd" viewing a display on the
US ambassador's Fourth of July reception, on show at USIS Mogadiscio was accompa-
nied by a note explaining that groups such as these could be seen from early morning

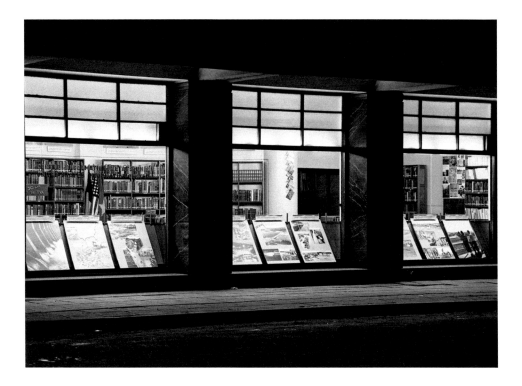

Fig. 95 "Opening of USIS Information Center Leopoldville," June 22, 1953.
Photographs of Information Center Service Activities in Foreign Countries,
1948–1954, Box 10, RG306, NARA. 306-CS-10F-7.

to late evening for the first five or six days, and proudly noting that its city center loca-
tion attracts considerably greater attention than similar displays by other countries.[31]
USIS Dakar was even able to report that a photograph of its window display on the
1960 election campaign, which attracted interest "day and night," was reproduced in
the city's only daily newspaper, *Paris-Dakar* (fig. 96).[32]

The genre was not unique to US public diplomacy. Sandrine Colard, for exam-
ple, identifies an example from circa 1955 in the archives of InforCongo, the colo-
nial information agency in the Belgian Congo.[33] The group is predominantly male,
a characteristic that holds true across a large number of comparable photographs in
the USIA archives. Nevertheless, I want to suggest that one can discern here some-
thing not found in the displays of their colonial predecessors: an imaginative invest-
ment in the idea of African engagement with US culture and a belief in the power of
photography, if not to foster a world community as Steichen would have it, then at
least to increase mutual understanding between Africans and Americans. This idea is
beautifully illustrated by a photograph showing a young boy in Senegal pictured from
behind, holding in his hands a copy of *Perspectives Americaines* (fig. 97); one imagines

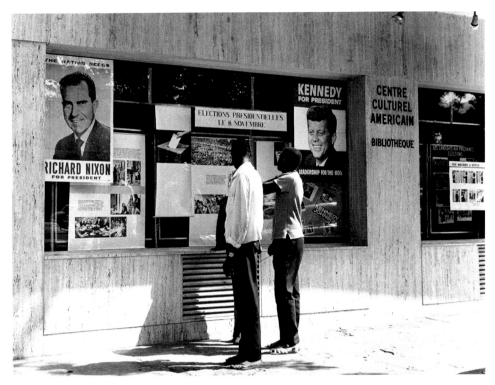

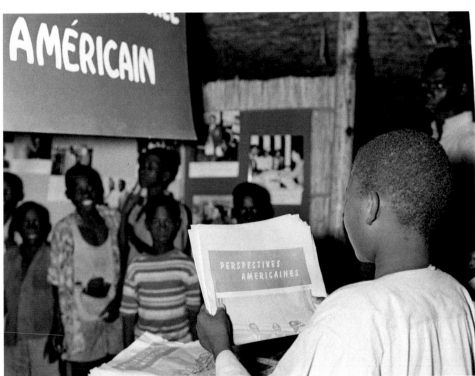

Fig. 96 "US Presidential Elections, Visual Material,"
USIS Dakar to USIA Washington, November 10, 1960.
Records Concerning Exhibits in Foreign Countries,
1955–1967, Box 32, RG306, NARA. [Declassified
Authority: NND931622.]

Fig. 97 "US Exhibit at Louga Youth Week Fair," USIS
Dakar to USIA Washington, July 12, 1963. Records
Concerning Exhibits in Foreign Countries, 1955–
1967, Box 32, RG306, NARA. [Declassified Authority:
NND931622.]

his gaze moving between the paper, the exhibition on display in the background, and a group of his friends who look toward the camera and smile.[34] The perspective may well be entirely American, but it is difficult to imagine finding a photograph quite like this in a colonial archive.

————

Important as they were both symbolically, as a window onto the West in African cities, and practically, in reaching urban audiences, center window displays were only one aspect of USIS photographic operations. Returning to the Burundi example, it is worth itemizing the distribution of the photographs that arrived from Washington. USIS Bujumbura received eight sets of nineteen photographs from the visit of Mwambutsa IV to Washington, along with a further two sets of four photographs from the World's Fair. In addition to the large window display, they sent a full set to the Burundi government information service, half a set each to two local periodicals—*Ngondozi* and *Burakye*—and another set to the ambassador's wife, to be shared among the wives of Burundi officials who had accompanied Mwambutsa IV. The remaining photographs were used to create seven panels of six photographs each for circulation to schools, military installations, and local government offices across the country.[35] Beyond the presence of these photographs in the public space of the capital, these further routes through which the images were distributed served to build and maintain direct political networks through the sharing of photographs as tokens of friendship and diplomacy, to shape official government and press coverage of US-Burundi relations, and to extend this message to audiences beyond the capital. This multilayered deployment of photography in Burundi was typical of most USIS field posts. In Fort Lamy (N'Djamena), Chad, USIS officers showed a similar attentiveness to the value of photography for relationship building, alongside presenting thematic messages. A monthly highlights report from 1965 offers two examples. In the first, field officers created a rapid photographic display of a group of Operation Crossroads participants during their visit, showing Africans and Americans working together to build a primary school, playing boule, and singing folk songs. In the second, they created a small exhibit to mark the inaugural flight of Air-Afrique. The exhibition made a point of highlighting the "cooperative effort" by several African nations that had made the flight to New York possible. When the exhibition was taken down, the photographs were sent as souvenirs to Chad's Minister of Finance, who appeared in several of the images.[36]

Twice yearly, posts were asked to provide a statistical report on the exhibitions program. These listed displays received from Washington, which they were invited to rate for "usability," as well as locally produced examples, provided estimates of audience figures and detailed display techniques (fig. 98). Audience numbers varied from a few hundred for small local displays to tens of thousands for high-profile exhibits

such as those on the March on Washington and President Kennedy, to take an example from USIS Yaoundé's December 1963 report.[37] Field officers provided additional comments on notable successes or failures. The same report from Yaoundé, for example, pointed to their achievement in placing photographs with the West Cameroon Office of Information. USIS photographs appeared together with local pictures in displays at community centers in Victoria (Limbé), Kumba, Mamfe, and Bamenda. In Mali, the PAO was pleased to be able to report that "gentle but persuasive" contact with the director of the government-owned bookshop Librairie Populaire had paid dividends when he gave permission to display *March on Washington* in front of the store.[38] Conversely, USIS Lagos noted that there were a number of exhibitions arriving from USIA Washington that they did not feel able to use, the most frequent reason for this being a lack of racial integration in the photographs.[39] A few posts documented a more limited offering. USIS Khartoum reported that from January to October 1965 there were no displays outside of USIS premises. Only occasionally were photographs on science and agriculture distributed to two nearby schools and "even less often" did they receive requests for material from schools or other organizations: "These are on a very sporadic basis, and it is impossible to determine their effectiveness, the size of the audience, or even their exact use."[40] USIS Kampala complained of the practical limitations that constrained its program: "Adequate exhibit areas or facilities are rare in Uganda and virtually everything . . . must be made or organized from scratch."[41] In many places, however, the local distribution of photographic displays entailed an extensive and complex logistical operation. Alongside the nine exhibition areas on its own premises, USIS Salisbury was responsible for a further seven in Lusaka and four in Blantyre, with its exhibitions workshop continuing to service these posts after the break-up of the Federation of Rhodesia and Nyasaland in 1963. The displays in each of these areas were changed approximately every four to five weeks. After being shown on USIS premises, they were then distributed to schools and colleges through its "Photo-packet Exhibits Service." In late 1963, there were forty such exhibition packets circulating to thirty-four schools and colleges, identified in a photo-packet placement chart. The report detailed the smooth running of the operation: "Each photo-packet has a card; the date and name of the school is entered thereon at time of despatch [*sic*] and the card placed in a manila jacket with the name of the school. Despatch is recorded on a Photo-packet Exhibits Placement Chart which makes it possible to see at a glance which school has or has had, a particular exhibit. Average display time is from three to four weeks. When the packets are returned, they are examined, repaired and repacked. Each packet has an average life of from 8–10 showings."[42] The post estimated that in the region of thirty thousand "young Rhodesians" had seen these exhibits in the first ten months of 1963, the majority of them in African secondary schools and teacher training colleges. At its furthest

IA-470
5-10-60

U. S. INFORMATION AGENCY	POST AND COUNTRY
STATISTICAL REPORT ON EXHIBITS PROGRAM	U.S.I.S. LOME -Togo
	XXX-ANNUAL PERIOD ENDING
	December 1st, 1964 - December 1st, 1965

I. EXHIBITS SHOWN DURING PERIOD

A. USIA PRODUCED

PROJECT NO. AND TITLE	NO. OF LOCA-TIONS	LANGUAGE(S) (Identify)	EST. TOTAL AUDIENCE	USABILITY EXCELLENT	ADEQUATE	INEFFECTIVE
P.S. 868 New Story Coton picture	2	french.	5.000	x		
" 942 Vice-President Humphrey	1	"	5.000		x	
" 934 Simulating a man on the moon	2	"	5.000	x		
5 -2 Ideas that Breed Independence	2	"	6.000	x		
5 When the United Nations was Born	2	"	6.000	x		
4-28 Red China's Neighbors	1	"	3.000		x	
985 Arthur Goldberg	1	"	3.000	x		
310 First Festival of American Arts	1	"	3.000		x	
P.S. The Battle Against Human Needs	2	"	1.500		x	

B. LOCALLY PRODUCED

TITLE OR SUBJECT	NO. OF LOCA-TIONS	LANGUAGE(S) (Identify)	EST. TOTAL AUDIENCE	TECHNIQUE USED	SIZE (Linear or sq. ft.)
Miscellaneous (photos on various subjects)	2	french	4.000	PP,PDB,WD,	50m2
Humanitarian Mission to Stanleyville	1	french	2.000	PDB	4m2
Events in Congo	1	"	5.000	WD	8m2
Heros Américains de Légende	1	"	2.000	PDB	2m2
Nimbus photos	1	"	2.500	PDB	"
Our activites :photos USIS staff & commodities	2	"	5.000	PDB	10 "
Exhibit of Togolese Paintings	1	"	3.000	OA	25m2

II. EXHIBIT OUTLETS

TYPE OF DISPLAY AREA	NO. OF OUTLETS	TIMES USED
USIS premises	1	24
USIS windows	3	60
schools, colleges	12	12
libraries	1	24

III. REMARKS

N.B. USIS windows include wooden panels affixed outside the library)

Fig. 98 "Statistical Report on Exhibits Program, December 1, 1964–December 1, 1965," USIS Lomé. Records Concerning Exhibits in Foreign Countries, 1955–1967, Box 37, RG306, NARA. [Declassified Authority: NND931622.]

Fig. 99 "ICS: Exhibits: United Nations," USIS Ibadan to USIA Washington, November 8, 1962. Records Concerning Exhibits in Foreign Countries, 1955–1967, Box 28, RG306, NARA. [Declassified Authority: NND931622.]

reaches, this was the kind of operation required to deliver the agency's ambition of a "constant flow" of photographs around the world.[43]

The exhibitions mounted and distributed by USIS posts in Africa ranged from large thematic displays on agriculture, civil rights and racial integration, science and technology, space exploration, the UN, and US history and culture, to small displays responding to local concerns and opportunities. Field posts generated their own displays on key agency themes, as well as adapting material shipped directly from Washington or touring from post to post across the continent. USIS Ibadan, for example, produced its own sixteen-panel exhibition on the UN for display at University College, Ibadan, accompanied by a series of events and lectures (fig. 99). Alongside the exhibition, the post produced a series of "UN kits" for distribution to one hundred secondary schools in western Nigeria. USIA Washington responded by complimenting the post and encouraging the use of a recent agency picture story on US support for the UN.[44] USIS Accra welcomed the agency's 1963 exhibition on Martin Luther King, which was displayed both on its own premises, alongside books by James Baldwin, and at the Padmore Research Library, receiving much "favorable comment." It reported, however, that a number of "changes and deletions" were required: the captioning of a photograph on training in nonviolence was felt likely to cause "much misunderstanding" in those not familiar with such procedures, and the photograph of King at Gandhi's shrine was "eliminated" as not meaningful for Ghanaians.[45] Later the same year, the post sought immediate permission by telegram to reuse several of the photographs from the King exhibition in a display rapidly installed in response to the events unfolding in Birmingham, Alabama. The PAO at the time, Mark Lewis, proposed introducing a banner caption across four of the photographs reading "We Support You," and including a statement from the US attorney general along with a portrait

under the title "His Men are in Birmingham." "We here had better be on the side of the angels," he reasoned.[46] In a similar vein, in 1964, USIS Fort Lamy put together a window display immediately following King being awarded the Nobel Peace Prize in Oslo, comprising the text of his acceptance speech and "numerous" photographs "depicting scenes from his life and accenting his role in seeking a non-violent course in establishing a rein of justice."[47] Not all populations were absorbed by the US civil rights story, however. USIS Monrovia reported little interest in the civil rights theme and few takers for its pamphlets on the subject.[48] And in Rhodesia, unsurprisingly, there was a degree of hostility from the White population. An exhibition displayed at the Bulawayo Trade Fair was criticized for being in "poor taste" and "increas[ing] local African discontent," albeit the post explained that the display was designed to counter Soviet propaganda on racial injustice in the US targeted at Africans rather than to garner favor with the White population.[49]

Agricultural modernization, technology, and space exploration featured in numerous exhibitions through the 1960s (fig. 100). The biannual exhibition reports show that at any one time there were multiple exhibitions on these themes circulating across the continent. Space was a topic that showcased US scientific prowess. Its assumed universal appeal was validated by popularity with local audiences in most locations, and the agency made efforts to Africanize the story—for example, identifying the chimpanzee on the Mercury flight in 1961 as Cameroonian.[50] Behind the scenes it was also pushing "the case for a Negro astronaut," a lack that had been "pointed up in a Radio Moscow broadcast in Hausa."[51] Nevertheless, field officers in Burundi requested exhibitions on more familiar technologies, in an effort to bring the displays closer to the reality of their target audience's everyday lives. An exhibition on the science of the automobile, it was suggested, would appeal to those in more remote areas who were unfamiliar with space exploration: "In small villages people stop to look at cars that come to visit or pass through. An exhibit on the automobile industry would be a natural for this type of audience."[52] Reporting on a locally produced space display, USIS Johannesburg managed to capture the both the interest in the US space program and the racial dynamics of the setting. The photograph sent to Washington shows a White student and a Black businessman standing opposite each other at a table display of pamphlets on space in the USIS Library; hovering above them suspended from the ceiling is a half life-size photograph of a US astronaut on a spacewalk, cut out and mounted on a polystyrene backing to give a "life-like" effect (fig. 101).[53] USIS centers also regularly presented displays on American culture, with the 1965 Christmas display in Bujumbura reportedly being the "talk of the town."[54]

Beyond exhibitions on broad agency themes, where most if not all of the photographs were supplied from Washington, field posts produced their own exhibitions

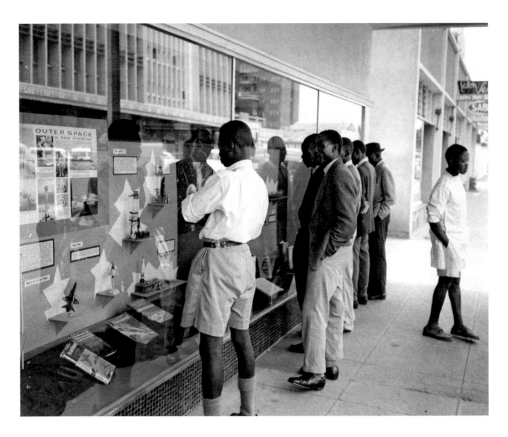

Fig. 100 "ICS/Exhibits—USIS Salisbury Exhibit 'Outer Space,'" January 24,
1961. Records Concerning Exhibits in Foreign Countries, 1955–1967, Box 31,
RG306, NARA. [Declassified Authority: NND931622.]

that addressed local, national, and continental politics, personalities, and issues. In
September 1960, as the Congo crisis began to unfold, USIS Leopoldville proposed an
exhibition that would serve as a form of pictorial political education. The exhibition
addressed the "surge of nationalism" that accompanied independence and, underpinned
by racist assumptions about the "insular" thinking of African citizens, was intended
to provide its viewers "a geographic, economic, political and ethnic perspective of the
world," in order that they might develop a greater awareness of "their place in the world
community and . . . conduct themselves accordingly." The central design was to be a
map of the continent broken down by country and populated with inset photographs
of African political leaders, US ambassadors, and US aid projects.[55] The idea of edu-
cating Africans about Africa appeared frequently in USIS exhibitions of the period. A
large-scale exhibition entitled *Here is Africa*, which documented development projects
across the continent, toured several African countries in the early to mid-1960s. Its dis-
play in the northern Cameroonian city of Garoua attracted positive comments from

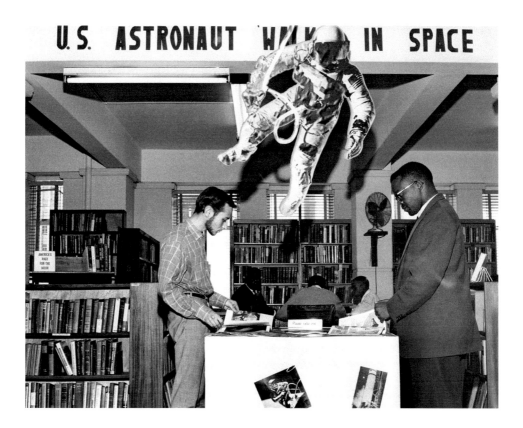

Fig. 101 "Johannesburg Library: Mr. Norman Kessel, student, and Mr. J. M.
Rakate, businessman, are attracted to pamphlets on space by this exhibit."
"Locally Produced Exhibits: Transmittal of Photographs," USIS Pretoria
to USIA Washington, November 24, 1965. Records Concerning Exhibits
in Foreign Countries, 1955–1967, Box 33, RG306, NARA. [Declassified
Authority: NND931622.]

local leaders. The Préfet de Bénoué was quoted as saying that the exhibition "assists us
greatly in awakening our people of the North to the great developmental task that lies
ahead," and a representative from the Federal Chamber of Commerce described it as
a "panoramic pictorial display of progress in other African countries," which "serves
as a tremendous incentive to Cameroonians."[56]

USIS centers regularly took the opportunity to bolster the image of preferred lead-
ers, and to showcase their connections to the US. The photographs of Julius Nyerere's
visit to the US, prior to Tanganyikan independence, were widely distributed, includ-
ing "colorful photo boards" displayed in the offices of the Tanganyika African National
Union and USIS windows, where a selection of Nyerere images were complemented
by scenes of the US cities he visited. The display "attracted large crowds with the fast-
est turnover in USIS Dar history," around ten people every fifteen minutes for the
first two weeks, according to the post report.[57] In the early 1960s, relations between

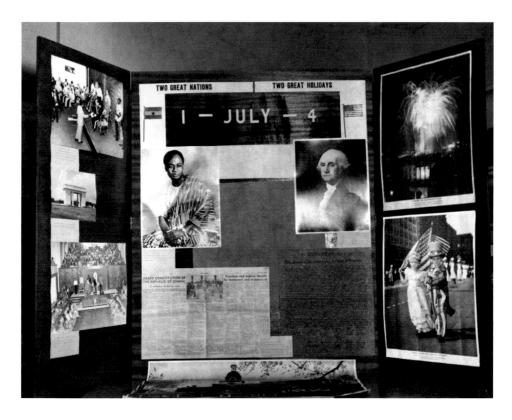

Fig. 102 "USIS Exhibit Commemorates American Independence Day
and Ghana's Republic Day," USIS Accra to USIA Washington, July 5, 1963.
Records Concerning Exhibits in Foreign Countries, 1955–1967, Box 11,
RG306, NARA. [Declassified Authority: NND931622.]

the US and Ghana blew hot and cold, but in mid-1963 USIS Accra presented a display marking a joint celebration of Ghana's Republic Day and American Independence Day (fig. 102). "Two Great Nations—Two Great Holidays" pictured Kwame Nkrumah and George Washington side by side at the center, with flanking panels showing photographs of respective national celebrations.[58] The following year, in a memo entitled simply "Effectiveness," the field officer responsible for the center in Somalia congratulated the agency on a recently received poster on President Johnson—"America's New Leader"—which included a photograph of a meeting with Somalia's Undersecretary of Foreign Affairs, and at the same time bemoaned the absence of any Somalians on the poster "Africans at the United Nations": "It seemed every African land was represented at least once in the exhibit, excluding Somalia."[59]

USIS posts were also willing to demonstrate support for African government campaigns where it met their objectives. In January 1966, for example, USIS Leopoldville carried an exhibition in its windows titled with a slogan adopted by General

Mobutu—"Retroussons les Manches" (Let us Roll up our Sleeves)—who had taken power in a coup d'état late the previous year. The display included photographs of Congolese troops cleaning up the capital, "cutting grass, cleaning gutters and streets, and hauling away refuse." Somewhat incongruously, it was accompanied by a second exhibition that month showing color photographs of *Landscape Scenes of the United States*.[60] Photographic and exhibition output was often used to build local relations at lower levels too. In Togo, for example, USIS Lomé ran a photo-display in their window of Polycarpe Johnson, editor for *Togo Presse*, following his visit to the US. This appears to have been part of a concerted effort to cultivate this relationship and open up space for the use of more agency materials. Placement of pictures, it was noted, had become "virtually an every other day affair," and according to the PAO, Duncan Emrich, Johnson's sponsored visit "may well prove to have been a top investment."[61] In Senegal, USIS Dakar reported supplying print and exhibition materials to two anti-communist organizations at the University of Dakar, both of which had been set up by former US grantees. Parenthetically, it was noted that the leftist organization that these groups were designed to combat had not hesitated to request materials for use either.[62]

Although positive visual imagery tended to dominate in the agency's visual output, there were nevertheless occasions when officers turned to forms of hard propaganda. This was emphatically the case during the Congo crisis of the early to mid-1960s. In late 1964, in the context of the insurgency in the east of the country, USIS Leopoldville organized a photographic exhibition on a joint operation by Belgian, US, and Congolese government forces to free Western hostages in Stanleyville (Kisangani). The exhibition traveled to the branch post in Elisabethville (Lubumbashi), attracting large crowds, and would have been shown in Bukavu but for the packet of photographs failing to arrive at its destination. The aim of the exhibition was twofold: "To explain the American position and to demonstrate that the first victims of rebel activities have been Congolese." Remarkably, the post planned to follow this exhibition with one on US national parks and monuments, with "eye-catching" color photographs. Despite appearing like "a blood-rush into escapism," however, it was in fact part of a two-pronged approach. By linking the exhibition to support for Upemba National Park, USIA intended to showcase the benefits of tourism. "Not said but implicit," the message intended by the juxtaposition of these two exhibitions was: "This and all other things . . . once there is peace in the land."[63] A number of other field posts also "took the bull by the horns," as the PAO from USIS Lomé put it, displaying hard-hitting photographs of events in the Congo and in Vietnam.[64] According to reports, this kind of visual spectacle attracted crowds often two or three deep. In Burundi, the PAO commented of local audiences: "They seem to love pictures of atrocities. I sometimes wonder whether it registers or

matters who committed these; and whether it isn't the murderer who is admired, or whether, disregarding the caption (in Kirundi and French), they do not think that we show pictures of our own victims. . . . Still, there are indications that the message gets through to some, perhaps more than we think."[65] If one can leave aside the racist prejudices in these speculative musings, it can be read as tacit admission of just how little some field officers understood the ordinary Africans who stood before the photographs they presented.

————

Photography was a central means of addressing African audiences, but the visual program did not settle for simply presenting still photographic displays. In this respect, generic images of local audiences standing and viewing agency exhibitions offer only a partial picture. The agency went to considerable effort to engender participatory forms of engagement, both through innovative forms of visual display and attention to how these were experienced by viewers. For USIA, in theory, if not always in practice, photography was already an immersive, experiential medium. The agency's approach was deeply influenced by modernist ideas around exhibition design that had taken shape in Europe in the early twentieth century and subsequently imported into the US in the 1930s, where they been adapted and popularized. *The Family of Man*, which remained a touchstone throughout the 1950s and 1960s, was central to the agency's thinking not only for its photographic humanism but for its design. A key figure here is the Bauhaus-trained designer Herbert Bayer. Bayer emigrated to the US in 1938 and worked with Edward Steichen at the Museum of Modern Art on the influential propaganda exhibition *The Road to Victory* (1942), which set the pattern for Steichen's later work. Bayer's idea of expanded vision sought to establish a dynamic relationship with the viewer, using spatial design and scale to create an experience of "sensorial immersion."[66] The modern exhibition, he believed, "should not retain its distance from the spectator, it should be brought close to him, penetrate and leave an impression on him, should explain, demonstrate and even persuade and lead him to a planned reaction."[67] Ironically, in the context of Cold War propaganda, Bayer's innovation was to theorize and popularize ideas that derived from Russian Constructivism, and specifically the work of El Lissitzky. Yet, for Bayer, exhibition design was "an ideology-free form of communication," equally applicable to the promotion of fascism in Germany and the development of advertising in the capitalist West as it was to building a new socialist society.[68] If others regarded the American approach to this as a "debased and falsified version" of the original, this was of little concern to USIA.[69]

It would be foolish to claim that displays mounted by USIS centers in Africa came anywhere near fully realizing the impact envisaged in these theories of exhibition design. Nevertheless, attenuated as the effects may have been, the underpinning ideas

remained a feature of how field officers understood and carried out their work. Those with no previous exhibition experience or training would have first encountered Bayer's ideas in *Display*, a book on the theory and practice of exhibition design by George Nelson published in 1953, which subsequently appeared as recommended reading in the agency's handbook for Country Public Affairs Officers (CPAOs).[70] Nelson, himself an exhibition designer, was responsible for a free-standing, modular exhibition system, which facilitated the kind of flexible image placement implied by Bayer's design concepts at the same time as enabling exhibitions of varying sizes to be transported easily at low cost and installed rapidly in small spaces. This was precisely the kind of system USIS centers in Africa needed and, unsurprisingly, a number either had or had requested Nelson display systems to support their programs. Indeed, in Gabon, in their absence, staff at USIS Libreville invented their own version, "using some sort of locally and easily produced self standing racks and panels" in order to display the new African packet series that had recently begun arriving from Washington. They clearly did a good job given that seeing the display "boosted considerably" the opinion of the series in the eyes of a visiting deputy director from the agency's Africa office: "He's now fully 'sold,'" the post reported.[71]

USIS visual displays took multiple forms, so many that the agency devised a series of fourteen display technique acronyms to be used for post reporting purposes, including, for example, medium-animated (MED), Paper Shows (PS), Photo Display Boards (PDB), Photo Exhibit Packets (PEP), Models (M), and Exhibit Kits (K).[72] Notwithstanding the presumed immersive and experiential quality of the medium, photography exhibitions rarely existed in isolation. More often, they were accompanied by interactive elements, talks and other kinds of events, and even competitions, all intended to encourage direct audience participation. In a discussion of the "psychological effectiveness of various learning sources," the above-mentioned CPAO Handbook noted that "seeing a picture, film or model of a thing or idea" was second only to "experiencing a thing directly." The section on exhibitions then went on to discuss multiple ways of bridging this gap and extending engagement beyond visual apprehension to create "a deeper impression": "Live demonstrations, button-pushing, turning of pages, physical examination with the hands, sound synchronization of background, are all possible in the exhibit medium." Displays could be the occasion "for group gathering and for group discussion," they were capable of starting "a word-of-mouth chain," and they had "event-making possibilities."[73] In this respect, there is an interesting intersection or overlap between the influence of modernist exhibition design ideas and methods on USIA's visual practices and the techniques that were being developed by their colonial predecessors in the 1930s and 1940s. In his study of colonial exhibitions, Richard Vokes argues that in order "to demonstrate to . . . African subjects various elements

of a model 'modern' citizenship," techniques went beyond simply presenting material in a didactic mode, instead seeking to foster an "embodied engagement."[74] Visual presentations often involved physical interaction with artifacts or models, and were accompanied by classes and competitions. There appears to be a degree of continuity here. This is not the place for a deeper inquiry into the international history and circulation of exhibition practices, but it seems likely that USIS field officers borrowed ideas from other colonial and postcolonial cultural and information operations on the continent, and, at the same time, that modern ideas of exhibition design were widely influential, even if USIA codified its exhibition practices more definitively than others and drew more explicitly on a paradigm that can be traced to the US in the postwar period.

Despite theories of display being confronted by many obstacles on the ground in Africa, there are numerous examples that can be cited as evidence that USIS field officers understood the value of photography in terms of the medium's centrality to the experience of modernity, and its ability to foster modern forms of sensory engagement, not simply as a tool for the provision of information. Reports to Washington were peppered with comments on the "eye-catching" quality of imagery; the use of color, especially where there was the facility to display backlit transparencies, was highly prized, as was the production of large-scale or life-size images. A report from Leopoldville, for example, remarked on the display technique of hanging the photographs from thin wires, which gave "an idea of three-dimension that catches the eye," and the backlit color transparencies of space flight were described as "sure winners." Indeed, such displays had the potential to be so engrossing that they generated a degree of anxiety about the safety of viewers. Where the Leopoldville center windows faced onto the parking area, the report noted that "traffic hazards are created"—"A USIS vehicle hitting a Congolese would not be good public relations."[75] USIS Libreville, similarly, reported on the adaptation of an unused lightbox in order to display color transparencies and a large, translucent color poster of the 1965 spacewalk, and on the installation of fluorescent tubes to allow displays to be viewable at night. At the same time, mindful of local viewing conditions, they installed a roof that extended over the viewer's head "protecting him from the hot midday sun as well as the tropical downpours," thereby allowing for extended periods of viewing.[76]

Photographic displays were often accompanied by physical objects and models. In Ethiopia, to "herald the arrival" of six F-86 "Sabrejet" fighter-bombers delivered by the US to the Imperial Ethiopian Air Force, the post created a window display comprising large color photographs, six plastic models of the F-86s, and a life-size dummy dressed in a jet pilot's suit, complete with helmet and oxygen mask.[77] The display attracted constant attention throughout the day. Somewhat less successfully, in Tunisia, photographs

on the theme of traffic safety were accompanied by a two-way traffic signal, a control box, and a magnetic traffic board. Unfortunately, the photo-panels and captions, shipped from Beirut, arrived "somewhat battered," elements of the display appeared "a little seedy," and the neon tubing for the pedestrian signal was "smashed completely." Notwithstanding these additional elements, and the fact that the exhibit occupied all eight of the center's display windows, it was thought to be of only "marginal value." The topic of traffic safety "arouses something less than lively interest in the average citizen," the post concluded.[78] In spite of field officers' commitment or enthusiasm there were also occasions when the lack of exhibition skills or training, indeed a sheer amateurishness, was manifest in the resulting displays. One of the most bizarre was the choice, for no discernible reason, of a stereotypically "Chinese"-style font for the title of a photographic display on "Americans Students in Community Work" shown at USIS Kampala. Unsurprisingly, this attracted criticism from Washington.[79]

USIS posts were also keen to deploy technological innovations in combination with visual media forms. In the early 1960s, the agency's Exhibitions Division had begun to develop a "talking exhibits" device. Although developed for the program in Latin America, USIS Tunis requested that it be made available for African posts too, "where illiteracy rates are high and pictures are popular."[80] In Burundi, field officers' appetite for multimedia displays led them to propose their own innovation. The idea was to display a working teletype teleprinter as a permanent window feature, with the latest news from Washington transmitted via the wireless file appearing directly as it arrived. "Teletype equipment is impressive to the uninitiated from any culture, no matter how sophisticated," the post contended. Likening the effect to the scrolling text on the *New York Times* building, they felt it would provide a powerful sense of immediacy for local audiences: "Watching the news appear on a piece of paper, untouched by human hands, somehow has a fascination that reading the same text after it is all received does not have." USIA Washington was not persuaded, however, and vetoed the idea. While it recognized the potential for a "strong mass attraction" it believed "a constant reminder of the flow of a foreign government's news service into Burundi" would not be helpful to the country objectives and was concerned about the potential for an "unfortunate display of a wrong item."[81] Even less controversial technological exhibits had to face the hazards of local conditions. In what was described as "the sad saga of the ice cream dispenser," USIS Accra reported on the failure to deliver soft chocolate ice cream, which had been "scheduled to play a key role" in the USIA exhibit at the 1967 Ghana International Trade Fair.[82]

Beyond visual and sensory engagement, displays were often the occasion for direct participation. In Algiers, the *US Progress in Space* exhibition, attended by around 145,000 visitors, included a full-size model of the Mercury capsule in which "visitors could

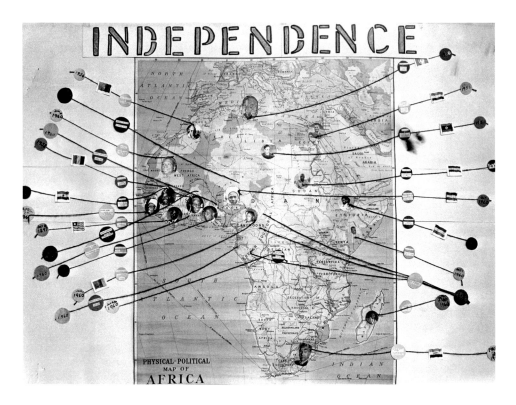

Fig. 103 "Exhibit: 1960 Political Map of Africa," USIS Monrovia to USIA
Washington, September 7, 1960. Records Concerning Exhibits in Foreign
Countries, 1955–1967, Box 25, RG306, NARA. [Declassified Authority:
NND931622.]

enjoy a simulated ride through space." USIS had a photographer "stationed near the
space capsule" making photographs of participants as they experienced the simulation.
The visitors were then invited to pick up their photographs at the USIS cultural center,
which provided an opportunity to promote the USIS Library. According to an agency
report, most of those who arrived to claim their photographs took out library member-
ship.[83] A participatory dimension was evident, too, in the use of photography as a form
of political education. Following a pattern common to many African posts, in mid-
1963 USIS Accra ran an exhibition of photographs of all African heads of state, "many
with American Negroes," under the title *To Widen the Area of Freedom and Unity*. This
exhibition was complemented by an another in the form of a competition—"Which
of these Countries in Africa can you identify?" The names and addresses of entrants
with the highest scores were posted in the USIS Library window, and winners received
a book prize.[84] In Liberia, a map of the continent on which were affixed circular pho-
tographs of heads of states of independent African countries, each attached to short
piece of string leading to the country flag and date of independence arrayed around

Fig. 104 "Lomé PAO Ronald Sher presenting prize book to Miss Josephine Abbey." "Photo Exhibit, USIS Lomé," USIS Lomé to USIA Washington, June 9, 1966. Records Concerning Exhibits in Foreign Countries, 1955–1967, Box 37, RG306, NARA. [Declassified Authority: NND931622.]

the outer edge of the frame, proved to be "the most popular display ever" (fig. 103). The display was photographed and prints given out to local audiences: "Government officials, Heads of Schools, and students literally came in groups to request copies of the photo."[85] These examples bear a striking resemblance to a photographic series that ran on the back page of *Bingo* magazine during the same period, wherein a photograph of an African head of state was cut into several pieces and mixed up in the form of a visual puzzle, which the reader was invited to solve—"Quel est cet homme d'état Africain?" The synergy of visual and political literacy, Bajorek argues, demonstrates the role of the magazine's photography in sustaining and transforming postcolonial forms of political belonging."[86] The extent to which the US was invested in similar forms of visual and political education indicates their applicability to the imagination of a range of alternative and overlapping postcolonial futures for the continent.

There was even a sense in which centers had the potential to become local hubs of photographic culture, extending beyond the medium's facility for representing agency themes and narratives. In Togo, when USIS Lomé mounted the exhibition *Le Togo: Une Esquisse Photographique par un Etranger*, by Peace Corps doctor William Anderson—a "first-class photographer"—not only did they hold a poll for the most popular photographs, but they also awarded prizes for those who selected the same ones as the post's chosen jury (Paul Ahyi, Professor of Art at Lycée de Tokoin, and François Metsoko, photographer with *Togo Presse*) (fig. 104). The ostensible content of the exhibition, described as affording an opportunity for the Togolese "to see themselves as others see them," provided the occasion for a lesson in photographic style and aesthetics.[87] To an extent, the agency operated as an arbiter of photographic quality. USIS Lagos,

for example, sought to coordinate the US contribution to the 1965 Nigerian Salon of Photography, both in terms of submitted photographs and the identification of an "expert photographer" who might participate in the lecture program.[88]

USIS centers also employed and trained photographers and exhibition staff from the local population. The Lomé exhibition provided excellent training for photographer Henri Aougah, who was guided by Anderson in the making of the final prints. Nor was this the first time Anderson had been employed to train local staff. He had previously provided exhibition training to employees at USIS Bangui, to enable them "to achieve cleaner, easier to read displays."[89] Similarly, in Dahomey, where a photographer had recently been appointed, the post was of the view that the availability of "good local photos" was largely attributable to a recent photographic workshop conducted in Cotonou.[90] As the Lomé exhibition competition indicates, however, the agency's confidence in its own sense of what made for good modern photography meant it was oriented more to inculcating this in employees and the local population than to learning from them.[91]

————

For USIA, photography was a medium for imagining and shaping postcolonial African futures in relation to the US. As the examples in this chapter demonstrate, this was not simply a matter of visual representation. Photography provided a means of actively fostering postcolonial political relations and forms of belonging. The considerable resources and effort the agency put into the photographic program for Africa aimed to build relationships with political, cultural, and business leaders, and, at the same time, afforded opportunities for imaginative participation on the part of a wider population. Yet one must acknowledge that the agency's approach to photography was framed by the parameters of its political imagination, shaped primarily by the twin concerns of the Cold War and domestic racial strife. I want to end the chapter with two examples that throw into relief the limits of the agency's photographic imagination, and of the archive that is its legacy. In doing so, they concede the existence of competing photographic visions, for which one must look elsewhere.

In late 1963, USIS Addis Ababa reported on an eighteen-column-inch paid advertisement that appeared in *The Ethiopian Herald* inviting its readers to submit photographs for a Moscow Exhibition of Art Photography entitled *Africa Today*. The appeal by the Photosection of the Union of Soviet Societies for Friendship and Cultural Relations with Foreign Countries was aimed at African audiences across the continent. The exhibition, the advertisement stated, would "familiarise the Soviet public with culture and life of African peoples and promote the further strengthening of friendship relations between the peoples of the USSR and Africa." Contributors were promised an illustrated catalog and a diploma, and prizes were on offer for the best photographs.[92]

"Any kind of photos, irrespective of subject and technique" was welcome, though the call expressed "special interest" in the "national-independence struggle of African peoples, Soviet-African Friendship Relations, the building of new life in the young African states, the history and nature of the African continent." Enfolded within the invitation was a desire for photography to deliver African perspectives on the period of decolonization and early independence, one that arguably outlives the historical moment. Whether or not a visual record of the Moscow exhibition might be retrieved from the Soviet archives, it is not my intention to argue here for some kind of fundamental distinction between US and Soviet approaches. Tempting though that might be, the evidence seems likely to be more equivocal, and it is clear that the latter had its own political propaganda values, which would no doubt have steered the selection of images for exhibition. Nonetheless, the openness of this invitation to photographs by Africans, "irrespective of subject and technique," presents a striking contrast to a US preoccupation with telling its own story, and the agency's efforts to implant its own photographic values among employees and audiences on the continent. I am not aware of any comparable US initiative, and it seems unlikely USIA would have proposed an exhibition of this kind. One would likely search in vain for such African photographic perspectives in the US archives. The principal current of USIA photography flowed from the US to Africa, not the other way around, and the agency had no authority to educate the US public about the continent.

The second example comes from the agency's own advice to officers in the field. In the idealized world of the CPAO Handbook, the USIS information center was intended not only to provide a "visible US presence" in Africa but ultimately to become "an accepted *community institution*" (emphasis in original).[93] Yet the handbook also makes plain the reluctance to grant concessions to local photographic practices. After extolling the virtues of photography, the handbook authors added a cautionary note. The photographic section, it states, "needs close supervision," lest it become "a financial leak": "cameramen often include unnecessary and non-program shooting, and the darkroom is a natural pressure point for special favors, not only from superiors, but also from friends of employees."[94] From an organizational perspective this was no doubt sound advice, but at the same time it points to the local cultural values and alternative photographic aspirations that were unaccounted for within the agency's view of photography in Africa, and on which the US archives remain all but silent.

Epilogue

From the perspective of the present, it is hard to imagine how, in the early 1950s, a member of a working group in the Department of State could believe there was a possibility that the issue of race in the international perception of the US might simply fade away. In the years since, every claim that the US was putting its house in order has been refuted by reality, just as the symbolism of *Brown vs. Board of Education* (1954), which provided USIA with its first propaganda boost, was followed by the brutal murder of Emmett Till in 1955, from which the agency inevitably averted its gaze. At the time I began the research for this book, in 2015, the US was led by Barack Obama, the first African American to be elected president and, for many, a sign that the nation's democratic promise was open to all its citizens. The following year saw the official opening of the National Museum of African American History and Culture (NMAAHC) on the National Mall in Washington, intended, in the words of its director, to "propel a national conversation around race."[1] In the context of this study, NMAAHC's presentation of Thomas Jefferson, surrounded by a pile of bricks, each inscribed with the names of the enslaved individuals he owned, might be read as a long overdue rejoinder to an approach that half a century earlier led to the wax figure of a slave on George Washington's porch at Mount Vernon being discreetly moved offstage for the arrival of African visitors. Moreover, although the museum charts many of the same landmark events that appeared in USIA coverage of civil rights, in stark contrast to the agency's upbeat narratives of racial progress it asks visitors to look directly at Till's murder, replaying for a wider national and international audience the ways in which it had been witnessed at the time, by largely African American audiences, on the pages of *Jet* magazine and in Mamie Till-Mobley's decision that her son's brutalized body should be seen at the funeral in an open casket.

Yet, despite this open accounting of racial violence and injustice at the heart of the capital, within two months of the opening of the museum Donald Trump had been elected to the White House. Whatever the failures and disappointments of the Obama presidency, this marked an unwelcome turn in the US national conversation

on race, giving as it did renewed impetus to the forces of White supremacy. Efforts to address the legacy of racism in the US present have since been met with an increasingly violent reaction from newly empowered White nationalists, as, for example, in Charlottesville in 2017. Notwithstanding the progress achieved in the struggle for racial justice, when I first visited NMAAHC in 2018 this was the context in which its narrative had to be figured, a point that has only been reinforced by subsequent events. If, as Richard Johnson argues, US history is marked by periods of "democratic backsliding," then despite the defeat of Trump in the 2020 election, one should be mindful that the sharply divided present contains multiple risks to the future.[2] As I write now, in the wake of the verdict in the trial of Derek Chauvin for the murder of George Floyd on Africa Day 2020, it seems important to reflect on the value of a return to the Cold War photographic archive to an understanding of race in the US, and to ask what it means to look at these images now.

I could hardly have anticipated at the outset the ways in which these archival photographs would resonate with events as the research unfolded. The parallels are compelling. The engagement with independent Africa coupled with civil rights protests at home positioned race at the heart of USIA's photographic imagination. In many ways, the agency's photography presented a knowingly misleading picture of racial progress in the US, and thus might be understood simply as an act of bad faith. At the same time, the international circulation of civil rights images and the extent to which protests forced the US government to confront questions of racial injustice pushed the agency beyond its earlier limits. There are moments when one can glimpse the possibility of something more valuable emerging from this federal investment in an exercise of national imagining. As the Black Lives Matter (BLM) protests erupted on the streets of US cities, and elsewhere in the world, following the murder of George Floyd, race once again came to the fore in the worldwide perception of the US. Much in the way the USIA's Office of Research compiled reactions to events in Little Rock and Birmingham, the Washington-based Center for Strategic and International Studies (CSIS) sought to gauge reactions to the death of George Floyd from a range of African writers, journalists, and activists. The themes are familiar, reflecting on the damage to the moral authority of the US, the tenacity of racism in US society, and the country's ability to "work its angles," hiding its record of injustice from the world, only for it to periodically explode into full view. Several respondents regretted the waning of solidarity between citizens of African nations and African Americans, with one contrasting the mid-twentieth century, when the twin streams of anti-colonialism and civil rights were mutually reinforcing in their quest for racial justice, with a present in which one has "run dry while the other continues to boil."[3] In a further echo of the past, in its statement on Floyd's death the African Union made a point of "recalling"

the OAU Resolution on Racial Discrimination in the US made by African Heads of State and Government at their First Assembly Meeting in Cairo in 1964, reaffirming their "rejection of the continuing discriminatory practices against Black citizens of the United States of America."[4]

Despite the bleak picture of US society that Floyd's murder presented, however, it is worth noting the move to discern a more positive visual counternarrative in the racial choreography of protest. In the light of Carl Rowan's injunction that USIA should ensure African audiences were aware that the Freedom Riders of 1961 were White as well as Black, it was striking to see Cornel West, in an interview on CNN the day of George Floyd's funeral, identify the multi-racial character of the BLM protests that followed his killing as a source of hope and common humanity.[5] The producers inserted a short sequence showing a racially mixed crowd of protestors on the streets to reinforce the point visually. Whether such images serve to obscure ongoing structural injustices in favor of a liberal narrative of racial and democratic progress or are instead an invitation to join a multi-racial community of protest with deep roots is a matter of debate, but it is a debate to which the Cold War photographic archive can bring historical perspective.

Important as it is, however, race is not the only issue deserving attention. The postwar period was one in which, in contrast to its former isolationism, the US embraced a global role in a bipolar world. In the realm of diplomacy and soft power, this necessitated new ways of imagining the nation and its international relations. Photography provided one of the means through which this imagination operated. US involvement in international institutions of government after 1945 and the promotion of the US model of democracy in Africa and elsewhere featured prominently in USIA visual programs. The role of the US in shaping the postwar world order was hardly disinterested of course, but this, too, is an area in which there has been backsliding in recent years. Where USIA had once proudly disseminated images of US contributions to World Health Organization programs, the anti-internationalism of Trump's America First ideology led to its withdrawal from the organization in 2020.[6] Even if there was both hubris and a large measure of self-interest, not to say dedicated anti-communism, in the promotion of its own version of democracy to newly independent Africa, in a context where democracy now appears to be in retreat across the world, there are those who once more regret the failure of the US to live up to democratic principles. As one Malawian journalist put it to CSIS, "the biggest problem now is that the world, especially Africa, has no one to look up to for lessons in democracy."[7] That this comment was made before a presidential election that saw an assault on US democratic institutions, enacted in the form of "dark comedy," as Mike Davis put it, underlines the depth of the crisis.[8] In spite of this unpromising context, however, and the depth of the crisis

in US democracy, a return to the photographic archive of the postwar period may in some small measure serve the critical task of imagining afresh its place in the world.

All of this is to say little of the lives and afterlives of the images when they arrived in Africa. Nor does it shed much light on the potential of African readings of the archive in the present. What did African audiences really think of the material USIA circulated across the continent? In what ways did it shape or constrain their imagination of postcolonial African futures? What was its place within local visual imaginaries and economies? From the early 1960s, USIA placed considerable emphasis on the quality of its print production for Africa, viewed as a matter of respect. Comparisons with elsewhere in the world, where imported print products were sought out for the material quality of their paper and turned to other uses, suggest USIA output may have had a value for some audiences quite different than intended.[9] At the same time, it is testimony to the persistence of photographs that in recent fieldwork on mobile phone usage in northern Côte d'Ivoire, Till Förster observed that images of President Kennedy meeting with the country's first president, Félix Houphouët-Boigny, continue to circulate in the digital present, in picture collections transferred from phone to phone for a small fee.[10] The reception of photographs in their various material and immaterial forms can be both complex and unexpected.

The African reception of USIA photography is a major limitation of this study, which might first and foremost be seen as a contribution to US photographic history. If I have tried to remain attentive to how the images were received on the ground when they arrived in Africa, one must admit that the evidence is anecdotal and inevitably filtered through the perceptions and interests of agency field officers. The same is true of in-house photographic production by African field offices and locally trained photographers, which is only sparsely represented in USIA files. These aspects, then, must remain the task for future research. Despite its limitations, however, I hope that the present study enlarges an understanding of African photography in its broadest sense. In a call for more Africa-centered writing on photography, Patricia Hayes and Gary Minkley state, rightly, that "the so-called dark continent has its own histories of light."[11] I want to suggest two ways in which the material discussed here might be positioned in relation to the development of new African photographic histories. The first is to consider the USIA collections as part of a vast, dispersed African photographic archive, displaced from the continent, yet able to speak to its histories and its futures. The peculiar circumstances of these photographs, originally made in the US solely for distribution overseas, and now archived in College Park, Maryland, means that where they were once out of sight of the US public, they are now largely unknown to contemporary African scholars. Yet perhaps it is in the very condition of African archives to suffer various forms of destruction, dislocation, and decay; the devastating fire in

the African Studies reading room at the University of Cape Town Library in 2021 offers just the latest example.[12] If USIA collections might in some senses be considered part of an African photographic archive, however, this is not to minimize the very real practical barriers to access faced by those working and studying in Africa—very few of the photographs, publications, and documents have been digitized—limiting the extent to which the knowledge they contain might be repossessed from an African perspective.

The second point is that, notwithstanding what the archive reveals about the US self-image, it is also centrally concerned with Africa's place in the world after decolonization. Photography from the late colonial and early independence period has drawn considerable attention in recent decades, both internationally and from within Africa, yet the overwhelming focus has been on the genre of portraiture, often celebrated as a mode of individual self-fashioning. The photographs discussed here do not typically lend themselves to such readings. Nor is this the archive for those drawn by "the lure of nostalgia and redemptive narratives."[13] Instead, these photographs provide an insight into a period in which, to use James Ferguson's term, African "membership" in contemporary global modernity was being negotiated, including its forms of diplomacy and exchange.[14] As Ferguson makes clear, however, the terms of membership, or as often exclusion, are far from settled. For contemporary Zambian mine workers, for example, the modern is not so much "an anticipated future" as "a dream to be remembered from the past."[15] At the same time, some parts of Africa seem to be experiencing a new wave of digital photographic futurism, as Richard Vokes describes in Yoweri Museveni's Uganda.[16] In this context, the photographic archive might prompt a return to the questions posed by decolonization, as articulated by Achille Mbembe: "Who are we and where are we in the present? What do we want to become? And what must we hope for the world?"[17]

USIA photography took shape during a period of openness and world-making. Yet its relation to that moment is fundamentally ambivalent, reflecting not only hope for a better world after the traumas of the Second World War and colonialism but also a concerted effort to shape the imagination of the future in a particular direction and to foreclose alternatives, not least in relation to African decolonization. The scope it offers for the retrieval of alternative futures or resistance to global forces is limited, and African voices are largely absent. In response to Mbembe's second question, one should observe that the USIA photographic archive primarily comprises a visual guide to a series of answers ready-made in the US for export to the continent. African futures imagined elsewhere. In that sense, it contributes to an archive of "false independences," which have seen the continued subjection of Africa to political and economic forces from outside at the same time as its own leaders have let go the promise of liberation.[18] It demands a critical perspective. Or to put it another way, in the

words of Mbembe again, "Is there really anything at all to commemorate, or, to the contrary, must everything be taken up again?"[19] If the USIA photographic archive can serve as a place to do "decolonial work"[20] or contribute to "the project of the Africa to come,"[21] then it must first be, in Ariella Azoulay's terms, a place of "unlearning"[22]— a place to revisit and deconstruct the political, pedagogical, and imaginative dimensions of US engagement with racial injustice at home and decolonization in Africa through photography.

Appendix: Archival Series Abbreviations

All other series are given in full.

Lyndon B. Johnson Presidential Library, Austin, Texas

AH	Administrative Histories
LMP	Personal Papers of Leonard H. Marks
NSF	National Security File
WHA	Office Files of White House Aides
WHCF	White House Central Files
WHCF Confidential	White House Confidential Files

National Archives and Records Administration, College Park, Maryland

Record Group 59, General Records of the Department of State

CDF	Central Decimal File
RIIA	Records Relating to International Information Activities

Record Group 306, Records of the United States Information Agency

AHP	Agency History Program Subject Files
FS	USIS Filmstrips
IAA	Office of the Assistant Director for Africa
ICS	Information Center Service
IOR	Office of Research
MFP	Master File Copies of Field Publications
MPL	Master File Copies of Pamphlets and Leaflets
PAM	Photographs Assembled for Pamphlet Production Relating to US Political, Economic, and Cultural Life
PB	Photo Bulletin
PS	Master File Photographs of US and Foreign Personalities, World Events, and American Economic, Social, and Cultural Life
SF	Subject Files
SFD	Subject Files of the Director

SS	Staff and Stringer Photographs
SSA	Photographs from Staff and Stringer Photographic Assignments Relating to US Political Events and Social, Cultural and Economic Life
ST	USIA "Picture Story" Photographs
TMP	Photographs Assembled for *Topic* Magazine Coverage of Political, Economic, and Cultural Life in the United States and Africa

Notes

Preface

1. See Newbury, "Ernest Cole and the South African Security Police" and "Ernest Cole's *House of Bondage*." A document recently discovered by James Sanders reveals that USIS field officer Argus Tresidder was also involved in the storage and movement into exile of Cole's photographs. Argus Tresidder to Ernest Cole, January 1, 1968, A3340, A1: Correspondence, 1967–69, Ernest Cole Photographic Collection and Papers, Historical Papers Research Archive, William Cullen Library, University of the Witwatersrand, Johannesburg. See Sanders, "Spearpoint Pivoted."

2. "Program Highlights: December 1–31, 1959," USIS Pretoria to USIA Washington, January 25, 1960. ICS Country Files, 1959–1966, Box 4.

Chapter 1

1. "Psychological Warfare and Propaganda. 10.025—Racial Propaganda." IOR Research Project Files, 1954–1985, Box 14. Unless otherwise stated, subsequent references in this section are to documents collected in this file.

2. On earlier attention to the foreign policy implications of domestic racism, see Hart, *Empire of Ideas*, 95.

3. See also Belmonte, *Selling the American Way*, 161–4.

4. The term "Third World" here refers to the political project and, to use Parker's expression, "philosophical nucleus," composed of "nonalignment, underdevelopment, race consciousness, and anticolonialism." Parker, *Hearts, Minds, Voices*, 169.

5. The international political implications of this parallel were not lost on the Americans: prosecution charges at Nuremburg were shaped to ensure that the US could not be similarly held to account for racial crimes at home. Olick, *In the House of the Hangman*, 107–8.

6. On the "budding mutual affinity between the leaders of the Indian civil disobedience and African American civil rights movements," see Parker, *Hearts, Minds, Voices*, 26.

7. *The Negro in American Life*. MPL, 1953–1984, Box 16.

8. "Minorities in the United States." IAA Country Files, 1953–1961, Box 11.

9. "Basic Guidance and Planning Paper No. 5," December 4, 1958. AHP, 1967–1975, Box 5.

10. For discussion of an earlier, short-lived attempt by the OWI to reach African audiences through photography, see Dentler, *Wired Images*, chapter four.

11. Dudziak, *Cold War Civil Rights*; Borstelmann, *Cold War and the Color Line*; Parker, "Cold War II"; Parker, *Hearts, Minds, Voices*; Plummer, *Window on Freedom*.

12. Parker, *Hearts, Minds, Voices*, 27.

13. Dudziak, *Cold War Civil Rights*, 12.

14. Parker, *Hearts, Minds, Voices*, 1.

15. Anderson, *Imagined Communities*; Chatterjee, *Politics of the Governed*.

16. Allbeson, "Photographic Diplomacy in the Postwar World," 4.

17. Ibid., 7. See also Röderer, "How to Educate the World," 84–5. A precedent for the perceived capacity of photography to foster a sense of global citizenship in the postwar period can be seen in the lantern slide lectures produced by the British Colonial Office Visual Instruction Committee in the early part of the century, intended to

interpellate colonial subjects as citizens of the Empire—"to teach the empire's schoolchildren what it meant *to look* and *to feel* like an imperial citizen" (original emphasis). Moser, "Photographing Imperial Citizenship," 192.

18. Hazard, *Postwar Anti-Racism*.
19. Stimson, *Pivot of the World*, 5.
20. Ibid., 11.
21. Morris-Reich, *Race and Photography*, 136.
22. Ibid., 142.
23. Ibid., 154. On photography in National Socialist exhibitions, see Pohlmann, "El Lissitzky's Exhibition Designs," 182–8.
24. Morris-Reich, *Race and Photography*, 186.
25. See O'Donnell, "Executioners, Bystanders and Victims," 627.
26. See, for example, Gigliotti, "Displaced Children of Europe," 165.
27. Azoulay, "Ending World War II," 164.
28. Ibid., 162. For good or ill, many decolonized African nations shared this framework, placing the emphasis on "the right of Africans to become legal communities," rather than the human rights of individuals. Bernault, "What Absence is Made of," 136–8.
29. The photographs in *We Europeans* were appropriated from an article in the BBC magazine *The Listener*, indicating that this counter to racist and eugenicist imagery was not confined to scientific circles.
30. Quoted in Turner, "*Family of Man*," 62.
31. *Courier* III, no. 6–7 (July–August 1950). Just two years later, USIA chose "a composite United Nations photo, faces of people of different races" for the first cover of its Asia-based magazine *Free World*. See Interview with Earl Wilson, October 14, 1988: https://www.loc.gov/item/mfdipbib001273/ (accessed February 17, 2021).
32. Ariss, "Exhibit Use of Anthropology"; Shorr, "Race Prejudice is Not Inborn." Installation photographs of the exhibition once held by the Natural History Museum of Los Angeles County now appear to be lost. Yolanda Bustos, personal communication, March 26, 2021.
33. Quoted in Brattain, "Race, Racism, and Antiracism," 1407–8.
34. Ibid., 1407.
35. Schmidt-Linsenhoff, "Denied Images," 81. A note of caution, however. It is historically inaccurate to read the photographs of the Nazi camps as being of the Holocaust since that interpretation has its own history and

was the result of a campaign that "imposed a political vision on a photographed catastrophe." Azoulay, "Ending World War II," 167.
36. Schmidt-Linsenhoff, "Denied Images," 81.
37. Quoted in James, *Common Ground*, 65. Part of the explanation for the absence of images of horror, especially in the material produced by UNESCO, may lie in the fact that the principal goal was no longer to confront the guilty but rather to educate a new generation, not tainted by the crimes of the past, away from the racial ideas that had proved so disastrous.
38. For a nuanced discussion of this shift, see Olick, *In the House of the Hangman*, 334–5.
39. James, *Common Ground*, 69.
40. *We Charge Genocide: The Crime of Government Against the Negro People* was edited by William Patterson and presented to the UN by Paul Robeson in 1951. Patterson expressed regret that a later petition in support of colonial peoples did not cite *We Charge Genocide*, linking racial conflict in the US with anti-colonialism and exposing the hypocrisy of US politicians. Weiss-Wendt, *Documents on the Genocide Convention*, No. 350.
41. Ibid., No. 344.
42. Turner, "*Family of Man*," 83.
43. Zamir, "Structures of Rhyme, Forms of Participation," 144.
44. Barthes, *Mythologies*, 108.
45. Zamir, "Structures of Rhyme, Forms of Participation," 155.
46. Truman quoted in Hazard, *Postwar Anti-Racism*, 17.
47. Quoted in Hazard, *Postwar Anti-Racism*, 19.
48. Natanson, *Black Image*, 84.
49. The overseas offices of the USIA retained the older designation of USIS, by which the agency was known to foreign citizens. USIA inherited some of its photographic infrastructure and staff from the FSA, via the Office of War Information (OWI).
50. Natanson, *Black Image*, 218.
51. Ibid., 220.
52. Ibid.
53. Quoted in ibid.
54. Schwenk-Borrell (*Selling Democracy*, 75–78) and Belmonte (*Selling the American Way*, 170) both argue that images of African American families were rare in USIA coverage of the 1950s, without reference to this image. Belmonte also mistakes the father on the cover for the African of the title.
55. Natanson, *Black Image*, 219.

56. Hazard, *Postwar Anti-Racism*, 115. Hazard discusses this special issue, though not the photographs.

57. Ibid., 113, 120.

58. Parker, "Cold War II," 868.

59. Hazard, *Postwar Anti-Racism*.

60. Stimson, *Pivot of the World*, 10.

61. Parker, "Cold War II," 870.

62. Ibid., 885.

63. Quoted in ibid. On the significance of Bandung, and its subsequent interpretation, see also Vitalis, "Midnight Ride of Kwame Nkrumah." Vitalis argues that scholarship on Bandung has tended to elide the differences between non-alignment and global racial consciousness, in effect echoing readings motivated by support for political solidarities, both at the time and subsequently. A majority of delegates, Vitalis argues, did not see race as a unifying force—in fact, racial talk was anathema (270). Gerits argues similarly that the emphasis on race reflected a US perspective: "Liberationist thinkers such as Frantz Fanon or postcolonial statesmen like Ghana's leader Kwame Nkrumah . . . were working to reach the opposite goal: the elimination of race as a factor in international relations." Gerits, "Jason Parker," 10.

64. The book was compiled by the Dutch publishing house Djambatan Ltd. The original text was in Indonesian and Dutch, translated into English for a later edition. On the visual record of the conference, see Lee, "Decolonising Camera."

65. Rand, "Book Reviews," 597.

66. For a critical perspective on the common ground between European imperialism and Third World nationalisms, see Chakrabarty, *Provincializing Europe*, chapter one.

67. Rand, "Book Reviews," 597.

68. Cowan, "World on the Move."

69. Ibid., 199 (emphasis added).

70. Rand, "Book Reviews," 597.

71. Edwards, "Photographs and the Sound of History," 31.

72. Vokes, "On 'the Ultimate Patronage Machine,'" 224.

73. Kunkel, *Empire of Pictures*, 40.

74. Chatterjee, *Politics of the Governed*, 5. See also Azoulay's notion of "civil imagination": "The interests that citizens display in themselves, in others, in their shared forms of coexistence, as well as in the world that they create and nurture." Azoulay, *Civil Imagination*, 5.

75. Nash, *Red Africa*. See also Vučetić and Betts, *Tito in Africa*.

76. Plummer, *Window on Freedom*, 3. Carol Anderson charts the opening and closing of the space for engagement with transnational anti-colonial struggles in the context of the Cold War. Anderson, *Bourgeois Radicals*.

77. Bajorek, *Unfixed*, xxxi.

78. Phu, Duganne, and Noble, *Cold War Camera*.

79. See, for example, *The Eye Behind the Camera's Eye*, Picture Story No. 726. ST, 1955–1984. All subsequent references with the prefix ST are from this series.

80. S-27–54, "Study of USIA Operating Assumptions." IOR Special Reports, 1953–1997, Boxes 5–6. The first of these examples is also cited in Parker, *Hearts, Minds, Voices*, 78. On the colonial association of color with "the primitive," see Taussig, *What Color is the Sacred?* On color photography in the context of Southern Africa, see Hayes, "Colour of History."

81. Morton and Newbury, *African Photographic Archive*, 5.

82. Jafri, *Independence Days*.

Chapter 2

1. "Photography a Vital Asset" by Leonard Marks, *Industrial Photography*, October 1967. SF, 1953–1999, Box 162.

2. Cull, "Public Diplomacy: Taxonomies," 40.

3. Cull, *Cold War*, 20. The administrative history of the information programs is more complicated than warrants a full account here. I have endeavored to use the nomenclature appropriate to the point in time being discussed without making things unduly difficult for the reader.

4. Ibid., 28.

5. "INP photo contracts for FY 1949," June 17, 1948. RIIA, 1938–1953, Box 155.

6. Dizard, *Inventing Public Diplomacy*, 39.

7. Ibid., 38.

8. Cull, *Cold War*, 28.

9. "INP photo contracts for FY 1949," June 17, 1948. RIIA, 1938–1953, Box 155.

10. Ibid.

11. "The Future Organization and Operations of the Publications Branch, INP—A Staff Study," 1952. SF, 1953–1999, Box 163.

12. Belmonte, *Selling the American Way*, 151.

13. "USIA Tells US Story with Pictures: Part II," *Popular Photography*, December 1965. SF, 1953–1999, Box 162.

14. Hart, *Empire of Ideas*, 112.

15. Dizard, *Strategy of Truth*, 41.

16. Bezner, *Photography and Politics in America*, 48–49, 129.

17. MacLeish cited in Hart, *Empire of Ideas*, 109.

18. Dizard, *Inventing Public Diplomacy*, 40–44.

19. Cited in Wang, "Telling the American Story," 24.

20. This interpretation of the Smith-Mundt Act became increasingly explicit. Cull, *Cold War*, 40.

21. "USIA Administrative History," 1–4. AH, Box 1.

22. "USIA Administrative History," 1–5. AH, Box 1. Subsequent quotations from the mission statement are from this source.

23. Saunders, *Cultural Cold War*.

24. Parker, *Hearts, Minds, Voices*, 68–70. On coordination in Guatemala following the US-supported coup d'état of 1954, see Cull, *Cold War*, 121.

25. For example, Project Kingfish subsidized newsreels produced by MGM for distribution in Africa and Asia. It was ended in 1967 due to concerns over the damage it would do the agency's credibility should it be exposed. Leonard H. Marks, "Memorandum for the President," February 2, 1967. WHCF Confidential, Box 33. See also Cull, *Cold War*, 282.

26. Schwenk-Borrell, *Selling Democracy*, 30.

27. "USIA Basic Guidance Paper," 1957. AHP, 1967–1975, Box 5. Andreas Feininger's photography for the OWI provides an early example of photography deployed by the US in the service of a "strategy of truth," although his European modernist industrial aesthetic with its emphasis on geometric form, surface, pattern, and light—"the cold, hard, and beautiful facts of industrial superiority"—was quite different from the photographic humanism more typical of US government photography. Swensen, "Strategy of Truth," 88.

28. Cull, "Public Diplomacy: Taxonomies," 31.

29. Cull, "Public Diplomacy Before Gullion."

30. Cull, "Film as Public Diplomacy," 258.

31. Schwenk-Borrell, *Selling Democracy*, is focused specifically on the film program through until 1976.

32. "Picture story and assignment list for coming six months," William Bennett, Chief, Acquisitions Section, to Eugene V. Brown, Chief, Photographic Branch, INP, April 26, 1950. RIIA, 1938–1953, Box 155. Subsequent citations here are from this document or attachments.

33. "Suggestions for Photographic Assignments," Marion K. Sanders, Chief, Magazine Branch, INP, to Eugene Brown, Picture Branch, INP, July 25, 1950. RIIA, 1938–1953, Box 155. Several of the above-mentioned assignments were distributed as filmstrips. *Catalogue USIS Filmstrips*. FS, 1942–1952. All subsequent references with the prefix FS are from this series.

34. Natanson, "Old Frontiers, New Frontiers."

35. The figures and quotations in this section come from three sources, all relating to 1950–1: "International Press and Publications Division Fact Sheet" and "Photographic Program." SF, 1953–1999, Box 163; "Campaign of Truth: The International Information and Educational Exchange Program, 1951." SF, 1953–1999, Box 1; "International Press and Publications Division (INP)." Records Relating to the International Press Service, 1948–1954, RG306.

36. On lantern slide lectures as an imperial mode of instruction, see Ryan, *Picturing Empire*, 190–91.

37. "Some changes in USIA since March 1961," Office of Public Information to USIA Employees, October 28, 1963. AHP, 1967–1975, Box 5.

38. "USIA: Its Purposes, Audience and Programs," AH, Box 2.

39. "Survey of Field Posts/Visuals," Harry S. Casler, IPS, to Charles P. Arnot, IPS, July 25, 1952. Records Relating to the International Press Service, 1948–1954, RG306.

40. The country and city names used in the text are consistent with the archival documents and the historical period being discussed; where this differs from present-day names, these are given in parentheses on first use.

41. "Agency History," Murray Lawson. AHP, 1967–1975, Box 8. On the origins of the Division of Cultural Relations, see Hart, *Empire of Ideas*, 23–24.

42. "United States Information Program in Africa, 1945–70: A History and Interpretation," Peter L. Koffsky. AHP, 1967–1975, Box 9. Koffsky was an agency intern tasked with writing a history of the Africa Program by Murray Lawson in 1970. The document is an unpublished draft and hence needs to be treated with some caution but given the

relative paucity of historical accounts of the Africa Program it is nonetheless a useful source.

43. The following section draws on the Country Papers for British East Africa (August 1950), French Equatorial Africa (December 1950), French West Africa (August 1950), the Gold Coast (August 1950) and Nigeria (February 1950). RIIA, 1938–1953, Box 41.

44. Vokes, *Media and Development*, 9. See also Rice, "Exhibiting Africa" and "From the Inside."

45. For a more sophisticated account of African responses to colonial film, see Newell, "Last Laugh" and "Screening Dirt."

46. FS-250 and FS-276.

47. Griff Davis had worked as a freelance photographer, publishing several stories in *Ebony* in the late 1940s before traveling to Liberia.

48. The conception of the postcolonial subject in these terms was widely shared. See, for example, Sluga, "UNESCO," 414.

49. Gerits, "Hungry Minds," 616.

50. Truman and Kennedy saw education in more instrumental terms, as means of sharing scientific advances, promoting economic growth, and producing human resources. Ibid., 610.

51. Ibid., 594.

52. Turner, "*Family of Man*," 58. For a historicization of the display techniques deployed in *The Family of Man* and their transportation into the US context via figures such as Herbert Bayer, see Ribalta, *Public Photographic Spaces*.

53. Although Eisenhower, like Churchill, held a paternalistic view of Africans, he departed from the latter with respect to the need for persuasive argument. Gerits, "Hungry Minds," 599. See also Newell, "Paradoxes of Press Freedom," 101.

54. The filmstrip program was discontinued in 1954, aside from a single filmstrip on racial equality tested with African audiences in 1962. "Evaluation of Experimental IPS Filmstrip 'Toward Equal Opportunity' by Ten Agency Posts in Africa," June 1962. IOR Program and Media Studies, 1956–1962.

55. "US Information Program in Africa," AHP, 1967–1975, Box 9.

56. Gerits, "Hungry Minds," 602.

57. "US Information Program in Africa," AHP, 1967–1975, Box 9.

58. "Outline Plan of Operations for the US Ideological Program," June 3, 1955; "Urban Native Attitude Trends Cause Concern; Need for Positive and Expanded USIS Program," May 5, 1958. CDF, 1955–1959, Boxes 2138–39. See also Stoner, "Selling America."

59. "US Information Program in Africa," AHP, 1967–1975, Box 9; Gerits, "Hungry Minds," 605.

60. The image is available on the website of ShareAmerica where it continues to play a role as part of US public diplomacy: https://share.america.gov/griff-davis-life-in-photography-and-diplomacy/ (Accessed March 3, 2019).

61. Beneath the symbolism, the export of cocoa was subject to Cold War calculation, with the Soviet Union offering to increase its purchases as part of an effort to win the Ghanaian government over to a socialist model of development and the US and Britain exerting pressure on them to resist such overtures. Iandolo, "Rise and Fall," 688.

62. "Salute to Ghana Independence," 1957–1958. MFP, 1951–1979, Box 124.

63. See Gerits, "Hungry Minds," 614.

64. Gerits suggests *Outlook* began in March 1952 as a weekly pamphlet published in a print run of 750. Gerits, "Ideological Scramble," 49.

65. Distribution November 1957: Ghana (55,000), Nigeria (45,000), Liberia (500), Gambia (500), Sierra Leone (500). MFP, 1951–1979, Boxes 89–90.

66. "US Information Program in Africa," AHP, 1967–1975, Box 9.

67. Memo from Edward Murrow to Ray Mackland, IPS, February 5, 1962. SFD, 1956–1972, Box 39.

68. *Topic* was a replacement for both *American Outlook* and *Perspectives Americaines*, which were quietly dropped. Telegraph to USIS Accra and USIS Leopoldville from Carl Rowan, April 12, 1965. IAA Correspondence Files, 1953–1967, Box 3.

69. "Guidelines for Africa Magazine," April 1965. IAA Correspondence Files, 1953–1967, Box 3. USIA reported that the Soviet Union launched a competitor within 18 months, under the title *Polar Star*. "Biweekly Report," for the President, October 3, 1967. WHA, Frederick Panzer, Box 422.

70. The RPCs were renamed Regional Service Centers (RSCs). The series print run for 1962 was 2,957. "Fact Sheet: Program in Africa," November 16, 1962. SFD, 1956–1972, Box 39. On the origins of World Photo

Review in Manila, see Interview with Earl Wilson, October 14, 1988: https://www.loc.gov/item/mfdipbib001273/ (accessed February 17, 2021).

71. Cull, *Cold War*, 145.
72. "US Information Program in Africa," AHP, 1967–1975, Box 9. See also Cull, *Cold War*, 183.
73. The depth and sincerity of Kennedy's interest in the continent is a matter of some debate among historians. See Muehlenbeck, "John F. Kennedy's Courting of African Nationalism."
74. "Fact Sheet: Program in Africa," November 16, 1962. SFD, 1956–1972, Box 39; "US Information Program in Africa," AHP, 1967–1975, Box 9.
75. "Some changes in USIA since March 1961," Office of Public Information to USIA Employees, October 28, 1963. AHP, 1967–1975, Box 5.
76. "Analysis of the Press in Africa," Carl T. Rowan, March 24, 1961. IAA Policy Files, 1959–1967, Box 10.
77. Gerits, "Hungry Minds." The agency's Office of Research produced regular reports on communist propaganda activities, Soviet and Chinese, noting, for example, that by 1964 the latter had begun distributing its *China Pictorial* in Swahili, as well as subsidizing local media production.
78. The Czech News Agency provided training for photographers, editors, and journalists. Muehlenbeck, *Czechoslovakia in Africa*, 15.
79. Edward Roberts cited in "Analysis of the Press in Africa," Carl T. Rowan, March 24, 1961. IAA Policy Files, 1959–1967, Box 10.
80. "US Information Program in Africa," AHP, 1967–1975, Box 9.
81. "Examples of Communist Bloc Aid to African Mass Communications Media," Edward R. Murrow to Alfred H. Landon, May 18, 1962. SFD, 1956–1972, Box 39.
82. "US Information Program in Africa," AHP, 1967–1975, Box 9. Carl Rowan seemed more skeptical of the value of appointing African American staff. "Colonialism Defined as Racism," memorandum from Lawrence J. Hall, Deputy Assistant Director, Africa, to Donald M. Wilson, Deputy Director, August 31, 1961. Reports and Studies, 1953–1998, RG306.
83. Murrow cited in "US Information Program in Africa," AHP, 1967–1975, Box 9.
84. Wilson cited in ibid.

85. Memo from Edward Murrow to Edward Roberts, May 30, 1961; Memo from Thomas Sorensen to Edward Murrow, June 1, 1961. SFD, 1956–1972, Box 23. The latter suggestion was countered by Thomas Sorensen, then head of the Office of Plans.
86. "African Public Opinion: Implications for USIA," May 12, 1961. SFD, 1956–1972, Box 23.
87. For an analysis of this propaganda strategy, see Heiss, "Exposing 'Red Colonialism.'"
88. Although it is beyond the scope of this study, it is important to recognize that newly independent African nations had their own media and public diplomacy strategies. See, for example, "African View of World Media," memo for Donald Wilson, Thomas C. Sorensen, and George Stevens, from Lawrence J. Hall, December 18, 1963. SFD, 1956–1972, Box 56. See also Gerits, "Ideological Scramble"; Gerits, "When the Bull Elephants Fight"; and Gerits, "Hungry Minds."
89. The reference to USIA being the "prisoners" of US foreign policy comes from remarks by Edward Murrow, cited in "USIA Administrative History," 1–9. AH, Box 1. All other quotations in this paragraph come from "African Public Opinion: Implications for USIA," May 12, 1961. SFD, 1956–1972, Box 23.

Chapter 3

1. PSB-53–6642. PS, ca. 1953–ca. 1994.
2. United Nations, *Looking at the United Nations*, 23.
3. "Reports of the United Nations Visiting Mission to Trust Territories in West Africa and Related Documents," Official Records of the Seventh Session of the Trusteeship Council, June 1–July 21, 1950, Supplement No. 2 (T/798), New York, 1951.
4. Ibid., 4.
5. Ibid., 5. This aspect of the Mission also attracted the prurient attention of the *New York Times*. Barrett, "Centenarian Fon of Bikom."
6. "Reports of the UN Visiting Mission," 28.
7. Ibid., 4.
8. Ibid., 30. On the disappointment in the UN felt by many Cameroonians, see Terretta, "We Had Been Fooled" and "From Below and to the Left?"
9. Center, "Supranational Public Diplomacy," 145. The phrase "Trust Territory Man" and

the quotations cited by Center come from the UN pamphlet, *A Sacred Trust: The United Nations Work for Non-Self-Governing Lands*, fourth revised edition, 1959.

10. On the importance of petitioning to a history of decolonization and human rights discourse, and the use of photographs of crowds by petitioners to the UN to demonstrate popular feeling, see Terretta, "We Had Been Fooled," 345.

11. Parker, *Hearts, Minds, Voices*, 12. See also Mazower, *Governing the World*, 214–43.

12. Parker, *Hearts, Minds, Voices*, 43.

13. FS-242.

14. Parker, *Hearts, Minds, Voices*, 59.

15. ST-222, *World Counts Its UN Blessings*.

16. ST-413, *Spotlight on the United Nations*.

17. ST-470, *Preparing for a Big Session*.

18. ST-553, *A Day at the UN General Assembly*.

19. ST-639, *Gifts to the United Nations*; ST-908, *Growing up with the United Nations*. IPS Photo Bulletin, 10. PB, 1964–1973, Box 1.

20. ST-618, *What Lies Ahead for Refugees*. World Refugee Year began in July 1959.

21. Muehlenbeck, *Betting on the Africans*, 123.

22. ST-406, *Independence Day Around the World*.

23. ST-509, *UN Trains Youth in International Relations*.

24. Gerits, "Hungry Minds," 599.

25. Ibid., 614.

26. Cited in ibid., 610. SS-1–7341, "President Eisenhower as he made his speech before the United Nations" (Photographer: Larry Riordan), September 22, 1960. SS, 1949–1969. All subsequent references with the prefix SS are from this series. Note file dates for all staff and stringer photographs indicate when they entered the USIA collection, which can sometimes differ from the production date.

27. US complicity in the assassination has been much debated. See, for example, De Witte, *Assassination of Lumumba*.

28. Photographs Collected for the Presentation *Man Shall Walk Free on the Earth*, ca. 1953–ca. 1960, RG306.

29. The first of these photographs was sourced from Lawrence Hata Photo—Hawaiian Visitors Bureau. The other three came from *The Family of Man*, and were by, respectively, Anna Riwkin-Brick, Homer Page, and Henri Cartier-Bresson. The photo-essay also included the photograph of the African American couple gazing at their newborn child that had previously appeared in

Courier (see chapter one), identified as Mr. and Mrs. Bernard Johnson.

30. Taken by *Life* magazine photographer Terry Spencer.

31. Although not named in the USIA files, this photograph was made by Todd Webb while touring several African countries on a photographic commission for the UN Office of Public Information. See Bessire and Nolan, *Todd Webb in Africa*.

32. On the Togoland Congress and Togo politics, see Yayoh, "Local Black Resistance," 78–105; and Thompson, *Ghana's Foreign Policy*, 81–87.

33. Center, "Supranational Public Diplomacy," 149–55. Center refers to photographs used in the 1973 UN Mission to Guinea (Bissau) as one example.

34. Azoulay, "*Family of Man*," 48.

35. Ibid., 44.

36. Wilder, *Freedom Time*. Bajorek argues that the "dashed" dreams of decolonization trouble any return to photographs expressive of an anti-colonial imagination. Bajorek, *Unfixed*, 240–42. In contrast, photographs of African leaders in the USIA collection might be considered to picture them in the process of compromising the more radical visions of liberation.

37. Photographs of official visits form two series: Duplicates of Photographic Albums Presented to Visiting Heads of State, 1949–1963; and Photographs of Visiting Dignitaries to the United States, 1961–1990, RG306.

38. These albums typically took several months and were expensive to produce. In the early 1960s, a more timely and efficient approach was adopted, saving 70 percent on costs and 50 percent on man-hours. "Replacement of Presidential Presentation Albums," Memo from Donald Wilson to Ray Mackland, IPS, April 19, 1963. SFD, 1956–1972, Box 63; and "Some changes in USIA since March 1961," Office of Public Information to USIA Employees, October 28, 1963. AHP, 1967–1975, Box 5.

39. Photographs of the state visit of Liberian President Edwin Barclay in 1943 are available in the OWI Collection, Library of Congress.

40. The quotation here is a reference to the album produced for President Habib Bourguiba's visit with Kennedy in 1961. Memo from Edward Murrow, USIA Director, to Walter Walmsley, US Ambassador, Tunis, February 28, 1962. SFD, 1956–1972, Box 39.

41. Kunkel, *Empire of Pictures*, 25.

42. SS-3–10094, "Lady Chesham Tanganyika member of Parliament" (Photographer: Rohn Engh), February 9, 1962.

43. "Locally-produced Malagasy-language pamphlet on American Activities in Malagasy Republic," USIS Tananarive to USIA Washington, September 2, 1964. MFP, 1951–1979, Box 295.

44. Chakrabarty, *Provincializing Europe*, 8.

45. Vokes, "On 'the Ultimate Patronage Machine,'" 223–25. Vokes discusses the place of photography within intimate exchange relations in Southwestern Uganda, and the extension of this into a conception of local political agency. This is not to suggest any specific attention to African photographic ontologies on the part of US information officers but a broader point about the medium.

46. *Salute to Ghana Independence*. MFP, 1951–1979, Box 124.

47. Gerits, "Hungry Minds," 618. The "'psychotic concern' with the issue of race relations" that USIA attributed to Nkrumah is one that the agency appeared to share.

48. Meriwether, "Worth a Lot of Negro Votes," 745.

49. *American Outlook*, August–September 1958. MFP, 1951–1979, Boxes 89–90.

50. SS-1–7339, "President Nkrumah of Ghana meets President Eisenhower at the Waldorf" (Photographer: Jack Lartz), September 22, 1960; SS-31–7345, "President Eisenhower and the President of the Togoland Republic, Sylvanus Olympio" (Photographer: Jack Lartz), September 23, 1960.

51. Muehlenbeck, *Betting on the Africans*, 98.

52. Ibid., 9.

53. Gerits, "Ideological Scramble," 150. US information officers in the field described coverage of Nyerere's visit in early 1960 as "splendid." "Salisbury Program Highlights for January and February 1960," USIS Salisbury to USIA Washington, March 1, 1960. ICS Country Files, 1959–1966, Box 2.

54. Gerits, "Hungry Minds," 616, 619. Gerits attributes the "cake and eat it" comment to the Bureau of International Cultural Relations; the reference to "natives" is attributed to Eisenhower. See also "Memorandum of Discussion at the 375th Meeting of the National Security Council," August 7, 1958, *Foreign Relations of the United States Africa, 1958–1960*, volume XIV, document 6.

55. Gerits, "Hungry Minds," 620.

56. Muehlenbeck, *Betting on the Africans*, 65–66. The story has a somewhat mythical quality, suggesting a certain desire for the reach of the Kennedy image in equal measure to what it might reveal about rural Guinea.

57. After returning home from his visit with President Kennedy in 1962, Touré dispatched a signed photograph of himself, inscribed with the message: "With the assurance of our desire for friendly cooperation with the Government and the people of America." Cited in Muehlenbeck, "Kennedy and Touré," 83.

58. Romano, "No Diplomatic Immunity," provides a detailed account of Sanjuan and the SPSS.

59. Ibid., 565.

60. AR6542-A, "President John F. Kennedy Meets with William H. Fitzjohn, Charge d'Affairs of Sierra Leone," April 27, 1961. JFK Presidential Library and Museum.

61. "Big Step Ahead on a High Road: The Racial Anger that Inflamed Route 40 Yields to Hard Work and Common Sense," *Life*, December 8, 1961, 32–39.

62. SS-6–11433, "Alexandre Adande, Dahomean Minister of Agriculture" (Photographer: Luis Morales), November 1, 1962. This was a field request from USIS Dahomey.

63. SS-6–11435, "President of National Assembly of Ivory Coast—Mr. Yace visits G.M." (Photographer: Bill Brunk), November 2, 1962.

64. SS-31–1465, "Nigerian Foreign Minister Visits NASA" (Photographer: George Szabo), October 21, 1963. The satellite conversation was featured in a comic book distributed to Africa. *Let's Explore Outer Space*, USIA Pamphlets, LMP, Boxes 10–13.

65. SS-5–11240, "Salah Dessouki, Governor of Cairo" (Photographer: Bill Brunk), September 26, 1962.

66. MFP 1951–1979, Box 240.

67. Memo from Donald M. Wilson, USIA Deputy Director, to Ralph A. Dungan, Special Assistant to the President, April 17, 1961. SFD, 1956–1972, Box 23. For Kennedy's speech, see US Government Printing Office, *John F. Kennedy*, 280–82.

68. Muehlenbeck, *Betting on the Africans*, 185.

69. SS-2–8960, "Miriam Makeba at Africa House" (Photographer: George Szabo), June 28, 1961.

70. Muehlenbeck, *Betting on the Africans*, 188.

71. Stoner, "Selling America," 172.

72. Ibid., 164.

73. Muehlenbeck, *Betting on the Africans*, 100.

74. SS-2–9044, "Prime Minister Julius Nyerere meets with Secretary Hodges" (Photographer: George Szabo), July 17, 1961.

75. On Nyerere's ambitions for the visit, see Muehlenbeck, *Betting on the Africans*, 115–16.

76. *Viongozi wa Amani: Mwalimu Nyerere Amtembelea Rais Kennedy* (Leaders for Peace: Mwalimu Nyerere visits President Kennedy), USIS Dar es Salaam, October 1963. MFP, 1951–1979, Box 268. See also Kunkel, *Empire of Pictures*, 72.

77. Kiruthu, "Kaunda, Kenneth," 310–12.

78. SS-14–753, "Solomon Kalulu of Rhodesia with United Nation background" (Photographer: Joseph Pinto), May 27, 1963.

79. SS-11–595, "Secretary Williams and Mr. Augustine Bwanauski, Minister of Works and Housing of Nyasaland" (Photographer: George Szabo), May 1, 1963; SS-11–594, "Secretary Williams and Simon Nxumalo, leader of Swaziland Democratic Party," (Photographer: George Szabo), May 1,1963; SS-3–10071, "Basutoland Chief at the State Department" (Photographer: Jack Lartz), February 27, 1962.

80. SS-13–730, "Kenneth Kaunda and Robert Kennedy" (Photographer: George Szabo), May 23, 1963.

81. SS-36–1718, "Kenya UN delegation visits Atlanta, Georgia and Martin Luther King" (Photographer: Floyd Jillson), December 26, 1963.

82. SSA-4–3937, "Negro Leadership Conference on Africa" (Photographer: George Szabo), September 25, 1964. SSA 1964–1979. All subsequent references with the prefix SSA are from this series.

83. While this approach was consistent with the attitude of the Kennedy administration, under Johnson the US government had "serious reservations about the ethnic approach to foreign policy" ANLCA represented. Memo from Rick Haynes to Robert W. Komer, March 25, 1965. Files of Ulric Haynes, NSF, 1963–1969. See also Krenn, *Black Diplomacy*, 117–20.

84. R-12–62, "Role and Trend of Public Opinion in Africa, 1961," February 1962. IOR Research Reports, 1960–1999.

85. Memo from Edward Murrow, USIA Director, to McGeorge Bundy, Special Assistant to the President, March 7, 1961. SFD, 1956–1972, Box 23. Muehlenbeck, *Betting on the Africans*, 77.

86. RN-17, "Lumumba Symbol in Africa," July 1961. IOR Research Notes, 1958–1962.

87. Rich, "Adoula, Cyrille," 96.

88. *Adoula Speaks to the World*. PAM, ca. 1957–ca. 1995.

89. Gerits, "Ideological Scramble," 278. See also Memo from Edward V. Roberts to Mr. Edmond, June 16, 1964; and Memo from Stephen W. Baldanza, Country Public Affairs Officer, to Edward V. Roberts, June 5, 1964. SFD, 1956–1972, Box 71.

90. SS-48–3211, "King of Burundi visits Department of State also Burundi Dancers" (Photographer: Ollie Pfeiffer), May 19, 1964; SS-52–3354, "Minister of State of Sierra Leone and Dancers at World's Fair," (Photographer: Larry Riordan), June 9, 1964.

91. SSA-13–5022, "African Pavilion at N.Y. World's Fair: Americans watch African dancers" (Photographer: Larry Riordan), June 25, 1965.

92. SS-24–1156, "Margaret Kenyatta—Africa (Kenya) at Disneyland" (Photographer: Bill Brunk), August 10, 1963.

93. Memo from Edward V. Roberts, Assistant Director for Africa, to Donald Wilson, Deputy Director, October 31, 1963. SFD, 1956–1972, Box 56.

94. R-212–63, "Foreign Reaction to the Presidential Succession," December 1963. Agency Files, NSF 1963–1969, Box 73.

95. Mark B. Lewis, PAO Ghana, to Edward V. Roberts, Assistant Director for Africa, August 16, 1963. SFD, 1956–1972, Box 56.

96. The image is available in the collection of the JFK Presidential Library and Museum.

97. SS-35–1683, "Negro Serviceman and Lieutenant in Guard at Kennedy Grave at Arlington" (Photographer: Jack Lartz), December 13, 1963.

98. *When the World Mourned the Death of a President*, January 1964. Foreign Post Photographs and Articles, 1955–1965, Box 1, RG306.

99. The agency also recorded the visit to Kennedy's graveside of Roy Wilkins, Director of the NAACP. SS-34–1638, "Roy Wilkins Dir. of NAACP places wreath at Kennedy grave" (Photographer: George Szabo), December 4, 1963.

100. Cited in Kunkel, *Empire of Pictures*, 60.

101. R-212–63, "Foreign Reaction to the Presidential Succession," December 1963. Agency Files, NSF, 1963–1969, Box 73.

102. Duganne, "Photographic Legacy," 305.

103. Memo from Rick Haynes to Bill D. Moyers, October 18, 1965; Memo from Rick Haynes to McGeorge Bundy, October 20, 1965; Memo from Rick Haynes to Bill D. Moyers, October 25, 1965; Memo from Rick Haynes to Robert W. Komer, October 27, 1965. Files of Ulric Haynes, NSF, 1963–1969.

104. *Mwambutsa IV Visits America*, March 1965. MFP, 1951–1979, Box 291.

105. Memo from Robert W. Komer to the President, March 27, 1965. Files of Ulric Haynes, NSF, 1963–1969.

106. Memo from Rick Haynes to Robert W. Komer, March 18, 1965. Files of Ulric Haynes, NSF, 1963–1969.

107. Memorandum for the record, Rick Haynes, April 5, 1965. Files of Ulric Haynes, NSF, 1963–1969.

108. Memo from Dean Rusk to the President, May 2, 1966. Country File: Africa, NSF, 1963–1969, Boxes 76–77.

109. Memo from W. W. Rostow to the President, May 4, 1966. WHCF Confidential, Box 33.

110. Memo from Bill Moyers to the President, May 26, 1966. Country File: Africa, NSF, 1963–1969, Boxes 76–77.

111. USIS Addis Ababa, for example, reported making "hundreds of photographs" of the visit and turning the best of them into a window display. "Monthly Highlights—June 1966," USIS Addis Ababa to USIA Washington, July 25, 1966. Records Concerning Exhibits in Foreign Countries, 1955–1967, Box 8, RG306.

112. Memo from Rick Haynes to Bill Moyers, May 17, 1966. Country File: Africa, NSF, 1963–1969, Boxes 76–77.

113. "Scenario for Reception of African Ambassadors," May 26, 1966. WHCF Confidential, Box 6.

114. "Unity of Purpose that Transcends Two Continents," MFP, 1951–1979, Box 425. The photograph also ran in issue ten of *Topic* with a key identifying all the leaders present.

115. Diop was the founder of the Senegalese magazine *Bingo*, which Jennifer Bajorek discusses for its decolonial photography. Bajorek, *Unfixed*, chapter three. On Diop, see Hogarth, "Diop, Ousmane Socé," 221–22.

116. The Bechers were German photographers working during the same period and were known for their typological images of industrial structures, often presented in grid format.

117. The agency adopted a comparable approach to a meeting with African ambassadors in July 1966, where photographs were transmitted to "each and every ambassador with the President's best wishes." Memo from Yolanda to Lucy, August 4, 1966. WHCF, Boxes 6–7.

118. Mark Lewis, USIA Assistant Director (Africa) proposed that Humphrey make a visit to Africa as early as August 1964. "Hubert Humphrey to Africa: Proposal," Memo from Mark B. Lewis to The Director, August 27, 1965. SFD, 1956–1972, Box 71. See also "AF Chiefs of Mission Conferences—'New Policy for Africa,'" June 5, 1965. Files of Ulric Haynes, NSF, 1963–1969.

119. "Report from Vice President Humphrey to President Johnson," January 12, 1968. *Foreign Relations of the United States Africa, 1964–1968*, volume XXIV, document 231.

120. Hubert Humphrey African Tour, 1967–1968, RG306.

121. Susana Martins has noted an explicit emphasis on images of touching in the photographs of presidential visits to Portuguese colonies. "Propaganda and the Visual Education of the Empire: The Photographic Albums of the Presidential Visits to the Portuguese Colonies (1938–39)," paper delivered at *Camera Education: Photographic Histories of Visual Literacy, Schooling and the Imagination*, Photographic History Research Centre, De Montfort University, June 15–16, 2020. See also Martins, "Circulating Pictures."

122. "Robert Kennedy in Africa," *Topic* 12 (1966). TMP, 1965–1990. Robert Kennedy's trip was a source of ambivalence for US information officers: on the one hand, there was a risk of Johnson being seen as behind Kennedy in his appeal to Africa; on the other, the agency recognized the positive publicity that the visit would provide for its output.

123. The genre was not exclusive to US photography. For comparable photographs circulated between African nations, see Bajorek, *Unfixed*, 245.

124. "Algerian Statement," Memo from Thomas C. Sorensen, Deputy Director (Policy and Plans), to Ralph A. Dungan, Special Assistant to the President, June 28, 1962. SFD, 1956–1972, Box 39. *America Welcomes*

Uganda to the Free Community of Nations, USIS Kampala, October 1962. MFP, 1951–1979, Box 242.

125. Memo from Bill Moyers to Jack Valenti, May 17, 1965. WHCF, Box 6.

126. *USIA World*, June 1968. LMP, Box 14. The photograph of Marks and Bourguiba was made by Joseph Pinto.

127. *Le President Bourguiba aux Etats-Unis*, 1968. USIA Files, Box 5, Lyndon B. Johnson Library.

Chapter 4

1. Memo from Lowell Bennett, Director of Research, to Edward Murrow, April 1, 1963. SFD, 1956–1972, Box 56.

2. The subject was subsequently raised by a Subcommittee of the Committee on Appropriations, House of Representatives, April 22, 1963, where Murrow suggested that a local artist's choice of sepia-colored paper had given the portraits a brown cast.

3. "Report to the Director from Lawrence H. Rogers II. USIA Tropical Africa, April 15, 1967." LMP, Box 28. For a striking alternative reflection on this trope from a contemporary perspective, see Ferguson, *Global Shadows*, 156.

4. On USAF flights, see "USAF Negro Officers on Africa Flights," Memorandum from Robert W. Ehrman, IAA, to Mr. Battey, Office of Plans, December 14, 1962; Memorandum from Donald M. Wilson, USIA Acting Director to Adam Yarmolinsky, Special Assistant to the Secretary of Defense, January 16, 1963; Memorandum from Adam Yarmolinsky, Special Assistant to the Secretary of Defense to from Donald M. Wilson, USIA Acting Director, February 19, 1963. SFD, 1956–1972, Box 56.

5. Schwartz, "Collective Memory and History," 482–88.

6. Berger, *Seeing Through Race* and *Freedom Now*.

7. Berger, *Seeing Through Race*, 7.

8. Ibid., 6.

9. Berger, *Freedom Now*, 10.

10. Berger, *Seeing Through Race*, 6–7. At times, Berger goes beyond what the archival records would appear to support and pays insufficient regard to the organized photography produced by civil rights organizations themselves, notably the Student Nonviolent Coordinating Committee

(SNCC). Nevertheless, he provides a productive set of critical questions with which to approach more recent representations of the period. On civil rights photography, see also Speltz, *North of Dixie*; Fackler, "Ambivalent Frames"; and Capshaw, *Civil Rights Childhood*.

11. Berger, *Seeing Through Race*, 58. Berger's argument draws on Dudziak, *Cold War Civil Rights*.

12. Berger, *Seeing Through Race*, 62.

13. Ibid., 8.

14. "Basic Guidance and Planning Paper No. 5." For examples of this approach in picture story form, see "'We Affirm our Intention'—Desegregation 1958," August 15, 1958. IAA Country Files, 1953–1961, Box 11.

15. *Negro in American Life*, 1952. MPL, 1953–1984, Box 2.

16. See Parks, "Lifting as We Climb."

17. Schwenk-Borrell, *Selling Democracy*, 262.

18. Ibid., 264–65.

19. Telegram from Accra to USIA, January 18, 1961. IAA Policy Files, 1959–67, Box 10.

20. Parker, *Hearts, Minds, Voices*, 158–59.

21. S-17–61, "Worldwide Reactions to Racial Incidents in Alabama," May 1961; S-18–61, "African Reaction to the Alabama Events," June 1961. IOR Special Reports, 1953–97, Box 17. Original telegrams from field posts can be found in the IAA Policy Files, 1959–1967, Box 10. Citations below are drawn from these three reports unless otherwise specified.

22. The response was not all a matter of editorial commentary. Delegates to the All-African Peoples Conference held in Cairo in March expressed virulent anti-US sentiments and denounced the US and South Africa for the "same savage policy of racial discrimination." RN-17, "Lumumba Symbol in Africa," July 1961. IOR Research Notes, 1958–1962, Box 4.

23. The latter quote comes from R-112–62, "Racial Prejudice Mars the American Image," October 1962. IOR Research Reports, 1960–1999, Box 10.

24. Telegram from Lagos to USIA Washington, May 25, 1961. IAA Policy Files, 1959–1967, Box 10.

25. The reference is to Robert Kennedy sending federal marshals to Alabama. S-17–61, "Worldwide Reactions to Racial Incidents in Alabama," May 1961. IOR Special Reports, 1953–1997, Box 17.

26. "Colonialism Defined as Racism," memo from Lawrence J. Hall, Deputy Assistant Director Africa, to Donald M. Wilson, Deputy Director, August 31, 1961. Reports and Studies, 1953–1998, Box 29, RG306.

27. Rowan was arguably reflecting an interpretation of Bandung's significance shaped by US preoccupations and anxieties, placing greater emphasis on racial consciousness and solidarity than merited by the evidence. See Vitalis, "Midnight Ride of Kwame Nkrumah," 268–71.

28. Schwenk-Borrell, *Selling Democracy*, 4. Parker describes this shift in USIA policy as a "calculated gamble." Parker, *Hearts, Minds, Voices*, 159.

29. For a more critical account of Kennedy's record on civil rights, see Bryant, *Bystander*.

30. SS-5–10790, "Swearing of Luke Moore (Negro) US Marshall and Kennedy Congratulates" (Photographer: Joseph Pinto), June 20, 1962.

31. SS-5–10899, "Dr Martin Luther King Speaks at National Press Club" (Photographer: Ollie Pfeiffer), July 19, 1962.

32. *Distinguished Young Americans*, 1962. PAM, ca. 1957–ca. 1995.

33. For example, the agency shut down filming of a sit-in at a cafe in Greensboro, North Carolina. Schwenk-Borrell, *Selling Democracy*, 186.

34. R-112–62, "Racial Prejudice Mars the American Image," October 1962. IOR Research Reports, 1960–1999, Box 10.

35. "Foreign Reaction to Segregation Since Little Rock," memo from IRS/A to USIA Acting Director, May 20, 1963. SFD, 1956–1972, Box 63.

36. Cited in Schwenk-Borrell, *Selling Democracy*, 282. A piece on Meredith appeared in *Perspectives Americaines* in November 1962.

37. "Foreign Reaction to Segregation Since Little Rock," memo from IRS/A to USIA Acting Director, May 20, 1963. SFD, 1956–1972, Box 63.

38. SS-14–746, "Attorney General Robert Kennedy and James Meredith" (Photographer: George Szabo), May 27, 1963.

39. SS-13–730, "Kenneth Kaunda and Robert Kennedy" (Photographer: George Szabo), May 23, 1963. Prints were sent to Salisbury, Dar es Salaam, Kampala, Nairobi, Pretoria, Cape Town, and Blantyre.

40. R-85–63, "Reaction to Racial Tension in Birmingham, Alabama," May 13, 1963. IOR Research Reports, 1960–1999.

41. Cited in Cull, *Cold War*, 213. Replaying an earlier framing, the Soviets likened the treatment of African Americans to Buchenwald and Auschwitz.

42. "Civil Rights—The Coming Months," memo from William C. Gausmann to Burnett Anderson, Office of Plans, May 29, 1963. SFD, 1956–1972, Box 63.

43. Schwenk-Borrell, *Selling Democracy*, 296. The film was *Five Cities of June* (1963).

44. Kennedy, *Public Papers*, 468–71.

45. Memo from Donald M. Wilson, Acting Director USIA, to Donald Dumont, American Minister, Usumbura, Burundi, July 12, 1963. SFD, 1956–1972, Box 63.

46. Kennedy felt there was reciprocity between his advocacy of civil rights and the new cohort of leaders in the postcolonial world. Telegram 2176 from President Kennedy to all ambassadors and principal officers, June 19, 1963, cited in Schwenk-Borrell, *Selling Democracy*, 316.

47. Memo from Donald M. Wilson, Acting Director USIA, to Edward V. Roberts, Assistant Director for Africa, October 31, 1963. SFD, 1956–1972, Box 56.

48. "New Patterns of Ghana Government and Press Attitudes Toward US Racial Situation," Mark B. Lewis, PAO, USIS Accra, June 14, 1963. SFD, 1956–1972, Box 63.

49. "Race and Revolution," memo from F. Victor Guidice, International Television Service, to Edward Murrow, USIA Director, May 31, 1963. SFD, 1956–1972, Box 63. The memo was forwarded by Murrow to Thomas Sorensen, Deputy Director of Policy and Planning, with a covering note, on June 11, 1963.

50. Reeves, *President Kennedy*, 521. Schwenk-Borrell, *Selling Democracy*, 299.

51. Memo from Donald M. Wilson, USIA Deputy Director, to Edgar Brooke, Director of Media Content, Office of Policy and Planning, July 2, 1963. SFD, 1956–1972, Box 63.

52. "IPS Civil Rights Coverage," memo from Ray Mackland, Press and Publications Service, to Edward Murrow, USIA Director, July 22, 1963. SFD, 1956–1972, Box 63.

53. Cull, *Cold War*, 211.

54. ST-819, *Protectors of Civil Rights for All Americans*.

55. See, for example, the United Press International photograph of Meredith flanked by Doar and James McShane held by the Library of Congress (LC-USZ62–13515).

56. Raiford, *Imprisoned in a Luminous Glare*, 95.

57. Danny Lyon was the first staff photographer at SNCC and worked for the organization between the summer of 1962 and the summer of 1964.

58. SS-16–849, "Evers' Funeral in Arlington Cemetery" (Photographer: Jack Lartz), June 19, 1963.

59. SS-17–889, "Atlanta Georgia Negro Children Visit Robert Kennedy," June 25, 1963.

60. SS-21–1083, "Roy Wilkins NAACP Testifies to Civil Rights Hearing" (Photographer: George Szabo), July 25, 1963.

61. SS-22–1092, "Police Department and NAACP Meet on Plan for March on Washington" (Photographer: George Szabo), August 5, 1963.

62. SS-23–1104, "March on Washington meeting with Murray and Senators" (Photographer: Jack Lartz), August 7, 1963.

63. SS-23–1111, "March on Washington Meeting" (Photographer: George Szabo), August 7, 1963.

64. "List of USIA Reporters, Announcers, Crew Directors and Others for Whom Police Passes Are Needed for Coverage of August 28 Civil Rights March." SFD, 1956–1972, Box 63.

65. ST-818, *Why They Marched*.

66. ST-821, *Faces of the March*. Photographs by Rowland Scherman.

67. ST-822, *Goodwill marks the Washington March*.

68. Memo for Ray Mackland, IPS, to Edward Murrow (through Mr. Wilson), November 1, 1963. SFD, 1956–1972, Box 63.

69. SS-25–1173, "Integrated Day Camp. Camp Hope," (Photographer: Joseph Pinto), August 21,1963.

70. On the more radical end of the camping movement, see Teal, "Moral Economy."

71. Schwenk-Borrell, *Selling Democracy*, 367. The original source cited here is Richard Wilson, "USIA Film on the March," *The Evening Star*, January 22, 1964, A-23. On the controversy surrounding *The March*, see Cull, *Cold War*, 234–35. The film was eventually released with an opening statement from Carl Rowan intended to reinforce the agency's message and constrain alternative interpretations.

72. Forman, *Making of Black Revolutionaries*, 219, 336.

73. Forman was an astute observer of the way in which USIA represented the civil rights movement for African audiences. Following his trip to the continent in 1964, he felt it "imperative . . . that SNCC create an African bureau." Forman, *Making of Black Revolutionaries*, 361, 411.

74. Raiford, *Imprisoned in a Luminous Glare*, 96.

75. Newbury, "Ernest Cole's *House of Bondage*."

76. SS-23–1118, "White Families Entertain Formerly Jailed Negro Demonstrators" (Photographer: I. Burt Shavitz), August 12, 1963. Roy R. Silver, "Ten Negro Students Visit on L.I. After Being Jailed in the South," *New York Times*, August 5, 1963.

77. The Great Neck Committee for Human Rights was involved in opposing housing segregation in this historically White area.

78. Bernard Lafayette's account of his and Colia's work in Selma in June 1963 is reproduced in Forman, *Making of Black Revolutionaries*, 316–26.

79. Shavitz later switched from photography to beekeeping and founded the company Burt's Bees, for which he is probably better known.

80. PS-63–4571 and PS-63–4574.

81. Schwenk-Borrell, *Selling Democracy*, 341–49. Schwenk-Borrell was a former resident of Bannockburn and provides an insightful discussion of the community and its involvement in civil rights. See also R-117–64, "Nigerian Reactions to #74 of 'Today' Film: A Preliminary Report," August 1964. IOR Research Reports, 1960–1999.

82. See https://snccdigital.org/people/dorothy-zellner/ (accessed August 7, 2019). Lyon's images are now available via Magnum.

83. See, for example, SS-29–1380, "Sunday March in Sympathy Birmingham Bombing" (Photographer: Edwin Huffman), September 22, 1963.

84. Cited in Hogan, *Many Minds, One Heart*, 149.

85. Ibid., 150. See also Forman, *Making of Black Revolutionaries*, 371–86.

86. On Moses, see Visser-Maessen, *Robert Parris Moses*. Original documents and photographs from the project are available in the Freedom Summer Collection, Wisconsin Historical Society. Director of the Freedom Summer Hattiesburg project, Sandy Leigh, invited Herbert Randall to document the program. His photographs are available at the

University of Southern Mississippi, McCain Library and Archives.

87. Greenberg, *Circle of Trust*, 79.

88. SSA-1–3455, "Mississippi Orientation Program" (Photographer: Harlan Johnson), July 10, 1964.

89. Greenberg, *Circle of Trust*, 78. One of the volunteers described the "swarm" of journalists and photographers that surrounded the orientation program. Martinez, *Letters from Mississippi*, 22.

90. Martinez, *Letters from Mississippi*, 15. According to Visser-Maessen, "relations between SNCC and the department were closer than generally assumed." Visser-Maessen, *Robert Parris Moses*, 131, 199–200.

91. Greenberg, *Circle of Trust*, 79–80.

92. "Plans for Orientation—For Staff Consideration," June 9, 1964. Available online at: https://www.crmvet.org/docs/640609_cofo _orientationplan.pdf (accessed August 8, 2019).

93. "Possible Role Playing Situations," Mississippi Summer Project Material (SNCC COFO), 1964. Jerry Tecklin papers, Archives Main Stacks, Mss 538, Box 1, Folder 5, Freedom Summer Collection, Wisconsin Historical Society.

94. Berger, *Seeing Through Race*, 36–38. Raiford, *Imprisoned in a Luminous Glare*, 69. See also the photograph "Demonstration of Nonviolent Self-Defense," June 1964, Herbert Randall Freedom Summer Photographs, University of Southern Mississippi; and Lyon's photographs in the SNCC pamphlet, "Danville, Virginia."

95. Hamlin, *Crossroads at Clarksdale*, 263; On Miller, see https://web.viu.ca/davies /h323vietnam/miss.summer.htm (accessed August 8, 2019).

96. Charles Stewart, "Report on Mississippi Summer Project," 1964. Archives Main Stacks, SC 3095, Freedom Summer Collection, Wisconsin Historical Society.

97. *Topic* 1 (1965). TMP, 1965–1990. The lead photograph of Moses in *Topic* (306-TMP-1–6) was made by Bill Shrout for the *Saturday Evening Post*. Unfortunately, the cost of licensing it for use here was prohibitive.

98. The text of the article misrepresented the outcome as a victory, when in fact Moses and his colleagues refused the compromise that was proposed. Forman, *Making of Black Revolutionaries*, 406. On the Mississippi

Freedom Democratic Party, see Gavins, *Cambridge Guide*, 191.

99. Raiford, *Imprisoned in a Luminous Glare*, 72, 94, 116, 122. See also Heron, "Photographing Civil Rights," 20; and Duganne, *Self in Black and White*, 97.

100. Bond appears in a group photograph of SNCC members made by Richard Avedon for his collaborative book project with James Baldwin, published in 1964. Avedon and Baldwin, *Nothing Personal*.

101. Carson, *In Struggle*, 135; Bond cited in Neary, *Black Rebel*, 73. On the Africa trip, see also Visser-Maessen, *Robert Parris Moses*, chapter nine.

102. Carson, *In Struggle*, 323; Visser-Maessen, *Robert Parris Moses*, 265.

103. Schwenk-Borrell, *Selling Democracy*, 380.

104. "Weekly Report," memo from Carl Rowan, USIA Director, to the President, June 30, 1964. WHCF Confidential, Box 135.

105. "African Reaction to Recent US Civil Rights Developments," memo from Carl Rowan, USIA Director, to the President, July 21, 1964. WHCF, Box 6.

106. "Five Priority Subjects," memo from Thomas C. Sorensen, Deputy Director Policy and Plans to All Heads of Elements, All USIS Posts, April 6, 1964. LMP, Box 27. See also Cull, *Cold War*, 236.

107. *The Road to Justice*, 1965. WHA, Yoichi Okamoto, Box 2. *For the Dignity of Man*, 1965, and *We Shall Overcome*, 1968. LMP, Box 46. An earlier version of *We Shall Overcome* was produced in 1965.

108. Memo from Jack Valenti, Special Assistant to the President, to G. Mennen Williams, Assistant Secretary of State for African Affairs, November 10, 1965; memo from Jack Valenti, Special Assistant to the President, to Arthur Goldberg, UN Ambassador, November 10, 1965. WHCF, Box 6.

109. Telegram from American Embassy, Nairobi, to USIA Washington, April 5, 1965. Agency File: USIA, NSF, 1963–1969, Box 74.

110. In a critique of the reformism of these civil rights leaders, Cuban filmmaker Santiago Alvarez appropriated one of the photographs of King, Farmer, Wilkins, and Young meeting Johnson at the White House for his short film *Now*. See Mahler, "Global South," 105.

111. SSA-9–4523, "Pickets in Front of White House Protest Brutality in Selma, Alabama" (Photographer: Jack Lartz), March 9, 1965.

112. For Matt Heron's iconic Selma photograph, made on the third march (March 21–25, 1965), see Kelen, *This Light of Ours*, 186.

113. SSA-9–4542, "American Nazis Picket the Pickets at White House" (Photographer: Jack Lartz), March 14, 1965.

114. SSA-9–4543, "Civil Rights Meeting in Lafayette Park" (Photographer: Jack Lartz), March 14, 1965.

115. ST-867, "Roy Wilkins, Civil Rights Leader."

116. Raiford, *Imprisoned in a Luminous Glare*, 68.

117. Cull, *Cold War*, 235.

118. Memo from Mark B. Lewis, Assistant Director (Africa), to Carl Rowan, USIA Director, October 27, 1964. SFD, 1956–1972, Box 71. Rowan also expressed frustration at the coverage Malcolm X received in Africa. Haley, "Foreword," 69–70. Malcolm X had a sophisticated understanding of visual propaganda and was well aware of the USIA program in Africa. As he observed, despite responding diplomatically to their endeavors, many African officials would have seen "duplicity" in the agency's narrative. Nonetheless, there may have been a measure of diplomacy in his own reception too. Malcolm X, *Autobiography*, 467. For further discussion of Malcolm X's engagement with African nations, see Curtis, "My Heart Is in Cairo."

119. Memo from Mark B. Lewis, Assistant Director (Africa), to Thomas C. Sorensen, Deputy Director, Policy and Plans, November 3, 1964. SFD, 1956–1972, Box 71.

120. For Malcolm X's perspective, see Malcolm X, *Autobiography*, 410–11.

121. SSA-9–4545, "Recognition Dinner Honoring Martin Luther King," March 15, 1965. The event took place on January 27, 1965, although the photographs do not appear to have entered the USIA collection until March 1965. The photographer may be Vernon Merritt, whose images of the event appear in *Life* (February 12, 1965), credited to Black Star, and also display an interest in picturing the King children.

122. *Martin Luther King: Man of Peace*, 1968. LMP, Box 46. The pamphlet was first planned in 1965. See "USIA Supplementary Materials, Civil Rights Movement," June 1965. WHA, Frederick Panzer, Box 330.

123. Ibid.

124. R-174–64, "Nairobi and Lagos Residents View US Race Relations Following the Civil Rights Act and the Harlem Riots,"

November 1964. IOR Research Reports, 1960–1999.

125. R-35–65, "World Press Reaction to Selma," March 1965; Memo from Carl T. Rowan, USIA Director, to the President, March 29, 1965. Agency File: USIA, NSF, 1963–1969, Box 74.

126. R-193–65, "Africans See Some Improvement in US Race Relations," December 1965. IOR Research Reports, 1960–1999.

127. Cull, *Cold War*, 317–18.

128. *Topic* 17 (1967). TMP, 1965–1990.

129. Cull, *Cold War*, 278.

130. The US was highly sensitive to any portrayal of Vietnam as a racial struggle and wrote to Kenneth Kaunda personally to "correct" his "misconception" following a speech in which he drew parallels with the situation in South Africa. Airgram from Amembassy Lusaka to Department of State, November 6, 1967. SFD, 1956–1972, Box 131.

131. S-3–66, "Racial Issues in the US: Some Policy and Program Indications of Research," March 1966. IOR Special Reports, 1953–1997. There is a tendency in some of the literature to overlook the uncertainty and experimentation in the USIA civil rights coverage of the early 1960s. Krenn, for example, reads the conclusions of the 1966 report back onto the preceding period, when some in the agency were thinking beyond simply "replacing black agency and action with a narrative that stressed the role of white Americans and the federal government in 'giving' civil rights to African Americans." His conclusion that the approach in the period after 1965, when US cities were beset with riots, was to "to try and bleach some of the angry blackness out of the disturbances" is no doubt accurate, however. Krenn, "Low Key Mulatto Coverage," 96, 106.

132. "Violence in American Cities," News Policy Note No. 21–67, July 28, 1967. LMP, Box 23. On King's response to Watts and Black Power, see Ogbar, *Black Power*, 146.

133. "Interim Report on Civil Rights" by Hubert H. Humphrey, USIS Magazine Reprint, 1968; "US Civil Rights and the War on Poverty," USIA Byliner, January 1966. WHA, Frederick Panzer, Box 330.

134. "Emphases for Output to Africa," News Policy Note No. 27–68, October 1, 1968. LMP, Box 23.

135. Memo from Thomas C. Sorensen, Deputy Director of Policy and Planning, to Edward

Murrow, USIA Director, June 3, 1963. SFD, 1956–1972, Box 63.

Chapter 5

1. SSA-4–3720, "Africans visit Wax Museum" (Photographer: Joseph Pinto), September 22, 1964. Quaye also met President Johnson and was gifted with a signed photograph of the occasion as a souvenir. "Four African students who will meet the President," June 4, 1965. WHCF, Box 6. Memo from Ulric Haynes to Blake Robinson, June 18, 1965. Files of Ulric Haynes, NSF, 1963–1969.

2. "US Information Program in Africa," AHP, 1967–1975, Box 9.

3. Gerits, "Hungry Minds."

4. Meriwether, "Worth a Lot of Negro Votes," 759. USIA's coverage of racial integration might be seen as precisely the reverse kind of play for Africa.

5. Ibid., 753.

6. "African Public Opinion: Implications for USIA," May 12, 1961. SFD, 1956–1972, Box 23.

7. "Some changes in USIA since March 1961," Office of Public Information to USIA Employees, October 28, 1963. AHP, 1967–1975, Box 5. Memo from Alfred Boerner to Edward V. Roberts, February 14, 1962; Memo from Edward V. Roberts to Edward R. Murrow, August 28, 1962. SFD, 1956–1972, Box 39.

8. "Material on African press operations for Rowan's memo to President," March 22, 1961. IAA Policy Files, 1959–1967, Box 10.

9. See, for example, "Fact Sheet: Program in Africa," November 16, 1962. SFD, 1956–1972, Box 39.

10. Bajorek, *Unfixed*, 120, 135–36. USIA publications may not have fostered the same level of interaction as the West African *Bingo*, but they nonetheless applied similar conventions and assumed a shared readership to at least some extent.

11. "African Public Opinion: Implications for USIA," May 12, 1961. SFD, 1956–1972, Box 23.

12. "Country Plan for the Chad, Fiscal Year 1963," USIS Fort Lamy to USIA Washington, October 10, 1963. SFD, 1956–1972, Box 56.

13. "Country Plan," USIS Abidjan to USIA Washington, July 19, 1961. SFD, 1956–1972, Box 56.

14. "Country Plan for the Republic of the Niger," USIS Niamey to USIA Washington, September 8, 1961. SFD, 1956–1972, Box 56. This criticism of US policy was still being made in 1965. Memo from Rick Haynes to Robert W. Komer, May 18, 1965. Files of Ulric Haynes, NSF, 1963–1969.

15. "Country Plan: Kenya," USIS Nairobi to USIA Washington, July 3, 1961. SFD, 1956–1972, Box 56.

16. *American Outlook*, No. 11, November 1964. MFP, 1951–1979, Box 295. The establishment of African national carriers was an important feature of agency coverage.

17. Wendl, "Entangled Traditions," 90–93. For a critical perspective, see Bajorek, *Unfixed*, 103–15.

18. *Perspectives Americaines*, October 1961. MFP, 1951–1979, Box 215.

19. SS-7–74, "Timothy Olu Farinre African student at University of Pennsylvania" (Photographer: Jules Schick), January 23, 1963.

20. SS-23–1125, "African student working for Los Angeles Construction Co." (Photographer: Don Goodwin), August 13, 1963. Tolo featured in an *Outlook* poster. "Vacation Life of African Students in the United States." MFP, 1951–1979, Box 268.

21. SS-7–33, "John Idakwa Kenya student at Howard University" (Photographer: Joseph Pinto), January 11, 1963.

22. SS-27–1262, "Africans tour US Post Office Department" (Photographer: George Szabo), September 16, 1963.

23. SS-48–3207, "Ivory Coast Doctors visit International Health and PHS" (Photographer: Ollie Pfeiffer), May 18, 1964.

24. SS-22–1058, "Two Congolese women visit Los Angeles" (Photographer: Don Goodwin), July 30, 1963.

25. SSA-1–3482, "Nigerian businessmen visit Prince George's Shopping Center" (Photographer: Joseph Pinto), July 15, 1964.

26. SS-12–700, "Kenyan students at American University" (Photographer: George Szabo), May 17, 1963; SS-13–723, "Kenyan students visit Foreign Affairs Committee at Capitol" (Photographer: Ollie Pfeiffer), May 22, 1963; SS-22–1089, "Echaria of Kenya trainee in town government" (Photographer: Al Mathewson), August 1, 1963; SS-22–1090, "Kibinge of Kenya trainee in town government" (Photographer: Al Mathewson), August 1, 1963. Kibinge returned to the US in 1969 as ambassador. Echaria held

diplomatic posts in Moscow, Ethiopia, and at the UN.

27. SS-23–1135, "African Policemen and Others attend Police Academy" (Photographer: Joseph Pinto), August 14, 1963.

28. SS-28–1312, "UAR police officials visit Inter-Police Service Academy" (Photographer: Joseph Pinto), September 24, 1963.

29. SSA-63–8727, "Somali Police Inspector at International Police Academy" (Photographer: Yuki King), August 19, 1968.

30. Ryan, *Statebuilding and Police Reform*, 145.

31. SS-18–958, "Emmanuel Boye of Ghana at Bell Telephone Laboratories," July 10, 1963.

32. This image featured on an *Outlook* poster. "African Student Life in the United States." MFP, 1951–1979, Box 268.

33. SS-9–121, "Nigerian student George K. I. Kalu at University of Wisconsin" (Photographer: Duane Hopp), February 5, 1963.

34. SS-47–3129, "Africans visit the National Archives" (Photographer: Joseph Pinto), May 6, 1964.

35. SS-8–96, "Ghana [*sic*] students tour Washington," (Photographer: Joseph Pinto), January 29, 1963.

36. SS-44–2061, "Guinea Youth Day Celebration" (Photographer: Edwin Huffman), March 28, 1964.

37. *Exchange Students in the USA*. USIA Pamphlets, LMP, Boxes 10–13.

38. The photograph of Offokaja formed the cover of the May 1957 edition of *American Outlook*. MFP, 1951–1979, Box 89. SS-7–63, "Kenyan student Fred Dalizu at Howard University" (Photographer: Joseph Pinto), January 7, 1963. For Dalizu's perspective, see Goffe, "Friends Salute Mboya's American Airlifts."

39. "More African Lecturers Teach in US," *Student Outlook*, June 1962. MFP, 1951–1979, Box 215.

40. Memo from Donald M. Wilson to Lerone Bennett Jr., February 7, 1963. SFD, 1956–1972, Box 56.

41. On Frelimo, Mondlane, and photography, see Thompson, "Visualising FRELIMO's Liberated Zones." Mondlane was aware of the political risks "associated with circulating pictures of Frelimo representatives travelling abroad to places like the United Nations in New York" (35).

42. *How to Photograph Foreign Visitors for the US Information Agency*. MPL, 1953–1984, Box 11.

43. "Urgent Request for Exhibits," USIS Algiers to USIA Washington, January 25, 1963. Records Concerning Exhibits in Foreign Countries, 1955–1967, Box 1, RG306.

44. For further discussion of the term, see Houston, *Nashville Way*.

45. SS-23–1114, "African students at Friends World College" (Photographer: Raimondo Borea), August 9, 1963. The students were from Ethiopia, Ghana, Nigeria, Sierra Leone, and Uganda.

46. The photographs were taken by Raimondo Borea. See https://www.gartenbergmedia .com/library-excavation-media-archiving /photographers/raimondo-borea (accessed July 27, 2020).

47. SSA-4–3725, "African students with American host families at East Grand Forks, Minnesota" (Photographer: Bud Nagle), September 24, 1964.

48. The students were Jean-Marie M'Bioka, Ali Nestor Mamadou, Antoine Koya Zounda, Henri Baya, and Raymond Sazo.

49. An assignment on a group of African women students at the University of Pittsburgh referred to "pix with white families," illustrating the slippage from national to racial identification in the agency's perception of the story value. SS-24–1171, "African women students at University of Pittsburgh" (Photographer: Morris Berman), August 20, 1963.

50. "Sioux City Welcomes the World," *Topic* 26 (1968). TMP, 1965–1990. USIA appear to have misspelt the family name of the Togolese visitor shown in the opening photograph.

51. "To All the World, Welcome!" *Life*, September 1, 1967, 46–53. The photographs were made by Lee Balterman.

52. Sioux City was one of the places visited in 1962 by the Ghana Young Pioneers, suggesting it offered a familiar setting for the kind of images the agency sought for distribution in Africa.

53. "'International Understanding' in Photos," *Photo Bulletin*, No. 21, 1965. PB, 1964–1973.

54. SSA-2–3620, "Mr. C. Lattier, Ivory Coast visits Pueblo Village," August 25, 1964.

55. Nzewi, "Contemporary Present and Modernist Past," 217.

56. Published accounts by Africans who spent time spent in the US include John Pepper Clark's *America, Their America* (1964) and Bernard Dadié's *Patron de New York* published the same year. Clark worked in

Nigeria's Ministry of Information immediately following independence.

57. "I Was a Foreign Student in the United States," *Photo Bulletin*, No. 3, 1964. PB, 1964–1973. Text and full captions are located in Foreign Post Photographs and Articles 1955–1965, Box 1, RG306.

58. On Ramrakha's career, see Vidyarthi and Haney, *Priya Ramrakha*.

59. Ibid., 57–101.

60. SS-32–1509, "African students at Dickinson College," November 1, 1963.

61. "African Students Star on US University Soccer Teams," *African Students' Outlook*, No. 2, 1964. MFP, 1951–1979, Box 268.

62. SS-47–3132, "Malima from Tanganyika at Dartmouth College" (Photographer: Adrian Bouchard), May 7, 1964.

63. SSA-12–4828, "Ethiopian student at East-West Center—Zemedu Worku" (Photographer: Werner Stoy), May 14, 1965.

64. Memo from Edward V. Roberts to Edward R. Murrow, August 28, 1962. SFD, 1956–1972, Box 39.

65. Goffe, "Friends Salute Mboya's American Airlifts."

66. These views were expressed by Frank Nabutete in a contemporary interview for the *New York Times*, cited in Stephens, *Kenyan Student Airlifts*, 35–36.

67. In at least one case, a USIS field office encouraged an African student to write a book about his experiences in the Soviet Union. Telegram from Carl Rowan to USIS Addis Ababa, June 11, 1965. IAA Correspondence Files, 1953–1967, Box 3.

68. "African Student's [*sic*] Open Letter," October 13, 1960. SFD, 1956–1972, Box 21. For further discussion of this incident, see Hessler, "Death of an African Student." On the Peoples' Friendship University, see Katsakioris, "Lumumba University." See also Mazov, *Distant Front*.

69. *An Open Letter to All African Governments*, 1962. MFP, 1951–1979, Box 210.

70. The image is reproduced in Hessler, "Death of an African Student," 47.

71. *African Students Behind the Iron Curtain*, April 1963. MFP, 1951–1979, Box 242. In this case the pamphlet was attributed.

72. Ghanaian students were at the forefront of the protests in Sofia, and in a comparison that would have been anathema to USIA, Nkrumah expressed resentment at exploitation of the incidents for propaganda, suggesting the treatment of Ghanaians in Bulgaria was comparable with "the sustained discrimination against Africans in America." Thompson, *Ghana's Foreign Policy*, 278.

Chapter 6

1. Telegram from Amembassy Ouagadougou to USIA WASHDC, January 4, 1966. Records Concerning Exhibits in Foreign Countries, 1955–1967, RG306. (The series is organized alphabetically by country.) Unless otherwise stated, subsequent archive references are from this series.

2. Kandeh, *Coups from Below*, 120–21.

3. "Activities Report—June and July," USIS Bujumbura to USIA Washington, August 18, 1964.

4. "Monthly Report of Activities in November," USIS Bujumbura to USIA Washington, November 30, 1964.

5. "Trip Report, Eastern Gabon," USIS Libreville to USIA Washington, August 31, 1965.

6. See, for example, Vokes, Peterson and Taylor, "Photography, Evidence and Concealed Histories" and Schneider, "Views of Continuity and Change."

7. Bajorek, *Unfixed*, 135.

8. Barber, "Preliminary Notes," 353–56.

9. Bajorek, *Unfixed*, 145.

10. Ibid., 145.

11. Newell, "Paradoxes of Press Freedom," 101. See also Buckley, "Cine-film, Film-Strips," 150.

12. Gerits, "Ideological Scramble," 301.

13. Ibid., 293–94.

14. The "demonstration effect" was conceived by Walt Rostow. Although USIA saw modernization as a politically neutral benefit, this was not always how it was received. See ibid., 279, 289.

15. Cooper argues that independence turned citizens into supplicants. Cooper, "Writing the History of Development," 15.

16. Gerits, "Ideological Scramble," 283.

17. "ICS: Post Photo Displays," USIS Mogadiscio to USIA Washington, July 29, 1964.

18. Newell, "Paradoxes of Press Freedom," 102.

19. Bajorek, *Unfixed*, 120.

20. "USIS/Congo (Leopoldville)," Michael R. Codel, Associated Press, to Leonard Marks, USIA Director. SFD, 1956–1972, Box 111.

21. "Agency Comments on Dummy of Unattributed Anti-Chicom Pamphlet," from USIA Washington to USIS Hong Kong and

USIS Lagos, January 13, 1966. IAA Correspondence Files, 1953–1967, Box 3.

22. In late 1964, the *Ghanaian Times* accused the USIS Library in Accra of pedaling the "opium of false propaganda and false values." Telegram from Amembassy Accra, December 16, 1964. WHCF Confidential, Box 33.

23. "Appearance and Location of USIS Centers in Africa," memo from Mark B. Lewis, Assistant Director (Africa) to USIA Director, June 8, 1966. SFD, 1956–1972, Box 111.

24. "Activities during February," USIS Conakry to USIA Washington, April 23, 1962. IAA Correspondence Files, 1953- 1967, Box 2.

25. "USIS/Congo (Leopoldville)," Michael R. Codel, Associated Press, to Leonard Marks, USIA Director. SFD, 1956–1972, Box 111.

26. "Status of USIS Zanzibar," from USIS Dar es Salaam to USIA Washington, February 21, 1967, SFD, 1956–1972, Box 131.

27. "Report on USIS Operations in South Africa," Lewis W. Douglas, US Advisory Commission on Information, August 10, 1961. Reports and Studies, 1953–1998, Box 29, RG306.

28. Sandeen, "Show You See with Your Heart," 478.

29. "Traffic Safety Exhibit, Project 62–336," USIS Tunis to USIA Washington, March 19, 1964.

30. "Opening of USIS Information Center Leopoldville," June 22, 1953. Photographs of Information Center Service Activities in Foreign Countries, 1948–1954, Box 10, RG306.

31. "ICS: Post Photo Displays," USIS Mogadiscio to USIA Washington, July 29, 1964.

32. "US Presidential Elections, Visual Material," USIS Dakar to USIA Washington, November 10, 1960.

33. Colard, "Afterlife of a Colonial Photographic Archive," 118. The photograph was credited to Joseph Makula.

34. "US Exhibit at Louga Youth Week Fair," USIS Dakar to USIA Washington, July 12, 1963.

35. "Activities Report—June and July," USIS Bujumbura to USIA Washington, August 18, 1964.

36. "Monthly Highlights Report for July," USIS Fort Lamy to USIA Washington, August 5, 1965.

37. "Statistical Report on Exhibits Program," USIS Yaoundé, December 31, 1963.

38. "ICS: Exhibits: Evidence of Effectiveness," USIS Bamako to USIA Washington, December 16, 1963.

39. "Statistical Report on Exhibits Program," USIS Lagos, January 15, 1963.

40. "Statistical Report on Exhibits Program," USIS Khartoum, January 1–October 31, 1965.

41. "Statistical Report on Exhibits Program," USIS Kampala, November 30, 1965.

42. "ICS: USIS Exhibits Program," USIS Salisbury to USIA Washington, October 21, 1963.

43. See, for example, the pamphlet, "Facts about USIA. Audience: The World." SF, 1953–1999, Box 2.

44. "ICS: Exhibits: United Nations," USIS Ibadan to USIA Washington, November 8, 1962; USIA Washington to USIS Lagos, USIS Ibadan, November 28, 1962.

45. "ICS: Exhibits on 'The New American Negro,' Abraham Lincoln, and Ralph McGill," USIS Accra to USIA Washington, February 13, 1963.

46. Telegram from USIS Accra to USIA Washington, May 5, 1963.

47. "Exhibits: Martin Luther King," USIS Fort Lamy to USIA Washington, December 14, 1964.

48. "Monthly Highlights, November 1966," USIS Monrovia to USIA Washington, December 22, 1966.

49. "Anti-Americanism and the Other Side of the Coin," USIS Salisbury to USIA Washington, June 6, 1961.

50. *Ici L'Amerique*, 2 (June 1961). MFP, 1951–1979, Box 179.

51. "Racial Discrimination—Astronaut," Memorandum from Lawrence J. Hall, Acting Assistant Director (Africa), to Edward R. Murrow, Director, August 7, 1962. SFD, 1956–1972, Box 39. See also ST-797, *First Negro Astronaut Candidate*, on Edward Dwight.

52. "ICS/E/IAA: Exhibits for Africa," USIS Usumbura to USIA Washington, November 22, 1963.

53. "Locally Produced Exhibits: Transmittal of Photographs," USIS Pretoria to USIA Washington, November 24, 1965.

54. "Monthly Report for December 1965," USIS Bujumbura to USIA Washington, January 4, 1966.

55. "ICS—Exhibit Suggestion," USIS Leopoldville to USIA Washington, September 20, 1960.

56. "Showing of Exhibit, 'Here is Africa' at Garoua, North Cameroon," USIS Yaoundé to USIA Washington, August 8, 1963. See also USIA Circular, CA-1492, December 16, 1959. IAA Country Files, 1953–1961, Box 7. The exhibition also appears to have an alternative title, *Africa Today*.

57. "Program Notes—February 1960," USIS Nairobi to USIA Washington, March 17, 1960. ICS Country Files, 1959–1966, Box 1.

58. "USIS Exhibit Commemorates American Independence Day and Ghana's Republic Day," USIS Accra to USIA Washington, July 5, 1963.

59. "Effectiveness," memo from Morton Glatzer to Mr. Sivard, ICS/E, April 8, 1964.

60. "USIS Leopoldville Highlights Report for January 1966," USIS Leopoldville to USIA Washington, February 9, 1966.

61. "Monthly Highlights Report for February 1965," USIS Lomé to USIA Washington, March 4, 1965.

62. "Country Assessment Report," USIS Dakar to USIA Washington, January 29, 1965.

63. "Program Notes—December 1964," USIS Leopoldville to USIA Washington, January 11, 1965 (ellipsis in original).

64. "Monthly Highlights Report for February 1965," USIS Lomé to USIA Washington, March 4, 1965.

65. "Monthly Report on Activities in January 1965," USIS Bujumbura to USIA Washington, February 8, 1965.

66. Ribalta, *Public Photographic Spaces*, 19.

67. Bayer cited in Phillips, "Steichen's 'Road to Victory,'" 375.

68. Pohlmann, "El Lissitzky's Exhibition Designs," 183.

69. Buchloh, "'Faktura' to Factography," 61. At stake is whether such innovative exhibition design fostered, or not, a critical autonomy on the part of the viewer. For an extended debate of these exhibition design ideas and their political implications, see Ribalta, *Public Photographic Spaces*.

70. *Country Public Affairs Officer Handbook*, USIA, Washington, January 1967. LMP, Box 28. Given the publication date it seems likely that Nelson's book would have circulated much earlier. Nelson had been chief designer for the American National Exhibition in Moscow (1959). On Nelson and his engagement with USIA exhibitions, see Eisenbrand, "Politics of Display."

71. "Notes on IAA Meeting," memo from R. L. Cook, ICS/EP, to Mr. Clarke, ICS/EP, March 3, 1967.

72. The full list appeared on the reverse of the proforma used for reporting on post exhibition programs.

73. *Country Public Affairs Officer Handbook*, USIA, Washington, January 1967. LMP, Box 28.

74. Vokes, "Photography, Exhibitions and Embodied Futures," 13. On a comparable use of film in the Gambia, see Buckley, "Cine-film, Film-Strips," 149.

75. "USIS/Congo (Leopoldville)," Michael R. Codel, Associated Press, to Leonard Marks, USIA Director. SFD, 1956–1972, Box 111.

76. "Monthly Report—September," USIS Libreville to USIA Washington, October 10, 1966.

77. "Publicity for US Military Program in Ethiopia," USIS Addis Ababa to USIA Washington, August 11, 1960.

78. "Traffic Safety Exhibit, Project 62–336," USIS Tunis to USIA Washington, March 19, 1964.

79. "Photographs of Post's Window Displays," USIA Washington to USIS Kampala, January 6, 1966.

80. "ICS/EP: Future Plans—Education in Agriculture and Talking Exhibits," USIS Tunis to USIA Washington, December 20, 1963.

81. "ICS Exhibits: IPS Wireless File: Proposal for more effective use of Wireless File as News-Exhibit," USIS Usumbura to USIA Washington, June 21, 1962; USIA Washington to USIS Usumbura, July 5, 1962.

82. "Sad Saga of the Ice Cream Dispenser," USIS Accra to USIA Washington, February 21, 1967.

83. "Special International Exhibitions, Fourth Annual Report, July 1, 1965—June 30, 1966," Report of the USIA. LMP, Box 21.

84. "IAA/ICS: 'Which of These Countries in Africa Can You Identify?'" USIS Accra to USIA Washington, September 9, 1963.

85. "Exhibit: 1960 Political Map of Africa," USIS Monrovia to USIA Washington, September 7, 1960.

86. Bajorek, *Unfixed*, 150–53.

87. "Photo Exhibit, USIS Lomé," USIS Lomé to USIA Washington, June 9, 1966.

88. "Nigerian Salon of Photography," USIS Lagos to USIA Washington, April 20, 1965.

89. "My visit to train Bangui locals," Will Anderson to PAO, USIS Bangui, July 15, 1965.

90. "Monthly Highlights Report, August 1963," USIS Cotonou to USIA Washington, October 8, 1963. For a comparable approach to the "devolution" of photographic work to local employees, see Buckley, "Cine-film, Film-Strips," 150.

91. This is not to say that field officers were not sensitive to local visual sensibilities, as the following quotation from the afore-mentioned CPAO Handbook makes clear: "Photo selection is also a very sensitive area. Indiscriminate use of photographs can have very considerable repercussions."

92. "Moscow Exhibition of Art Photography—'Africa Today,'" USIS Addis Ababa to USIA Washington, November 19, 1963.

93. *Country Public Affairs Officer Handbook*, USIA, Washington, January 1967. LMP, Box 28.

94. Ibid.

Epilogue

1. Cited in Kratz, "Where Did You Cry?" 230.

2. Johnson, *End of the Second Reconstruction*, 5.

3. "Africa Reacts to George Floyd's Death and US Protests," June 4, 2020. https://www.csis.org/analysis/africa-reacts-george-floyds-death-and-us-protests (accessed April 29, 2021).

4. "Statement of the Chairperson following the murder of George Floyd in the USA," May 29, 2020. https://au.int/en/pressreleases/20200529/statement-chairperson-following-murder-george-floyd-usa (accessed April 29, 2021).

5. The interview is available online: https://edition.cnn.com/videos/us/2020/06/10/cornel-west-george-floyd-cooper-ac360-vpx.cnn (accessed April 29, 2021).

6. The move was reversed by President Joe Biden at the start of his term of office in 2021.

7. "Africa Reacts to George Floyd's Death and US Protests."

8. Mike Davis, "With the Capitol riot the Trumpists have become a de facto third party," *The Guardian*, January 8, 2021. https://www.theguardian.com/commentisfree/2021/jan/08/capitol-riot-republican-party (accessed April 28, 2021).

9. I am grateful to Chris Pinney for this observation with respect to imported print products in India.

10. Förster, "Mirror Images," 87.

11. Hayes and Minkley, *Ambivalent*, 1.

12. See "Cape Town fires: police investigate causes after library damaged," *The Guardian*, April 19, 2021. https://www.theguardian.com/world/2021/apr/19/cape-town-fire-table-mountain-evacuate-university-jagger-library (accessed May 5, 2021). On the condition of colonial photographic archives, see Buckley, "Objects of Love and Decay."

13. Bajorek, *Unfixed*, 241.

14. Ferguson, *Global Shadows*, 166. Ferguson's main point here is that Western anthropologists working in Africa and their informants are often talking at cross-purposes when they speak of the "modern"; the former are usually speaking about cultural practices, the latter about "shamefully inadequate socio-economic conditions and their low global rank in relation to other places" (186).

15. Ibid.

16. Vokes, "Signs of Development."

17. Mbembe, *Out of the Dark Night*, 230.

18. Bajorek, *Unfixed*, 241.

19. Mbembe, *Out of the Dark Night*, 226.

20. Bajorek, *Unfixed*, 264.

21. Mbembe, *Out of the Dark Night*, 230.

22. Azoulay, *Potential History*.

Bibliography

Allbeson, Tom. "Photographic Diplomacy in the Postwar World: UNESCO and the Conception of Photography as a Universal Language, 1946–1956." *Modern Intellectual History* 12, no. 2 (2015): 383–415.

Anderson, Benedict. *Imagined Communities: Reflections on the Origins and Spread of Nationalism.* London: Verso, 1991.

Anderson, Carol. *Bourgeois Radicals: The NAACP and the Struggle for Colonial Liberation, 1941–1960.* Cambridge: Cambridge University Press, 2015.

———. *Eyes Off the Prize: The United Nations and the African American Struggle for Human Rights, 1944–1955.* Cambridge: Cambridge University Press, 2003.

Ariss, Robert M. "An Exhibit Use of Anthropology Man in Our Changing World Los Angeles County Museum, Los Angeles, California." *Museum International* 8, no.2 (1956): 113–24.

Avedon, Richard, and James Baldwin. *Nothing Personal.* Harmondsworth: Penguin, 1964.

Azoulay, Ariella Aïsha. *Civil Imagination: A Political Ontology of Photography.* London: Verso, 2012.

———. "Ending World War II: Visual Literacy Class in Human Rights." In *The Routledge Companion to Literature and Human Rights*, edited by Sophie McClennen and Alexandra Schultheis Moore, 159–72. New York: Routledge, 2016.

———. "*The Family of Man*: A Visual Universal Declaration of Human Rights." In *The Human Snapshot*, edited by Thomas Keenan and Tirdad Zolgahdr, 19–48. Berlin: Sternberg Press, 2013.

———. *Potential History: Unlearning Imperialism.* London: Verso, 2019.

Bajorek, Jennifer. *Unfixed: Photography and Decolonial Imagination.* Durham: Duke University Press, 2020.

Barber, Karin. "Preliminary Notes on Audiences in Africa." *Africa* 67, no. 3 (1997): 347–62.

Barrett, George. "The Centenarian Fon of Bikom Convinces UN Mission That He Needs His 110 Wives." *New York Times*, February 10, 1950.

Barthes, Roland. *Mythologies.* London: Paladin, 1973. First published 1957 by Éditions du Seuil (Paris).

Belmonte, Laura A. *Selling the American Way.* Philadelphia: University of Pennsylvania Press, 2008.

Berger, Martin A. *Freedom Now! Forgotten Photographs of the Civil Rights Struggle.* Berkeley: University of California Press, 2013.

———. *Seeing Through Race: A Reinterpretation of Civil Rights Photography.* Berkeley: University of California Press, 2011.

Bernault, Florence. "What Absence Is Made Of: Human Rights in Africa." In *Human Rights and Revolutions*, edited by Jeffrey N. Wasserstrom, Lynn Hunt, and Marilyn B. Young, 127–41. Lanham, MD: Rowman & Littlefield, 2000.

Bessire, Aimée, and Erin Hyde Nolan. *Todd Webb in Africa: Outside the Frame.* London: Thames & Hudson, 2021.

Bezner, Lili Corbus. *Photography and Politics in America: From the New Deal into the Cold War.* Baltimore: Johns Hopkins University Press, 1999.

Bond, Julian. "Foreword." In *This Light of Ours: Activist Photographers of the Civil Rights Movement*, edited by Leslie G. Kelen, 13–17. Jackson: University Press of Mississippi, 2011.

Borstelmann, Thomas. *The Cold War and the Color Line: American Race Relations in the Global Arena.* Cambridge: Harvard University Press, 2003.

Brattain, Michelle. "Race, Racism, and Anti-racism: UNESCO and the Politics of Presenting Science to the Postwar Public." *American Historical Review* 112, no. 5 (2007): 1386–413.

Bryant, Nick. *The Bystander: John F. Kennedy and the Struggle for Black Equality.* New York: Basic Books, 2006.

Buchloh, Benjamin H. D. "From 'Faktura' to Factography." In *Public Photographic Spaces: Exhibitions of Propaganda from "Pressa" to "The Family of Man," 1928–55*, edited by Jorge Ribalta, 29–61. Barcelona: Museu d'Art Contemporani de Barcelona, 2008. First published as "From Faktura to Factography," *October* 30 (Autumn 1984): 82–119.

Buckley, Liam M. "Cine-Film, Film-Strips and the Devolution of Colonial Photography in The Gambia." *History of Photography* 34, no. 2 (2010): 147–57.

———. "Objects of Love and Decay: Colonial Photographs in a Postcolonial Archive." *Cultural Anthropology* 20, no. 2 (2005): 249–70.

Capshaw, Katharine. *Civil Rights Childhood: Picturing Liberation in African American Photobooks.* Minneapolis: University of Minnesota Press, 2014.

Carson, Clayborne. *In Struggle: SNCC and the Black Awakening of the 1960s.* Cambridge and London: Harvard University Press, 1995.

Center, Seth. "Supranational Public Diplomacy: The Evolution of the UN Department of Public Information and the Rise of Third World Advocacy." In *The United States and Public Diplomacy: New Directions in Cultural and International History*, edited by Kenneth. A. Osgood and Brian C. Etheridge, 135–63. Leiden: Martinus Nijhoff, 2010.

Chakrabarty, Dipesh. *Provincializing Europe: Postcolonial Thought and Historical Difference.* Princeton: Princeton University Press, 2000.

Chatterjee, Partha. *The Politics of the Governed: Reflections on Popular Politics in Most of the World.* New York: Columbia University Press, 2004.

Clark, John Pepper. *America, Their America.* London: Andre Deutsch, 1964.

Colard, Sandrine. "The Afterlife of a Colonial Photographic Archive: The Subjective Legacy of InforCongo." *Critical Interventions* 12, no. 2 (2018): 117–39.

Cooper, Frederick. "Writing the History of Development." *Journal of Modern European History* 8, no. 1 (2010): 5–23.

Cowan, C. D. "A World on the Move: A History of Colonialism and Nationalism in Asia and North Africa from the Turn of the Century to the Bandung Conference" (review). *Bulletin of the School of Oriental and African Studies* 22, nos. 1–3 (1959): 198–99.

Cull, Nicholas J. *The Cold War and the United States Information Agency: American Propaganda and Public Diplomacy, 1945–1989.* Cambridge: Cambridge University Press, 2008.

———. "Film as Public Diplomacy: The USIA's Cold War at Twenty-Four Frames Per Second." In *The United States and Public Diplomacy: New Directions in Cultural and International History*, edited by Kenneth A. Osgood and Brian C. Etheridge, 257–84. Leiden and Boston: Martinus Nijhoff Publishers, 2010.

———. "Public Diplomacy Before Gullion: The Evolution of a Phrase." *CPD Blog* (2006). Accessed February 18, 2021. https://uscpublicdiplomacy.org/blog/public -diplomacy-gullion-evolution-phrase.

———. "Public Diplomacy: Taxonomies and Histories." *Annals of the American Academy of Political and Social Science* 616 (2008): 31–54.

Curtis, Edward E., IV. "'My Heart Is in Cairo': Malcolm X, the Arab Cold War, and the Making of Islamic Liberation Ethics." *Journal of American History* 102, no. 3 (2015): 775–98.

Dadié, Bernard B. *Patron de New York.* Paris: Présence africaine, 1964.

Dentler, Jonathan. *Wired Images: Visual Telecommunications, News Agencies, and the Invention of the World Picture, 1917–1955.* PhD dissertation, University of Southern California, 2020.

De Witte, Ludo. *The Assassination of Lumumba.* Translated by Ann Wright and Renée Fenby. London: Verso, 2002.

Dizard, Wilson P., Jr. *Inventing Public Diplomacy: The Story of the U.S. Information Agency.* Boulder and London: Lynne Rienner Publishers, 2004.

———. *The Strategy of Truth: The Story of the U.S. Information Service.* Washington: Public Affairs Press, 1961.

Djambatan. *A World on the Move: A History of Colonialism and Nationalism in Asia and*

North Africa from the Turn of the Century to the Bandung Conference. Based on an outline prepared by Dr. J. Romein and Dr. W. F. Wertheim, with captions by H. M. Van Randwijk. Amsterdam: Djambatan International Educational Publishing House, 1956.

Dudziak, Mary L. *Cold War Civil Rights: Race and the Image of American Democracy*. Princeton: Princeton University Press, 2011.

Duganne, Erina. "The Photographic Legacy of Lyndon Baines Johnson." *Photography and Culture* 6, no. 3 (2013): 303–23.

———. *The Self in Black and White: Race and Subjectivity in Postwar American Photography*. Hanover: University Press of New England, 2010.

Edwards, Elizabeth. "Photographs and the Sound of History." *Visual Anthropology Review* 21, nos. 1–2 (2005): 27–46.

Eisenbrand, Jochen. "The Politics of Display: Exhibition Design in the Cold War." In *Re-Reading the Manual of Travelling Exhibitions, UNESCO, 1953*, edited by Andreas Müller and Aaron Werbick, 221–26. Leipzig: Spector Books, 2018.

Fackler, Katharina M. "Ambivalent Frames: Rosa Parks and the Visual Grammar of Respectability." *Souls* 18, nos. 2–4 (2016): 271–82.

Ferguson, James. *Global Shadows: Africa in the Neoliberal World Order*. Durham and London: Duke University Press, 2006.

Forman, James. *The Making of Black Revolutionaries*. Seattle: University of Washington Press, 1997.

Förster, Till. "Mirror Images: Mediated Sociality and the Presence of the Future." *Visual Studies* 33, no. 1 (2018): 84–97.

Fraser, Cary. "An American Dilemma: Race and Realpolitik in the American Response to the Bandung Conference." In *Window on Freedom: Race, Civil Rights, and Foreign Affairs 1945–1988*, edited by Brenda Gayle Plummer, 115–40. Chapel Hill: University of North Carolina Press, 2003.

Gavins, Raymond. *The Cambridge Guide to African American History*. New York: Cambridge University Press, 2016.

Gerits, Frank. "Hungry Minds: Eisenhower's Cultural Assistance to Sub-Saharan Africa, 1953–1961." *Diplomatic History* 41, no. 3 (2017): 594–619.

———. "The Ideological Scramble for Africa: The US, Ghanaian, French and British Competition for Africa's Future, 1953–1963."

Doctor of History and Civilization thesis, European University Institute, Florence, 2014.

———. "Jason Parker. *Hearts, Minds, Voices*." *H-Diplo Roundtable Review* XIX, no. 10 (2017): 8–11.

———. "'When the Bull Elephants Fight': Kwame Nkrumah, Non-Alignment, and Pan-Africanism as an Interventionist Ideology in the Global Cold War (1957–66)." *International History Review* 37, no. 5 (2015): 951–69.

Gigliotti, Simone. "Displaced Children of Europe, Then and Now: Photographed, Itinerant and Obstructed Witnesses." *Patterns of Prejudice* 52, nos. 2–3 (2018): 149–71.

Goffe, Leslie. "Friends Salute Mboya's American Airlifts." *New African* (2014). Accessed March 23, 2021. https://newafricanmagazine.com/4195/.

Greenberg, Cheryl Lynn. *A Circle of Trust: Remembering SNCC*. New Brunswick: Rutgers University Press, 1998.

Haley, Alex. "Foreword." In *The Autobiography of Malcolm X*, by Malcolm X, 11–78. London: Penguin, 2007.

Hamlin, Françoise N. *Crossroads at Clarksdale: The Black Freedom Struggle in the Mississippi Delta After World War II*. Chapel Hill: University of North Carolina Press, 2012.

Hart, Justin. *Empire of Ideas: The Origins of Public Diplomacy and the Transformation of U.S. Foreign Policy*. New York: Oxford University Press, 2013.

Hayes, Patricia. "The Colour of History: Photography and the Public Sphere in Southern Africa." In *The Public Sphere from Outside the West*, edited by Divya Dwivedi and Sanil V, 147–63. London: Bloomsbury, 2015.

Hayes, Patricia, and Gary Minkley, eds. *Ambivalent: Photography and Visibility in African History*. Athens: Ohio University Press, 2019.

Hazard, Anthony Q., Jr. *Postwar Anti-Racism: The United States, UNESCO, and "Race," 1945–1968*. New York: Palgrave Macmillan, 2012.

Heiss, Mary Ann. "Exposing 'Red Colonialism': U.S. Propaganda at the United Nations, 1953–1963." *Journal of Cold War Studies* 17, no. 3 (2015): 82–115.

Heron, Matt. "Photographing Civil Rights." In *This Light of Ours: Activist Photographers of the Civil Rights Movement*, edited by Leslie G. Kelen, 19–25. Jackson: University Press of Mississippi, 2011.

Hessler, Julie. "Death of an African Student in Moscow." *Cahiers du monde russe* 47, nos. 1–2 (2006): 33–63.

Hogan, Wesley C. *Many Minds, One Heart: SNCC's Dream for a New America*. Chapel Hill: University of North Carolina Press, 2007.

Hogarth, Christopher. "Diop, Ousmane Socé." In *Dictionary of African Biography*, edited by Henry Louis Gates Jr. and Emmanuel Akyeampong, 209–11. Oxford: Oxford University Press, 2012.

Hoskyns, Catherine. "The African States and the United Nations 1958–1964." *International Affairs* 40, no. 3 (1964): 466–80.

Houston, Benjamin. *The Nashville Way: Racial Etiquette and the Struggle for Social Justice in a Southern City*. Athens and London: University of Georgia Press, 2012.

Iandolo, Alessandro. "The Rise and Fall of the 'Soviet Model of Development' in West Africa, 1957–64." *Cold War History* 12, no. 4 (2012): 683–704.

Jafri, Maryam. *Independence Days*. Cologne: Walther und Franz König, 2021.

James, Sarah. *Common Ground: German Photographic Cultures Across the Iron Curtain*. New Haven: Yale University Press, 2013.

Johnson, Richard. *The End of the Second Reconstruction*. Cambridge: Polity Press, 2020.

Kandeh, Jimmy D. *Coups from Below: Armed Subalterns and State Power in West Africa*. New York: Palgrave Macmillan, 2004.

Katsakioris, Constantin. "The Lumumba University in Moscow: Higher Education for a Soviet-Third World Alliance, 1960–91." *Journal of Global History* 14, no. 2 (2019): 281–300.

Kelen, Leslie G., ed. *This Light of Ours: Activist Photographers of the Civil Rights Movement*. Jackson: University Press of Mississippi, 2011.

Kennedy, John F. "Radio and Television Report to the American People on Civil Rights." In *Public Papers of the Presidents of the United States. John F. Kennedy: Containing the Public Messages, Speeches, and Statements of the President, January 1 to November 22, 1963*, United States Government Printing Office, 468–71. Washington: Office of the Federal Register, National Archives and Records Service, General Services Administration, 1964.

Kiruthu, Felix. "Kaunda, Kenneth." In *Dictionary of African Biography*, edited by Henry Louis Gates Jr. and Emmanuel Akyeampong, 310–12. Oxford: Oxford University Press, 2012.

Kratz, Corinne A. "Where Did You Cry? Crafting Categories, Narratives, and Affect through Exhibit Design." *Kronos: Southern African Histories* 44, no. 1 (2018): 229–52.

Krenn, Michael L. *Black Diplomacy: African Americans and the State Department, 1945–1969*. Armonk: M. E. Sharpe, 1999.

———. "'The Low Key Mulatto Coverage': Race, Civil Rights, and American Public Diplomacy, 1965–1976." In *Reasserting America in the 1970s: U.S. Public Diplomacy and the Rebuilding of America's Image Abroad*, edited by Hallvard Notaker, Giles Scott-Smith, and David J. Snyder, 95–110. Manchester: Manchester University Press, 2016.

Kunkel, Sönke. *Empire of Pictures: Global Media and the 1960s Remaking of American Foreign Policy*. Oxford: Berghahn, 2016.

Lee, Christopher J. "The Decolonising Camera: Street Photography and the Bandung Myth." *Kronos: Southern African Histories* 46, no. 1 (2020): 195–220.

Mahler, Anne Garland. "The Global South in the Belly of the Beast: Viewing African American Civil Rights Through a Tricontinental Lens." *Latin American Research Review* 50, no. 1 (2015): 95–116.

Malcolm X. *The Autobiography of Malcolm X*. London: Penguin, 2007.

Martinez, Elizabeth, ed. *Letters from Mississippi: Reports from Civil Rights Volunteers and Poetry of the 1964 Freedom Summer*. Brookline: Zephyr Press, 2007.

Martins, Susana S. "Circulating Pictures: Photography and Exhibition in the Portuguese Pavilion at Expo 58." *Visual Studies* 34, no. 4 (2019): 364–87.

Maxwell, Anne. *Picture Imperfect: Photography and Eugenics, 1870–1940*. Eastbourne: Sussex Academic Press, 2010.

Mazov, Sergey. *A Distant Front in the Cold War: The USSR in West Africa and the Congo, 1956–1964*. Stanford: Stanford University Press, 2010.

Mazower, Mark. *Governing the World: The History of an Idea*. London: Penguin, 2012.

Mbembe, Achille. *Out of the Dark Night: Essays on Decolonization*. New York: Columbia University Press, 2021.

Meriwether, James H. "'Worth a Lot of Negro Votes': Black Voters, Africa, and the 1960 Presidential Campaign." *Journal of American History* 95, no. 3 (2008): 737–63.

Morris-Reich, Amos. *Race and Photography: Racial Photography as Scientific Evidence, 1876–1980*. Chicago: University of Chicago Press, 2016.

———. "Race, Ideas, and Ideals: A Comparison of Franz Boas and Hans F. K. Günther." *History of European Ideas* 32, no. 3 (2006): 313–32.

Morton, Christopher, and Darren Newbury, eds. *The African Photographic Archive: Research and Curatorial Strategies*. London: Bloomsbury, 2015.

Moser, Gabrielle. "Photographing Imperial Citizenship: The Colonial Office Visual Instruction Committee's Lanternslide Lectures, 1900–1945." *Journal of Visual Culture* 16, no. 2 (2017): 190–224.

———. *Projecting Citizenship: Photography and Belonging in the British Empire*. University Park: Pennsylvania State University Press, 2019.

Muehlenbeck, Philip E. *Betting on the Africans: John F. Kennedy's Courting of African Nationalist Leaders*. New York: Oxford University Press, 2012.

———. *Czechoslovakia in Africa, 1945–1968*. Houndmills: Palgrave Macmillan, 2016.

———. "John F. Kennedy's Courting of African Nationalism." *Madison Historical Review* 2, no. 1 (2004).

———. "Kennedy and Touré: A Success in Personal Diplomacy." *Diplomacy and Statecraft* 19, no. 1 (2008): 69–95.

Müller, Andreas, and Aaron Werbick, eds. *Re-Reading the Manual of Travelling Exhibitions, UNESCO, 1953*. Leipzig: Spector Books, 2018.

Nash, Mark. *Red Africa: Affective Communities and the Cold War*. London: Black Dog Publishing. 2016.

Natanson, Nicholas. *The Black Image in the New Deal: The Politics of FSA Photography*. Knoxville: University of Tennessee Press, 1992.

———. "Old Frontiers, New Frontiers: Reassessing USIA and State Department Photography of the Cold War Era." Paper presented at *The Power of Free Inquiry and Cold War International History*, National Archives, College Park, Maryland, September 25–26, 1998. Accessed February 14, 2021. https://www.archives.gov/research/foreign-policy/cold-war/conference/natanson.html.

Neary, John. *Julian Bond: Black Rebel*. New York: William Morrow & Company, 1971.

Newbury, Darren. "Ernest Cole and the South African Security Police." *History of Photography* 35, no. 1 (2011): 76–79.

———. "Ernest Cole's *House of Bondage*, the United States Information Agency, and the Cultural Politics of Race in the Cold War." In *Cold War Camera*, edited by Thy Phu, Erina Duganne, and Andrea Noble, 33–65. Durham: Duke University Press, 2023.

Newell, Stephanie. "The Last Laugh: African Audience Responses to Colonial Health Propaganda Films." *Cambridge Journal of Postcolonial Literary Inquiry* 4, no. 3 (2017): 347–61.

———. "Local Cosmopolitans in Colonial West Africa." *Journal of Commonwealth Literature* 46, no. 1 (2011): 103–17.

———. "Paradoxes of Press Freedom in Colonial West Africa." *Media History* 22, no. 1 (2016): 101–22.

———. "Screening Dirt: Public Health Movies in Colonial Nigeria and Rural African Spectatorship in the 1930s and 1940s." *Social Dynamics* 44, no. 1 (2018): 6–20.

Nzewi, Ugochukwu-Smooth C. "The Contemporary Present and Modernist Past in Postcolonial African Art." *World Art* 3, no. 2 (2013): 211–34.

O'Donnell, Therese. "Executioners, Bystanders and Victims: Collective Guilt, the Legacy of Denazification and the Birth of Twentieth-Century Transitional Justice." *Legal Studies* 25, no. 4 (2005): 627–67.

Ogbar, Jeffrey, O. G. *Black Power: Radical Politics and African American Identity*. Baltimore: Johns Hopkins University Press, 2004.

Olick, Jeffrey K. *In the House of the Hangman: The Agonies of German Defeat, 1943–1949*. Chicago: Chicago University Press, 2013.

Parker, Jason. "Cold War II: The Eisenhower Administration, the Bandung Conference, and the Reperiodization of the Postwar Era." *Diplomatic History* 30, no. 5 (2006): 867–92.

———. *Hearts, Minds, Voices: US Cold War Public Diplomacy and the Formation of the Third World*. New York: Oxford University Press, 2016.

Parks, Gregory S. "'Lifting as We Climb': The American Council on Human Rights and the Quest for Civil Rights." *American University Journal of Gender, Social Policy and the Law* 25, no. 3 (2017): 261–325.

Phillips, Christopher. "Steichen's 'Road to Victory.'" In *Public Photographic Spaces:*

Exhibitions of Propaganda from "Pressa" to "The Family of Man," 1928–55, edited by Jorge Ribalta, 367–78. Barcelona: Museu d'Art Contemporani de Barcelona, 2008.

Phu, Thy, Erina Duganne, and Andrea Noble, eds. *Cold War Camera*. Durham: Duke University Press, 2023.

Plummer, Brenda Gayle, ed. *Window on Freedom: Race, Civil Rights, and Foreign Affairs 1945–1988*. Chapel Hill: University of North Carolina Press, 2003.

Pohlmann, Ulrich. "El Lissitzky's Exhibition Designs: The Influence of his Work in Germany, Italy, and the United States, 1923–43." In *Public Photographic Spaces: Exhibitions of Propaganda from "Pressa" to "The Family of Man," 1928–55*, edited by Jorge Ribalta, 167–90. Barcelona: Museu d'Art Contemporani de Barcelona, 2008.

Raiford, Leigh. *Imprisoned in a Luminous Glare: Photography and the African American Freedom Struggle*. Chapel Hill: University of North Carolina Press, 2011.

Rand, Christopher. "Book Reviews." *Journal of Asian Studies* 16, no. 4 (1957): 595–97.

Reeves, Richard. *President Kennedy: Profile of Power*. New York: Simon & Schuster, 1993.

Ribalta, Jorge. *Public Photographic Spaces: Exhibitions of Propaganda from "Pressa" to "The Family of Man," 1928–55*. Barcelona: Museu d'Art Contemporani de Barcelona, 2008.

Rice, Tom. "Exhibiting Africa: British Instructional Films and the Empire Series (1925–8)." In *Empire and Film*, edited by Lee Grieveson and Colin MacCabe, 115–33. Houndmills: Palgrave Macmillan, 2011.

———. "From the Inside: The Colonial Film Unit and the Beginning of the End." In *Film and the End of Empire*, edited by Lee Grieveson and Colin MacCabe, 135–53. Houndmills: Palgrave Macmillan, 2011.

Rich, Jeremy. "Adoula, Cyrille." In *Dictionary of African Biography*, edited by Henry Louis Gates Jr. and Emmanuel Akyeampong, 95–96. Oxford: Oxford University Press, 2012.

Röderer, Fabian. "How to Educate the World: UNESCO's Human Rights Exhibition Album (1950) as an Educational Device." In *Image Journeys: The Warburg Institute and a British Art History*, edited by Joanne W. Anderson, Mike Finch, and Johannes von Müller, 77–87. Passau: Dietmar Klinger Verlag, 2019.

Rogers, Alan. "Passports and Politics: The Courts and the Cold War." *The Historian* 47, no. 4 (1985): 497–511.

Romano, Renee. "No Diplomatic Immunity: African Diplomats, the State Department, and Civil Rights, 1961–1964." *Journal of American History* 87, no. 2 (2000): 546–79.

Ryan, Barry J. *Statebuilding and Police Reform: The Freedom of Security*. London: Routledge, 2011.

Ryan, James R. *Picturing Empire: Photography and The Visualization of the British Empire*. Chicago: Chicago University Press, 1998.

Rydell, Robert W. *World of Fairs: The Century-of-Progress Expositions*. Chicago: University of Chicago Press, 1993.

Sandeen, Eric. "'The Show You See with Your Heart': 'The Family of Man' on Tour in the Cold War." In *Public Photographic Spaces: Exhibitions of Propaganda from "Pressa" to "The Family of Man," 1928–55*, edited by Jorge Ribalta, 471–86. Barcelona: Museu d'Art Contemporani de Barcelona, 2008.

Sanders, James. "The Spearpoint Pivoted." In *House of Bondage*, by Ernest Cole, 21–28. New York: Aperture, 2022.

Saunders, Frances Stonor. 2013. *The Cultural Cold War: The CIA and the World of Arts and Letters*. New York: The New Press, 2013.

Schmidt-Linsenhoff, Viktoria. "Denied Images: *The Family of Man* and the Shoa." In *The Family of Man 1955–2001. Humanism and Postmodernism: A Reappraisal of the Photo Exhibition by Edward Steichen*, edited by Jean Back and Viktoria Schmidt-Linsenhoff, 81–99. Marburg: Jonas Verlag, 2004.

Schneider, Jürg. "Views of Continuity and Change: The Press Photo Archives in Buea, Cameroon." *Visual Studies* 33, no. 1 (2018): 28–40.

Schwartz, Barry. "Collective Memory and History: How Abraham Lincoln Became a Symbol of Racial Equality." *Sociological Quarterly* 38, no. 3 (1997): 469–96.

Schwenk-Borrell, Melinda M. *Selling Democracy: The Unites States Information Agency's Visual Portrayal of American Race Relations, 1953–1976*. PhD dissertation, University of Pennsylvania, 2004.

Shorr, Howard. "'Race Prejudice Is Not Inborn: It Is Learned': The Exhibit Controversy at the Los Angeles Museum of History, Science and Art, 1950–1952." *California History* 69, no. 3 (1990): 276–83.

Sluga, Glenda. "UNESCO and the (One) World of Julian Huxley." *Journal of World History* 21, no. 3 (2010): 393–418.

Smith, Jessie Carney. *Black Firsts: 2,000 Years of Extraordinary Achievements*. Detroit: Visible Ink Press, 1994.

Speltz, Mark. *North of Dixie: Civil Rights Photography Beyond the South*. Los Angeles: The J. Paul Getty Museum, 2016.

Stephens, Robert F. *Kenyan Student Airlifts to America 1959–1961: An Educational Odyssey*. Nairobi: East African Educational Publishers, 2013.

Stimson, Blake. *The Pivot of the World: Photography and its Nation*. Cambridge: MIT Press, 2006.

Stoner, John C. "Selling America Between Sharpeville and Soweto: The USIA in South Africa, 1960–76." In *Reasserting America in the 1970s: U.S. Public Diplomacy and the Rebuilding of America's Image Abroad*, edited by Hallvard Notaker, Giles Scott-Smith, and David J. Snyder, 163–77. Manchester: Manchester University Press, 2016.

Swensen, James. "A Strategy of Truth: Andreas Feininger and the Creation of Propaganda for the Office of War Information, 1942." *History of Photography* 43, no. 1 (2019): 84–109.

Taussig, Michael. *What Color Is the Sacred?* Chicago: Chicago University Press, 2009.

Teal, Orion A. "The Moral Economy of Postwar Radical Interracial Summer Camping." In *The Economic Civil Rights Movement: African Americans and the Struggle for Economic Power*, edited by Michael Ezra, 58–74. New York: Routledge, 2013.

Terretta, Meredith. "From Below and to the Left? Human Rights and Liberation Politics in Africa's Postcolonial Age." *Journal of World History* 24, no. 2 (2013): 389–416.

———. "'We Had Been Fooled into Thinking that the UN Watches Over the Entire World': Human Rights, UN Trust Territories, and Africa's Decolonization." *Human Rights Quarterly* 34, no. 2 (2012): 329–60.

Thompson, Drew A. "Visualising FRELIMO's Liberated Zones in Mozambique, 1962–1974." *Social Dynamics* 39, no. 1 (2013): 24–50.

Thompson, W. Scott. *Ghana's Foreign Policy 1957–1966: Diplomacy Ideology, and the New State*. Princeton: Princeton University Press, 1969.

Turner, Fred. "*The Family of Man* and the Politics of Attention in Cold War America." *Public Culture* 24, no. 1 (2012): 55–84.

United Nations. *Looking at the United Nations*. New York: United Nations Department of Public Information, 1952.

United States Government Printing Office. *John F. Kennedy: Containing the Public Messages, Speeches, and Statements of the President, January 20 to December 31, 1961*. Washington: Office of the Federal Register, National Archives and Records Service, General Services Administration, 1962.

Vidyarthi, Shravan and Erin Haney. *Priya Ramrakha: The Recovered Archive*. Heidelberg: Kehrer Verlag, 2018.

Visser-Maessen. *Robert Parris Moses: A Life in Civil Rights and Leadership at the Grassroots*. Chapel Hill: University of North Carolina Press, 2016.

Vitalis, Robert. "The Midnight Ride of Kwame Nkrumah and Other Fables of Bandung (Ban-doong)." *Humanity: An International Journal of Human Rights, Humanitarianism, and Development* 4, no. 2 (2013): 261–88.

Vokes, Richard. *Media and Development*. London: Routledge, 2017.

———. "On 'the Ultimate Patronage Machine': Photography and Substantial Relations in Rural South-western Uganda." In *Photography in Africa: Ethnographic Perspectives*, edited by Richard Vokes, 207–28. Woodbridge: James Currey, 2012.

———. "Photography, Exhibitions and Embodied Futures in Colonial Uganda, 1908–1960." *Visual Studies* 33, no. 1 (2018): 11–27.

———. "Signs of Development: Photographic Futurism and the Politics of Affect in Uganda." *Africa* 89, no. 2 (2019): 303–22.

Vokes, Richard, Derek R. Peterson, and Edgar C. Taylor. "Photography, Evidence and Concealed Histories from Idi Amin's Uganda, 1971–79." *History of Photography* 44, nos. 2–3 (2020): 151–71.

Vučetić, Radina, and Paul Betts, eds. *Tito in Africa: Picturing Solidarity*. Belgrade: Museum of Yugoslavia, 2017.

Wang, Jian. "Telling the American Story to the World: The Purpose of U.S. Public Diplomacy in Historical Perspective." *Public Relations Review* 33 (2007): 21–30.

Weiss-Wendt, Anton, ed. *Documents on the Genocide Convention from the American, British, and Russian Archives*. London: Bloomsbury, 2018.

Wendl, Tobias. "Entangled Traditions: Photography and the History of Media in Southern Ghana." *RES: Anthropology and Aesthetics* 39 (2001): 78–101.

Wilder, Gary. *Freedom Time: Negritude, Decolonization and the Future of the World*. Durham: Duke University Press, 2015.

Wolbring, Barbara. "Nationales Stigma und Persönliche Schuld: Die Debatte über Kollektivschuld in der Nachkriegszeit." *Historische Zeitschrift* 289, no. 2 (2009): 325–64.

Yayoh, Wilson. "Local Black Resistance Against Colonial Integration of Ewedome (British Trust Territory), 1951–1956." In *Fight for Freedom: Black Resistance and Identity*, edited by Moussa Traoré and Tony Talburt, 78–105. Legon-Accra: Sub-Saharan Publishers, 2017.

Zamir, Shamoon. "Structures of Rhyme, Forms of Participation: *The Family of Man* as Exhibition." In *The Family of Man Revisited: Photography in a Global Age*, edited by Gerd Hurm, Anke Reitz, and Shamoon Zamir, 133–58. London: I. B. Tauris in association with Centre National de l'Audiovisuel (CNA), Luxembourg, 2018.

Index